Symbol and Image in Celtic Religious Art

Miranda J. Green

Routledge

London and New York

First published 1989
by Routledge
11 New Fetter Lane, London EC4P 4EE
29 West 35th Street, New York, NY 10001

Typeset in 10/12pt Times Compugraphic
by Colset Private Ltd, Singapore
Printed in Great Britain
by T.J. Press, Padstow, Cornwall

British Library Cataloguing in Publication Data
Green, Miranda
 Symbol and image in Celtic religious art.
 1. Celtic, religious, visual, arts.
 Symbolism
 I. Title
 708.9364

 ISBN 0–415–03419–1

Library of Congress Cataloging in Publication Data
Green, Miranda J.
 Symbol and image in Celtic religious art.

 Bibliography: p.
 Includes index.
 1. Art, Celtic—Gaul—Roman influences. 2. Gods,
Celtic, in art. 3. Symbolism in art. I. Title.
N6842.G7 1989 730'.09364 88–35729

Cyflwynaf y gyfrol hon
i goffadwriaeth
John Legonna

I dedicate this book
to the memory of
John Legonna

and to John Ferguson
'fortis vir sapiensque'
with love and gratitude

Contents

List of illustrations

Maps

In the earliest times, which were so susceptible to vague speculation and the inevitable ordering of the universe, there can have existed no division between the poetic and the prosaic. Everything must have been tinged with magic. Thor was not the god of Thunder; he was the thunder and the god.

Jorge Luis Borges, 'The Gold of the Tigers'

Preface

This book has come about through the first John Legonna Celtic Research Prize, which was awarded to me by the National Library of Wales, Aberystwyth in March 1986. John Legonna (1918–78) was a celtophile whose father was Cornish and his mother Welsh. He had a lifelong commitment to the promotion of the identity of Wales and of all the Celtic countries. In 1971 John Legonna made a gift of his farm and lands at Pen Rhos Fach and 'Chastell Cadwaladr' at Llanrhystud near Aberystwyth to the National Library of Wales, in order to establish the John Legonna Celtic Research Prize. This he intended to foster Celtic studies and to enable scholars awarded it to pursue further research within their chosen field. The prize has enabled me to spend several weeks studying Celtic religious iconography in European museums and, consequently, to write *Symbol and Image in Celtic Religious Art*. It is for this reason that I have dedicated this book to the memory of John Legonna.

By the later first millennium BC the Celts had occupied much of Europe and had penetrated into Asia Minor, where they settled in Galatia (Map 1). By the early first millennium AD much of this Celtic territory had fallen under Roman domination. This book is primarily concerned with the pagan religious iconography of the main Celtic heartland of Gaul between *circa* 500 BC and AD 400. Detailed reference is made to Britain but, since the British material is relatively well documented and has been the subject of a number of recent surveys, most of my evidence for the present work has been collected from research in France, the Netherlands, and the Rhineland. The majority of the iconography examined here dates to the period of Roman influence on Celtic lands. My concern here is not with Celtic religion as a whole but with the contribution made by the divine images presented in the iconography to the interpretation of Celtic belief-systems. This is of especial interest because of the conflation of the Roman and Celtic cultures to form a distinctive Romano-Celtic tradition of cult-expression. It is this tradition which forms the focus of the present work.

Acknowledgements

I should like to express my gratitude to the following individuals and institutions: first the National Library of Wales, Aberystwyth for awarding me the John Legonna Celtic Research Prize, which made it possible for me to undertake the research for this book; in particular, I should like to thank the three assessors for the award: Dr Brynley Roberts, Librarian of the National Library of Wales; Professor Geraint Gruffydd, Director of the Centre for Advanced Welsh and Celtic Studies; and Professor Ellis Evans, Professor of Celtic, Jesus College, Oxford. I am also grateful to Professor John Ferguson and Dr Terry Thomas for their support; the central staff of the Open University and the staff of the Open University in Wales, who made it possible for me to take research leave in order to complete the work; Paul Jenkins of the Design Department of the National Museum of Wales, who drew the line-illustrations; Betty Naggar, who provided Figures 87, 88 and 92. Most of all, I wish to thank Stephen Green for his most generous help and encouragement in all aspects of the work.

The following institutions are thanked for allowing me access to their collections, for their help in the research and for permission to photograph and publish their material: Aix-en-Provence, Musée Granet; Alise-Sainte-Reine, Musée Archéologique; Autun, Musée Lapidaire, Musée Rolin; Bath, Roman Baths Museum; Beaune, Musée des Beaux Arts, Musée de Beffroi; Bonn, Rheinisches Landesmuseum; Cardiff, National Museum of Wales (copyright Figures 14, 90); Chalon-sur-Saône, Musée Denon; Châtillon-sur-Seine, Musée Archéologique (Figure 84); Chaumont, Musée Archéologique; Cirencester, Corinium Museum (Figures 39, 83); Copenhagen, National-museet (Figure 1); Daoulas, Abbaye de; Dijon, Musée Archéologique (Figure 70); Gloucester, City Museum (Figure 22); Graz, Landesmuseum Joanneum (Figure 56); Köln, Römisch-Germanisches Museum; Leiden, Rijksmuseum van Oudheden (Figures 2–4); Marseille, Musée Borély; Metz, Musée d'Art et d'Archéologie; Newcastle, University Museum of Antiquities (Figure 41); Nîmes, Musée Archéologique (Figure 30); Orléans,

Musée des Beaux-Arts (Figures 55, 59, 63); Paris, Musée de Cluny; Poitiers, Musée Saint-Croix; Reims, Musée Saint-Rémi; Rennes, Musée de Bretagne; St-Germain-en-Laye, Musée des Antiquités Nationales (Figures 36, 44, 46); St-Rémy-de-Provence, Musée des Alpilles; Saintes, Musée Archéologique; Senlis, Musée d'Art et d'Archéologie; Strasbourg, Musée d'Archéologie, Château des Rohan (Figure 43); Stuttgart, Württembergisches Landesmuseum (Figure 51); Toulouse, Musée Saint Raymond; Tours, Hôtel Guain; Trier, Rheinisches Landesmuseum;Zürich, Landesmuseum (Figure 58).

1

Prologue

Most of our knowledge of Celtic religion derives from iconography and epigraphy dating to the Roman period. This is augmented by both classical and vernacular Celtic (Irish and Welsh) literary material, though much of the latter is chronologically too late in its extant form to be useful. In addition to the inevitable interpretative bias of the Graeco-Roman authors, their writings dwell largely on ritual rather than the nature of belief-systems. Thus, although the Druids and sacrificial ceremonial are discussed at length by such commentators as Strabo and Caesar, there is little mention of the gods themselves. In the pre-Roman period, the elaborate character of many Iron Age graves attests only the strong belief in an afterlife, endorsed by contemporary Mediterranean observers. Once again we are brought no closer to the deities of the Celtic world.

In general, Iron Age Celts did not possess the tradition of consistent physical representation of their divinities. There are some images dating to this early phase: two main clusters, in southern Gaul near the Greek colony of Massilia (Marseille) and the Rhineland, may be particularly identified, and there is other early iconography too. But the presence of divine images vastly increases under the influence of Rome when the stimulus of mimetic representation applied to previously tacit, aniconic divine concepts brings the Celtic gods into sharp focus for the first time. Certain scholars, indeed, believe that these gods may have come into existence only after Celtic submission to Rome and the formation of the Romano-Celtic provinces. But the fully developed nature of these divinities early in the Roman period, combined with archaeological evidence, demonstrates that many of these beings must have been present as concepts in the earlier 'free' Celtic phase. Unsupported by written sources from the Celts themselves, who were virtually illiterate, iconography is both ambiguous and potentially misleading. None the less, certain features of Celtic symbolism are sufficiently distinctive to suggest recurrent patterns of religious thought-processes. It is these which are my prime concern in succeeding chapters.

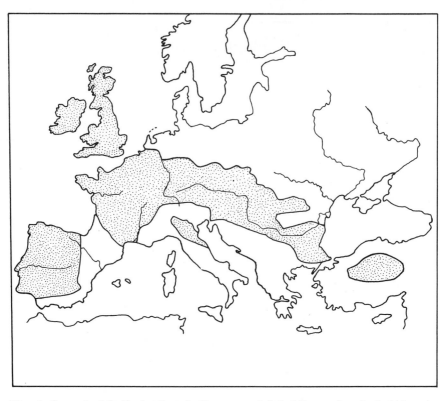

Map 1 Spread of Celtic territory in Europe and Asia Minor: after J. de Vries, *La Religion des Celtes*, 1963.

The Celts and the gods

During both the pre-Roman 'free' Celtic and the Roman phases, the pagan peoples of Gaul and Britain consisted essentially of rural societies whose economies, unsheltered by the protective screen of urban life, were pre-occupied with such observable natural phenomena as the behaviour of the seasons, the weather, and the cosmo-celestial activities of the sun, thunder, lightning and rain. All these forces were apparently supernatural and at times capricious; naturally they were objects of fear, wonder, veneration, and worship, not least because the Celtic livelihood was so immediately dependent upon the fertility of crops and domestic beasts, themselves in turn reliant upon sun and rain.

This focus upon the natural environment is reflected in Celtic religious symbolism. While the Celts had a multiplicity of deities, as evidenced by inscriptions of the Roman period and by the very varied iconographic types, the dominant powers were those of the sky, weather, and fertility and the

2

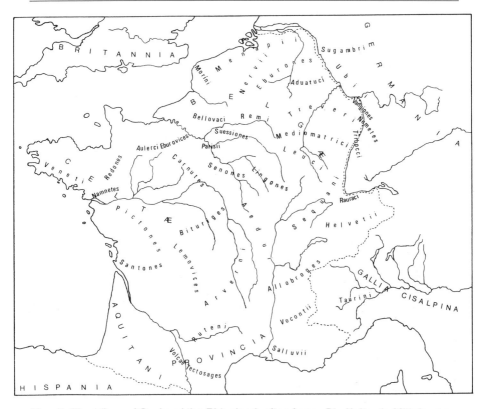

Map 2 The tribes of Gaul and the Rhineland: after Anon, *Die Kelten in Mitteleuropa*, 1980.

land. The imagery and symbolism of cult-expression reflects these religious *foci*. Many divinities were closely associated with topography – with mountains, lakes and springs – and others wielded the elemental forces of the cosmos. The close ties with the natural world are seen also in the prominent tradition of animal symbolism: in a Celtic milieu, beasts assumed a dominant role, frequently representing an aspect of belief unaccompanied by any humano-divine image.

Regional differences in belief (Maps 2–8)

In a tribal, rural society where communications could be slow and difficult, it was inevitable that local conservatism should manifest itself in religious belief and express itself in iconography. Many Celtic deities appear to have been tribal protectors who, according to Irish legend, married the local goddess of the land and together watched over particular areas. In fact it is possible to recognize several strata in the divine hierarchy or pantheon.

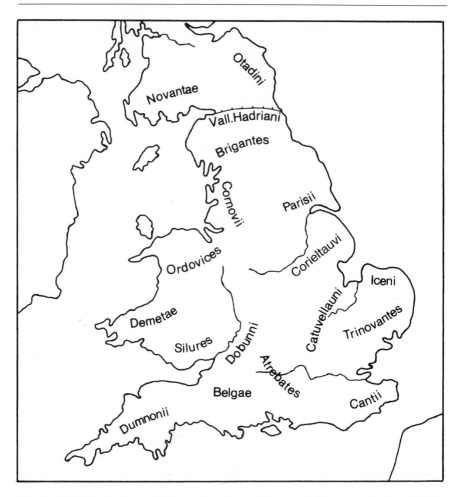

Map 3 Tribal territories in Britain: after J. de Vries, *La Religion des Celtes*, 1963.

Certain divine concepts, namely, sky-gods, sun-gods, and the mother-goddesses, transcended regional boundaries and appear to have been worshipped all over the Celtic world. But even here regional preferences in symbolism and representation may be distinguished. For instance, the sky-god appears as a warrior-horseman in north-east Gaul and the Rhineland; in the lower Rhône Valley of Provence, the symbolism is explicitly solar and the sky-god image is projected by his sun-wheel; but in the Pyrenees the celestial deity is represented by a different solar symbol – the swastika. Similar diversity is reflected in the iconography associated with the mother-goddess cults. In many areas the mothers are presented as a triple image, but in Burgundy the maternal role of the triad is emphasized by the depiction of

4

nursing babies, swaddling clothes, and bathing apparatus. By contrast, the triple goddesses in the Rhineland are portrayed as two solemn middle-aged matrons flanking a young girl and all carrying not emblems of human fertility but fruits symbolic of the productive earth. The horse-goddess Epona is supraregional but specific to Burgundy is her depiction on a mare with a suckling foal. Other divine images have discrete distributions: the Gaulish hammer-god appears particularly in Lorraine and in the Rhône Valley between Burgundy and Nîmes. The antlered god belonged principally to north-east and central Gaul. The triple-headed form of image was especially beloved of the Remi. In Britain, the hooded triplets (the *genii cucullati*) are associated above all with the Dobunni of the Cotswolds and the area of Hadrian's Wall. In the lowest stratum of the divine hierarchy, we have the very localized spirits, perhaps occurring only once and associated with a particular village, spring, or tree.

Symbolism and divine images

This book is primarily concerned with the physical, visual expression of the divine, with the images people envisaged and projected of supernatural entities and with the animate and inanimate symbols with which pagan Celts endowed their depictions of the gods. It is the accompanying symbols which frequently give clues to a deity's function or identity. Sometimes an emblem or attribute may be of a general character, like a *cornucopiae*, shared by several different gods, imbuing them with a fertility and prosperity function. Other emblems may be divinity-specific, like the wheel of the sun-god or the hammer-god's attribute. Epona always has an equine companion; Nehalennia is nearly always portrayed with a dog. All these symbols enhance the image of a divine representation. Sometimes the symbolism is contained within the divine depiction itself – the triple-headed image or the antlered Cernunnos are examples of this. Again such symbolism is there to identify, to enhance, extend or project a message to the beholder.

We have to enquire as to what is the function of a created image. Religious representation may serve several purposes, not necessarily all mutually exclusive or distinct. A stone carving of a deity placed in a shrine may possess a function that is different from its placement in a domestic or sepulchral context. A depiction of a god in a temple may be the cult-image, which means that originally at least the divinity was considered as residing within that image. Perhaps a carving was not always seen as housing the god specifically, but was sometimes set up to demonstrate reverence and honour to the deity by symbolic physical representation, in exactly the same manner as the erection of a statue may commemorate a revered human individual at the present day. An image could be created and established within a shrine as a focus of worship, its presence serving to channel the attention of the devotee and to stimulate thoughts about the divine. All of these functions may be true,

especially of the more monumental portrayals. Liturgical items such as sceptres or vessels may well have been invested with sanctity or holy power; they were directly employed in the service of the gods. The role and status of personal items is more complex: figurines may be regarded as straightforward divine images, with the same function as monumental depictions, writ small. But items like jewellery will have combined sacred and secular functions.

If cult-images were visual expressions of belief, we need to clarify the responsibilities involved in their production. At least two individuals were generally associated with their creation – the initiator and the executor. We have on the one hand the patron-purchaser-dedicant and on the other the artist-craftsman. Both would be key figures in determining the type of image; both would need to be in sympathy with the form of image required. The symbolic content would be a matter of conscious choice by people who were fully cognizant with the means best employed in endowing a cult-object with the greatest potency. Related to this point is the matter of methods of physical cult-expression. Some parts of this book are concerned with the way images were portrayed rather than the symbols themselves. Certain stylistic traditions may be identified which veer away from realistic depictions of human and animal images. This may be achieved by means of plurality, exaggeration, or schematism. But each tradition was meaningful and possessed a definite purpose. In general, it is fair to say that this divergence from naturalism in art-style is the result of Celtic influences.

Celt and Roman

With the exception of material which demonstrably dates to well before the Roman period, the iconographic form in which the evidence for Celtic religious art is preserved owes a great deal to Mediterranean artistic tradition. But the concepts which are expressed in this art and which underlie it are often no more Roman than Iron Age. Celtic art (which owes so much of its inspiration to external influences) is anything but Celtic. In the Romano-Celtic phase, there is a shifting balance in the iconographic and religious contributions of the Celtic and the Graeco-Roman world. The Romans brought to Celtic lands the recurrent tradition of representing deities by images which were more or less mimetic, where artists used naturalistic human and animal models as the basis for image-projection. Alongside this tradition was that of epigraphy – giving the gods names which were inscribed in the Latin alphabet, names which were sometimes associated with these images and sometimes alone. Lastly, the Romans introduced divine concepts which were on occasions absorbed and adapted by indigenous belief-systems. Succeeding chapters present the full gamut of hybridization: at one end of the spectrum are such divine entities as Apollo and Mercury who often apparently retain their Mediterranean identity as far as icono-

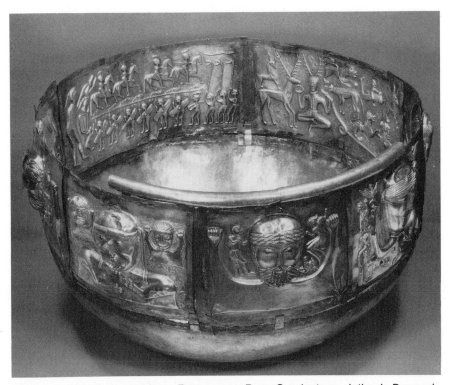

Figure 1 Gilt silver cauldron: Raevemose Bog, Gundestrup, Jutland, Denmark. Fourth/second century BC. Nationalmuseet, Copenhagen. Diameter 69cm. Photograph: Nationalmuseet, Copenhagen.

graphy is concerned, but who adopt alien native epithets and Celtic consorts who owe nothing to the Roman world. At the other are the semi-monstrous images – like the antlered god and the triple-headed Remic deity. In between are representations of gods whose symbolic content may owe little to the classical world – the hammer-god and Epona fall into this category; Sucellus' hammer is probably not of Graeco-Roman origin and neither is Epona's mare. The mother-goddesses owe rather more to Mediterranean iconography: but for their frequent triplism, they often strongly resemble Roman maternal concepts and indeed the *cornucopiae*, ubiquitous symbol of prosperity/fertility among Romano-Celtic deities, is entirely classical in origin. Nevertheless, the image of the triple mother-goddess owes its presence essentially to Celtic religious traditions.

Some images of Celtic divinities occur for the first time under Roman influence. The mother-goddesses, Nehalennia, divine couples and many more image-types cannot be traced prior to the Roman period. But others may be found in the – albeit comparatively rare – stonework of southern

7

Gaul and the Rhineland, in the rich iconographic area of Celtic coinage and the unique cauldron from Gundestrup in Jutland (Figure 1). This controversial cult-vessel, made of over 90 per cent pure silver, originally gilded and with a capacity of 130 litres, may have been manufactured in Thrace in the fourth or third century BC. But despite its provenance and its possible origins, the cauldron may well have been a Celtic liturgical object. Some of the images fashioned in repoussé on its inner and outer plates – the antlered deity, the wheel-god and the ram-horned serpent for instance – are too idiosyncratic to belong other than to the Celtic world. All of these image-types have close parallels in later, Romano-Celtic, cult-iconography. Finally, there is the evidence of the wooden images from Celtic healing springs, dating to around the time of the Roman conquest, precursors of the stone votive carvings which were offered to the resident curative divinity during the Romano-Celtic phase. These, and other scattered and often insecurely dated but stylistically similar wooden images which are lucky survivals in water-logged contexts, are suggestive of a wealth of iconography which has not survived, perhaps examples of similar Celtic images to those placed in a sacred grove near Massilia which have been immortalized by the Roman poet Lucan:

> . . .simulacraque maesta deorum
> Arte carent caesisque extant informia truncis.
> Ipse situs putrique facit iam robore pallor
> Attonitos; non vulgatis sacrata figuris
> Numina sic metuunt: tantum terroribus addit,
> Quos timeant, non nosse deos

> 'The images were stark, gloomy blocks of
> unworked timber, rotten with age, whose
> ghastly pallor terrified their devotees –
> quite another matter from our own rustic
> statues which are too familiar to cause alarm'
>
> (Lucan, *Pharsalia*, III, 412–17)

2

The female image

This chapter concerns the feminine principle in Celtic cult-expression. I exclude here the multiple deities such as the three mothers, since they are discussed as a distinct group elsewhere (Chapter 6). The goddesses considered here are multifarious and performed a number of varying but interrelated functions. The evidence upon which I concentrate is the symbolism implicit in the art-form. However, other factors are taken into account where relevant: thus the names of goddesses, when given epigraphically, may be helpful, especially where such a name recurs frequently – like that of Epona or Nehalennia, or where the name itself conveys symbolism – like that of Rosmerta ('the Great Provider'). In this way, the name may give a clue to identity which may reinforce the deity's interpretation as inferred from the iconography, or the name may add a new dimension in understanding role and function. The other main factor is context: once again, the circumstance of discovery may endorse iconographic interpretation or may, instead, suggest new ideas concerning the function of an image. Thus the finding of a mother-goddess relief at a healing-spring sanctuary may inform us that her sphere of influence extended beyond the purely maternal. Likewise a mother-image occurring in a grave suggests an important sepulchral dimension to the goddess as a protectress after death.

The overwhelming message which comes across from the iconography is the maternal character of the Celtic goddesses. This maternalism itself embraced a wide range of activities. It included many facets of life – birth, adolescence, maturity, fertility, healing, regeneration, protection against all manner of evil, and indeed continued to take a hand in the destiny of humankind even after death.

The dominance of the mother-cult, and the ubiquity of her images, argues for a society in which the female principle was important. I have suggested elsewhere[1] that women played a fundamental role within Celtic society: we have Graeco-Roman literary evidence for this,[2] and it is interesting that polyandry was practised in Britain.[3] It may be that Celtic mother-goddess

symbolism was the product of a sedentary, perhaps even a matrilinear, society. Certainly the vast numbers of images – ranging from large cult-statues in shrines to small, cheap, mass-produced personal clay figurines – argue for her universal adoption throughout the pagan Celtic world.

In Romano-Celtic Europe, effigies of goddesses whose imagery reflects fertility and prosperity cluster in certain regions and sometimes have very distinctive forms. For instance, Normandy has a particular concentration of small pipe-clay figures and in the Charente area of western Gaul, among the tribe of the Santones, the mother-goddess is represented particularly in double form. In Gallia Narbonensis, images are few but epigraphic evidence for maternal goddesses is common.[4] A named goddess concerned with the protection of seafarers – Nehalennia–occurs at two shrines in the Netherlands, with a large number of monuments at each, and she may have been worshipped nowhere else in Europe. Epona, on the other hand, is ubiquitous, but she was venerated particularly in the north-east of Gaul and the German frontier region.

Evidence from the vernacular literature of Wales and Ireland is notoriously unreliable if we attempt to link it closely with pagan Celtic iconography. However, the dominance of the female is readily demonstrated especially in Irish legend, and it is worth alluding here to those traditions which are sympathetic to the iconographical evidence. In Irish tradition there is a strong connection between sovereignty and the earth-goddesses. The female deities of the land married mortal kings and thus mutually contributed to the prosperity of Ireland. Some Irish queens definitely possessed divine status: a case in point was the polyandrous queen Medb of Connaught 'whose husbands are never more than sleeping partners'.[5]

Nehalennia

From two sites close to the North Sea in the Netherlands, we know of an important Celtic goddess who was sufficiently popular to have had numerous large, well-carved and inscribed monuments erected in her honour (Figures 2–5). Her iconography, whilst complex and varied, displays an essential homogeneity. We know a great deal about her dedicants, since they often described themselves on the stones. We also know her name, Nehalennia.

On 5 January 1647 the dunes near Domburg on the Island of Walcheren were partly swept away by severe storms, thereby revealing some thirty altars from a second- to third-century temple to Nehalennia, sadly mostly destroyed by fire in 1848. That the site was on a trade route was surmised from finds of imported pottery and coins. The stone for the temple and the altars may have been brought by water over 400 miles from the quarries near Metz.[6] On 4 April 1970, a fisherman working off Colijnsplaat fished up three fragments of two altars to Nehalennia from the Oosterschelde estuary. In

1970 and 1971 more than eighty stones, altars, and stelai were recovered, together with pottery and part of a structure. The site, called 'Ganuenta' in antiquity, was submerged by the waters of the estuary at the end of the Roman period.[7]

Nehalennia may have been a local goddess belonging to the tribe of the Morini. She was worshipped not only by local people, but perhaps more frequently by travellers. The siting of her shrines, the professions of her dedicants and, above all, her iconography, proclaim her to be a goddess of seafarers. Some of her devotees were Roman citizens, many were Celts, and there is the occasional Germanic name. The homelands of Nehalennia's worshippers ranged from Trier and Köln to Besançon and Rouen. Their professions varied from sea-captain to merchants dealing in wine, salt, and fish-sauce. One altar from Domburg records a trader in pottery between Gaul and Britain.[8] These merchants gave thanks to the goddess for safe journeys across the North Sea, for success in business transactions, and for the welfare of themselves and their families; they asked for her protection in the hazards of their lives. Even her name 'Leader' or 'Steerswoman', proclaims her pre-eminence not only over the tangible waters of earth but through the uncharted seas of the world beyond the grave.

The iconography of Nehalennia is complicated and fascinating: the three dominant types of symbol are, first, the dog, her constant companion; second, images of fertility, including fruit-baskets, corn and *cornuacopiae*; and, third, symbols concerned with sea-travel – boats, steering-oars, marine creatures and her association with the Roman water-god Neptune. Nehalennia herself (Figure 2) appears as a youthful goddess, often clad in a distinctive, perhaps local costume with a short shoulder-cape and circular cap. She usually sits in a chair, sometimes beneath a shell-canopy, surrounded by her symbols and with her large, benign, hound-like dog seated beside her, a fruit-basket in her lap and another, larger one by her side.[9] Sometimes she is shown standing, with one foot on the prow of a boat (Figure 3).[10]

The marine symbolism of Nehalennia is a recurrent and dominant theme, proclaiming the goddess as presider over the waters of the North Sea. This is expressed, for instance, by her appearance standing on a ship's prow and by her possession of a steering-oar or rudder.[11] Sometimes Nehalennia grasps the rope of a boat along with her oar.[12] On a stone dedicated by a man from Augst in Switzerland,[13] the depiction of a sailing-boat laden with casks indicates the occupation of the devotee to have been that of wine-merchant. Straightforward sea-imagery is sometimes belied by other symbols such as Fortuna's globe, seen on a stone from Colijnsplaat.[14] Fortuna also traditionally holds a rudder, and it may be that there is conflation between the symbolism of Nehalennia as leader of men over the sea and Fortuna as guider of men through the hazardous journey of life. In any case, the sea-symbolism may be interpreted on a number of levels: the protectress of

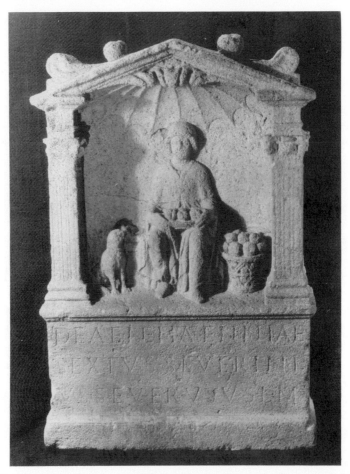

Figure 2 Altar to Nehalennia, dedicated by Sextus Severinus Severus: Colijnsplaat, Netherlands. Rijksmuseum van Oudheden, Leiden (cat. no. 1971/11.53). Base width 59cm. Photograph: Rijksmuseum van Oudheden.

voyagers may also have evoked the image of spring and the reawakening of seafaring after winter. The marine imagery of sea-monsters or dolphins[15] may represent not only the sea itself but the journey of the soul across the water to the Isles of the Blessed – a classical symbolism of the dolphin.[16]

That Nehalennia was concerned with fertility is demonstrated by abundant iconography in which she is associated with vegetation and crops; but she was not overtly concerned with human fecundity. That she was a provider is shown by her constant association with baskets of produce and, moreover, on the top surface of many altars are carvings of fruits heaped as

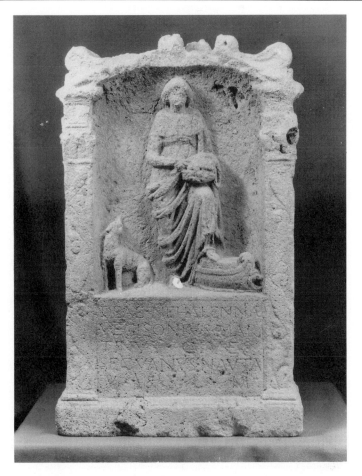

Figure 3 Altar to Nehalennia, dedicated by Vegisonus Martinus, sea-captain or ship-owner: Colijnsplaat, Netherlands. Rijksmuseum van Oudheden, Leiden (cat. no. 1970/12.13). Base width 46.5cm. Photograph: Rijksmuseum van Oudheden.

if on an offering-table. Again, *cornuacopiae* (Figures 4, 5) are frequently present;[17] trees too are depicted,[18] perhaps symbolic of the florescence of life. Indeed, there is no representation of Nehalennia where at least some vegetation or evidence of fruitfulness is not present, and many of the altars stress this aspect of the goddess's benefaction by presenting such multiple images of her bounty as *cornuacopiae* brimming with fruit and pine-cones, and fruit-baskets overflowing with produce.

Nehalennia's greatest distinction, in iconographic terms, is her canine companion (Figure 2). The dog does not always appear but on the vast

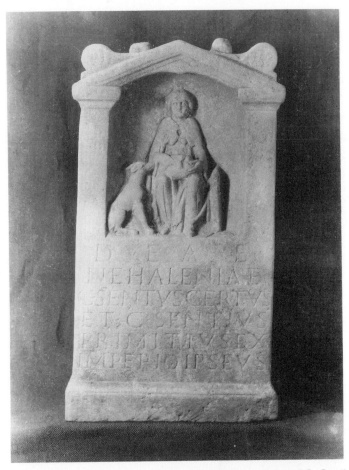

Figure 4 Altar to Nehalennia, dedicated by C. Sentius Certus and C. Sentius Primitivus: Colijnsplaat, Netherlands. Rijksmuseum van Oudheden, Leiden (cat. no. 1971/11.68). Base width 41cm. Photograph: Rijksmuseum van Oudheden.

majority of her monuments a large beast with pointed ears, alert expression and benevolent mien sits watchfully at her side. The dog often gazes up at the goddess[19] and, on one altar at Domburg, the close relationship between animal and deity is indicated by the attitude of the beast which sits so close that it touches her knee with its nose.[20] Sometimes the dog is very large and occupies a prominent position on the stone.

The purpose of the image of the dog is often debated for it is not immediately apparent. Though the animal is very different from the small lap-dogs of the Treveran goddesses, it is none the less evidently peaceful and

Figure 5 *Cornucopiae* decorating side of altar to Nehalennia (Figure 4). Photograph: Miranda Green.

obviously has a beneficent companionable role. It would seem that the dog's size, coupled with its benevolence, gives it a role as protector and friend of humankind, just as the goddess is herself a guardian. But an underworld symbolism may also be present, as suggested for other canine associates of the goddesses. Here, the vegetation imagery may fall into place as indicative of the goddess' influence over life, death, and rebirth. Nehalennia sometimes has a pomegranate, a fruit closely linked with fertility and the afterlife, being sacred to the classical Proserpina. The water symbolism, too, with its evocations of life, healing, and renewal, would be appropriate for a deity concerned with the well-being of her subjects in life and after death. The presence of Victory at Domburg[21] may indicate the triumph of Nehalennia over death. That the goddess was extremely powerful, with many spheres of influence, is demonstrated by the multiplicity of her motifs and symbols but also by her divine associates and by personal features of the goddess herself.

That she possessed a cosmic role is indicated by her wearing of a solar amulet at Domburg[22] and by the radiant sun at the top of another altar from the site.[23] This sun symbolism is balanced by the lunar motif worn by Nehalennia at Colijnsplaat.[24] Her cosmic connections may be shown also by her association, at Domburg, with Jupiter.

The cult of Nehalennia stands out in the wealth, variety and yet essential homogeneity of its iconography. The prominence of the goddess is clear from the dedicants she attracted – men of the prosperous middle-classes of Romano-Celtic society. The combination and intertwining of vegetation, fertility, and marine symbolism, with the many possible levels of interpretation, provides us with opportunities to speculate on the complexities of one particular well-documented form of worship. Of all the symbols, the dog is perhaps the most interesting and enigmatic. It watched over the goddess and humankind with calm assurance in its capacity to protect from harm and, perhaps more than any other of her attributes, binds together the many different facets of Nehalennia's role as protectress, goddess of prosperity and regeneration.

Epona the horse-goddess

Epona's name means 'horse', and numerous monuments were dedicated to her. Like Nehalennia, Epona was invoked on a number of dedications and images, but she was far more widespread in Roman Gaul and the Rhineland, with particular concentrations in Burgundy, the Metz–Trier region, along the Meuse and on the German *limes* (Map 4). Epona's worshippers came from a broad spectrum of Celtic society: the epigraphy argues for a strong contingent from the legionary fortresses east of the Rhine and the Danube Valley;[25] but equally important were the small domestic images which graced Burgundian houses and personal shrines. Indeed, it is in this latter region of the Aedui that the only proven temple to Epona is recorded: two inscriptions come from the ruins of a shrine at Entrains-sur-Nohain (Nièvre), one of which dedicates the sanctuary to her.[26]

Although Epona is unequivocally a Celtic goddess there is some classicism in her art-style and, on several of her images,[27] Epona is portrayed with her cloak billowing gracefully about her head as a 'nimbus', precisely similar to traditional Mediterranean depictions of Europa and the Bull (Figure 6). But the concept of Epona owes nothing to Roman religious themes, where equestrian goddesses form no part of the iconographic repertoire.[28]

Images of Epona are of two main types: most common, occurring in central and northern Gaul, the Germanies and Burgundy, are depictions of the goddess mounted side-saddle on a mare. A specifically Burgundian feature is the presence of a foal either suckling the mare, asleep beneath her or being fed from a *patera* offered by the goddess (Figures 6, 7). The other main group, appearing especially in the Rhineland, is of Epona between two

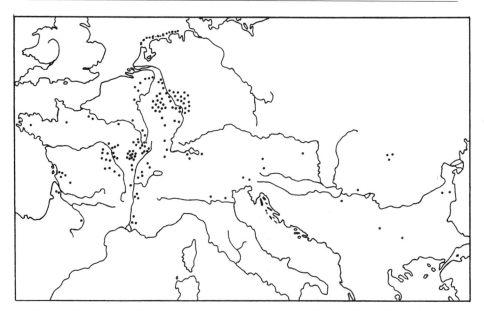

Map 4 Distribution of Epona monuments in Continental Europe (including epigraphy and iconography): after K. Linduff, 'Epona a Celt among the Romans', *Latomus*, vol. 38, fasc. 4, 1979.

or more horses. At Worms[29] the goddess sits between two animals, feeding them from a basket of fruit; at Beihingen[30] she is shown seated between two groups of three and four horses which walk towards her as if in homage. Essentially similar is a relief from Seegraben near Zürich[31] where Epona stands amongst five beasts which surround her. The iconography of Epona demonstrates that the horse is crucial to her symbolism; she never appears without this equine image. Before we examine in detail the precise significance of the horse motif, the other aspects of the cult need to be studied. We shall see, both from the imagery itself and from its context, that the goddess had a complex set of roles and functions which ranged from that of benefactress and dispenser of life's bounties – in fact a form of mother-goddess – to presider over healing thermal sanctuaries and over the dead in their tombs.

The association between Epona and water is striking: she occurs at a number of therapeutic spring-sites in Gaul[32] including Ste-Fontaine de Freyming (Moselle) where Epona was associated with the healers Apollo and Sirona.[33] At sites like Allerey (Côte d'Or), image and context come together for, at a spring shrine, Epona appears in the guise of a semi-nude water-nymph, half-reclining on her mare as if on a water-lily leaf.[34] Apart from this image of the goddess as a nymph, there is little in the iconography which links Epona with water and healing. A possible exception is her association

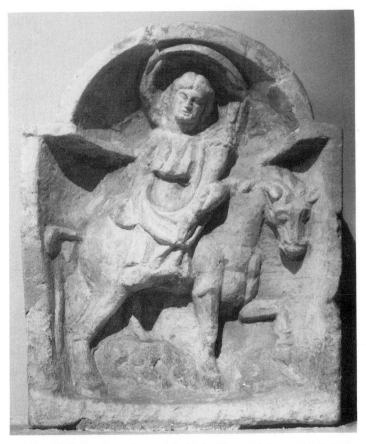

Figure 6 Epona with *cornucopiae*, and with foal beneath her mare: between Meursault and Puligny. Beaune, Musée des Beaux-Arts. Width 23cm. Photograph: Miranda Green.

with dogs: at Altrier in Luxembourg, for instance,[35] Epona has a dog and raven – perhaps healing and death symbols, though dogs could themselves be symbolic of death (Chapter 5). Other depictions of Epona in this region carry dogs: the Medingen (Luxembourg) sculpture is an example;[36] and dogs and Epona are associated as far away as Rouillac in Aquitaine.[37]

Epona is recurrently linked with death symbolism, perhaps, like the mothers, in connection with regeneration and rebirth – an aspect which ties in with water and healing. We have seen, at Altrier, that Epona was associated with the chthonic emblem of the raven. Other aspects of her imagery also reflect this funerary role. For instance, at Grand (Vosges) and Gannat (Allier)[38] Epona is seen with keys, perhaps only those of the stable but maybe also to the entrance of the otherworld. The symbol of the rosette is usually

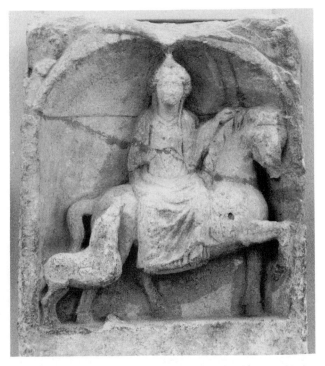

Figure 7 Epona with mare and foal: Mellecy. Musée Denon, Chalon-sur-Saône. Length 99cm. Photograph: Miranda Green.

associated with death and occurs on Roman tombstones: its presence with Epona at Meursault in Burgundy, at Clermont-Ferrand (Puy de Dôme)[39] and elsewhere may indicate a funerary aspect to Epona's cult, as may the shape of the goddess's stone at Luxeuil[40] which is identical to monuments at the site which are indisputably gravestones.[41] At Agassac in south-west Gaul, a marble funerary plaque depicts Epona as a Nereid but on horseback surrounded by sea-monsters and cosmic signs, as if Epona acted here as protectress of the dead in their journey over the sea to heaven.[42] Epona's link with death is observed above all at the cemetery of la Horgne-au-Sablon at Metz. This capital of the Mediomatrici,[43] like the neighbouring land of the Treveri, was an important cult-centre for the horse-goddess. Here she was perhaps first and foremost a guardian of the dead. At the la Horgne graveyard she appears on several images[44] and on one of these[45] the chthonic symbolism is clear: the goddess sits on her mare accompanied by an individual who follows close behind; Epona is here a tomb-protectress, leading the soul of the dead to the afterlife.

Apart from the horse symbolism itself, the main feature of Epona's iconography is the imagery of fertility and the earth's fruitfulness. The fecundity

of horses themselves and, by implication, that of humans and the land is demonstrated in striking manner among the Burgundian tribes, including the Aedui. Epona was important here, in an area where horses were bred.[46] The consistent image shown is that of the goddess, side-saddle upon her mare and accompanied by a foal (Figures 6, 7). Sometimes the foal lies curled up asleep beneath its mother;[47] on many depictions, the foal raises its head to eat from a *patera* held out by the goddess.[48] The fertility aspect of the imagery is even more overt at Rully[49] and Santenay[50] where the foal suckles its mother; and at Chorey (Côte d'Or)[51] the 'human' element has been dispensed with altogether and the imagery is simply that of mare and feeding foal. There is one special feature of some of the Burgundian images of Epona with her mare and foal, where[52] Epona, sitting side-saddle on a mare, rests her feet on the back of the foal which stands or trots beside its mother. The precise significance of this gesture is obscure, but Drioux[53] suggests that healing symbolism

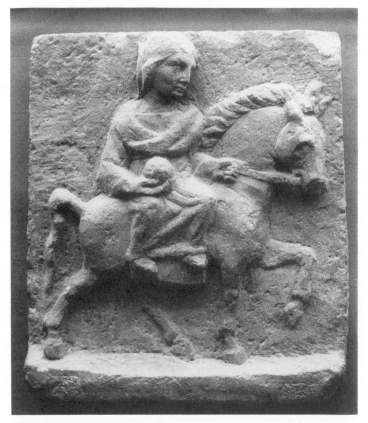

Figure 8 Epona with fruit: Kastel. Rheinisches Landesmuseum, Bonn. Maximum width 25cm. Photograph: Miranda Green.

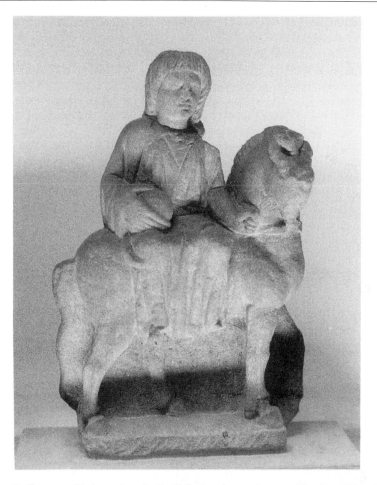

Figure 9 Epona with bread or fruit: Dalheim, Luxembourg. Musée d'Histoire et d'Archéologie, Luxembourg. Height 39cm. Photograph: Miranda Green.

is involved and that the contact between Epona's feet and the foal reflects the curing of injuries associated with the feet or hoofs. But it may be that the gesture simply indicates no more than the close, protective relationship between Epona and the young animal as well as with the mare herself.

Elsewhere, Epona shows her concern for fertility and the well-being of human- and animal-kind by her possession of the attributes of the earth's fruitfulness – corn, *paterae*, fruit, and bread (Figures 8, 9). In this she has clear links with the mother-goddesses. Indeed, at Thil-Châtel in Burgundy[54] where a mid-third-century AD dedication associates Epona and the mothers, not only are both mentioned but Epona is herself referred to in the plural.

Again, at Jabreilles (Haute-Marne) the images of Epona and the mother-goddesses share the same stone.[55] Finally, at Hagondange (Moselle) Epona is depicted as a triple image, exactly like the three mothers[56] (Chapter 6).

It is interesting to examine regional preferences in the imagery of Epona as bountiful benefactress: the Treveri were good horsemen and perhaps it was for this reason that they were such ardent supporters of Epona's cult, especially in the Luxembourg area.[57] Here, as at Dalheim (Figure 9), Epona is usually depicted with a basket of fruit[58] and she is often accompanied by a dog.[59] Indeed, there may have been a temple to the goddess at Dalheim where several images have been found. One curious image from the site shows Epona sitting on a mare inside a 'stèle-maison' (or house-shaped stone) where she may be viewed through a hole in the front of the stone, with an accompanying dedication.[60] Another image from this site which deviates from the normal 'Epona-on-mare' type of this region, is a portrayal of the goddess in an armchair flanked by horses.[61] From the same tribal area, though away from Luxembourg, at Trier, comes a beautiful relief of Epona on a mare which high-steps in formal parade-style and has an elaborately dressed mane and tail.[62] By contrast to the formal style of her mount, the goddess herself is schematized, with her hair pleated into the form of a cap in the Celtic fashion, and carrying a tray of fruit of exaggerated size.

Epona was popular among the Mediomatrici, where she was worshipped specifically as a goddess of the tomb. South-east of the tribal capital of Metz, at Mussig-Vicenz near Strasbourg,[63] Epona appears without overt symbols of fertility but with a *mappa* or napkin. The *mappa* has a definite horse-association in that it was used in Roman contexts for starting off horse-races.[64] But, if we look behind the basic symbolism, it may be that Epona is here shown as a goddess presiding over the beginning of life, just as she appears elsewhere with a key, symbolic of the end of life on earth. Certainly the mothers (Chapter 6) appear with emblems of their guardianship at the beginning and end of human life. Depictions of Epona from the German provinces vary from the conventional type of the goddess on her mare to a form particularly favoured in the Rhineland. Whilst the commoner type does occur, as at Kastel (Figure 8),[65] often Epona appears between two horses to whom she may offer food, and she frequently is portrayed seated between two horses or ponies, holding a large fruit-basket on her lap.[66] This same image-type occurs at Plovdiv in Bulgaria (Upper Moesia) where Epona caresses two horses which approach her.[67] Whether Epona is depicted on her mare or among horses, the fruit-basket is a ubiquitous emblem in the Germanies. Interestingly, the best-preserved of the few Epona images from Britain is of this 'Epona-between-two horses' type. This is an unprovenanced bronze from Wiltshire[68] which shows the goddess seated between two small ponies. Here Epona has a yoke and a *patera* filled with corn resting on her lap, from which the ponies feed. The fertility symbolism of the corn is enhanced by the fact that the animals are respectively male and female.

Johns[69] suggests that the ponies are deliberately represented as small in size so as to emphasize their mortality and thus the divinity of Epona herself; likewise, the yoke may reflect the submissive attitude of the beasts towards their patroness.

That Epona was an extremely important Celtic goddess is demonstrated not only by the multiplicity of her monuments but by their widespread distribution. Whilst concentrated in eastern Gaul and the Rhineland, they none the less appear also in Aquitaine in western Gaul.[70] In Provence, at Glanum,[71] a small stone altar is dedicated to Epona by a crude inscription alone, with no accompanying image. Epona was worshipped, albeit rarely, in Britain, and was venerated also along the Danube, in Dalmatia,[72] in Italy and even in North Africa.[73]

The status of Epona as a goddess is indicated by her prominence even in Italy and Rome itself. Epona had a Roman festival on 18 December and was the only Gaulish goddess officially honoured in the capital of the Empire.[74] There are, in addition, a number of classical literary allusions to her.[75] Mediterranean commentators speak of Epona's images decorating the stables of Thessaly, that home of horsemen. Typically, in terms of Graeco-Roman comments on Celtic deities and ritual, these observations are both superficial and ill-informed,[76] Epona's cult having been far more profound than her role as stable guardian.

In order to understand how the cult grew up in the Celtic world, it is necessary to examine the attitude of the Celts to horses (Chapter 5). Thus, in Gaul, the horse was important in religion, war, and the economy. Horses were essential for traction and transport and were accordingly valued by Celtic cavalry. The high status of this animal is reflected in its association with a number of high gods: we know of a Celtic equestrian warrior-god and, more especially, a Celtic sun- and sky-god who frequently rode horses (Chapter 4). Indeed, the cults of Epona and the Celtic sky-horseman may have been linked, in that the distribution of their respective images coincides in eastern Gaul and the Rhineland. Even before the Roman period, the solar character of the horse is indicated by the recurrent association of images on the Celtic coins of Gaul and Britain.[77]

Linduff and Oaks[78] both stress the importance of the cavalry in the rise of the Epona-cult. Aeduan cavalry were respected by Caesar from the beginning of the Roman occupation of Gaul and, after the conquest, Gaulish auxiliaries were still necessary for the control of the *limes*.[79] The mounted units of the Roman army were primarily Gauls, then Germans. Linduff[80] would see the horse imagery attached to the cult of Epona as crucial in attracting cavalrymen to her worship. We know, moreover, that some military devotees were concerned specifically with riding: one dedicant was a riding-instructor.[81] Certainly the worship of a horse-deity is appropriate for cavalry: the power, skill, and speed of their mounts was essential to their safety,[82] and Epona may well have acted as a protectress of Celtic cavalry and

their horses. Oaks[83] has suggested that Epona may have achieved promi-
nence because free Celtic horsemen or *equites* were the elite of Gaulish
society and because kings were traditionally chosen from this class of
knights. Sovereignty involved the keeping of peace within the tribe using
cavalry to ensure the stability of the tribal frontiers so that fields might be
tended and yield fruitful crops. Thus Epona would have a place in the Celtic
pantheon as a goddess of high status and of fertility. The horse was not only
fundamental in military contexts but, more widely, to Celtic life in general.
Here, the fact that Epona is female; that she rides side-saddle in the tradi-
tional feminine manner; and that her equine companion is a mare (often
associated with a foal) may be crucial to the understanding of her cult.
Epona would seem, in one major aspect at least, to be a goddess of the craft
of horse-breeding. Her imagery indicates that the goddess's relationship to
her horses is one involving Epona as guardian, nourisher, and promoter of
fertility.

At one level, then, Epona is a patroness of horses and her symbols – fruits
of the earth to feed them, keys to unlock stable doors, and *mappa* to begin
the horse-race – are all interpretable at this basic level. But the same symbols
can also take on a more profound meaning, that of protectress in life and
death. Thus the fruit-basket, key, and *mappa* become images of the well-
being of man and the progress of his journey through this world and the next.
Epona was basically a mother-goddess, but of a special kind, beginning at
least as a guardian of horses. However, her cult broadened to an extent
where she transcended the horse identity and became fundamentally
associated with fertility and prosperity in life and in the otherworld, with
healing and with regeneration. Epona was never thought of in terms of
straight animal-worship; she was not regarded as a mare in human form, but
was always an anthropomorphic deity and thus able to widen her sphere of
influence. Despite her importance, however, Epona was not one of the high,
Jupiter-like king-gods. As her images often show, she was essentially a
homely, domestic, beneficent goddess, a friend to man in all the vicissitudes
of his existence.

The mistress of beasts

Animals of various *genera* accompany goddesses as frequently as symbols of
prosperity or children. Some of these goddesses, like Epona or Nehalennia,
achieved such prominent status as to be treated separately (above). But the
general notion of the female deity presiding over and protectress of beasts is
itself widespread. Animal and goddess seem mutually supportive, each
enhancing the symbolism of the other. As early as the fourth to second
century BC on the Gundestrup Cauldron,[84] a goddess appears surrounded by
beasts. More frequently only one or two animals are involved. Most impor-
tant of the recurrent beasts accompanying the goddess are the snake, bird

(usually crow or raven), dog, and horse. Most oddly of all, the goddess may herself be horned.

The goddess with a snake

Snake symbolism is common to a number of Romano-Celtic religious images. Snakes seem, as in other religions, to have combined a beneficent with a chthonic or underworld role. The practice of skin-sloughing gave rise to associations with death and rebirth; the earthbound character of the reptile emphasized links with the underworld; and the venom of some species must have invested it with awe and fear. The Germanic mothers were often linked with the imagery of snakes, who twined themselves in the branches of trees, perhaps reflecting the connection between upper and lower worlds and the Tree of Life.[85] Single goddesses with serpents are interesting in that they appear not only with snakes of normal type but, on occasions, with the Celtic iconographic hybrid, the ram-horned or ram-headed snake, which seems to have come into being through an attempt to combine the imagery of the ram (a fertility motif) with the chthonic emblem of the snake.

Snake-goddesses are not absolutely confined to one part of Celtic Europe, but they occur most frequently in the north-east of Gaul (the homeland of the ram-horned snake itself). One British goddess from Ilkley in Yorkshire stands grasping two snakes in her hands; she is schematically depicted with characterless features and an overlarge head, and her snakes are rigid, zig-zag shapes.[86] It is possible that we have a name for this goddess: she may be Verbeia the goddess of the river Wharfe in Ilkley, where an altar to her was set up;[87] indeed the form of the snakes themselves may represent rippling water. In north-east Gaul, in the area of Villiers-le-Sec (Haute-Marne)[88] a goddess stands with a ring-headed sceptre of authority in one hand and a jar held against her chest; at her feet is another jar and what is probably a snake. The vessels may symbolize prosperity as portrayed by wine, honey, or mead, with perhaps the added dimension of renewal and resurrection (pp. 34–5); the snake could possess similar imagery, the presence of an animate associate maybe making the iconography all the more powerful. But in addition, the rippling image of the snake may evoke liquid, reflected already in the presumed contents of the jar. The goddess at Mavilly[89] also possesses snakes and perhaps holds a torch in one hand; she, like the Ilkley goddess, may be associated with water: the site of Mavilly[90] was a healing-spring shrine in Burgundy apparently especially associated with eye disease (Figure 25). The regeneration aspect of the snake gave it healing associations, and here the torch may reflect the lighting of the world in a context where blindness may have been a common affliction. It is interesting that at Mavilly also, a divine couple are associated with a ram-horned snake (Figure 26). To the north of Mavilly, at Xertigny and at Sommerécourt (both Haute Marne), in the land of the Leuci, are depictions of a goddess accompanied by ram-horned

serpents. The Xertigny goddess[91] is seated with a small snake held in her lap in both hands, like a pet dog. The stone at Sommerécourt[92] is more complex: here is depicted a cross-legged seated female, with long hair and a torc (neck-ring). Her left hand holds on her lap a deep-bellied vessel filled with mash and apple-like fruit. Her right hand holds a *cornucopiae* and three more fruits, and there is a pomegranate beneath her left hand. Both hands are huge and coarsely carved, as if their size were important but not the quality of their portrayal. A ram-horned snake, partly hidden by drapery, entwines the goddess' body and feeds from the bowl on her knees. This relief is of special interest since this divinity could perhaps be the consort of an antlered god from the same place but on a separate sculpture, who feeds two ram-horned snakes from an identical bowl of mash.[93] In any case, the goddess is herself interesting: Wightman[94] has pointed out that the pomegranate as a Mediterranean fruit indicates classical influence, as indeed does the ubiquitous *cornucopiae*. Otherwise, though, the goddess is of almost entirely native character, depicted as a patroness, benefactress, and protectress of the mythical beast who eats from her hands and who expands her symbolism as sovereign over fertility, death and rebirth.

The goddess with crows

Carrion birds associated with goddesses are significant: the symbolism of these creatures is complex and seems to involve the dual imagery of death and flight, lower and upper worlds. So, like the snake, regeneration and rebirth may be symbolized. There is the added concept of the winged soul, often thought of in those terms after it leaves the body's confines at death. Certainly, there is sometimes a very close association between bird and goddess, culminating, perhaps, in the winged nature of the divinity herself. Of interest in this connection is the Irish vernacular tradition of transmogrification of the goddess to a raven or crow, seen in the case of the battle-raven Badb Catha; it may be that the Celtic coins bearing the image of ravens riding on the backs of horses[95] may represent a similar war-raven theme.

Certain goddesses, then, appear in company with crows or ravens: we may note the bronze figure with two ravens in the museum at St Germain;[96] and the stone mother-goddess with ravens at Saintes.[97] More interesting are depictions of a goddess to whom we can give a name: Nantosuelta (below). The most prominent example is the altar found near Sarrebourg *mithraeum*[98] which bears the image of a standing goddess with the attribute of a house on a long pole and a hive-like object upon which is perched a raven. Although this stone[99] does not name the goddess, an altar found with it (Chapter 3) bears the images of a divine couple named Sucellus and Nantosuelta (Figure 18), the female bearing the same emblems of house-sceptre and associated with a raven. We look elsewhere (p. 42) at Nantosuelta herself; here it is sufficient to note the juxtaposition of domestic and chthonic imagery, the

26

house and hive representing earthly well-being, the raven the otherworld. We have identical symbolism on the unnamed (and lost) portrayal from Spire[100] in the territory of the Nemetes, where a female bears a house-sceptre and fruit and has a raven perched at her feet. It is interesting that the crow- or raven-emblem recurs on the house-shaped *aediculae* enclosing images of mother-goddesses among the Treveri,[101] as if reiterating in different form the dual themes of domestic prosperity and chthonicism. On occasions, partial transmogrification from anthropomorphic goddess to bird is expressed in the imagery: thus at Etaules near Avallon,[102] a nude, cross-legged goddess with multiple breasts is winged; once again, fertility and maybe otherworld symbolism are combined. The double theme recurs at Alesia, where a bronze figurine shows a winged goddess with her robe held up to carry fruit in her lap.[103]

The horned goddess

The animal symbolism associated with goddesses reaches its apogee with horned female images, usually adorned with antlers, more rarely bull- or goat-horns. Horns are generally a male prerogative, like phalli, a thrusting image of masculinity and aggression. But in a few instances goddesses may bear this symbol of a very close link with the animal world. Here, as with winged deities, the goddess is herself transcending human form to adopt the powerful fertility image of the stag or bull.

The antlered god Cernunnos is well known in eastern Gaul (Chapter 4). A female counterpart may be found, however, at Clermont-Ferrand (Puy de Dôme) and at Besançon (Doubs), where bronze antlered goddesses sit cross-legged with *cornuacopiae*.[104] A similar theme may be represented at Richborough in Kent where a horned (not antlered) goddess is depicted in local pottery of the first century AD.[105] In all these instances, the imagery suggests fecundity and the drawing on an animal's specific qualities to enhance her own strength.

The forest goddesses of boar and bear

Certain female deities were specifically associated with beasts which were hunted in the forest. They were naturally conflated with the Roman Huntress Diana. Arduinna[106] was one such divinity; she was a denizen of the forests of the Ardennes and guardian of the wild boar on whose back she rides on a figurine from the region. Artio (Figure 10) was another inhabitant of the woods, this time associated with the bear, whom she confronts on a bronze group from Muri in Switzerland.[107] Arduinna's name proclaims her as an essentially topographical deity, but Artio's name means 'bear' and demonstrates the very close affinity between goddess and animal. These goddesses are equivocal in their relationship to their beasts: their role

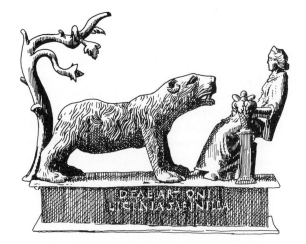

Figure 10 Bronze group of the goddess Artio with her bear: Muri, near Bern, Bern Historisches Museum. Height 20cm. Illustrator: Paul Jenkins.

appears to be that of protectress but at the same time they are helpers of the hunt. Indeed, it is not clear from the Muri bronze whether Artio is communing with or warding off her ursine companion who, incidentally, is depicted very much larger than the goddess herself.

The goddess with a dog

Dogs are perhaps the most common animal companions to the goddesses, and appear throughout Romano-Celtic Europe. There are two main iconographic types: the goddess may nurse a small lap-dog, or a larger beast may sit by her side, often looking up at her in a gesture of adoration. What is common to both forms is the affectionate, benevolent character of the animal, quite unlike the ravening Cerberus of the classical underworld.

The goddess with a lap-dog appears both in monumental form and as small personal cult-objects. The animal may be her only attribute or the imagery may be more complex. The region of the Moselle Valley around Trier is prolific in mother-and-dog images: here clay figurines depict a goddess, sometimes offering fruit to the dog, sometimes holding corn and other fertility emblems in addition to the beast itself.[108] In the Altbachtal temple complex at Trier, a temple to the goddess Aveta was full of pipe-clay mothers with baskets of fruit, lap-dogs or swaddled babies, as if these symbols were, to an extent, interchangeable. Outside another chapel was a stone statue of a mother-goddess holding a deep basket of fruit and with a dog by her side.[109] The rural shrine of Dhronecken, also in Treveran territory, produced a number of clay images of the mother once again with a dog or swaddled infant.[110] The Treveri of the Luxembourg area also worshipped

a goddess with lap-dog: here stone reliefs show the mother with no other attribute than the small animal nursed on her knees.[111] At Altrier and Titelburg in the same region, clay figures similar to the Moselle group indicate the widespread worship of this particular goddess form among the Treveri.[112] The Sequani too, at Windisch in Switzerland, worshipped a similar deity;[113] likewise the Ubii of Köln and Bonn, who offered clay figures of the goddess with lap-dog in personal shrines.[114] One figurine at Köln depicts a goddess with a small dog, perhaps feeding from a cluster of fruits before it on her lap,[115] and the same goddess is depicted here in monumental form.[116] The lap-dog goddess even found her way to Britain, where she was invoked at Canterbury;[117] and at Dawes Heath in Essex she appears as a small bronze figure at the site of a possible villa, her left hand caressing a small dog seated on her knee.[118]

The second iconographic type, the goddess with the dog at her side, usually occurs in monumental form and is akin to the homogeneous Nehalennia reliefs of Holland (below). At Köln[119] the goddess sits in an armchair with, to her right, a couchant dog who looks back at her. The goddess's lap is occupied by a basket of fruit but the dog is, in any case, too large for her lap. Very similar is the stone statue from Trier,[120] alluded to earlier, where again attendant dog and fruit-basket are both present. Some iconography is more complex: thus a relief from Bordeaux[121] in Aquitaine depicts a goddess wearing a mural crown (signifying her protective role over the city), with a *cornucopiae* of fruit and vine-leaves (reflecting the fertility of the vineyards of the region). To her left a dog looks up at her, and to her right is a bull with its front hooves on a small altar. The stone is dedicated to 'Tutela', the patroness of the town. Similar in theme is the clay figure from Saintes,[122] also in Aquitaine, where a goddess stands with *cornucopiae*, child, stag, and dog; and dog and child are associated, too, at Amiens[123] where a mother sits with fruit-basket on lap, holding in her other hand a dog which seeks to grasp a small child standing next to its mother. The complex group at Naix (Meuse), with fruit-bearing goddess and two young attendants,[124] one with a jar and the other with a similar vessel and a bunch of keys, also depicts a small dog between the feet of the main deity.

It is quite clear from most images of the mother-with-dog that the beast was closely linked to the other attributes, more obviously fertility symbols, usually possessed by her. We can see this from the interchangeability of corn, fruit, children, and dogs on some of the Moselle figures. But the dog must possess a further symbolism (Chapter 5): we know that in the Graeco-Roman world the dog was associated with healing and renewal. That there was a Romano-Celtic as well as a classical association between dogs and the underworld is demonstrated by the burial of dogs and dog images in Romano-Gaulish graves[125] and by the interment of dogs in deep pits, as at Muntham Court in Sussex.[126] The reason for the association between dog and mother-goddess may be as a symbol of death and rebirth. Healing involves renewal,

and the fertile seed-corn needs seemingly to lie dead in the earth before germination. Thus the dog may symbolize the cycle of life and death not only of crops but also of human beings. Certainly the mother-goddess, both in single and triple form, was closely associated with healing-spring sanctuaries in Gaul and Britain.[127] Another dimension may embrace the concept of hunting, with the Divine Hunt once again symbolizing death and resurrection.[128] Celtic huntress-goddesses, such as Abnoba of the Black Forest and Arduinna of the Ardennes, have canine companions and sometimes have the appearance of the classical Diana. The moon symbolism of this goddess, with its undertones of the female monthly cycle, occurs associated with mother-goddesses in the Rhineland, who sometimes wear lunar amulets, and indeed the small clay mother with lap-dog at Köln[129] wears a moon-pendant, as if fertility, the moon, and dogs are symbolically linked. Certainly, where other beasts are involved in the imagery – the bull at Bordeaux and the stag at Saintes – the fertility symbolism of both beasts serves to enhance the image of the mother as having dominion over the earth and all its animate and inanimate bounty.

The mother-goddess with children

Infants, toddlers, or older children are the constant companions of single mother-goddesses, just as they are in the triple form. The association occurs occasionally in bronze and very frequently in clay, and appears also in the more monumental stone-carvings of the goddess. The Celtic pipe-clay 'Venus' (see p. 39) sometimes appears with one child of perhaps 8 to 10 years old.[130] Another type,[131] exemplified by a figurine from a pit at St-Honoré-les-Bains (Nièvre), portrays a goddess accompanied by several children who surround her as if clustering around a benefactress.[132] The other main type of clay mother-goddess is the so-called 'Dea Nutrix'[133] or 'nursing goddess'. Representations are invariably seated, with one or two babies at the breast.[134] Variations may carry grain or fruit[135] and, at Köln (Figure 11) a young girl is burdened with two massive *cornuacopiae* instead of babies.[136] 'Deae nutrices' are very common in Gaul and Germany, occurring in shrines, houses and graves.[137] At Dhronecken near Trier, a shrine was apparently dedicated to such a nursing mother, with numerous figurines not only of the goddess herself but also busts of children who were protected by her.[138] Images of the nursing goddess made in the workshops of central Gaul are distinctive in that they sit in high-backed basket-chairs which may reflect a local type of secular furniture; this chair is absent from the Rhenish-made figurines.[139]

The stone depictions of mothers with children are more varied and show some regional or tribal grouping: the mother of the Santones, worshipped especially in the tribal area of Saintes, is usually depicted in an armchair with a small child held in her lap and steadied by her left hand.[140] One of these[141] is

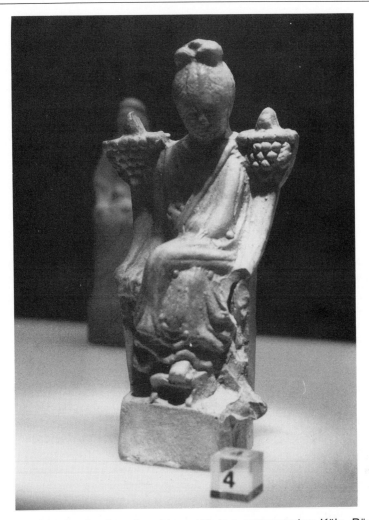

Figure 11 Pipe-clay figurine of goddess with two *cornuacopiae*: Köln. Römisch-Germanisches Museum, Köln. Height approx. 10cm. Photograph: Miranda Green.

curious in that beneath the goddess the upper part of a large human head may be distinguished. This feature recurs on a relief in the 'grotte de la vallée du Loup' (Alpes Maritimes),[142] where a mother-goddess holds a human head, and at Auxerre (Yonne) where a mother with an ithyphallic child on her lap is supported by the bust of a being with closed eyes.[143] The precise significance of the head occasionally associated with a mother-goddess image is obscure; but the head is often seen as representative of death, especially where the eyes are closed,[144] and may therefore be present as a symbol

of the dominion of the mother even over death. But the head itself has also a fertility dimension[145] and Celtic heads may sometimes be phallus-shaped. In this circumstance, the presence of the head in company with a mother-goddess and emphasized phallus may serve simply to stress the fertility element of the imagery. If the exaggerated sex of the child is significant, the dedicant may well have wished to convey the message to the deity that a male infant was desired.

Other depictions of mothers with children vary between those with babies in arms to others accompanied by children of various ages. It is appropriate, here, to mention a few of the more distinctive and complex images. At Saintes, a relief of a mother bearing a *patera* and *cornucopiae* is accompanied by a girl – a daughter, devotee, or perhaps an acolyte.[146] The Altbachtal temple-precinct at Trier produced a small statuette of a mother-goddess flanked by two small children or worshippers;[147] the image of an elderly mother at Naix[148] has two young persons with her; again it is impossible to say whether these are her children or attendants/suppliants. The same is true of a mother surrounded by young individuals at Amiens.[149] Toddlers in a less equivocal relationship to the mother are also common: at Langres, capital of the Lingones, a seated goddess has a bared right breast and two naked toddlers, one seated, one standing at her side. The fecundity symbolism is very clear in the action of one infant who plunges one hand into the purse between his feet and raises the other to his mother's *cornucopiae*; his sibling clutches at the nourishing *patera*.[150] The close relationship between mother and children is demonstrated at St-Aubin in Normandy[151] where, in the entrance to a late-first-century AD temple, sat a mother-goddess wearing a diadem and a Celtic torc in an armchair flanked by two children, probably a boy and girl, who hold on to her skirts like any human toddler.[152] Where the infants are suckling babies[153] their function seems purely to reflect human fertility, as is the case where the triple mothers nurse infants. But older children may have additional symbolism. We saw at Langres how the children point out the prosperity imagery of their mother; and at Agney-le-Duc in north Burgundy[154] a seated goddess is accompanied by a child who carries her mother's *cornucopiae*.

Symbols of fertility and prosperity

Many female images, especially stone statuettes or reliefs, betray only a generalized function concerned with well-being and prosperity. They are, for the most part, nameless, and where they occur outside an informative context (such as a grave or a thermal spring), only the visual symbolism itself gives clues as to the function of the images. Such goddesses are most frequently depicted seated in armchairs; they are of mature years and sit comfortably, in modestly draped robes, gazing serenely upon their worshippers and holding symbols of their beneficence. Most common of these

symbols is the *cornucopiae* or horn of plenty, a fertility emblem taken from the iconographic repertoire of the Mediterranean world. It is often depicted brimming with the fruits of the earth – corn, apples, grapes, or pine-cones. The sacrificial platter or *patera* is another frequent symbol of nourishment accompanying the Celtic goddesses and is again of Graeco-Roman origin. This *patera* may be full or empty, offered to a suppliant or companion, or simply resting on the hand of the deity. Baskets of fruit or corn are likewise common prosperity images carried by the Celtic mother, and she may also carry a pot, perhaps holding honey, mead or wine. Cakes or loaves complete the imagery of the nourishment necessary to humankind symbolized as the blessings imparted by the goddess.

Often the attributes of these divinities are emphasized or overlarge: at Saintes in Aquitaine[155] a goddess is depicted sitting with a large and brimming *cornucopiae*, while a goddess at Luxembourg carries an immense bowl of fruit;[156] and at Alesia in Burgundy, the mother-goddess, perhaps personifying the spirit of the city itself, holds a number of huge fruits in her lap (Figure 12). She comes from a cellar which may have been a domestic shrine.[157] Several such 'mothers' come from the same town; and the bust of a serene benefactress wearing a Celtic torc and mural crown[158] seems definitely to represent the spirit of the prosperous capital of the Mandubii.

Various combinations and regional differences in the range of symbols may be observed: the Santones favoured the *cornucopiae* and *patera* or basket of fruit;[159] and elsewhere in Charente similar divinities were worshipped.[160] The grouping of pot and fruit as the possessions of a goddess from Ceyssat (Puy-de-Dôme)[161] may represent here the general concepts of food and wine; and the pot and loaf or cake of a goddess at Entrain[162] may symbolize the familiar combination of bread and wine. The *patera* and *cornucopiae* were favoured as attributes of a goddess in Burgundy.[163] In the Luxembourg area of the territory of the Treveri, the type chosen for the local goddess was a female sitting in a small stone shrine or *aedicula* closely resembling a house (Figure 13), as if to emphasize the essentially homely, domestic character of the cult.[164] These Treveran mothers usually hold fruit-baskets,[165] and some wear curious bonnet-like head-dresses reminiscent of the head-gear of the Germanic maternal triads. This feature, exemplified at Dalheim,[166] is presumably reflective of local costume. The other images from Treveran and neighbouring Mediomatrician territory are essentially similar in their basic emphasis on prosperity.[167]

The British goddesses are far fewer in number than their European sisters, but some of them have interesting attributes or associations: the Lydney goddess[168] is conventional in being portrayed seated and with a *cornucopiae*, but her interest lies in her association with the healing sanctuary of the god Nodens. The context of the small Caerwent stone figure (Figure 14) is likewise perhaps significant: she was found near the bottom of a deep pit near the Romano-Celtic temple beside the forum-basilica.[169] This may possibly

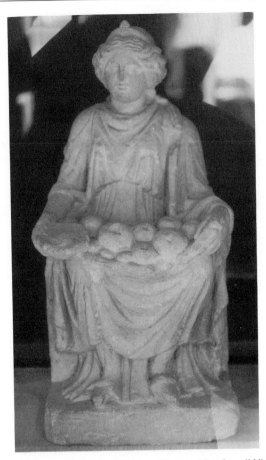

Figure 12 Statuette of mother-goddess: Alesia. Musée d'Alise Sainte-Reine. Height 45cm. Photograph: Miranda Green.

represent an underworld function; she carries a small round fruit in one hand but also the curious attribute of a palm or conifer in the other. This may symbolize the Tree of Life, or perhaps the palm of victory over death.[170] The context of the stylized little stone mother at Carrawburgh[171] is curious: the sculpture was found in the anter-room of the *mithraeum* – that bastion of male exclusiveness and elitism. Mithraism attracted other religions, and it may be that a Celtic clientèle felt happier to include a familiar and powerful local deity almost as a counterbalance to the rarefied atmosphere associated with the secret aloofness of the Persian god.

A very interesting fertility/prosperity symbol of the British goddesses is the vessel of regeneration and replenishment. This may be the symbolism of the small pot on some of the Gaulish reliefs. But here it often takes the form

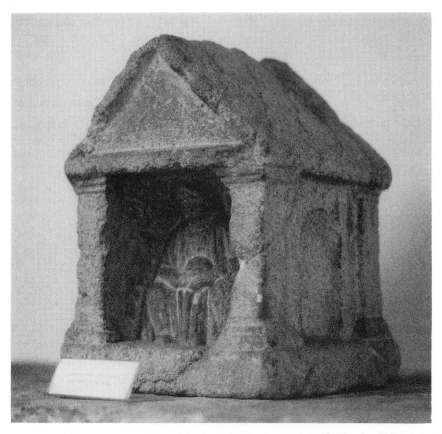

Figure 13 Goddess seated in *aedicula*: Dalheim, Luxembourg. Musée d'Histoire et
d'Archéologie, Luxembourg. Height 34cm. Photograph: Miranda Green.

of a substantial bucket or cauldron. This attribute appears in both north and
south Britain; at Carlisle, an altar portrays a mother with what appears to be
a bowl and a ladle;[172] and at Corbridge, a goddess appears with a vat and
pestle or a bucket and a ladle or spoon.[173] What may be an image of the same
goddess appears again at Newcastle, where she has a bucket and a spoon or a
remarkably spoon-like *cornucopiae*.[174] Webster[175] interprets all such figures
as Rosmerta, arguing from the presence of a bucket on one or two reliefs of
Mercury and Rosmerta from Gloucester (Figure 22) and Bath (Chapter 3). I
would prefer to see this attribute as a general British symbol of earthly
prosperity and, at a higher level, of regeneration and rebirth. Cauldrons
figure prominently as symbols of renewal in Welsh and Irish literary tradi-
tion[176] and in the ritual of later European prehistory. These, and certainly the
metal buckets of the Late Bronze Age, Hallstatt and later Iron Age, were
wine-mixing vessels, and it may be that the symbolism of the vat on the Celtic

35

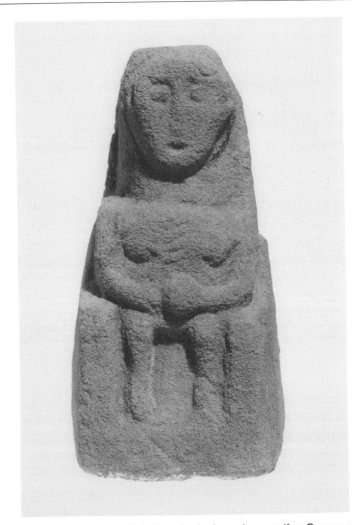

Figure 14 Mother-goddess with fruit and palm-branch or conifer: Caerwent, Gwent. Newport Museum. Height 27 cm. Photograph: National Museum of Wales.

goddess images may represent not only the presence of wine but specifically of red wine and therefore blood, death, and resurrection.

Another very distinctive symbol of life after death is the key, generally seen as the key to the door or Heaven or the happy otherworld. Keys frequently occur with the horse-goddess Epona, who had a very definite otherworld role. But keys also occur with more conventional mother-goddesses: the wrinkled mother from Naix[177] appears with adolescent attendants one of whom has a pot and a bunch of keys; both symbols could refer to regenera-

tion. The pot could represent a replenished wine-vessel and the keys may admit the soul to the afterlife. A remarkable standing wooden image of a goddess from Winchester (Hampshire)[178] wears a cloak and torc, a *mappa* or napkin in one hand and a large key in the other. Webster[179] has interesting observations on the symbolism of the *mappa* which, as he points out, was in secular contexts a personal, individual possession of the diner in Roman society. He notes also that the *mappa* was used for starting horse-races.[180] Whilst I would go along with the suggestion that the dual imagery of *mappa* and key could symbolize the beginning and end of life, Webster's contention that the Winchester goddess is Epona is, I think, unnecessarily speculative and flies in the face of this goddess' constant association with specific horse-images.

The two final inanimate motifs associated with miscellaneous mother-goddess images concern war and the sun. The link between female divinities and war is prominent in Irish vernacular sources[181] and we know also of a British war-goddess to whom the tribe of the Iceni offered sacrifices at the time of the Boudiccan Rebellion.[182] The imagery of the Divine Couple (Chapter 3) also contains a war element (Figure 27). But in Britain, the association of certain mother-goddesses with war imagery is both curious and interesting. At Daglingworth near Cirencester[183] an image of the Dobunnic mother-goddess sits with three hooded godlets, two of whom bear swords (Figure 83). A relief from Kingscote (Gloucestershire), also in the land of the Dobunni, associates a throned goddess who holds bread or fruit with a warrior. This association of images may symbolize either war or sovereignty: horses and knights were representative of the regal elite of Gaulish society.[184] Goddesses and war are occasionally linked in late pre-historic European contexts; for instance, pots with incised decoration from Sopron in Hungary[185] bear images of goddesses associated with warriors; and certain Gaulish coins depict a naked running woman with flying hair, brandishing weapons in each hand.[186]

The evidence of an association between goddesses and the sun adds a totally new dimension to the mother-goddess cult, and may possibly represent an obscure reference to a mythological marriage between sky/sun father and earth-mother, though there is no direct evidence for this tradition. Certain unequivocal pointers to a definite link between sky and fertility and mothers do, however, exist in Celtic iconography. The mother-goddess from Trier[187] bears an inscription above her gabled niche 'to Jupiter Best and Greatest'. A stone at Köln[188] associates Jupiter and the mothers on a dedication. But the iconographic interest lies in the visual association of sun and fertility symbolism. At Clarensac (Gard), an area of southern Gaul where the Celtic sun-god flourished (Chapter 4), a dedication to Jupiter and Terra Mater was accompanied by a Celtic solar wheel.[189] An unprovenanced altar from the Cotswolds[190] shows a demure group of mothers seated under a gabled niche which is decorated with a large and clear sun-wheel. Solar and

fertility symbols appear together in other circumstances not strictly associated with the mothers: at Naix[191] a sky-god's throne is ornamented with sun-wheel and *cornuacopiae*; and at Netherby in Cumbria[192] a god carries a wheel and *cornucopiae*.

The most curious sun-goddess association occurs on some of the clay 'Venus' figurines (Figure 15) made in central Gaulish pipe-clay manufactories.[193] These mass-produced a popular type of cult-object, usually faithfully following the classical Venus Pudica in iconographic type[194] and almost certainly in reality a type of Celtic domestic fertility-goddess which is indistinguishable in apparent function from the conventional mother-goddess type. This argument is based almost entirely on the occurrence of the 'Venus' figures in domestic, healing-spring shrines and sepulchral contexts, and the dearth of Celtic dedications to Venus or stone monuments associated

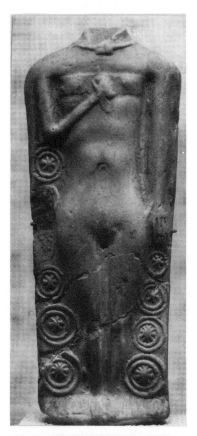

Figure 15 Pipe-clay goddess with solar symbols: Toulon area (Allier). Musée des Antiquités Nationales, St-Germain-en-Laye. Height approx. 12cm. Photograph: Miranda Green.

with her worship.[195] The pipe-clay 'Venus' was apparently invoked by the lower echelons of Romano-Celtic society, especially by women, for the restoration or continuance of good health, fertility, and protection after death. She helped particularly as a protectress against childbirth complications and her presence at such healing-spring shrines as Vichy (Allier) and Walbrook in London may have been with this role especially in mind. Her appearance in some graves[196] may symbolize the goddess's continued guardianship in the hazardous journey of the unknown. The translation of the iconographical type of the classical Venus to that of a domestic Celtic protectress is logical in that the classical Venus was not simply a goddess of love but had very real links with fertility.[197] After all, Venus was originally a power associated with gardens and the fertile soil.[198]

Our real interest in the Celtic 'Venus' in the present context is in the link, on a few of her many images, with the cult of the sun.[199] Generally, sun-bearing female figures are fairly crudely modelled, portraying a naked standing, youthful female with solar wheels and circles adorning or flanking her body.[200] A figurine from Bro-en-Fégréac (Loire Atlantique)[201] is ornamented with spoked-wheel signs; another[202] is decorated with sun motifs on her breast, belly and thighs, and her back as well. Both the abundance of sun-images on this statuette and their position on the sexual parts of her body may be significant in interpreting the importance of the solar image for fertility. A different form of 'Venus'[203] with cosmic symbols is represented at Toulon (Allier) where the goddess appears with a child in front of her and with her hand on its shoulder in a gesture of protection; here the fertility imagery of the goddess is overtly demonstrated.

Fertility and the sun are logical partners in imagery, though usually absent in Mediterranean (and indeed Celtic) contexts. The union of sky and earth is common to a number of religions – it figures prominently, for instance, in the Egyptian myth of Creation – and its presence should not surprise us here, though the clarity of the symbolism is very interesting. The sun, like the mothers, was acknowledged as having powers of regeneration, renewal, healing, and protection; its warmth is necessary for germination and growth, and the penetration of the sun's rays into the dark womb of the earth gave scope in the imaginative Celtic mind in the visual linking of these two crucial religious themes.

Some other goddesses

Inscriptions provide us with some knowledge of a multiplicity of Celtic goddesses. Where images are also present, we may even have some idea as to the nature of the cult expressed. But where dedications are not associated with specific images, we are left wondering whether the names do not perhaps refer to some of the anonymous deities occurring iconographically in the same area. Sometimes the name itself, however, provides clues as to

the character of these image-less goddesses. Nemetona was a deity of 'the sacred grove' occurring usually in company with a Celtic version of Mars. Her appearance among the German tribe of the Nemetes may indicate her tribal status. As well as a function as goddess of the grove, she could have had war associations: thus Nemain was the 'Frenzy' of Irish myth[204] who strode among warriors, wreaking havoc in battle. We know little about Icovellauna, recorded epigraphically at Metz[205] and Trier,[206] but despite the dearth of images, the name itself and the context of dedications give the goddess a character and function. 'Ico' can mean water and at Metz the goddess Icovellauna presided over the octagonal shrine and spring of Sablon, presumably as a healer-deity.[207] Ritona was a Treveran goddess of fords,[208] and Souconna a deity of the river Saône at Chalon;[209] many other imageless spring-water goddesses are recorded. Vagdavercustis, on the other hand, was a Germanic divinity about whose cult we know nothing[210] beyond the fact that she was probably some kind of spirit attached to one specific locality, perhaps taking its name. Occurring only at Köln, the presence of trees on the side panels of her altar may indicate a vegetation symbolism. Many of these obscure goddesses appear perhaps only once.

Other goddesses possessed names and images to go with them. Visual expression and dedication may enhance each other in terms of cult-interpretation. Sequana and Coventina were both water-deities. Sequana was the goddess of the river Seine at its source near Dijon, at a shrine which predated the Roman period and where the coins range from the first century BC to the late fourth century AD. We know how the goddess was envisaged (Figure 16) since she appears as a large bronze figure of a woman wearing a diadem and standing in a duck-prowed boat, her arms outstretched to welcome pilgrims to her sanctuary.[211] As well as this cult-statuette, several votive items were dedicated to this healer-goddess, including a pot filled with bronze and silver models of organs to be healed by Sequana. Wooden and stone figures and parts of bodies were offered to the spirit in the reciprocal hopes of a cure. A number of devotees may have been blind, and several pilgrims are represented with dogs in their arms as offerings to her. We know of a tradition that the lick of a dog could heal;[212] we know, too, that votive dogs were dedicated to the British healer-god Nodens at whose shrine at Lydney (Gloucestershire) there is evidence for eye-troubles.

Coventina was first and foremost a British goddess, whose sanctuary was at Carrawburgh on Hadrian's Wall. Dedications have been found, too, in north-west Spain and Narbonne. Where evidence exists, Coventina's worshippers came from the Celtic and German provinces. Her sanctuary in north Britain took the form of a shrine with the *cella* replaced by a well. This was built as a functional cistern in the early second century AD but soon acquired a religious significance.[213] That Coventina was an important deity is demonstrated by her titles of 'Augusta' and 'sancta'. Iconographically, she was represented as a semi-nude, nymph-like female reclining on lapping

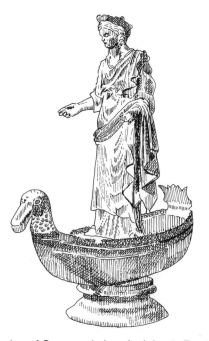

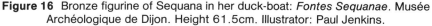

Figure 16 Bronze figurine of Sequana in her duck-boat: *Fontes Sequanae*. Musée Archéologique de Dijon. Height 61.5cm. Illustrator: Paul Jenkins.

waves, brandishing a water-lily leaf in one hand and resting one elbow on an overturned pitcher.[214] Coventina is thus represented in the conventional attitude of nymphs in a pose common to the whole of the Roman Empire. But her name and devotees proclaim her as a Celtic deity. We know from the presence of the well and from the iconography that the goddess presided over the spring and, indeed, votive objects were deposited actually in the well itself. She could have been a healer, but the water possesses no medicinal properties.

A curious goddess inhabiting Baden-Württemburg in the Stuttgart area was Hericura or Aericura, the name being akin to that of the classical goddess Hecate (an underworld divinity). A stone at Cannstatt[215] is dedicated to her and depicts a mother-goddess on a throne with a fruit-basket in her lap. Other, unnamed but similar reliefs from Cannstatt[216] and Rübgarten[217] are presumably also images of the goddess. On one monument[218] the deity is accompanied by a small naked individual, its diminutive size perhaps expressing its human rather than divine status. Another obscure goddess was Ianuaria, known only from a spring-sanctuary at Beire-le-Châtel in Burgundy. A small stone statuette of a young female clad in a heavy pleated coat and holding a set of pan-pipes was inscribed 'Deae Ianuariae'.[219]

Nantosuelta, Rosmerta, and Sirona

These three goddesses are distinctive in being each usually associated with a divine consort (Chapter 3), but they do, on occasions, occur on their own, showing that they possessed independent status and were not simply feminine counterparts of a fundamentally male concept.

Nantosuelta's name is generally interpreted as 'Winding Brook' or 'Meandering River', thus giving the goddess a water dimension. However, visual images of the deity, whether alone or with her partner, do not express this aquatic symbolism, unless this is reflected in the pot she sometimes carries. Nantosuelta's most distinctive symbol is a small house-shaped object on a long pole. On the relief from Sarrebourg in Mediomatrician territory (Figure 18)[220] she stands with her house-symbol in one hand and with what appears to be a hive on which perches a raven in her other hand; to her left are three objects piled in a heap on the ground which have been interpreted[221] as honeycombs. If there is honey symbolism here, then it may be endorsed by some of the images of the divine couple where barrels are depicted, perhaps representative of the fermentation of mead. Raven and house-on-pole are repeated on a lost relief at Spire[222] in Nemetan territory: here the presence of a radiate head in the gable above the goddess may indicate a solar association, a feature of her partner the hammer-god.[223] A carving at Teting (Moselle) in the land of the Treveri[224] portrays a goddess with a pot and again the house-like symbol. On none of these representations in Nantosuelta named, but she is sometimes, as on a relief at Sarrebourg[225] where she stands with Sucellus, and with her distinctive attributes of house-sceptre and raven. All Nantosuelta's imagery, apart from the raven, gives her prosperity symbolism and authority over domestic affairs. The house-sceptre, pot, and hive proclaim her as a homely spirit, protecting hearth and home and dispensing her benefaction as goddess of the good things of life. A sombre note introduced by the raven implies that she, like so many of the mothers, had a darker side and presided over death as well.

Rosmerta, like Nantosuelta, belonged fundamentally to a partnership, usually appearing with the Celtic Mercury (Figures 22, 23). Rosmerta's name means 'Great Provider', and places her firmly within the wide fertility and prosperity sphere of influence enjoyed by so many of the goddesses. Her purse reflects her role as a deity concerned with commercial success (for example on a stone in Mannheim Museum).[226] The few appearances of Rosmerta on her own indicate that she was of greater importance than the many reliefs of the divine couple would suggest. Among the Aedui of Burgundy, Rosmerta may have been far more prominent than her consort: at Escolives-Sainte-Camille (Yonne), Rosmerta was associated on her dedication with the emperor. She stands alone in a niche, with *patera* and *cornucopiae*, not with Mercury's attributes of purse and *caduceus* with which she is generally associated when depicted in company with her partner.[227] In the

same tribal area of the Aedui, at Gissey-la-Vieil (Côte d'Or),[228] Rosmerta appears as a goddess of a spring, again linked epigraphically with the emperor. Two points emerge from these occurrences: one is that Rosmerta achieves high status, in her association with the emperor; the other is that Rosmerta's appearance alone calls into question the relative ranks of the goddess and her usual male companion. It is generally considered that Mercury is the dominant partner, with Rosmerta borrowing his normal emblems and occurring simply as a female counterpart. The Aeduan evidence appears to accord Rosmerta a sovereignty of her own.

Sirona belongs with the Celtic Apollo. Though she appears as an independent image at Hochscheid (Figure 17), her portrayal is balanced by a statue of Apollo himself (Chapter 3). Likewise at Ste-Fontaine near Freyming (Moselle), Sirona appears as a bust of a goddess with stylized features and a dedication to her by herself,[229] but Apollo is also present at the site. Sirona was worshipped as a healer at Metz-Sablon[230] but again so was Apollo. However, the goddess does occur alone on a Breton inscription to 'Tsirona', invoked with the 'numen' of the emperor at Corseul.[231] Sirona's name has astral associations but, as is the case with Nantosuelta, her image does not convey this. At Hochscheid, for instance, Sirona is depicted as a fertility and healing deity, with eggs and a snake,[232] the latter perhaps symbolic of both water and regeneration.

Conclusion

Study of the imagery and symbolism of the goddesses reveals the wide range of functions attributed to them. The images cannot, by themselves, lead to a true understanding of a cult. What they can do is to point to an underlying complexity and a tacit but vibrant mythology. Many goddesses were local, topographical spirits, dwelling at one healing spring or presiding over a river or settlement. Others were widespread and achieved tribal, indeed international, status. But despite variety in symbolism and importance, the overwhelming feature, perhaps common to all the female divinities, is a fundamental concern with life, fertility, and regeneration. The goddesses are not, from their images at least, concerned with war, unlike the Irish queen-goddesses of Insular tradition. They are serene benefactresses, with a 'dark' aspect in their association with the 'womb' of earth and with death. But even in their underworld aspect, rebirth and renewal are frequently promised and there is little that is forbidding or fearful in their symbolism.

The Celtic love of ambiguity[233] and understatement manifests itself in the symbols associated with the goddesses. Thus, attributes and associates may be interpreted at a number of levels. Nehalennia is a prime example; her boat-imagery reflects, at one level, her guardian role as a seafarers' deity, but in greater depth the ship symbolism may be linked with the journey through

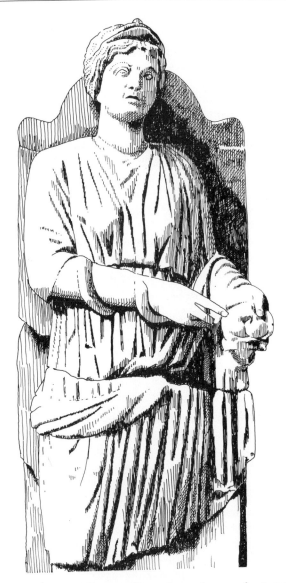

Figure 17 Stone statue of Sirona with snake and eggs: from curative shrine at Hochscheid. Rheinisches Landesmuseum Trier. Height (originally) 1m 69cm. Illustrator: Paul Jenkins.

life to the ultimate goal of the otherworld, or with the imagery of the seasonal cycle. It is perhaps the presence of these different strata of expression which made the goddesses so appealing and their cults so fulfilling throughout the Celtic world.

3

The divine marriage

Pairing of deities was a concept especially dear to the Celtic heart. The classical gods sometimes had consorts – Jupiter and Juno for instance – but couples were much more prevalent in Celtic iconography. Here, divinities of Graeco-Roman origins, such as Mercury and Apollo, acquired female counterparts for the first time, these being of indigenous stock. This coupling of male and female deities, which is observable iconographically, is reflected also in epigraphy, where on occasions a god with a Roman name is linked to a native wife, or both deities may have indigenous Celtic names. What is interesting here is that whilst Roman male name and Celtic female name are frequently linked, the reverse is never true; the goddess is always a native divinity. The pairing of names may take one of three forms: the god may have an entirely Roman name (Mercury and Rosmerta for instance); he may have a Roman first name and a Celtic surname (for example Apollo Grannus and Sirona); or both may have entirely Celtic names (Sucellus and Nantosuelta, to name but one such pair). Two other points concerning the epigraphic evidence should be noted: first partner-swapping, polygamy and polyandry may sometimes be observed – Apollo may appear with, for example, Sirona or Damona, and Damona herself may be married to either Apollo Moritasgus or to a related Celtic god, Bormo; second, many pairs occurring in the epigraphy are not clearly attested in the iconography. Many of these couples occur perhaps only once or twice: Veraudinus and Inciona appear only at Widdenberg in Luxembourg;[1] Luxovius and Bricta at Luxeuil;[2] Ucuetis and Bergusia only at Alesia, where they may have been craft-gods.[3] Mars Loucetius and Nemetona, on the other hand, appear more frequently, at Bath and elsewhere.[4]

With divine couples such as these, it is problematical as to which, if either, is the primary or principal deity. Certainly, if the names are anything to go by, the female is the Celtic concept. The Irish vernacular sources indicate the existence of territorial goddesses mating with mortal sovereigns, and a similar idea may lie behind the divine couples represented in pagan

epigraphy. Here may be the 'prototypal coupling of the protecting god of the tribe or nation with the mother-goddess'.[5] But, in terms of art-form, the male is frequently the more complex; his essential celticism is demonstrated by his Gaulish tunic and *sagum* (heavy coat or cloak), and he has the more varied attributes. What we shall seek to establish is the precise nature of the relationship between the two partners: whether they have separate identities; whether they may sometimes be merely male and female principles in a given context; whether one is dominant; whether the fact of a divine marriage may itself promote the symbolism of fertility, the latter being such a prominent theme within the iconography itself.

The nature of the divine couples represented artistically is varied and embodies a number of roles. Where partners are named but without iconographical expression, interpretation can only be through the name itself. Frequently, such names are topographical: this is the case with Luxovius of Luxeuil and his consort Bricta, the name of both site and god reflecting light-symbolism.[6] Where the name of the male partner is Roman, then his function may be similar to that of the classical divinity. Thus Mercury and Rosmerta may be seen to be deities of commercial success and, indeed, Rosmerta's Celtic name 'The Great Provider' endorses this prosperity image. But it is the iconography which gives us an insight into how the Celts regarded these divinities and what they considered their roles to be.

I shall group together here partners who are either named or who consistently possess certain distinctive attributes. Where a couple is named on only one or two occasions, I shall use the name to define all such images. This may or may not be valid in religious terms, but it will be used for the sake of convenience.

Sucellus and Nantosuelta: the hammer-god and his consort (Map 5)

This divine couple is distinguished by the possession of one dominant symbol by the male partner – namely a long-shafted hammer or mallet (Figures 18–20). The hammer-god Sucellus is interesting partly because he is wholly Celtic; because he is so widespread; and because he occurs very often by himself (Chapter 4). He is thus established as an important divinity in his own right. Our especial interest here lies in his association, on a number of occasions, with a female consort. Whether or not this couple has the same identity when the deities appear in Provence, Germany, Burgundy, or among the Mediomatrici is not known, but the long-shafted mallet is such a distinctive symbol that the identity of the couple may have been shared over a wide area of Celtic Europe.

We begin with the couple's occurrence among the north-western Gaulish tribe of the Mediomatrici centred on the tribal capital of Metz. The occurrence of the hammer-god and his consort is especially significant at Sarrebourg (Figure 18) because they are named 'Sucellus and Nantosuelta'.

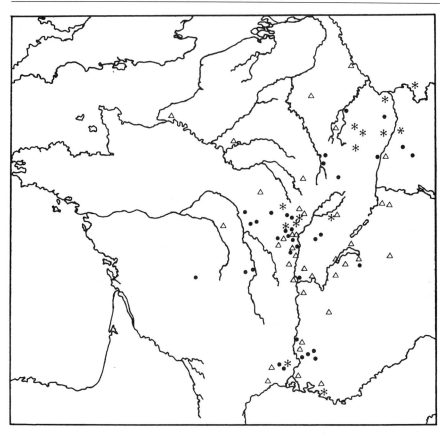

Map 5 Distribution of the Gaulish hammer-god:
- • stone monuments of god alone
- △ bronze figurines
- * stone monuments of hammer-god and consort

After P. Lambrechts, *Contributions à l'étude des divinités celtiques*, 1942.

His name means 'the Good Striker' or He who strikes to good effect'; hers means 'Winding Brook'. The relief in question was found near the Sarrebourg *mithraeum* and combines the dedication with a representation of the couple.[7] The deities stand together in a niche: she is draped, with long hair, and is depicted sacrificing onto a balustrade-like altar; in her other hand she holds a long pole or staff surmounted by a house-shaped emblem. Her male companion, a mature god with curly hair and beard, carries a small pot in his open right palm and a long-handled mallet in his left. Beneath the couple is a raven. The imagery here is similar to other occurrences of these gods, in the presence of the hammer itself and the small pot or *olla*. Particularly distinctive is the presence of the raven and the house-sceptre carried

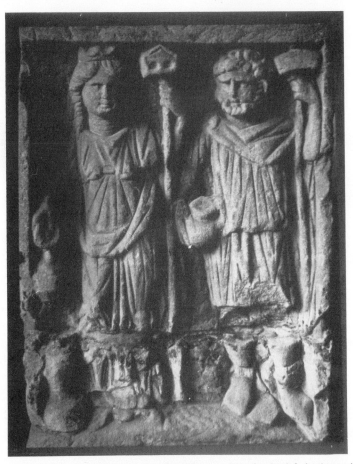

Figure 18 Sucellus and Nantosuelta: Sarrebourg. Musée Archéologique de Metz. Base width 34cm. Photograph: Miranda Green.

by Nantosuelta and these are limited geographically to this area, presumably indicative of specific functions. We have already seen (Chapter 2) that Nantosuelta occurs on her own in this region, with her house-attribute and raven. We have seen, too, that among the neighbouring Treveri, especially in the area around Luxembourg, goddesses are associated with house-shaped *aediculae* or shrine models. It may be that domesticity is a particular feature of the goddess here, with an additional chthonic dimension expressed by the symbol of a carrion bird.

There is a Rhineland group of images of the hammer-couple. Two examples occurring on the left bank, from Oberseebach (Bas-Rhin) and Mainz (perhaps belonging both to the tribe of the Rauraci) are distinctive in

48

that the deities are accompanied by dogs. The former stone[8] depicts a standing couple; the male, like his Mediomatrician counterpart, is portrayed as a mature man with beard and abundant hair, with his mallet on long staff and his pot. A feature here is the reversal of attributes; on most occasions the hammer-god holds his main emblem – the hammer – in his left hand, as if it is a badge of office rather than a tool (if one assumes the normal right-handedness of humankind and therefore of its gods). Here, though, the hammer is grasped in the right hand. A dog sits at his right leg. The goddess again is a divinity of domestic well-being, with a *cornucopiae* in her right hand and an apple in her left. The Mainz depiction[9] may be part of a Jupiter-column (pp. 123–9): on one surface of a multiple-carved stone, a bearded god carries a mallet and is accompanied by a dog, while his consort appears as a Celtic Diana with bow and quiver. Whilst the dog may be seen as a chthonic emblem, the equivalent of the raven at Sarrebourg, the Mainz imagery complicates things, and here there is an element of the divine hunt as well, of which the dog may be a part. In any case, the concept of the hunt is itself a theme suggestive of renewal and resurrection after death, and the Roman Diana, as a moon-goddess, had connections with night and with women's monthly cycle and therefore fertility. The relief at Grünwinkel[10] is from the right bank of the Rhine but not far from Oberseebach. Here the couple sit together on a throne; they are high gods, he wearing a crown and she a diadem. Again, her fertility/prosperity imagery is indicated, this time by her basket of fruit.[11] The god appears as normal, bearded, with his mallet (again in his right hand), but on this occasion the implement has a double axe-blade near its base. The association of hammer and double-axe is an interesting one, repeated on other iconography; for example, an altar from Carpentras in southern Gaul[12] bears a hammer on one side and a double-axe on the other. Hatt[13] suggests that both hammer and double-axe may be thunderbolt symbols (see Chapters 4, 5). What may be more significant is that, as a double-edged weapon, the double-axe could be a symbol of something facing or looking both ways – up and down – thus providing a link between upper and lower worlds and demonstrating the god's dominion over both.[14]

The Burgundian group of hammer-gods with consorts forms the most prolific and interesting cluster (Figures 19, 20). Belonging to the Aedui, or their neighbours the Lingones, the hammer-group of divine partners is just one of a number of divine-couple types occurring in the area. What is especially significant is the pair's association, in a great wine-growing area, with imagery reflecting this particular aspect of the earth's plenty and fecundity. The goddess of this Aeduan group is remarkably homogeneous. In nearly all instances, she holds a *cornucopiae* and a *patera*, symbols of nourishment and fertility. At Jouey[15] and Alesia[16] the goddess has no *patera* but she holds an exaggerated *cornucopiae* and her companion has the offering-dish instead. On another Alesia relief, the goddess has both attributes but, in

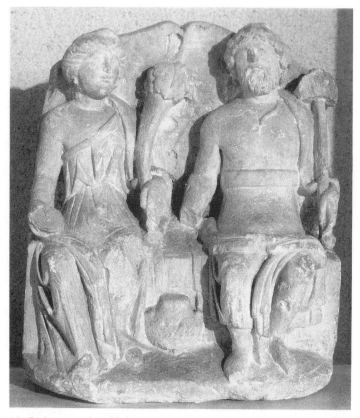

Figure 19 Divine couple with hammer, *cornucopiae*, *patera*, and jar: Dijon. Musée Archéologique de Dijon. Width 39cm. Photograph: Miranda Green.

addition, a rudder to her right. This brings her into line with her sister-deities, the mothers and Nehalennia, whose rudders proclaim their symbolism as Fortuna-like guardians over the chancy journey of life. Otherwise, the goddess-wife of the Burgundian hammer-god reflects the consistent image of prosperity and well-being. Fruits at Alesia[17] replace her *patera* which is instead held by her consort. Her close relationship with her partner is demonstrated, for instance, at Dijon[18] where she holds her *cornucopiae* up against her left shoulder in precisely similar manner to her husband's shouldering of his hammer.

The Aeduan hammer-god is more varied than his female partner. He usually appears as a middle-aged, curly-haired, bearded god, with long-handled mallet in his left hand. But, as on the Dijon relief, his face is given more sculptural detail than his wife's, and his non-hammer attributes display a greater variety of functions. The god sometimes holds a *patera*, the latter

50

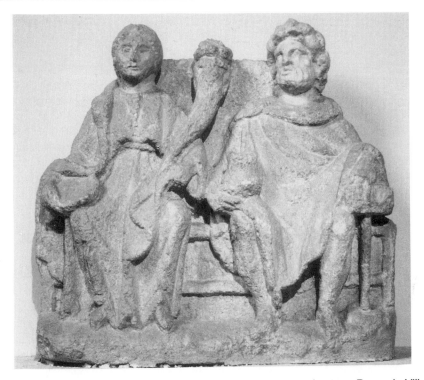

Figure 20 Divine couple with hammer, pot, *cornucopiae*, and *patera*: Pagny-la-Ville. Beaune, Musée des Beaux Arts. Width 37 cm. Photograph: Miranda Green.

generally a feminine symbol.[19] On many carvings, the *patera* appears to replace the pot (seen both outside Burgundy and within the present group).[20] One of the Alesia reliefs[21] is significant in that here the hammer-god holds a sword in addition to his hammer. This associates him with another group of couples where the male appears as a warrior (below, pp. 64–9), in this peaceful context presumably as an image of protection against evil, a bad harvest, and poverty rather than of war in the strict sense of combat against people. This versatility on the part of the male partner contrasted with the homogeneity of the female may imply that she is merely a cipher, but may equally be interpreted by the assumption that the female is one great goddess, whilst her consort, of lesser status, may vary depending upon precise locality or other factors.

Apart from personal attributes, the Aeduan group has very specific prosperity emblems, some suggestive of viticulture and the success of the wine harvest. The large amphora-like pot set on the ground between the couple at Dijon (Figure 19) and Bolards may reflect this; and even more indicative is the unequivocal wine-barrel between the partners at Alesia.[22]

The large sack at the god's feet at Jouey[23] may be full of grain, but equally perhaps of grapes or vine-leaves. The Alesia stone,[24] where the goddess pours liquid from a *patera*, may also contain wine symbolism; and indeed all the pots and *paterae* enhance the imagery of liquid and perhaps wine. The barrel imagery is extremely evocative: where the hammer-god is considered as a lone entity (Chapter 4), it may be observed that hammer and barrel are very closely linked; the two objects may touch each other; the hammer-head often resembles a barrel, and indeed hammer and barrel may merge into one composite motif. At Alesia[25] it is suggested that the barrel the god is leaning on may actually replace the hammer symbol.

We have no real clue as to the identity of the Burgundian hammer-deities. The goddess' mural crown at Alesia[26] may indicate that she personifies the city itself; and it is suggested that another Alesia depiction[27] may portray the named couple Ucuetis and Bergusia. The goddess's diadem at Dijon[28] may reflect a high status, as may the couple's frequent attitude seated on a double throne. That the pair is benevolent is demonstrated by their symbols of fecundity and well-being. They are grave but serene: he is a beneficent, paternal figure and she, younger, shows a gracious, kindly face to her subjects. Whatever the precise meaning of the hammer symbol here, it is certainly not destructive (unless of evil) and must have a positive function. It is difficult to determine which deity is the senior: he is older, and we have observed the greater detail sometimes given to his face, but she wears a crown or diadem and she is the one to whom the main symbols of fertility belong. The sword-bearing hammer-god may be protecting her as the main deity. All in all, though, the two deities seem evenly balanced in terms of importance of imagery, and they are depicted as similar in size, even allowing for sexual dimorphism. Yet they are not mirror-images of one another, for they carry different attributes and so cannot possess identical roles. The only thing really suggestive of the god's dominance is his frequent occurrence in Burgundy on his own (Chapter 4), but the goddess's imagery is so similar to that of many mother-goddesses that it is impossible to tell whether a single female image occurring in the area is the same deity or not (since the identifying emblem of the hammer is necessarily absent).

Two isolated images of the hammer-god and his consort may be considered together. A relief from Besançon (Doubs) in the land of the Sequani is an outlier of the Burgundian group.[29] The male partner here is precisely similar to the Aeduan god, with long curls and luxuriant beard; and with hammer or mallet and pot; the only attribute of his companion is a second vessel. An unprovenanced stone[30] comes from the Lyon area, where the hammer-god as an isolated image is common. On this depiction he is younger than normal and beardless, with his hammer and pot; his wife has a *patera* and *cornucopiae*. Further down the Rhône Valley, the divine couple occurs in Drôme, Ardèche, and in the area of Nîmes, a region where, once again, the hammer-god alone is popular. The Drôme and Ardèche examples

52

are from Romans, south of Lyon and Alba[31] in the tribal area of the Allobroges. The third is from Marguerittes (Gard) near the Rhône's mouth.[32] The three stones are distinctive in that they, like the two from the west Rhine, include the dog in the imagery of the couple. At Romans and Alba the pair appear in normal attitude, he with hammer and pot, curly hair and beard. At Romans the goddess bears a *cornucopiae* and a purse or fruit; her representation at Alba is too worn for her emblems to be identified. On both, a dog raises its muzzle to gaze up at the hammer-god. The southernmost stone, from Gard in 'The Province' is essentially similar, but with the added complexity of a snake curling round the hammer handle. This reptile may echo the essentially chthonic role of the dog but may, again like its canine companion, reflect healing and regeneration, an image enhanced by the snake's skin-sloughing properties and rippling water imagery. As with other deities, the presence of the animals enriches the symbolism belonging to their anthropomorphic associates, rendering it the stronger by acknowledging the especial qualities present in certain beasts (Chapter 5). They were not themselves deities but they were venerated and respected and may have possessed a divine sphere of influence. One additional feature about the dog, in this context, could perhaps be its symbolism simply as a companion of humankind, emphasizing the simple, domestic nature of a couple who reflected the homeliness of earthly life.

The final hammer-couple I wish to look at is a unique representation from Britain, from East Stoke in Nottinghamshire, in the territory of the Corieltauvi. The stone forms two gabled niches: on the left stands a bushy-haired goddess wearing a heavy torc and flounced skirt and holding a bowl of apples in front of her. Next to her is an elderly, though beardless, god with curly hair and short tunic and with what appears to be a long-shafted hammer in his left hand.[33] If this couple has been correctly identified, then the representation is very significant. The hammer-god Sucellus is referred to on an inscribed silver finger-ring at York[34] and maybe also appears on a crudely embossed bronze sceptre-binding at a temple in Surrey,[35] but the Corieltauvian carving is the only British example of the couple themselves. Whilst there is a local variation in the goddess's dress, the similarity in general to the Gaulish iconography argues for the worship of the same two deities. Whilst the Sucellus ring at York may well be an import, the Midland stone must surely be the work of a local artist commissioned by an indigenous patron.

The dominant role of the divine couple is as a partnership designed to promote the image of fertility, prosperity and, especially among the Aedui, of a good wine harvest. Most of the monuments, particularly in the Rhône Valley, from Burgundy in the north to Nîmes in the south, are small, the property of individuals involved in personal devotion rather than the result of corporate worship. Often the distribution of the couple reflects areas of popularity of the hammer-god alone. It is difficult to be certain, at least in

Burgundy, where divine couples with diverse attributes are present,[36] whether we have essentially the same couple appearing in different roles, or whether the hammer-god and consort are a specific entity. I would surmise, from the couple's other occurrences, that they are a distinct image with a real and separate identity. The hammer is, after all, a specialist attribute. The god is definitely a local, indigenous deity, in the clothes of a humble Celtic peasant, a people's god. Prosperity is the couple's main function but, like so many Gaulish divinities, there is dualism, and chthonicism is never far away. Thus the carrion bird, the raven, among the Mediomatrici, reminds us of the dark side to their cult; the dog and snake of the Rhône and Rhine encapsulate the dichotomy of healing, renewal, death and resurrection. Nantosuelta, among the Mediomatrici, is a goddess of life and death; the raven allies her to the crow-goddesses of Ireland[37] who combine maternity and war, domesticity and destruction, and the war element comes in again at Alesia. Nantosuelta's name proclaims her as a water-deity, but in the iconography water is less evident than wine, perhaps the red wine of life and blood and regeneration after death. The vessels depicted with this couple may themselves be connected not only with the wine of earthly life but with the ever-replenishing cauldron of magic and the otherworld. The hammer is more equivocal: at one level it is a weapon; at a practical viewpoint, it may belong to the work of carpenters or perhaps coopers. It is, in fact, often depicted as a wooden mallet rather than a hammer proper and, as such, may possess the symbolism associated with fence-posts and therefore sacred or secular boundaries. It may be a noisy symbol of thunder; it is sometimes suggested as chthonic, with overtones of the Etruscan Charun's implement,[38] but there is none of the horror of Charun in Sucellus' mien. The fact that the *cornucopiae* could replace the hammer among the Aedui[39] shows that the hammer is itself a beneficent image. In addition, the resemblance of Sucellus to Jupiter and his carrying of the hammer with its long shaft, almost as if it were Jupiter's sceptre, gives the Celtic god a dignified role, the hammer perceivable in terms of a badge of office and high rank: here the usual left hand as the one bearing the implement is indicative of its passive role rather than as a functioning tool. The divine couple, with their multifarious symbols and images, protected both the living and the dead. The two states were not, in any case, far apart and it was natural for the images to reflect the concern of these deities for all events endured by humankind.

Mercury and Rosmerta: a divine couple of success

This pair of divinities differs from the hammer-god and his partner in that the male is of Roman origin (Figures 22–3). The gods are named on dedications which are sometimes, at Eisenberg[40] and Metz[41] for example, accompanied by images of the couple. Mercury was whole-heartedly adopted by Gaulish and British Celts, presumably because he possessed qualities

sympathetic to their own religious ideas. In the Celtic world, Mercury was first and foremost a deity of commercial prosperity and success. His iconographic attributes of cockerel, ram or goat, and tortoise refer to aspects of his original Mediterranean mythology, but in addition, the goat and ram have fertility symbolism. Indeed the classical Hermes-Mercury possessed considerable fertility functions. In the present context, Mercury's greatest interest lies in his adoption of a Celtic consort – Rosmerta, 'The Great Provider' – the descriptive epithet firmly proclaiming her as a goddess of fertility and prosperity. Whilst Mercury had other Gaulish consorts, Rosmerta was by far his most common partner. The distribution of the couple's images is widespread but favours the central and eastern areas of Gaul, along the Rhône, Meuse, Moselle, and Rhine, among the tribes of the Aedui, Lingones, Treveri, Mediomatrici, Triboci, and Leuci; across the Rhine among the Germanic tribes on the east bank; and an outlying cluster among the Dobunni of south-west Britain.

The iconography of this divine couple is remarkably homogeneous, especially as far as Mercury is concerned. The god appears in classical guise, frequently with his *petasos* or winged cap (indicative of his herald's role and that of messenger of the gods).[42] His most frequent attributes are his *caduceus* (the staff entwined with two serpents, traditionally used for leading souls to the otherworld) and his purse, symbol of commercial transactions. He appears often with his cockerel, but more important is his fertility emblem of the goat, which occurs on very many depictions of the couple. Interestingly, Mercury's purse is frequently shown in direct relationship to the goat;[43] thus it may be positioned either between or just above the goat's horns, as if thereby perhaps gaining power as a fertility symbol. Mercury himself shows little sign of celticism in his imagery, but some exceptional features demonstrate that he does not entirely escape Celtic influence: the god sometimes wears a Celtic torc or necklet, as at Trier;[44] again the money chest between the two partners on the same stone is a Gaulish feature.[45] Least romanized of all is perhaps the stone from Néris-les-Bains (Allier)[46] (Figure 21) where the god is accompanied by the Gaulish symbol of the ram-horned snake, a beast which combines the fertility imagery of the ram with the chthonic/renewal motif of the snake. But here, his partner is not Rosmerta in typical guise but appears, instead, as a healing-spring nymph, and it may be that Mercury is here linked with another indigenous goddess and not with Rosmerta herself.

If Mercury is generally envisaged as a Roman god – though his role may in fact be very different – we must look to Rosmerta to provide the overt Celtic element in the iconography and, indeed, to show that the god himself is Gaulish. A consort for Mercury is unknown in the classical tradition. Accordingly, Rosmerta's very existence, and her possessing a totally Celtic name, bring the couple into the large, heterogeneous group of Celtic divine partners. Rosmerta herself appears to have a varied relationship with

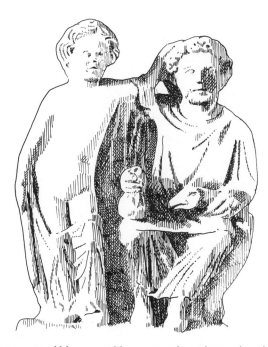

Figure 21 Stone group of Mercury with purse and ram-horned snake, accompanied by a Nymph or Rosmerta: Néris-les-Bains. Musée de Néris. After E. Thevenot, *Divinités et sanctuaires de la Gaule*, 1968, p. 88. Illustrator: Paul Jenkins.

Mercury and her status is equivocal. Her common attributes of *patera* and *cornucopiae* link her to the great group of fertility/prosperity goddesses; in this she resembles the consort of the hammer-god and indeed many single or triadic mother-goddesses. Thus among the Aedui[47] and at Metz[48] of the Mediomatrici, Rosmerta complements Mercury's function as a fertility god and his prosperity role as purse-holder. Sometimes the relationship between Mercury and Rosmerta is extremely close: at Baden[49] in Germany, where there was a temple to the two deities, the couple have identical attributes of purse and *caduceus*, but Rosmerta's are in reverse order to Mercury's, a feature which may be due rather more to artistic balance than anything else. Rosmerta frequently herself adopts Mercury's purse, the attribute thus occurring twice on the same monument: on some reliefs[50] the goddess holds a purse and a *patera* while he carries a second purse and a *caduceus*, or both deities may carry purses.[51] At Metz[52] the divinities actually share one purse; and at Wiesbaden[53] Rosmerta sits on a throne receiving the contents of a purse offered to her by Mercury who stands before her. Two other features concerning this symbols of commercial prosperity are significant: on a monument in Mannheim Museum, of unknown provenance,[54] it is Rosmerta alone who holds the purse, clasped against her breast, whilst a snake rests its

head on the purse as if deriving nourishment from it. This recalls both the portrayal of Sirona at Hochscheid (pp. 42–4), around whose arm is twined a snake and who holds eggs in her hand, and the goddess at Sommerécourt (pp. 25–6, 72) who feeds a ram-horned snake from a bowl on her lap. The idea would seem perhaps to be mutual nourishment, the serpent gaining strength but in its turn, by its own symbolism of renewal, enhancing the inanimate attribute itself. The other monument to note is that from Chatenois near Strasbourg.[55] Here both Mercury and Rosmerta carry objects which look like a cross between purses and the small pots carried by Sucellus and his consort. Indeed, Mercury's long-handled *caduceus* also resembles Sucellus' mallet. Here the purse may have become a vessel of replenishment, a view supported by the iconography of the stone from Toul near Metz[56] where Rosmerta appears to hold a cup.

As well as the purse or moneybag, Rosmerta occasionally adopts Mercury's other major symbol, that of the *caduceus* or snake-twined staff, again emphasizing the close association between the deities. Thus at Bierstadt[57] Mercury and Rosmerta sit side by side in identical posture, each holding a *caduceus* against their left shoulders. The iconography may be similar at Bath[58] where again the couple sit, he with his *caduceus* against his left shoulder and his partner with either a *caduceus* or a wand held in exactly the same attitude. At Schorndorf,[59] Rosmerta takes over the symbol completely, clasping the staff in both hands against her chest, and her consort carries only a purse.

All the foregoing evidence serves to illustrate the bond between the two divinities. It may even be that Rosmerta only exists as a feminine version of Mercury and has no real identity of her own. This viewpoint is supported by the imagery on the stones from Trier[60] and Bierstadt, where the dedication is to Mercury alone. But there is a substantial amount of evidence which indicates that Rosmerta had a very real personality and imagery of her own and was considered as an independent goddess (pp. 42–3). Indeed, she may even have pre-existed Mercury in Gaul, with Mercury her consort rather than vice versa. Certainly, on occasions, Rosmerta introduces elements foreign to Mercury's normal repertoire of images. We have seen this in the *patera*, *cornucopiae*, and the snake, for instance. But Rosmerta's essentially alien, indigenous Celtic character is demonstrated on a number of monuments. This independence is illustrated especially well by the British evidence: at Bath, Mercury is conventional, with *petasos*, purse and *caduceus*. Apart from Rosmerta's own 'caduceus' (which may instead be a wand of authority), she rests her right hand on a cylindrical receptacle – box, casket, or bucket. The Celtic character of the couple is enhanced by the presence of three minute *genii cucullati* at the base of the stone. Gloucester must have possessed at least one temple to the divine couple, since three monuments to them survive from the *colonia*. On all these, Rosmerta's special nature is indicated. From the Shakespeare Inn, Northgate Street[61] comes a relief of the

Figure 22 Mercury and Rosmerta, with sceptre, ladle and bucket, cockerel and *caduceus*: Shakespeare Inn, Northgate Street, Gloucester. Gloucester City Museum. Height 58.5cm. Photograph: Gloucester City Museum.

couple: he with his cockerel, *petasos, caduceus*, and money-bag, but Rosmerta bearing a curious sceptre in one hand and a ladle in the other, poised over a cylindrical wooden, iron-bound bucket on the ground (Figure 22). This evidence, from two West Country sites, of Rosmerta's association with a vessel, suggests links with cauldrons of renewal and regeneration, with blood-red wine and therefore resurrection, associating her with the Burgundian wine-imagery already noted for the hammer-god and goddess.

Rosmerta's independence, and her association with a profound

symbolism of regeneration, is indicated again at Gloucester, on a stone from the Bon Marché site[62] where Rosmerta is joined by another goddess who resembles Fortuna. The two females wear elaborate headdresses reminiscent of the 'coiffure' of the Germanic mothers (Chapter 6). Rosmerta holds a rod-like object turned downwards and Fortuna an upraised, similar object held against her left shoulder; these are best interpreted as torches, one held up, one reversed, perhaps symbolic of life and death, light and darkness and dominion over all states of being, in imagery similar to that of the mithraic Cautes and Cautopates. The third goddess possesses, in addition, the rudder and globe usually associated with Fortuna. We have seen the imagery before, in connection with the mothers, with Nehalennia and with the consort of the hammer-god. The idea seems to be that of guardianship or protection in all the chances life may bring, and in the vicissitudes of death and the afterlife. The association between Rosmerta and a Fortuna-like being is even stronger at Glanum[63] (Figure 23), where Mercury and Rosmerta occur alone but this time with the goddess herself having taken over the guise of Fortuna, complete with large *cornucopiae* and rudder perched on a globe. Mercury

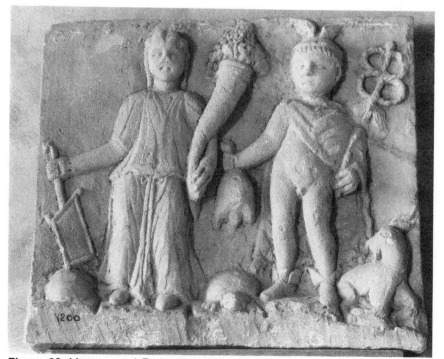

Figure 23 Mercury and Rosmerta, with rudder on globe, *cornucopiae*, tortoise, purse, *caduceus*, and goat: Glanum. Musée des Alpilles, St-Rémy-de-Provence. Width 53.5cm. Photograph: Miranda Green.

himself is surrounded by all the usual paraphernalia of his imagery: he wears a winged cap and carries a large purse and *caduceus*; his tortoise and goat are both present. The symbolism on this stone is intensified both by the multiplicity of the supporting motifs and by their large size.

Rosmerta's personal identity, as distinct from Mercury's, is shown above all by two instances, among the Aedui, where she occurs by herself. As discussed in Chapter 2 (pp. 42–3), it is clear that Rosmerta cannot be dismissed as a mere adjunct or feminine aspect of what was basically a male divine concept, whether or not, as Bémont suggests,[64] this proves Rosmerta's preexistence in Gaulish religion before the advent of Roman influence and of Mercury himself.

One or two other points concerning the cult of this divine couple remain to be made. One is the specifically Celtic nature of the cult, which may be seen both in context and in the associated imagery. We have noted the presence of the Celtic *cucullati* at Bath, the pot-like purses at Chatenois and the curious imagery of the Gloucester depictions. To these we need to add the monument at Trier[65] where the image of the couple shares a stone with an unequivocally Celtic god – Esus – who hacks at a willow tree containing a bull's head and three egrets (Chapter 4). The association of the deities, too, with spring-sanctuaries, like Bath and Metz, demonstrates that Mercury is outside his normal Graeco-Roman role in the Celtic world. The way in which the couple is usually presented may also be significant. They sometimes appear in the garb of Gaulish peasants,[66] and they are frequently represented stylized, as if carved by Celts for Celts. That the cult was an important one is indicated not only by the number and widespread distribution of the monuments and inscriptions, but by the known presence of temples, as at Wasserburg in Alsace[67] where the dedicant, in AD 232, was a freedman of the emperor Severus Alexander's mother Julia Mammaea, and a *tabularium* (keeper of archives) of the emperor.

The nature of the cult of Mercury and Rosmerta is demonstrated by its visual symbols to be linked to that of other Gaulish divine couples. Mercury is fairly stereotyped, but the goddess is associated not only with commercial success, but adds a new, visually present, dimension in her concern for prosperity and well-being in all aspects of life and death. Rosmerta was not Mercury's only Celtic consort. In the eastern Vosges, for instance at Langensoultsbach,[68] she was replaced by Maia, Mercury's mother in the classical pantheon, but here transformed into a Celtic consort to form a traditional indigenous divine couple. It is even possible that Mercury's association with the mothers, for instance in the Rhineland,[69] may be another aspect of the partnership of a Roman god with a Celtic goddess. The idea is the same: in Gaul and Britain a popular god of Roman origin was married to a native goddess, thereby producing a powerful composite symbolism which embraced the whole gamut of human florescence – good luck, success in business or farming, fertility and well-being in this world and in the other-

world. It is Rosmerta who provided the cult's profundity; she protected from harm as well as promoted success; she lit the darkness of the soul, guided people through the capriciousness of Fate and she symbolized resurrection and regeneration after death. Some of these roles are implicit in Mercury's imagery, but less overtly present. Rosmerta provided an immediate visual comfort that was readily identifiable to a sometimes naïve Celtic clientèle.

The Celtic healers

Certain divine couples were associated very specifically with healing, usually appearing at therapeutic spring-sanctuaries. They may be found throughout the Gaulish heartland but are concentrated among the Treveri, the Aedui, and the Lingones. The Treveran Mars Lenus and Ancamna fall into this group but are generally unrepresented iconographically. The male deity is equated most frequently with the Mediterranean Apollo, whose classical roles included those of sun and light, healing (often associated with sacred springs) prophecy and the care of flocks and herds. It was his healing element that was singled out for adoption in Gaul, and like Mercury, he was given a Celtic female consort. Unlike the evidence for Mercury and Rosmerta, the Celtic healer-couples were more often represented by dedicatory inscriptions than by visual expression. The names themselves may give clues as to their interpretation. The healers differ again in that, whilst they have a common curative role, they may have different names, and in that Apollo is more Celtic than Mercury in possessing a number of Celtic surnames.

One important couple were called Apollo Grannus and Sirona, worshipped especially among the Treveri at, for instance, the curative spring-shrine of Ste-Fontaine (Moselle),[70] the temple at Nietaldorf[71] and at the thermal sanctuary of Hochscheid in the Moselle Valley between Trier and Mainz.[72] Whenever Apollo appears, his iconography is that of the classical god; he is nude and carries his lyre, symbolic of his patronage of music. At Hochscheid he is accompanied by his griffon: at this site Apollo's Celtic surname is not mentioned, but he is probably the same Apollo Grannus found with Sirona at Ste-Fontaine and elsewhere.

Sirona is far more interesting in terms of imagery than her male partner. Her name is associated with stars and her companion 'Grannus' also implies light, as is the case with Belenus, another of the healer's surnames.[73] Sirona is a native goddess, appearing at Hochscheid with a snake curled round her right wrist and reaching out towards a bowl of three eggs carried in her left hand (Figure 17). The snake here probably appears as an aquatic and regenerative symbol, supporting the goddess' role as a healer. Several small pipe-clay figurines dedicated to the goddess at the temple depict a seated mother-goddess, holding a small dog in her lap or in her arms.[74] Presumably this animal is present in its healing capacity and serves to link the imagery of the goddess with that of many mother-goddesses (pp. 28–30) who adopted

the dog as a symbol of renewal. Coins suggest that the main temple at Hochscheid was built in the second century AD, succeeding an earlier free Celtic wooden structure.[75] It was an elaborate sanctuary for what was a relatively remote area, and the high quality of the art of the sculptures argues for a wealthy, romanized clientèle and for the popularity and success of the healing cult. Apollo Grannus and Sirona were worshipped again among the Treveri at Bitburg, another curative-spring site.[76] Not all that far away at Mainz, Sirona was represented with ears of corn, a fertility image which recurs at Hochscheid with the bowl of eggs; and at Ste-Fontaine the goddess appears with corn and fruit. Fertility and healing were closely linked in this cult.

Apollo Grannus and Sirona were especially beloved of the Treveri, but they were venerated as far away as Aquincum in Hungary, where the goddess's name was altered to 'Sarana'.[77] Elsewhere, the couple appear iconographically at Mâlain (Côte d'Or) (Figure 24) among the Lingones or Aedui, where a unique bronze group depicts the pair, who are named on a basal dedication.[78] They are here depicted as youthful deities: he has a lyre and a baton-like object, perhaps a staff of authority; she has a snake around

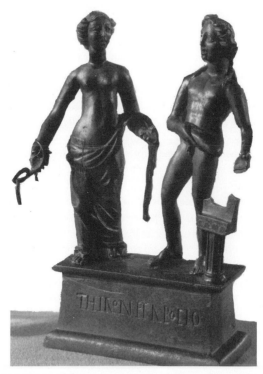

Figure 24 Bronze group of Sirona and Apollo: Mâlain, Côte d'Or. Musée Archéologique de Dijon. Width approx. 8cm. Photograph: Miranda Green.

her wrist – again, as at Hochscheid, presumably as a renewal/healing motif. As is the case with Rosmerta, Sirona was a powerful religious entity in her own right. We may judge this partly on account of the independence of her iconography and partly because of her frequent appearance on her own in as widely separated places as Brittany and Noricum. Here, at Baumburg, she appears with grapes and ears of corn, endorsing her role as a fertility-deity as well as a healer. Her presence at curative thermal sanctuaries outside her main Treveran cult-centres[79] is nevertheless testimony to her consistent curative function.

At Alesia Apollo was linked with a goddess similar to and maybe identifiable with Sirona: he himself is called Apollo Moritasgus, his name meaning 'masses of sea-water'. His consort was Damona, her name, curiously, meaning 'Great Cow', presumably a straight fertility allusion. An inscription to the couple[80] dedicates a shrine at the healing spring and a head crowned with corn and a hand with a serpent curled round it are all that remains of a cult-statue of the goddess, who presided over the small pool in which sick pilgrims immersed themselves in the hope that the touch of the sacred water would cure their afflictions. Damona's polyandrous nature is demonstrated by her association with another Celtic Apollo-entity, Borvo or Bormo, whose name 'bubbling spring-water' ties him unequivocally to such eponymous thermal sites as Bourbonne-les-Bains and Bourbonne-Lancy.[81] What must be the same deities appear as Bormanus and Bormana at Die (Drôme) far away to the south. The essential independence and originality of the goddesses is indicated by their occasional occurrence unaccompanied.[82] The healer-couple are interesting in the variety of names and possible identities which are suggested. Often the symbolism is evoked by names rather than by visual imagery. The male, equated with Apollo, is of complex character: whilst his iconography indicates that he was untouched by celticism, his Celtic surnames belie this and he was, in any case, far more popular than a direct import of the god from classical lands would warrant. Apollo's Mediterranean healer-role was picked out as a suitable conflation with a hitherto formless native religious concept. The female partner was totally indigenous except that her art-form owed a good deal to Graeco-Roman depictions of Hygeia, Apollo's mother. Though she too was first and foremost a healer, her symbolism has also a strong fertility element. The mother-goddesses, too, were very closely linked with healing[83] as a regenerative force. Once again, it was the goddess who provided the distinctive iconography. Here may be another example of Roman conqueror – in the form of a god of Roman origin – marrying the indigenous goddess of the occupied land. But, once more, the vitality lay with the female and with her individualized imagery; indeed, she may well have been the driving force within the partnership.

The warrior-guardians and underworld protectors

The male of some divine couples occasionally appears as a warrior, taking on the guise of a Celtic Mars, whereas the female was regularly envisaged as a peaceful protectress, giver of bounty and provider of fertility and well-being. However, we know from epigraphic and contextual evidence that the Celtic Mars often shed his normal Roman military role, using it merely for protection, guarding against the evils of the world – barrenness, disease, and ill luck (reverting thereby to his original Italian role as agricultural god and guardian of fields and their boundaries). Thus the divine couple may be seen as equally active in this guardianship role rather than being simply beneficent providers. This protective function is indicated most clearly by the great healing Treveran shrines of, for example, Mars Lenus at Trier and Pommern.[84] A spring-sanctuary north of Trier, at Möhn,[85] produced a dedication to a divine couple Mars Smertrius and Ancamna. This is significant for a number of reasons: Ancamna was the consort of Mars Lenus at Trier;[86] again, the name 'Smertrius' may be interpreted as 'Provider of Abundance' and is of the same root as 'Rosmerta' ('The Great Provider'). So prosperity appears to be one important sphere of influence of this couple whose context suggests a healing function. We meet Smertrius again on the *Nautes Parisiacae* pillar in Paris,[87] where he is not only named but depicted as a club-wielding, Hercules-like figure, exuding power and strength. At Möhn, pipe-clay figurines offered at the shrine imply that Ancamna was envisaged as possessing a maternal role. So we have disparate evidence at the site: the name of the god and the iconography of the goddess are indicative of a prosperity role; their context suggests healing, and other imagery of the god displays a combative show of strength. The only common theme is that of protection and defence against the evils that could beset their devotees. Smertrius and Ancamna may, indeed, be represented not far away at Freckenfeld (Rheinland-Pfalz) where a god and goddess stand together, she portrayed as a young woman with a basket of fruit on her arm, he with a sword and club.[88] Once more we see warrior-protector and goddess-of-plenty in association, the club providing a distinctive image of power.

Mavilly (Côte d'Or) was another great therapeutic-spring establishment, belonging to the Aedui of Burgundy. Here a Celtic Mars and consort were worshipped, once again as guardians. The curing of eye-disease appears to have been the main therapeutic function of the shrine,[89] and one carving depicts the god with his dog (symbol of healing, death, and rebirth), accompanied by a pilgrim with his hands over his eyes, as if suffering from an eye-affliction (Figure 25). Mavilly has produced iconography suggesting the veneration of a divine couple who presided over the curative sanctuary: a stone pillar[90] portrays, on one surface, a warrior wearing a Celtic torc and holding a shield and spear, who is accompanied by a goddess and a ram-horned serpent (Figure 26). The goddess turns towards her partner, lays one

64

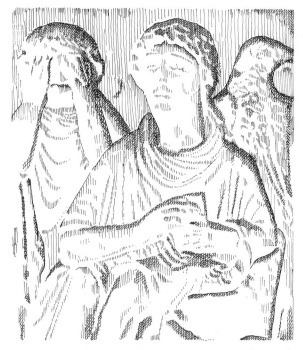

Figure 25 Healer-god with afflicted pilgrim and raven: Mavilly. Château de Savigny. After E. Thevenot, *Divinités et sanctuaires de la Gaule*, 1968, p. 68. Illustrator: Paul Jenkins.

Figure 26 Relief of Mars and goddess, with ram-horned snake: Mavilly. Château de Savigny. Height of pillar 1m 79cm. Illustrator: Paul Jenkins.

hand on his shoulder and the other on the god's hand which rests on his shield. The iconography here is interesting: the presence of specifically Celtic divinities is demonstrated by the torc, the shield (of hexagonal La Tène III type) and, above all, by the hybrid Celtic beast, the ram-horned snake. The imagery at Mavilly is repeated on a fragmentary relief of which only the snake and the lower legs of the couple survive.[91] This creature accompanies deities of fertility, its ram element conveying this image, and the snake itself possesses a dual chthonic and regenerative symbolism. We shall see (Chapter 4) that the creature is a constant companion of the stag-antlered Cernunnos, himself a lord of animals, crop-growth and vegetation. Interestingly, too, the serpent accompanies another Celtic Mars-figure, this time far away at Southbroom in Wiltshire, where a little bronze helmeted statuette clasps two of the snakes by the neck.[92] The close companionship between the god and goddess at the Burgundian site is expressed by the physical contact between them. He is seen to have a predominantly protective role, combating illness, displaying his prowess as a conventional warrior. She is present perhaps not just as a supporter, but as a symbol of serene well-being; and the serpent adds its own life-force as a beneficent image of healing, renewal, and light after darkness, emerging from the blind depths of earth into daylight and the sun: the war against blindness was well-fought.

The Aedui worshipped other warrior-couples not specifically associated with healing but more with simple prosperity: several pieces of iconography from their territory attest their veneration, and here we have no names, only the visual symbolism. Alesia provides the strongest evidence, with at least three images. One relief[93] shows a seated couple, very much in the attitude of the hammer-partners (Figure 27); she carries the nourishing emblems of a *patera* and *cornucopiae* surmounted by a basket of bread or fruit; he is nearly naked, holding a lance in one hand and a *patera* in the other. Here the god's protective rather than war-like, offensive, role is clearly demonstrated, not only in the presence of his partner but in his own attributes – the weapon is balanced by the symbol of nourishment and food or drink. The couple's equation with the peaceful hammer-god and consort is displayed unequivocally on another stone at Alesia;[94] indeed, we have met this couple already, since the god is both a warrior and a hammer-bearer (above, p. 51). His sword, perhaps significantly, is in its scabbard, emphasizing his passive, watchful, guardian-function. His wife with her mural crown, may personify Alesia itself, and her *cornucopiae* and liquid-pouring *patera* demonstrate her prosperity-function. On the third image,[95] the couple stand together, he again young and naked, like the first carving, with his right hand raised, holding a spear which was painted but not sculpted. She, once again, is a goddess of plenty and holds what must be a heavy *cornucopiae* since it takes both hands to support it. Her diadem proclaims her high status. Another Aeduan relief, from the tribal capital of Autun,[96] displays imagery which is indicative of the same couple as portrayed at Alesia. Again, the god is young

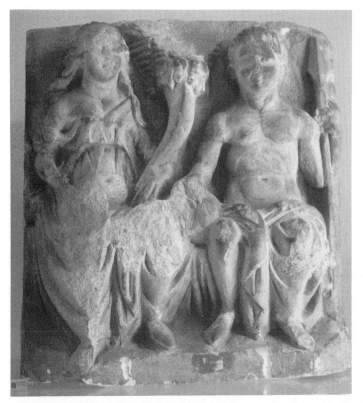

Figure 27 Divine couple with *cornucopiae, patera*, and spear: Alesia. Musée
Archéologique de Dijon. Width 26cm. Photograph: Miranda Green.

and beardless; he has a spear and a shield; she has a *cornucopiae* and *patera*.
Two points which may be relevant strike us from the imagery of this
Burgundian war-couple. One is that the god occurs naked, and we know that
the Celts traditionally fought unclothed.[97] The second concerns the presence
of the female partner. Here again we may see a Celtic tradition, for we know
from Graeco-Roman sources[98] that Gaulish women were nearly as large and
powerful as their men and just as formidable in warfare. We know also from
early Irish tradition that the mother-goddess had a warrior role as well.[99]

Various other divine partners, of the same general warrior-type, are
portrayed on a few scattered reliefs. The Remi at Reims[100] worshipped a
couple who once again combine the roles of warrior-guardian and prospe-
rity-goddess (Figure 28): here the situation is complicated by the presence of
a religious theme very dear to the Remi – the association of their gods with
elements of the Celtic Mercury. We will see (Chapter 6) that their main cult-
image, the triple-faced god, was linked by attributes of ram and cockerel to

Figure 28 Divine couple with spear, goat, and cockerel: Reims. Musée Saint-Rémi, Reims. Height approx. 30cm. Photograph: Miranda Green.

iconography associated with the veneration of Mercury. Here the imagery is repeated: the deity holds a spear, but Mercury's fertility emblem of the head of a goat is in the crook of his left arm, and the herald's cockerel is also present. The goddess has her usual symbol of plenty, the *cornucopiae*. Among the Triboci at Oberbetschdorf near Strasbourg (Bas-Rhin) a divine couple stand together, he with a lance and shield, she with a pot; the image is accompanied by a dedication to Mars,[101] but the normal Mars-image is belied by the goddess's presence, her pot symbolizing perhaps wine and therefore

both the fertility of the vine and resurrection, like the partner of the hammer-god. British evidence for the divine warrior-couple is scarce and ambiguous: one possible candidate is the sculpture from Calcot Barn in the West Country which portrays a mounted god (the Celtic Mars in Britain is often depicted as an equestrian warrior) accompanied by a seated goddess.[102] The mother-goddess accompanied by sword-bearing *cucullati* from near Cirencester (Figure 83)[103] could perhaps be taken as belonging to a similar tradition. It is shown in Chapter 6 how triplication may sometimes depict the same religious entity three times; thus we may have here the two elements of protector-guardian and fertility-goddess that we saw among the Aedui.

A form of divine couple typical of south Germany and the Balkans[104] consists of a partnership whose concern is not so much to protect humankind from the vicissitudes of this life as of the next. They are underworld deities, whose function seems to have been to guide the souls of the dead in their dark journey to the unknown, and to guard them against the powers of death's evil. The couple are sometimes named: she has a Celtic name – Herecura or Aericura, and we have already met her on her own (Chapter 2, p. 41). His name is Dispater, and here an indigenous god has adopted the name of his Roman underworld counterpart. The mothers, in both their single and triple form (Chapters 2, 6) had very strong links with death, presumably in their regenerative function which is akin to fertility and healing. Herecura too is shown to have maternal attributes: at Salzbach near Ettlingen[105] the goddess sits with a basket of fruit on her lap, whilst her partner unrolls the scroll of life. The underworld symbolism is enhanced, for instance at Varhély in Dacia, where the god may appear with a three-headed dog (perhaps reminiscent of the classical Cerberus) and Herecura may hold a key as a symbol of the entry to the gates of heaven, recalling the imagery of Epona in her underworld role.[106]

An anonymous partnership of fertility

The final group of divine partners is a fairly homogeneous but nameless type, displaying varying imagery but with the emphasis firmly on fertility. The couple belongs particularly to the Burgundian Aedui, but the Santones, Leuci, and Mediomatrici all venerated couples whose attributes tie them closely to the same fecundity and prosperity images. A possible British variant is represented by a sculpture from the Cirencester area[107] of a *genius cucullatus* and a mother-goddess, the latter carrying fruit or a loaf while the god bears an egg, a potent fertility symbol, recalling the attributes of Sirona at Hochscheid.

The Aeduan couple is represented on a large number of monuments, as is the case with the hammer-god and his consort. Indeed, it has been argued[108] that the same couple is portrayed in all instances regardless of whether war emblems, hammer or fertility-motifs are present, but with different

emphases on different occasions. Sometimes the symbolism of florescence and plenty is simply represented by the possession of *paterae*, loaves, cakes, or *cornuacopiae*, sometimes repeated to intensify the imagery.[109] Sometimes, as at Autun[110] the *cornucopiae* may be enormous; here[111] the god's virility and fertility-potential is expressed by his bared genitals and, at Alesia,[112] the maternity of the goddess is emphasized by an exposed right breast. These images are interesting in that they provide the few instances of direct human-fertility symbolism among these couples, even though the fact of their partnership might be expected to stimulate such imagery. The relationship of the pair may be remarkably close; at Néris-les-Bains, outside the boundaries of Aeduan territory, the hand of the goddess rests on her companion's shoulder.[113]

A striking feature of the Aeduan couple is the imagery of viticulture, already observed in that of the hammer-god and goddess, as representative of the florescence of this land of vineyards. The well-being produced by the success of the grape harvest and the imbibing of good wine is amply expressed: at Volnay[114] the god holds a wine goblet in both hands; his consort carries a pot and supports her bibulous partner with a helping arm. He is bigger than his wife, but they are dressed identically, emphasizing the bond between them. At Vitteaux near Alesia,[115] the seated couple each carry large stylized *cornuacopiae*, and the fertility symbolism of the goddess is stressed by her large loaf or cake; but the goblet of the male expresses his vinous nature. Wine is the dominant theme at Alesia itself[116] where three wine barrels appear on the same stone, two held by the god, the other adjacent to his wife's leg. General well-being and success are illustrated at Meloisey-en-Renouille[117] where the god and goddess carry a *patera* and a purse respectively; but a large jar, perhaps a wine-vessel, reposes on the ground between them. The purse-and-pot themes recur at Nevers[118] where the goddess holds a pot and purse and her companion a pot and loaf. Here, bread, wine, and money are all symbolized, encompassing most peasants' hopes of life. Bread and wine are repeated at Alesia;[119] and the couple worshipped at Solutré (Saône et Loire) in the same tribal territory[120] combine the imagery of the pot with that of *patera* and *cornucopiae*, the latter symbol being repeated as an attribute of both partners. Here the position of the symbols may be significant: the point of her horn of plenty resting on the lid of his pot again stresses the couple's intimate relationship and the mutual prosperity symbolism of the wine-vessel and the image of plenty are here both present. This combination of pot and *cornucopiae* recurs at St-Boil[121] where a couple represented with finely modelled heads are turned towards each other in companionship, she with a heavily fruit-filled *cornucopiae*, he balancing a large jar on his knee. A relief from Vertault[122] bears a slightly different set of fertility images, still with a vinous theme. She is fragmentary but he – a youthful clean-shaven god – holds a *patera* full of money, small cakes or grapes and a curious object which may be a crook or hoe. This last may be an

agricultural implement associated with viticulture; indeed, a special viner's billhook may be observed with some isolated hammer-god depictions (Chapter 4). The wine-growing theme recurs outside Aeduan territory among the Mediomatrici where, at Hérange (Meurthe)[123] a goddess holds a *cornucopiae* and a bunch of grapes and her partner a long goblet and a sinuous object which may again be a wine-growers tool or possibly a vine-stick.

The symbolism of a number of divine couples, both within and outside the land of the Aedui, is enhanced by their zoomorphic companions. Saintes (Charente Inférieur) and Sommerécourt (Haute Marne) of the Santones and Leuci respectively[124] have both produced evidence that the cross-legged, antlered god Cernunnos (Chapter 4) sometimes had a female companion. At Saintes (Figure 29) the god is represented cross-legged, carrying a torc on his right hand and a purse in his left; his head, with its probable antlers, is unfortunately missing. To his left sits a goddess holding an attribute which may be a bird and a *cornucopiae* in the crook of her left shoulder; a smaller female, perhaps a daughter, acolyte, or devotee, stands by her side, probably with another horn of plenty.[125] The imagery is intensified by the carving on the

Figure 29 Divine couple; male cross-legged with torc, female with fruit and *cornucopiae*: Saintes. Musée Archéologique de Saintes. Height 84cm. Photograph: Miranda Green.

71

reverse of the stone, where an antlered, cross-legged deity reposes between a male and female figure. Similar symbolism may occur at Sommerécourt: here the couple appear on two separate sculptures, but their imagery is so similar one to the other as to lend credence to their worship as a pair. The goddess feeds a ram-horned snake from a bowl of mash and holds the regenerative symbol of a pomegranate (an emblem belonging to the classical goddess of the underworld, Proserpina) in her hand.[126] Her antlered consort feeds two of the reptiles from an identical bowl. We will examine the interpretation of the stag-horned god in Chapter 4. Here it is enough to observe his occasional appearance with a consort. Her existence is supported by the occurrence[127] of a goddess who is herself crowned with antlers. The antlers, snake and other attributes proclaim Cernunnos as a powerful fertility-god, lord of animals. The fecundity and regeneration symbol of the ram-horned snake is a fitting companion to such a couple.

The Aeduan partners sometimes possess a snake, a normal, non-hybrid reptile.[128] At Alesia the couple, once more, sit half-turned towards each other, with serene expressions of easy companionship. He is a bearded, mature god with a small snake in his left hand, while his other hand rests on hers, thereby having contact not only with his wife but also her *cornucopiae*. The couple are very close here. The imagery at Autun again shows the snake as the specific attribute of the male deity; this time it is entwined round a small column beside him, balanced by his consort's horn of plenty next to her left foot.

The imagery of the final divine couple to be discussed in this group intensifies the associated animal symbolism to an extreme degree. Among the Aedui at Santosse[129] the couple is represented as presiding over the animal world. They sit side by side with their feet resting on two stags beneath them. The god offers a goblet of wine to a horse on his right, whilst his partner presents a similar cup to a second horse which she caresses with her other hand. The anthropomorphic partners are complemented by a zoomorphic imagery which again presents two of each beast in artistic and religious balance. The wine symbolism appears again; the pair are maybe offering immortality to their equine companions, and the close association between gods and stags is expressed by physical contact. We are reminded that the horse-goddess Epona was popular in this horse-breeding region of Burgundy (she is often depicted with her feet resting on the back of a foal), and that the stag-antlered Cernunnos himself was also venerated among the Aedui.

Conclusion

The Celtic concept of the Divine Couple is specific to the mainland of western Europe, centred on the Gaulish heartlands. Gaul had a predilection for partnered deities, observable both in epigraphic and iconographic data. The dominant imagery of the goddess is that of well-being, human and

animal fertility and earthly productivity. The male appears in many guises – as the 'Good Striker', as a wine-god, a warrior-guardian or as a god of successful business transactions. That they are Celtic deities is shown by their names – hers is always indigenous – and often by their clothes and attributes, especially the zoomorphic ones. Detailed study of the symbolism reveals fascinating nuances of balance, juxtaposition, and association. But the theme common to all the types here defined is that of a partnership, a true marriage. This concept is central to their worship. Dominance of one or the other cannot be demonstrated from the iconography. We do not know whether we may sometimes have a god of Roman origin marrying a local goddess, or whether a universal goddess of the land is consorting with different and more localized gods. In a sense this is unimportant. What matters is the marriage itself. The good things in life and comfort after death are stressed, and the mutual strength given to one partner by the other. Whilst human fertility is not usually emphasized overtly, there is nevertheless tacit acknowledgement that in marriage comes fulfilment in every sense, whether it be conquered joined to conqueror, man to woman, or protector-god to fertility-goddess. The result of the partnership is success: in war, against disease or barrenness, in the success of the wine harvest, in the earth's general fruitfulness, and in commercial transactions. For the Aedui above all, couples were important to their cults, to their worship and as a way of envisaging divinity. Unlike triplication and simple multiplication of images, the couple brought to their worship the strengths of the mutual support born of the intimate relationship between male and female. Divine couples were usually represented on small, domestic, personal monuments, many being set up in houses or domestic cellars in private veneration, to bring prosperity to the household. Nourishment in both worlds was a dominant theme and the couple brought comfort by its imagery of a down-to-earth, familiar god and goddess, easily identifiable with the average peasant family, a couple who understood marriage, ordinary hopes and fears, who protected against evil in all its manifestations, and who rejoiced with their devotees when times were good.

4

The male image

The imagery of male divinities in the Romano-Celtic world displays a vitality and variety in repertoire which certainly equals and may sometimes surpass that of the goddesses and the couples. The traditionally masculine prerogatives of war and hunting are represented; the worshippers of the supernatural power emanating from the sun and sky may be seen to have envisaged a predominantly masculine image. But in addition to the aggressive deities, the conquering warrior-guardian and sky-lord, there appears a group of gentler gods, whose main concern seems to be quiet beneficence, good-will and prosperity. Gratitude for the abundance and fruitfulness of earth is expressed by the veneration of gods whose sphere of influence was wine, crop-growth, and the care of animals. It is especially in this latter context that we may observe a very close link between the symbolism of the male partner in the divine marriage (Chapter 3) and gods who appear by themselves. We will thus meet many familiar entities: the hammer-god; the antlered Cernunnos; and the Celtic Mercury. We see once more the ambiguous role of the Celtic Mars, who is a warrior at one level but a healer and protector against barrenness at another.

As with the couples we looked at earlier, there is the problem of epigraphic versus iconographic evidence. For instance, inscriptions inform us that both Mars and Mercury were fully integrated into the Celtic pantheon – as topographical spirits, healers, givers of prosperity and as tribal guardians. But iconographically, their normal appearance is that of the Mediterranean image, and it is not easy to explain why, with such an imaginative Celtic artistic repertoire as was demonstrably present, the imagery of these gods of Roman origin was left in its classical traditionalism. The answer may be that here the god-name was sufficient to evoke the image. By contrast, the Celtic sky- and sun-god did depart from his usual Graeco-Roman symbolism, and we see glimpses of a complicated Celtic mythology, perhaps even a theogony. That Mercury and Mars acquire new indigenous imagery is illustrated in a few very powerful pieces of iconography, but they are in a minority. It is

almost as if Celtic names and Celtic imagery were a substitute one for the other.

Several very general characteristics of the male deities may be noted. One is the curious feature of maturity which is apparent in many of the groups. Indeed the warriors are unusual in being more often (and indeed appropriately) depicted as youthful men. A second feature is the very frequent appearance of native Gaulish costume. A third is the multiplicity of symbols and, allied to this, the frequency of the presence of zoomorphic companions. The close bond between anthropomorphic god and beast is expressed most clearly in the actual transmogrification of some images, where the god himself is seen as half-man, half-beast. This rarely occurs with the goddesses. Finally, celticism is often demonstrated by the recurrent presence of the torc or necklet, which may sometimes be the only Celtic motif, but which was such a fundamental decorative emblem of the indigenous population (especially those of high rank) as to point unequivocally to the claiming of gods so adorned as Celtic.

Sucellus, the hammer-god (Map 5)

The Gaulish hammer-god is of the utmost importance both in terms of iconography and of religious expression. Depictions of him are numerous, occurring on over two hundred stone and bronze representations, and his imagery shows him to have been a complex deity with a very wide sphere of influence. Moreover, he was a purely indigenous Gaulish divinity, with very little classical influence, except in the relatively naturalistic form of his iconography. Monuments and bronzes form four main clusters: north-east Gaul, among the Leuci and Mediomatrici; Burgundy, in the lands of the Aedui and Lingones; the area around Lyon; and the mouth of the Rhône, centred on Glanum. Outliers occur in Brittany, at St-Brandon[1] and Carhaix[2] and in Britain, as at York.[3] Apart from depictions of the god as an anthropomorphic entity, his hammer symbol frequently appears alone, sometimes in the form of a three-dimensional stone votive hammer-head common on Burgundian sites, or as an incised carving on altars, which occur in quantity in the southern Gaulish sites.

Imagery, association, and context all throw light on the complicated cult of the hammer-god and reflect the wide role envisaged for him by his worshippers. His name 'Sucellus' ('the Good Striker') accurately reflects the definition of the god as a hammer-bearer, by which he is identified in the iconography. If we look at the god's physical characteristics, the homogeneity of the image is very striking. In the great majority of representations, the god is depicted as of mature age, with long abundant curly hair and beard, and serene, benevolent expression (Figures 30–2). His essential 'Gaulishness' is indicated by his native garb of short belted tunic and *sagum* or Gallic cloak. There is a variation on the god's clothes in Narbonensis,

Figure 30 Altar to hammer-god, with long-shafted hammer, pot, and dog: Nîmes. Musée Archéologique de Nîmes. Base width approx. 18cm. Photograph: Miranda Green.

where he was conflated with the Roman woodland-god Silvanus; he appears on bronzes sparsely clad in a wolf's pelt and leaf-crown, reflecting both the relative warmth of the Provençal climate and the nature of the deity as a god of wild things,[4] to which we will return. The two main inanimate attributes of the hammer-god are the hammer itself and a small pot or goblet. The hammer-bearing partner of the divine couple (Chapter 3) usually carries his hammer in his left hand, but this is less common for the hammer-god alone, who sometimes bears the implement in his right hand as if it were a working

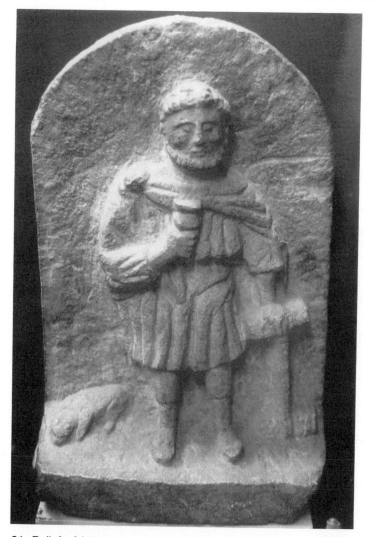

Figure 31 Relief of hammer-god, with hammer, barrel, pot, and dog: Monceau. Musée Rolin, Autun. Height approx. 20cm. Photograph: Miranda Green.

tool. The hammer itself is worth examining more closely: whilst it is frequently represented as a true hammer, with wooden shaft and metal blade,[5] it is equally often depicted as a wooden mallet, with a cylindrical head[6] (Figures 32, 34). Another feature of the implement is the long narrow shaft (Figure 30) which is almost always present and may reflect its partial function as a wand or sceptre of authority and rank. At Köln, for instance,[7] the hammer is held exactly as a sceptre. But on some portrayals, the god instead

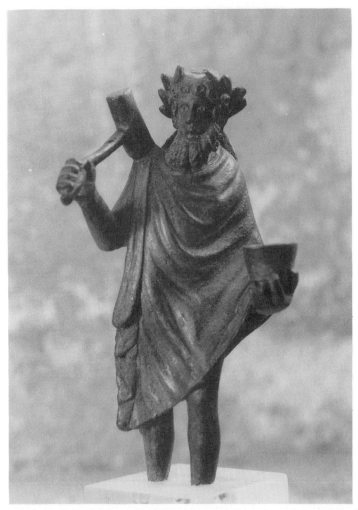

Figure 32 Bronze figurine of hammer-god, with hammer, pot, and leaf-crown: Glanum. Musée des Alpilles, St-Rémy-de-Provence. Height 11cm. Photograph: Miranda Green.

may brandish the hammer like a weapon;[8] or he may lean on the blade or shaft as if resting from labour.[9]

Having observed some general characteristics of the hammer-god's imagery, it will be useful to examine his occurrences in different geographical areas, where symbolism and context combine to reflect both differences and similarities in interpretations.

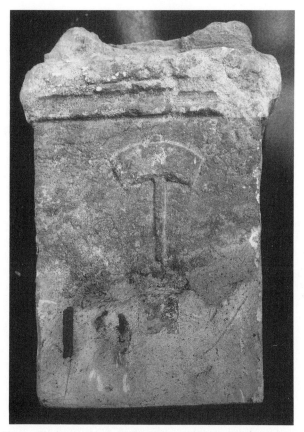

Figure 33 Altar with hammer symbol: Nîmes. Musée Archéologique de Nîmes. Width 11.5cm. Photograph: Miranda Green.

The hammer-god of southern Gaul and the Lower Rhône

Both stone and bronze images of the hammer-god in this region proclaim him as a god of woodland, vegetation, wild and domestic nature. Likewise, hammer symbols appear on altars with dedications to the Roman forest-god Silvanus. Bronze depictions show a fairly consistent image of a god with the usual associations of hammer and pot seen elsewhere in Gaul, but with the additional feature of a wolf pelt either instead of, or as well as, a tunic.[10] This donning of an animal skin proclaims the hammer-god as a wild deity of the countryside, a hunter perhaps and a protector against savage beasts. The other feature of bronze images is the leaf-crown, which occurs, for instance, at Orpierre and at Glanum,[11] where the god has an incongruously elaborate ringleted coiffure and a beard treated in the same manner (Figure 32).

Stone hammer-god images in southern Gaul usually occur as small

monuments, indicative of modest private sanctuaries (Figure 30). But multiple altars are common, perhaps reflecting the presence of an important cult-centre, even if patronized by people of moderate means. Thus the healing-spring shrine of Glanum attracted devotees of the hammer-god, to whom were dedicated perhaps a hundred small altars. Glanum is of particular interest because images of the hammer-god himself are sparse, but the inanimate motif of the hammer was frequently carved on little altars and offered to the god. Here the hammer itself was the efficacious symbol. A bronze image does occur, and also a crudely incised relief of a god with a hammer and pot,[12] but these are far outnumbered by the simple hammer-altars. Some have crude cursive epigraphic dedications to Silvanus; others simply a hammer (the hammer was not an attribute of the classical Silvanus). Especially interesting is the association of hammer symbols and human limbs: one altar, for example (Figure 68) has a hammer on the front, an arm and hand carved on one side-surface and a leg on the other.[13] Bearing in mind the presence at Glanum of a spring-sanctuary dedicated to 'Glanis' the local spirit, such imagery may well reflect a healing-cult and the offering of models or images of afflicted parts of the body to a curative deity in reciprocity, hoping to be healed and given new, whole organs or limbs in exchange for those diseased. We may observe this custom at many of the great Gaulish thermal shrines, such as *Fontes Sequanae*, where stone and wooden models were cast into the pool at Sequana's shrine[14] (pp. 156–61).

Nîmes is the other site revealing multiple devotion to the hammer-god, where again a healing-spring sanctuary to Nemausus, the spirit of the place, was established long before the Roman period. As at Glanum, images of the god in human form, and inanimate symbols of his potency, were offered in worship (Figures 30, 33). A bronze image is recorded, but more important are several reliefs depicting a god with a hammer held like a sceptre and a pot or *patera*. A feature of the Nîmes representations is the dog sitting at the god's feet, raising its muzzle towards the vessel held in his hand, as if expecting to be fed.[15] On a recently-found stone, the hammer-god is nude,[16] like a depiction from Arles,[17] whereas a bronze figurine from this latter site, by contrast, shows the god wearing a sleeved *sagum*.[18] On one of the stones at Nîmes[19] a cockerel (perhaps symbolic of the welcome daytime) accompanies the god and dog; this association may be seen also at Vaison.[20] Both Nîmes and Vaison, like Glanum, produced small altars carved with nothing but hammer-symbols.[21]

Other sites in southern Gaul produced anthropomorphic images of the hammer-god. The spring context of Nîmes and Glanum is repeated at 'La Hillère', Montmaurin, where a thermal shrine with a hexagonal basin produced a hammer-god relief.[22] The Vaison stone is interesting in that the god is actually carrying a spear and pot, but with a reversed or inverted hammer on one pillar of the niche enclosing the deity. The presence of the spear perhaps reinforces the hunting-image indicated by the equation with

Silvanus. Finally, we should note the very classical-looking god, in tunic and cloak, at Séguret,[23] who carries a hammer but also a syrinx (pan-pipes) instead of a pot, recalling the Mediterranean Orpheus whose musical instrument charmed beasts and vegetation or the wild nature-god Pan.

The multiplicity of symbols is an interesting feature of hammer-god imagery. We have noted the frequency of small altars bearing hammer-symbols at Glanum and Nîmes. Bagnols (Gard) near by has produced several similar altars, all with differently-shaped hammers and one with two symbols side by side.[24] At St-Gilles (Gard) in the same region an altar dedicated to Silvanus has a pot on one side-surface and on the other a long-shafted hammer surmounted by three smaller, but otherwise identical, implements.[25] This plurality is present again not far away at Rouvière near Montelimar[26] where a clean-shaven (unusual) hammer-god in a hooded tunic carries a long-handled hammer placed between four others, three upright and one reversed.

Two altars bearing only inanimate emblems are especially significant in that the hammer symbol is associated with other images, some of which are not generally linked with the god. The imagery at Vernègues[27] combines the familiar signs of hammer and pot with a tree and wheel; the tree may be understood as a vegetation symbol of Silvanus-Sucellus, but the wheel is totally foreign to the hammer-god's normal repertoire. The Aigues-Mortes (Gard) altar is more complex still: it was dedicated to Jupiter and Silvanus and has three sculpted surfaces decorated with motifs appropriate to both deities. On one short side a thunderbolt and wheel (emblems of the Celtic Jupiter) are depicted, balanced on the other by a billhook, pot, and hammer (motifs associated with the Silvanian hammer-god of the south). On the front, below the dedication, are the combined symbols of hammer, wheel, and thunderbolt.[28] We will be examining the Celtic sun/wheel-god later. Here we need to establish a link between this god and Sucellus-Silvanus. The association between them is made clear by the invocation which is to the sky-god and to the southern Gaulish hammer-god, but using only Roman names. The question of how these deities are linked is not easy to resolve. We know that Jupiter and Sucellus were equated on a dedication at Mainz[29] to 'IOM Sucaelus'. We know also that at Farley Heath in south-east England[30] on a sheet bronze sceptre-binding with repoussé imagery, a figure brandishing a long-shafted hammer is associated with a human head next to a solar wheel.[31] That the hammer-god had a solar aspect is indicated by bronzes from the Burgundy area and elsewhere (see below) decorated with solar symbols. There may also be other links between the Romano-Celtic Jupiter and the hammer-god. Boucher[32] has pointed to the physical resemblance between Jupiter with his sceptre and Sucellus with his hammer and, sometimes,[33] the facial characteristics of the hammer-god may be very similar to those of the sky-god. Both deities are mature, majestic men with long luxuriant hair and beards. The hammer symbol, too, is often[34] considered a noisy implement,

allied to Jupiter's thunderbolt. So there may be both iconographic and symbolic links between the two divine concepts. We will come back to this question when considering the interpretation of the hammer-god as a whole.

The images of the hammer-god higher up the Rhône Valley, in the area of Lyon, show characteristics not dissimilar to the iconography of the extreme south of Gaul but with a few significant distinctions. One piece of evidence is informative in its direct proof of the identification of Sucellus with the hammer-god of this region: this is a vessel inscribed 'Sucellum propitium nobis' and with the image of a god with a hammer or mallet, dog, tree, and flask.[35] The hammer-god was popular at Lyon and its environs[36] where images of the god himself are essentially similar to those of Nîmes, consisting of a bearded god with long-shafted hammer and small pot,[37] and sometimes a dog.[38] One of the Lyon stones[39] is distinctive in the replacement of the pot in the god's hand by a sickle, which appears also as an attribute of the hammer-god at Escles;[40] at Bourbonne-les-Bains, the hammer-god's pot is replaced by a (? vineyard) billhook.[41] But at Lyon the pot symbol is still present in the form of a large jar on the ground. Interestingly, the Lyon group includes also stones bearing inanimate symbols alone; sometimes the hammer is isolated, but it may be balanced by the ubiquitous small pot;[42] at Fins Annecy near Vienne[43] an altar displays a long-shafted hammer between two pots. In these instances, the two major attributes of the hammer-god were envisaged as potent enough without the image of the god himself.

A distinctive feature of the Lower Rhône group is the introduction of the triple symbol of hammer, barrel, and solar image fused into one motif. This occurs on a bronze statuette at Vienne (Isère)[44] where a god of southern Gaulish type, wearing a wolf skin over his head and shoulders, carries an extraordinary object consisting of a long shaft terminating in a barrel-like hammer-head from which radiate five spokes each ending in a smaller barrel/hammer-head. The image quite obviously belongs to the hammer-god group of bronzes, but his principal attribute is here transformed into a symbol which combines barrel and solar motifs as well. The sign has a close parallel at Dôle (Jura) where a stone is carved with a wheel-like object whose spokes end in little barrels.[45] Other bronzes from the Lyon area[46] bear odd crosses or cosmic signs on their bodies, and we will see this recurring in Burgundy. The barrel symbol, too, is something endemic to the Aedui/Lingones of the Upper Rhône and Saône, and the implication of wine imagery is maybe reflected also in the large vessel and sickle (perhaps a viner's tool) at Lyon.[47]

The symbolism of the hammer-god in southern Gaul and the Lower Rhône is reasonably homogeneous. We are shown the image of a benevolent, mature deity whose visual attributes indicate his role to be that of peasant protector of the harvest, god of wild nature and vegetation. His leaf-crown, animal skin, sickle, and billhook all display a concern with crops and beasts. He is thus appropriately identified with Silvanus. Even his hammer, which

may resemble a wooden mallet, may have a relevant function as a tool for driving in fence-posts and thus guarding property. The dog, his frequent companion, may indicate a hunting-role, seen also perhaps in the wolf pelt. But an underworld symbolism may be suggested also by the presence of this beast, and by the association of hammers and pine-cone motifs on altars at Glanum (the pine-cone possessed the resurrection imagery of the evergreen). Certainly healing and regeneration are reflected in the southern Gaulish god's link with curative spring-sanctuaries, and again the dog may be an apposite companion here. The symbolism of wine, so prominent in Burgundy, is maybe reflected further south by barrel, jar, and the persistent small pot. Finally, again repeated in Burgundy, the complex character of the god is observed in his solar associations.

The Burgundian hammer-god

The divinity depicted in southern Gaul and the Lyon region as a god of nature and vegetation, appears among the Lingones and Aedui of Burgundy as a very specific god of the grape-harvest and the well-being of the vine. This is reflected most frequently on stone monuments where wine barrels and jars are depicted as major attributes of the god. Frequently, as further south, a dog is present as the god's companion, watchful and alert at his side. The relationship of hammer and barrel is interesting if we recall the ambiguous hammer/barrel symbolism of Vienne. At Mâlain[48] and Monceau[49] the god has a hammer whose base rests on a barrel, a dog at his other side (Figure 31). At Cussy-le-Châtel[50] the hammer-god is portrayed as a tipsy old man, with a short stocky hammer and his right foot resting on a barrel. The barrel recurs at Marmagne near Autun.[51] An alternative to the wine barrel is the large jar or amphora, seen already at Lyon, and present in Burgundy as a symbol of the god[52] A variation may be represented by the sack – perhaps of grapes – at Alesia.[53] Two outliers to this Burgundian group intensify the vinous imagery: at Gannat (Allier) the hammer-god has hammer, barrel, and wine goblet;[54] and the Vichy hammer-god[55] has a pot, barrel, and amphora. Small pots or goblets are constant symbols, recalling the more southerly images. More general prosperity motifs include purses, at Nolay (Côte d'Or)[56] and at Jouey.[57] At Alesia, the god with the sack bears a curious hybrid between hammer and *cornucopiae*.

The healing-spring association seen in Provence is very dominant in Burgundy. The drunken god at Cussy was from a spring site; and the source of the river Arroux was presided over by 'Succelus';[58] the outlying site of Vichy was the home of the spring-healer Mars Vorocius who specialized in curing eye diseases. Votive stone hammers[59] were dedicated in Burgundian thermal shrines. The spring-god at Vertault,[60] depicted with a flowing urn held over water, was accompanied by two sacrificing male devotees, one of whom is flanked by hammers. The image of the hammer-god at Trouhans,[61]

another spring site, is interesting in that the god bears both a small hammer and a club. Recalling the bronze Hercules-like figures at the shrine of Borvo at Aix-les-Bains[62] (Hercules was the traditional classical divine club-bearer), it may be that the hammer-god is here symbolized as combater of evil and disease, reflecting the pugnacity and potency of the Graeco-Roman demi-god.

Finally, in considering Burgundy, we should examine the evidence for solar association, observed in southern Gaul. Here a number of bronzes depict the hammer-god with sun signs: the figurine at Prémeaux[63] (Figure 34) bears crosses on his tunic and, interestingly (if we recall the Vienne hammer/barrel/sun motif), a barrel-like hammer-head on a long pole; and several bronze figurines of the hammer-god[64] bear stamped cosmic motifs on their bodies.

The Burgundian evidence enhances and extends the picture of the hammer-god's role and symbolism presented in southern Gaul. There are many features of similarity; the presence of the dog, healing-spring associations, and solar imagery. But the preoccupation with the wine crop, only hinted at further south, comes to full prominence only in Burgundy, the heartland of Gaulish wine-growing.

Eastern Gaul and the Rhineland

The tribe of the Mediomatrici of north-east Gaul could be regarded as the homeland of the cult of Sucellus since here, at Sarrebourg, was found the best-documented inscription dedicating an altar, bearing depictions of a hammer-god and consort, to Sucellus and Nantosuelta (see Chapter 3). But there are comparatively few portrayals of the hammer-god alone in north-east Gaul. What evidence there is reinforces the image of the deity as expressed in Burgundy and the South. A (lost) carving from Toul near Metz[65] displayed the hammer-god with his mallet, pot, dog, and two wine barrels; and a fragmentary relief at Trier shows the god as a mature, bearded man with his pot and long-shafted hammer. Nature and cosmic symbolism are present at Soulosse[66] where the hammer-god is associated with planetary deities and a boar and tree. Perhaps most curious of all is a bronze figure from Viège (Valais, Switzerland)[67] where the god (whose implement is missing) bears the image of a large nail and an odd-looking tool stuck in his belt. Deonna suggests that this is itself a hammer, but Webster[68] has put forward the notion that it may be a lynch-pin, reflecting the hammer-god's 'key-role'. The nail symbol does suggest that the hammer was meant to be used.

The symbolism of the hammer-god

The image of a native god bearing a long-shafted hammer as his main

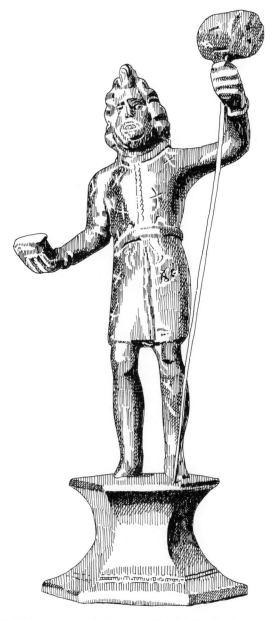

Figure 34 Bronze hammer-god: Prémeaux. Musée des Beaux Arts, Beaune. Height approx. 12–15cm. Illustrator: Paul Jenkins.

emblem seems to have come into being during the Romano-Celtic period in Gaul. We do know of Celtic coins of the Namnetes bearing images of running figures brandishing hammers,[69] so the cult may possibly have its origins in later prehistory. The hammer itself is a striking implement, a weapon, a fencing-mallet, a wood-cutter's tool or maybe a cooper's mallet. But the hammer was also an image of power: it could be a wand of authority or rank, like a sceptre. My own view is that the hammer-god's emblem could symbolize the striking and awakening of life after the 'death' of winter or the real death of people. The curative-spring context of many hammer-god images would be appropriate in these circumstances, as would the god's observed role as a lord of vegetation, animals, and crops. The hammer could ward off enemies, evil and disease, or strike a blow on a follower's behalf. The red wine of Burgundy perhaps symbolized not only wine itself but blood and immortality. The consistent motif of the small pot may have similar regenerative symbolism to a sacred cauldron. The god's wide and profound role is expressed in his solar associations. The hammer in its upward position, pointing to the sky, may have been envisaged as acting like a thunderbolt causing rain. In its inverted position, noted on a few monuments, the hammer may reflect the bringing of fertility to the land. What is evident is that it was with the hammer that the real power lay: it was so strong that it could represent the god himself, without the anthropomorphic image. Its symbolism displays its possession of wide-ranging, sometimes ambiguous functions. At one and the same time it could embody images of the sun and wine as well as its own power as a striking tool. This ambiguity was, I am sure, deliberate and emphasized the god's ability to perform functions in many dimensions and at different levels. He was a peasant's deity, but he could rise to sublime heights, rivalling Jupiter, the Roman lord of gods, in his celestial role.

The antlered god Cernunnos

The Celtic imagination produced images of gods who transcended the bounds of the human form and who could adopt animal features. The reason for this was presumably in acknowledgement of the particular properties of certain beasts and in order to enhance the symbolism of the god's image by adding a powerful zoomorphic dimension. Thus the purpose may be seen as similar to that of multiplication and triplism (Chapter 6) – namely enhancement by unnatural addition. The presence of animal features on an anthropomorphic image may reflect transmogrification – the ability of a deity to change at will from human to animal form. This was a quality common to Celtic divine beings and is reported in the vernacular literature of Wales and Ireland.[70] The most important animal-characteristic adopted for anthropomorphic gods was that of antlers or horns (the latter usually those of a bull or ram). Antlers and horns seem to have had different symbolism depending

on the animal concerned: antlers belong to beasts which, though aggressive towards each other during the rutting season, are otherwise benign, shy animals and certainly not generally belligerent towards humankind. Bulls, on the other hand, are pugnacious and may be dangerous to people. These different characteristics are reflected in the gods who borrow such animal emblems: the antlered deity is a beneficent god of prosperity and well-being, whilst the other horned gods (below, pp. 96–9), especially those of northern Britain, often possess aggressive, martial natures in addition to fertility symbolism.

The origins of Cernunnos

The antlered deity differs from many other Celtic divinities occurring during the Roman period in that he appears iconographically well before the Romano-Celtic phase in western Europe. True, he is not named until the reign of Tiberius, when he is called '(C)ernunnos' ('the horned one') (Figure 36), but his image may be traced back to the fourth century BC at Camonica Valley in northern Italy. The Iron Age Camunians were Celts[71] who, like their Neolithic and Bronze Age ancestors, carved on the local rocks depictions of their gods and rituals. One of these carvings portrays a large standing figure in a long garment, with antlers sprouting from his head and wearing a Celtic torc on each arm (Figure 35). He is accompanied by a small

Figure 35 Rock-carving of Cernunnos; fourth century BC: Val Camonica, Italy. Illustrator: Paul Jenkins.

ithyphallic devotee and a horned serpent.[72] The Camunians were forest-dwellers and the stag would have been an important and hunted beast. It is depicted recurrently on the rock-carvings and may have been the subject of, perhaps seasonal, rituals where the spring growth and autumn shedding of deer antlers may have been re-enacted to symbolize the earth's fertility cycle. The interest of the iconography at Camonica lies in its being the earliest known representation of the stag-horned god and in the many features which recur in later images of the deity. The presence of the torc, sometimes twice; the ram-horned snake; the evidence of fertility symbolism are all major characteristics of the Romano-Celtic Cernunnos. Another early image of the antlered god appears on one of the plates of the Gundestrup Cauldron, whose date may be as early as the fourth or third century BC.[73] Its origin is controversial, but there can be little doubt that much of its iconography is Celtic in origin. Cernunnos sits cross-legged, anticipating his normal Romano-Celtic attitude, wearing a twisted torc and carrying a second in one hand; in the other hand he grasps a ram-horned snake (Plate 1). The god is the lord of animals here: not only is he himself antlered but he is accompanied by his familiar, a true stag, and he is associated with other animals, including a bull, hound, and boar.[74] The intimate relationship between god and stag is demonstrated by the identical, stylized treatment of the antlers on both beings. There is no doubt that at Gundestrup we have the image of the stag-antlered god of the Romano-Celtic world. The torcs, the cross-legged attitude and the presence of the distinctive horned snake assure his identity; such features, taken *in toto*, are too idiosyncratic for alternative interpretation.

Two other pieces of early evidence for Cernunnos are significant: one is the image on the silver cup from Lyon, dating to the Augustan period (probably around 12 BC), where Cernunnos is accompanied by Mercury – just as he sometimes appears on later imagery. The god, again with two torcs (one round his neck and a second held in his hand) reclines on a couch, accompanied by his stag, a dog, tree, and snake. Next to him at a table sits the commercial god Mercury counting out money and accompanied by his tortoise and other beasts.[75] The other image is that on a Celtic silver coin from Hampshire.[76] On the obverse is an antlered head with a sun-wheel sign between the antlers. This association between Cernunnos and sun symbolism is curious and unique. The Celtic sun-god does appear at Gundestrup but on a different part of the cauldron; and I know of no other direct cosmic associations for the god. However, the Bronze Age rock-art of Scandinavia and the Bronze Age rock-carvings of Val Camonica and Mont Bego do associate stag and sun symbolism. It will be seen (below) that Cernunnos' major function in the Romano-Celtic world was prosperity and abundance, and it may be that the sun is present on this occasion as an emblem of fertility, an aspect of the sun which is present in its veneration (pp. 166–7). The later image of Cernunnos, at Reims,[77] depicts Apollo as

one of his two associates, and we know that one of this deity's roles was as a god of light. But there may be a less profound reason for the presence of the wheel on this coin, namely that the sun as a wheel is a very common motif on Celtic money, and may appear here simply as part of a conventional pattern.

Cernunnos in Romano-Celtic Europe

Images of the antlered deity occur, for the most part, on stone monuments. Their distribution is mainly in north-central Gaul, but they appear in western areas, as at Saintes[78] and even in south-west Britain, at Cirencester (Figure 39).[79] The tribes with whom Cernunnos was most popular included the Sequani, Aedui, Bituriges, Arverni, Santones, and Namnetes.[80]

The iconography of Cernunnos possesses many features which are recurrent but yet are not always present. The one constant is the presence of antlers which serve to identify him. The variables include the cross-legged seating position, which is very common, the presence of one or more torcs, which may be held or worn, and the association of prosperity symbolism such as Mercury's purse. The ram-horned snake is a common companion of the god, though it appears with a variety of deities including the Romano-Celtic Mars and Mercury; it too has a predominantly north-central Gaulish distribution (pp. 92-3). The indigenous Gallic, non-Roman nature of Cernunnos' imagery is very marked: gods in semi-human, semi-zoomorphic form were not worshipped by the Romans, who would never admit of the divine status of animals in themselves. The cross-legged pose is another purely native feature and specific to this god, though he does not always appear thus: indeed unantlered cross-legged beings are depicted in the icono-graphy. In itself the cross-legged attitude need not be significant: we have literary evidence from Graeco-Roman commentators[81] that the Gauls commonly sat on the floor, and thus to sit cross-legged would be comfortable and natural. Accordingly, this seating posture may have been chosen to represent an essentially native form of divinity.

The imagery of Cernunnos

On a stone of Tiberian date in Paris[82] (Figure 36) are carved the head and shoulders of an elderly man, bald and bearded, with both human and cervine ears, with antlers springing from his head, from which hang two torcs. His name, epigraphically stated, is '(C)ernunnos' the 'horned' or 'peaked' one.[83] So we are given the god's name, and the Parisian image has two of the main features by which the god's iconography is defined – antlers and torcs. In addition, the close link with the stag itself is indicated by the presence not only of antlers but of stag's ears in addition to his own. This image brings to mind a bronze statuette from Bouray (Seine-et-Oise) (Figure 37), perhaps in the same tribal area of the Parisi, where a cross-legged, naked god

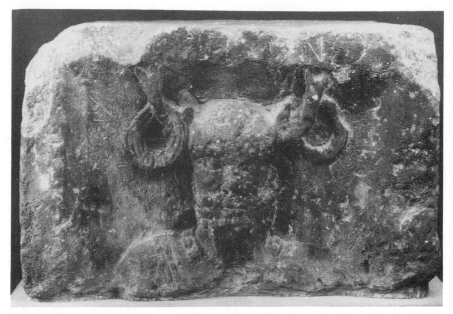

Figure 36 Bust of Cernunnos, with antlers and torcs, and with inscription to him above: from *Nautes Parisiacae* monument, Nôtre Dame, Paris. Musée de Cluny. Height 47cm. Photograph: Réunion des Musées Nationaux.

(unantlered) wears a heavy torc and possesses stag hooves,[84] as does Cernunnos himself on a stele at Beaune.[85]

Two other features of interest are also connected with the personal imagery of the god himself rather than with his companions and associated motifs. One is his occasional appearance as a triple-headed being: thus on a complex bronze statuette from Etang-sur-Arroux (Saône et Loire),[86] Cernunnos appears cross-legged, wearing one torc and with another above his lap. His main head was once antlered, but there are two subsidiary heads above his ears.[87] Cernunnos is once more three-faced at Nuits St Georges, in Burgundy, where a triad of deities consists of a mother-goddess, a hermaphrodite and a triple-faced antlered god, all seated.[88] A relief from a well at Beaune near by[89] (Figure 79) incorporates a similar combination of symbols, but here Cernunnos is not himself triple-visaged, being instead accompanied by two gods one of whom has three heads. The other characteristic of Cernunnos himself is the presence of removable antlers, at Etang-sur-Arroux and on a stone sculpture at Sommerécourt (Haute-Marne),[90] where sockets in the top of Cernunnos' head proclaim the fitting of separate antlers of wood, metal, or even (in the case of Sommerécourt) real antler. The purpose of this may well be associated with seasonal ritual, in imitation of the autumnal shedding and spring growth of the antlers of Cernunnos' beast.

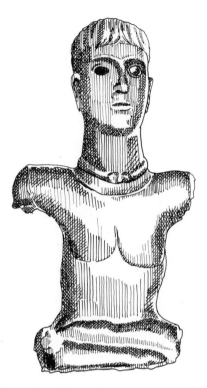

Figure 37 Bronze hooved god wearing torc: Bouray. Musée des Antiquités Nationales, St-Germain-en-Laye. Height 45cm. Illustrator: Paul Jenkins.

On some images, the stag-symbolism apparent in the god's adoption of antlers is intensified by the additional presence of the stag itself. We have seen this at Gundestrup, and the double symbolism recurs on such Romano-Celtic monuments as Reims,[91] where a seated Cernunnos, flanked by Apollo and Mercury (Figure 38), pour grain or coins from a large sack to 'feed' a stag and bull beneath his throne. The stag accompanies the god again on the Nuits St Georges relief where, as at Gundestrup, the god appears to be lord of beasts, with his stag, bull, dog, hare, and boar, grouped around a tree bearing a peacock. A variation on the Cernunnos-with-stag theme appears among the Treveri at Titelberg,[92] where a young male with a *cornucopiae* is accompanied by the heads of a bull and stag which vomits money. We may here be seeing a more romanized form of the Cernunnos concept, where the· deity himself is wholly anthropomorphic but his stag repeats the prosperity theme seen at Reims.

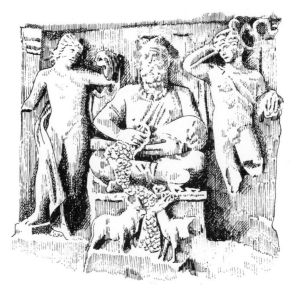

Figure 38 Relief of Cernunnos, Apollo, and Mercury, with bull, stag, and sack of money: Reims. Musée St Rémi, Reims. Height 1m 30cm. Illustrator: Paul Jenkins.

The ram-horned snake

Whilst this composite, unnatural creature is the companion of multifarious Celtic deities, its consistent association with Cernunnos argues for a very particular affinity between the images of snake and antlered god. The separate motifs of ram and snake embody symbolism of fertility on the one hand and combined chthonicism and regeneration themes on the other. Fertility is everywhere apparent in the imagery of Cernunnos – in the virility of the stag itself and in the wealth of symbolism associated with abundance and prosperity. There is less overt underworld imagery, but on the stele at Reims (Figure 38)[93] a rat crouches in the gable above Cernunnos' head. The presence of this burrowing, scavenging animal may well imply a chthonic aspect to the stag-god.

Where the ram-horned serpent appears with Cernunnos, he frequently holds it behind the head.[94] Again, there may be more than one such reptile; and the beast is often depicted receiving nourishment at the hand of the god. The relationship between divinity and animal thus appears to be of mutual benefit: the snake eats from Cernunnos' hand, but it in turn enhances his own potency as a god of fertility and regeneration. On the images at Etang-sur-Arroux and Sommerécourt, Cernunnos is entwined by two ram-horned snakes who feed, respectively, from a heap of fruit and a bowl of mash or porridge. The close physical link between man-god and beast is demon-

strated again at Yzeures-sur-Creuse (Indre-et-Loire) where a Roman villa site produced a sculpture of a young man sitting cross-legged upon a goat (itself a fertility emblem in the classical world). His right hand rests on the body of a ram-horned snake which winds itself round his legs and rests its head against his stomach.[95] But the culmination of this intimate relationship is expressed at Cirencester (Figure 39)[96] where two ram-horned serpents, rearing their heads to flank Cernunnos' face, with their tongues protruding, actually form the legs of the god. Before we leave snake symbolism, the stele at Vendoeuvres (Indre)[97] should be noted (Figure 40). Here two serpents flank Cernunnos, on each of which stands a youth grasping the god's antlers. The snakes are not ram-horned but have human faces, endorsing the semi-human theme at Cirencester. In both these depictions, the animal features of an anthropomorphic god are reflected in reverse, with the animal itself adopting human imagery.

Cernunnos as lord of animals

Very strong links exist between the antlered god and his two recurrent zoo-morphic companions, the stag and the hybrid, monstrous serpent with its

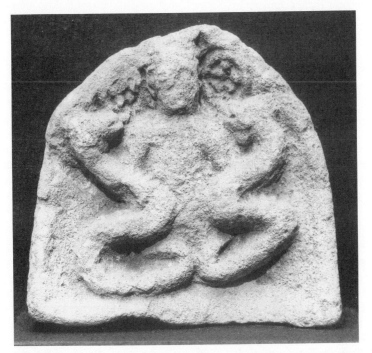

Figure 39 Relief of Cernunnos, with two ram-horned snakes: Cirencester, Gloucestershire, Corinium Museum. Height 22.8cm. Photograph: C. J. Bowler, for Corinium Museum.

ram-horns. But Cernunnos' predominating role as lord of beasts, seen so clearly at Gundestrup, is expressed also in other imagery. The bull is a frequent zoomorphic associate, seen in early imagery at Gundestrup (Figure 1) and on the Lyon cup. In Romano-Celtic contexts, the bull appears with Cernunnos, for instance at Reims (Figure 38) where it balances the stag at the foot of Cernunnos' throne and shares the bounty of grain or money pouring from the god's open sack. The bull again accompanies the stag at Titelberg, where once more the theme of nourishment recurs in the imagery of the stag spitting out coins.[98] At Nuits[99] the bull is just one of many zoomorphic companions of the stag-god, again including the stag. But bulls occur alone at Saintes[100] where Cernunnos' throne is supported by bulls' heads. Dogs and goats are not infrequent animal-attributes of the antlered deity: dogs appear at Gundestrup and at Lyon; on the Romano-Celtic depiction at Beaune (Figure 79)[101] one of Cernunnos' two divine associates carries a *cornucopiae* and offers the contents of a *patera* to a small dog, and so again, as with the snake, the theme of feeding is present. At Nuits, Cernunnos has several beasts, one of which is a dog. Two curious reliefs from elsewhere reflect an association between Cernunnos and goats: a thermal-spring shrine at Genainville (Oise), which was established before the Roman conquest, produced an image of a cross-legged god holding a small goat against his chest;[102] and at Yzeures-sur-Creuse[103] Cernunnos with his snake sits cross-legged on a goat.

Cernunnos' animals possess general or more specific significance: as lord of beasts, at Gundestrup and Nuits St Georges, the clustering of animals of different species suggests a Noah-like fatherly benevolence towards the earth and its animate symbols of fertility. More particularly, certain creatures suggest detailed symbolism associated with the god's character. Thus the dog may be a healing, restorative and perhaps chthonic companion. Goats and bulls suggest fertility and, in the former case, we should recall that the goat belonged to Mercury, the Roman god of success, an associate of Cernunnos and a deity who, on occasions, shared the symbol of the ram-horned snake.

The regenerative and prosperity roles of Cernunnos

Context and association sometimes proclaim Cernunnos to have possessed a function as a god of healing and renewal. His presence at curative-spring sanctuaries[104] suggests that the god could have a therapeutic concern. Likewise, his association with Apollo, who was first and foremost a healer in Romano-Celtic contexts, may point to this dimension in his cult. Thus at Reims (Figure 38)[105] one of Cernunnos' two companions is Apollo depicted with his lyre; and at Vendoeuvres (Figure 40)[106] Apollo with lyre and raven (symbol of death, renewal, and prophecy) appears on the lateral surface of a stone whose principal face is occupied by Cernunnos with two young acolytes riding on serpents.

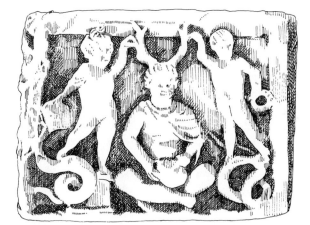

Figure 40 Relief of Cernunnos with attendants and snakes: Vendoeuvres. Musée de Châteauroux. After E. Thevenot, *Divinités et sanctuaires de la Gaule*, 1968, p. 150. Illustrator: Paul Jenkins.

Associated symbolism confirms Cernunnos' major role as that of a god of prosperity, crop-growth, and human and animal well-being. On occasions, as on representations at Lyon and Reims, Mercury, the Romano-Celtic deity of commerce, accompanies the antlered god. At Lyon, Mercury counts out money; at Reims, he holds his *caduceus* and purse, the latter emphasizing the bounty portrayed in the form of the outpourings of Cernunnos' sack. Purses as symbols of business success and wealth frequently appear as possessions of the antlered god himself, again stressing his link with Mercury – the normal divine purse-bearer of the Roman world. The stag-god may carry this emblem himself.[107] At Nuits, Cernunnos has a purse by his feet; and the Cirencester god is flanked by two open purses to which his ram-horned snakes turn their open mouths for nourishment. A similar prosperity symbolism, more to do with the earth's fruitfulness than commercial success, is the *cornucopiae*, beloved of so many of the Romano-Celtic gods of fertility. Both the triadic Burgundian groups at Beaune[108] and Nuits St Georges[109] associate Cernunnos with the horn of plenty. At Beaune, all three gods carry the symbol, tripling its potency, and the imagery of nourishment is augmented by the act of Cernunnos' companion who offers food to his dog. We have already noted the intense zoomorphic symbolism at Nuits: the theme of fecundity here is further enhanced not only by the presence of a *cornucopiae* but by the fact that its possessor is hermaphroditic and that the other associate of the antlered god is a mother-goddess.

It is clear that Cernunnos belongs to the great group of Celtic fertility and prosperity deities, exemplified so graphically by the mothers and, to an extent, by the hammer-god. Cernunnos is associated with many symbols of

fruitfulness: he possesses *cornuacopiae*, purses, grain, and ithyphallic devotees; and he feeds animals with fruit or porridge. But his closest link is with the particular emblem of the stag, who accompanies him and whose antlers he borrows. The stag is a forest animal, but the tree symbolism is enhanced by the branch-like shape of its antlers, and the motif may well incorporate images not only of the stag *per se*, with its speed, fertility, and mating-season aggression, but also of the forest itself. That seasonal rites may have been enacted is suggested by the removable antlers on some depictions. The closeness of the connection between Cernunnos and the beast is indicated not only by the antlers but by other features such as hooves and ears. His other powerful zoomorphic associate, the ram-horned snake, is also very close to him; it winds itself around his body and merges into his legs. The boundary between humankind and the animal world is blurred and even dissolved, and Cernunnos' image is that of a true blend of man and beast. We may even perhaps here be witnessing transmogrification, the act of transformation from anthropomorphic to theriomorphic image frozen half-way; or it may be that the intensity of Cernunnos' concern for the wild things of earth was such that it was recognized on cult-images as true identification. Whilst Epona is joined inextricably to her mare, she never actually merges with the equine image; Cernunnos goes the whole way and his iconography demonstrates the lack of constraints felt by the Celtic craftsman and devotee in expressing the special qualities of the divinity.

The horned gods

Images of deities with horns probably do not point to any one specific divinity, unlike Cernunnos whose image was consistent. Horns seem to have been used to increase the symbolism of whatever role a god already possessed; thus we find horns adorning figures with multifarious attributes. They may be worn by the Celtic Mercury, by a war-god, or a woodland deity of vegetation and hunting. Taken by themselves, horns seem to have symbolized fertility and virility (qualities seen especially in bulls and rams, whose horns are most frequently adopted for anthropomorphic images), combined with aggression, ferocity, and the ability to inflict pain. So it is appropriate that the divinities who sometimes bear horns are often either gods of prosperity and nature or are war-deities.

Gods with horns sometimes appear in later prehistoric contexts, though comparatively rarely: the stone pillar from Holzerlingen in Germany probably dates to the fifth or fourth century BC. It consists of a plain block topped by a janiform head wearing a twin-horned crown. The 'body' has its arms crossed about its chest and wears a belt.[110] Some Iron Age Celtic coinage displays horned heads: we can point to Hungarian tetradrachms depicting horsemen with horns sprouting from their hair;[111] and horned figures appear on Cunobelin's coins at Colchester.[112] A coin from the area of

Marseille[113] bears an ithyphallic figure with horns. Horned helmets in later Iron Age imagery confirm the association between war and horns: the Arch at Orange probably dates to the early first century AD and here multiple examples of La Tène armour are represented[114] with a number of bull-horned helmets, very similar in form to that worn by the small wheel-bearing companion of the sky-god on the Gundestrup Cauldron[115] (Figure 48). The first-century BC Waterloo helmet, found in the Thames, was undoubtedly a piece of ceremonial armour,[116] but nevertheless makes the same connection between war and horns.

This identification between horns and aggression may be seen on Romano-Celtic iconography, especially in the north of Britain. The god at Beckfoot in Cumbria[117] has long hair, horns, a cape and a spear. Warriors with pronounced horns are frequent, for instance at Maryport, where they are often nude, ithyphallic and brandish large knobbed spears and rectangular shields.[118] Indeed, horned gods are endemic to northern Britain, clustering especially in the great hegemony of the Brigantes (Figure 41).[119] Here they may be identified with war, with prosperity, nature or animal symbolism, or be without visible attributes. Thus the lead plaque of a horned god at Chesters[120] closely resembles the stone sculpture at Beckfoot, but without attributes to identify its precise function. The same is true of the god at Moresby (Cumbria) who wears a pleated cape and has two long horns on the top of his head.[121] Many gods are represented simply as a horned head, the horns sometimes identifiable as those of a ram, which may imply the aggression of fertility and the rutting season rather than belligerence *per se*.[122]

Horned gods may be associated with the prosperity imagery of the Celtic Mercury, and here there is occasionally an interesting ambiguity in the iconography, which may be deliberate. At Uley in Gloucestershire[123] and Emberton (Bucks)[124] representations of Mercury appear where the usual head-wings are replaced by horns. At Uley, a temple dedicated to Mercury produced several conventional depictions of the Roman god but just one with the quirk of horns. The Emberton image is from a possibly sacred well context, and the whole figure is schematized and very un-Roman (Chapter 7), so horns would be appropriate to a representation of marked Celtic style. What is interesting here is the Celtic play on a Roman attribute: there has been the subtle transformation of Roman wings to Celtic horns, something which required little visual change but which vastly altered the symbolism.

Images bearing horns are comparatively rare in continental Romano-Celtic contexts; those which are recorded are generally either without role-specific motifs or belong to the group of prosperity/fertility gods. On two German reliefs[125] a horned version of Mercury is represented, with his classical attributes of purse and *caduceus*. At Beire-le-Châtel in Burgundy, the emphasis of the temple imagery is healing and wellbeing. The horn symbolism here is intense: not only are there several triple-horned bulls at the

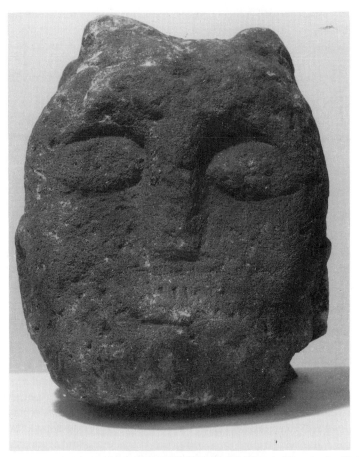

Figure 41 Stone horned head: Carvoran, Northumberland. Newcastle University Museum of Antiquities. Height approx. 18cm. Photograph: the University and the Society of Antiquaries of Newcastle-upon-Tyne.

sanctuary (Chapter 6), but two human carved heads display, respectively, triple horns and a double set of horns.[126] The faces of these gods are serene; the three-horned one resembles Apollo, and there is no doubt that a peaceful enhancement of whatever role these deities played in the cult of the temple was envisaged. The bulls themselves are placid and benign; there is no hint of aggression in the imagery at this spring shrine. A god at Selle Mont Saint Jean (Sarthe) in north-west Gaul[127] is particularly interesting in his resemblance to the hammer-god as a peasant deity of vegetation: he is bearded and clad in a tunic and coat; he carries a bow in one hand and a billhook in the other, and he has horns. This divinity has quite clearly been endowed with this animal attribute to increase his potency as a hunter and protector of the

woodland and crops. His implements are not those of war (Celtic warriors rarely used bows) but of the forest.

Like Cernunnos, the horned gods show a particular affinity with the animal world; once again there is a basic identification between the supernatural and natural worlds. The gods themselves are unnatural: they have become monsters and are outside the normal anthropomorphic divine image. But horns play a different role from antlers. They may denote aggression, war, and ferocity; they may be an acknowledgement of fertility; but above all they represent power pure and simple: power to increase any symbolism the god may possess or simply that of the image itself.

Gods of nature and abundance

There is a group of Celtic gods who are not identified by any one recurrent attribute such as hammer or antlers, but who fall firmly within the sphere of deities with responsibility for wild nature and the bounty of the earth. They are distinguished by their association with animals or birds – they may appear in the guise of hunters or benign animal-protectors; their images may link them closely with vegetation; or they may simply carry symbols of the earth's fecundity – wine, oil, loaves, or *cornuacopiae*.

Many divinities were very closely associated with natural places or with the land on which settlements grew up. They were quite literally spirits of particular locations, topographical divine entities. In this, they are similar to the *genii loci* of the Italian world. Often we know them only by name: in Gallia Narbonensis, for example, many of these spirits are named often only once, by descriptive epithets tied to that of the place itself. Thus we know that Vasio presided over Vaison-la-Romaine; Arausio over Orange; Leno was worshipped at Lérins; Telo at Toulon; and the spring-deities Nemausus (a Celto-Ligurian name this) at Nîmes[128] and Glanis at Glanum.[129] Groves of trees might have a venerated male spirit, as indicated by two altars to the 'god of six trees' at Montespan in the Pyrenees; and several small altars in this region depict simple conifers.[130] Erriapus in the Garonne area was a male divinity envisaged as a head projecting from foliage.[131] In mountainous regions, it was the spirits of high places who were sometimes named; thus we have an altar to Silvanus and the local mountains at Marignac,[132] and dedications to the god of the Vosges, both at Le Donon[133] and, further away from the Vosges themselves, at Titelberg in Luxembourg.[134] Normally local names like these are not supported by iconography; but an exception may be 'Antenociticus' who had a shrine at Benwell on Hadrian's Wall, and who had a cult-statue, the youthful head of which survives, with a groove for a metal torc.[135]

Gods of beasts and forests

That local male deities, strongly attached to nature and the countryside, were represented iconographically is clearly demonstrated by context or symbolic association. The link with animals and with the fruits of earth is unequivocal evidence of their role. Some gods were at the same time hunters and, curiously, protectors of the beasts they pursued. Thus, the hunter-god from Touget (Figure 42), depicted naked except for a cloak, with his hair in Celtic capped and striated style, is accompanied by his hound, yet he holds his quarry, a hare, quite tenderly in his arms.[136] The relief at Reichshoffen near Strasbourg portrays a god wearing a Gaulish *sagum* and carrying a charming piglet under his arm. He may well be the 'Vosegus' or spirit of the Vosges worshipped in this region.[137] The same god may be represented at the high mountain sanctuary of the Donon near by: this was a shrine dedicated to the Celtic Mercury, and so situated as to be accessible to three neighbouring tribes – the Triboci, Leuci, and Mediomatrici.[138] The imagery of the local god has a great intensity of animal and vegetation symbolism. Two apparently identical depictions of him are documented,[139] though one is very worn. The better-preserved stone shows a woodland god carrying the fruits of the forest – including a pine-cone, acorns, and nuts – in an open bag under his left arm (Figure 43). He wears a wolf-skin and carries a long hunting-knife at his left side; his boots are decorated with small animal-heads. The god's ambiguity as a hunter-protector is shown, on the one hand, by the wolf-skin cloak, the large curved chopper for smiting wild beasts that he bears in his left hand, and a lance by his right side; on the other hand, his close relationship with a stag who stands next to him and on whose antler he rests his hand demonstrates the god's role as guardian of the denizens of the forest, itself represented on the stone by stylized foliage.

Stags and hunting scenes recur in other imagery: at Treclun in Burgundy[140] a naked god is associated with a crudely incised hunt-scene where six animals, some recognizable as stags, advance towards a human figure facing them with a hound on a lead which strains towards them. No beater is represented driving the animals towards destruction, and the same ambiguity of hunting and protection may be symbolized. Imagery which is basically similar occurs at Risingham in northern Britain where an altar to Cocidius and Silvanus (Cocidius was a native god identified variously with war or hunting) portrays a hunter holding bow and quiver, between a dog and a stag which turns towards him. Associated with the scene are a doe and a young grazing deer; the forest is represented by trees with knobbly foliage which may be acorns or nuts.[141] Again the stag is not fleeing the hunter and there seems to be mutual respect between god and beasts. He is a hunter, but doe and young browse peacefully near him. Cocidius hunts the stag but also guards the forest. The London hunter-god[142] presents related imagery, with bow, quiver, stag, and hunting-dog. The stone is one of a group of broken

Figure 42 Stone hunter-god with hare and dog: Touget (Gers). Musée des Antiquités Nationales, St-Germain-en-Laye. Height 75cm. Illustrator: Paul Jenkins.

sculptures of third century AD date dumped into a late Roman well which lies beneath Southwark Cathedral. The apparent ambivalence of hunter and hunted is not necessarily as dichotomous as it seems. The Divine Hunt, in many cultures, symbolized not only the pursuance and destruction of the

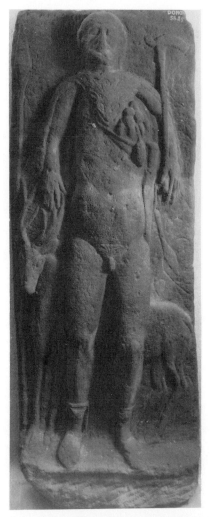

Figure 43 Relief of nature deity with wolf-skin and stag: sanctuary at Le Donon. Strasbourg, Musée Archéologique. Height 1m 76cm. Photograph: Strasbourg, Musée Archéologique.

animals of the forest, but also the concept of death and resurrection. Thus, by the act of killing, immortality was gained, the hunter becoming a benefactor.

There were images of deities associated with beasts, birds, and trees, where the hunting motif is not evident. Here, the idea of simple guardianship or protection may lie behind the symbolism, but sometimes the relationship of god to beasts and plants may be more obscure. The divinity from an *oppidum* at Amboise (Indre et Loire) has two torcs – one around his neck and

another in his hand – strongly reminiscent of Cernunnos at Gundestrup and elsewhere. But this god holds a dog in his lap,[143] like so many mother-goddesses we have seen. Another god resembles Cernunnos in his role as lord of animals: at Panosses (Isère)[144] a nude divinity holds an enormous snake in one hand and there is another elsewhere on the stone; a small dog is clasped in the god's other hand, and associated are a mule and a boar. The human bust beside the mule may represent a devotee.

Animal and tree symbolism together, seen with the hunter-gods, appears on other imagery unassociated with hunting *per se*. At Paris (Figure 44)[145] and Trier[146] a woodcutter – called Esus on the Paris stone – chops at a willow tree. The symbolism on the two sculptures is not identical but so similar is the theme that the same deity and cult-event must be portrayed on

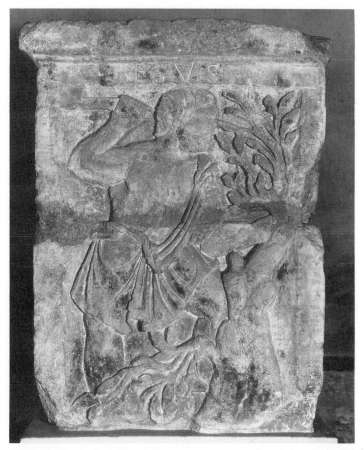

Figure 44 Esus chopping down willow: from *Nautes Parisiacae* monument, Nôtre Dame, Paris. Musée de Cluny. Height 74cm. Photograph: Réunion des Musées Nationaux.

103

both. At Trier the god attacks a willow in which repose three egrets and the head of a bull. At Paris, on a block found with five others (including the 'Cernunnos' stone) in 1711 at the site of Nôtre Dame, Esus cuts branches from a willow. On a juxtaposed scene is another willow associated with three egrets and a bull. Willow, egrets, and bulls are appropriate earthly companions since these birds favour willows and eat the tics from the hides of cattle. The wood-cutting activity is less explicable; MacCana suggests that Esus is pruning the tree for sacrificial purposes. It may be that the Tree of Life is represented, with its associations of destruction and death in winter and rebirth in the spring. The birds may be simply egrets at one level, but may symbolize the flight of the soul (perhaps the soul of the tree) at another. The bull may be a sacrificial animal, but the mutual, symbiotic benefit derived from the relationship between bull and birds (comfort and food) may itself evoke a cyclical image. Finally, we should not forget that a good deal of the symbolism – willow trees and marsh-birds – has links with water.

Birds and vegetation are linked with male deities at Alesia and Moux (Figure 45), both in Burgundy. Alesia seems to have been the centre of a cult involving a bird-god: several fragmentary sculptures depict a bearded head flanked by two birds which may be doves or ravens.[147] A virtually complete statuette[148] shows us a god with curly hair and beard and a mural crown. An oak tree laden with acorns supports two doves which appear to perch on the god's shoulders, and a now headless dog sits at his feet. The mural crown suggests that the divinity is a city-protector; he may even be the Apollo Moritasgus whose thermal shrine was a curative centre for diseased pilgrims. The other Burgundian stone, at Moux (Figure 45), depicts a similar image, in Gaulish breeches and cloak, his right hand resting on a knotted branch. He clasps a billhook in his left hand, pinning three round fruits against his chest. Once again, he has a dog at his feet, and two long-beaked birds perch on his shoulders, facing his head.[149] At both Moux and Alesia, the elements of foliage, dog, fruit, and birds are present, suggesting that the same deity is represented. In physiognomy he resembles the hammer-god, and he appears to belong to the great group of Burgundian gods of abundance of whom the hammer-god is one. The dog may represent the hunt or, more likely, be present simply as a companion, but the presence of birds suggests a more profound symbolism here. Birds, especially ravens, could be oracular, prophetic creatures, sacred to Apollo; or they could perhaps represent souls after being freed from the body.[150] If there is a chthonic element in the imagery, then the dog may also be present in its capacity as an underworld image, especially if, as has been recorded,[151] the Alesia dog was originally three-headed (recalling the classical Cerberus of Hades).

The final god-and-beast image to mention is the stone from Euffigneix (Haute-Marne) (Figure 46).[152] The relationship between divinity and animal is here as close as that apparent on the horned and antlered images. Transmogrification may again be reflected in the symbolism of a stone block, the

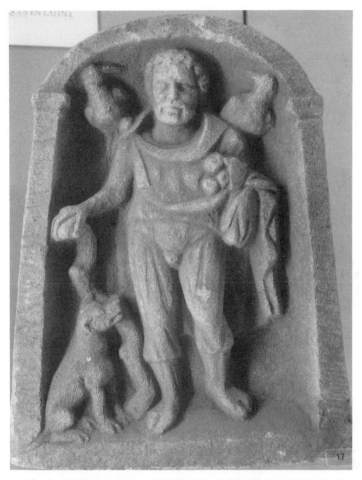

Figure 45 God with birds, fruit, and dog: Moux. Musée Archéologique de Dijon. Width 27 cm. Photograph: Miranda Green.

trunk of the body left rough and unfashioned, surmounted by a stylized face, a torc round the neck. On the 'chest' of the figure is a boar, marching in profile down the torso; on the sides of the block are two large eye motifs, the same size as the boar. The sculpture may date to before the Roman period; certain Celtic coins from the tribal area of the Aulerci Eburovices of Evreux show identical images of a human, torc-wearing figure with a boar depicted along its neck.[153] If the Euffigneix god is a hunter-protector, then the boar is so closely linked that virtual identification has taken place between hunter and hunted. The qualities recognized in the boar – ferocity, strength, and indomitability – were revered and adopted in enhancement of the human image. The particular veneration the Celts had for boars is something which

105

Figure 46 Statuette of god with torc, boar, and eye-symbols: Euffigneix. Musée des Antiquités Nationales, St-Germain-en-Laye. Height approx. 28cm. Photograph: Réunion des Musées Nationaux.

is repeatedly documented in both literary and archaeological sources. The eye motifs made the image even more powerful in making it all-seeing and maybe warding off the evil eye as well.

Gods of fertility and plenty

Some divine male imagery closely resembles that of many Romano-Celtic goddesses in that fertility and abundance seem to have constituted the major role of the deities depicted. These images are consistent in portraying a mature man with long luxuriant hair and beard and wearing Gaulish clothes – usually a tunic and *sagum*. Water, wine, or other liquid is often the main symbol, maybe expressing the florescence of the vine or the life-source of water on the one hand, but perhaps immortality and regeneration at a higher level. Indeed, there is sometimes a specific association with spring-

106

water and healing. Thus at Entrains in Burgundy,[154] a god holding a goblet appears at the same site as the Celtic spring-healer Borvo.[155] The prosperity-attributes of the Entrains deity are multiplied for, apart from the wine-cup, he has a purse and a *patera* of fruit in his lap. Another image from the same site,[156] found in a cellar in the artisan quarter, holds two long loaves of bread in hands which are exaggerated out of all proportion to the body. Intensity of symbolism recurs at St-Aubin-des-Chaumes also in Burgundy, where a god holds a pot, presumably for some liquid, an amphora, and a *cornucopiae* filled with fruit; on a table set between his legs is a large cake divided into four and two smaller cakes.[157] Here the basics of life are represented: bread, wine, and maybe oil or water. Water or wine symbols recur elsewhere in Burgundy, at Meursault,[158] where a god sits holding a pot and *patera*; and at Forêt de Chavigny in Lorraine[159] where, at a thermal-spring site, a beardless god (his foot on a mound) carries a cylindrical vessel. In Britain at Corbridge, a god named 'Aericurus' (?related to the Rhineland Aerecura, pp. 41, 69), naked but for a cloak, is associated with a cup and urn.[160] With several of these indeterminate deities, fruit is the fertility motif adopted, either held in a *patera*[161] or in a *cornucopiae*.[162]

Occasionally, prosperity and well-being are indicated by animate symbolism. At Dennevy (Saône et Loire)[163] (Figure 80), a god with a *cornucopiae* is accompanied by a mother-goddess-like female and a triple-headed image, a type which (Chapter 6) itself had links with prosperity. The Donon sanctuary to Mercury in the Vosges produced images of naked gods, one with a purse or bag, as befitted the Romano-Celtic god of commercial prosperity,[164] but also an ithyphallic image, thereby establishing human virility as the determinate symbolism. Finally there is an image at Lantilly in Burgundy[165] where a spring site produced a naked seated god with a ram-horned snake. We have seen (pp. 92–3) that this composite beast accompanies beneficent deities such as the antlered god; its own symbolism appears to combine fertility, regeneration, and chthonicism, appropriate company for a god who may have presided over a curative-spring shrine.

The gods of fertility and plenty do not possess any one distinctive motif or identifying emblem. All they have in common is the possession of one or more attributes of well-being and abundance. Such imagery may be intense and often combines the same multiple symbols which we observed as associates of the divine couples. The synthesis of bread, fruit, and wine provides balanced symbolism of nourishment in this life; but there are hints at greater profundity, and these gods represent also renewal and rebirth in the otherworld.

Before leaving the benevolent gods of florescence and success, we should look at a final category of images which are distinctive in that the art-form of the Roman Mercury has been used to depict a god of commercial success and of general prosperity. We saw in Chapter 3 that Mercury could be 'celticized' by his possession of an indigenous Gaulish partner, Rosmerta, which, in

itself, brought him within the realms of fertility imagery. That Mercury was adopted as a native god, because of his Graeco-Roman role as god of success in trade and business, of fertility and the underworld, is demonstrated also by the variety of his Celtic names, some of which indicate that he could be a mountain-god, worshipped as such at the high Vosges sanctuary of Le Donon.[166] At Bonn a second-century altar depicting Mercury in full Roman guise is nevertheless dedicated to 'Mercury Gebrinius' – perhaps denoting a local Ubian deity.[167] Mercury Cissonius appears again among the Ubii at Köln[168] but also far away at Saintes.[169] Cissonius alone was venerated in the Metz region.[170] On none of these dedications is the god represented iconographically; that he was not merely a local spirit is indicated by the wide scatter of invocations, though it is, of course, possible that the same devotee travelled among the Ubii, the Mediomatrici of eastern Gaul and the Rhineland and among the Santones of Aquitaine in the west.

Despite the wealth of epigraphic proof of an indigenous Celtic Mercury, most iconographic data reflect the image of the Mediterranean god. We saw this phenomenon with Mercury and Rosmerta. But there are some visual indications of celticism: the god appears as a benign old peasant in a heavy Gaulish cloak on a sculpture found at the entrance to the pottery workshops of Lezoux (Allier),[171] eschewing his normal youthful appearance and resembling, instead, the venerable indigenous gods we have already encountered; only his winged hat and large money-bag identify him as Mercury. The deity may be subjected to triplication, as we see in Chapter 6, being occasionally three-headed or three-phallused. We saw that the iconography of Cernunnos associates this antlered Gaulish god either with Mercury's attributes (the purse, for instance) or with the god himself, as at Reims and Lyon. That the two images were closely linked is demonstrated at Puy-de-Touges (Haute Garonne), where a bronze Mercury sits cross-legged in the stance of Cernunnos.[172] Equally evocative in this context is the association between Mercury and the ram-horned snake: at Beauvais[173] a stele depicts the 'classical' Mercury, but on each side-panel is a ram-horned snake. The relationship between the images of snake and deity is even stronger at Néris-les-Bains (Allier)[174] (Figure 21) where Mercury, again mature and bearded like the Lezoux image from the same region, has an enormous ram-horned serpent draped over his knee, in a manner similar to those depictions of the antlered god who feeds the reptiles which entwine themselves about his body. In these circumstances, Mercury becomes virtually indistinguishable from an unnamed god of plenty and beneficence. Only his Graeco-Roman attributes – especially his money-bag and *petasos* – remind us of his original identity, and we have seen that even his wings can become Celtic horns (p. 97).

War-gods and protectors

We are informed by such classical commentators as Caesar and Strabo that Celtic society was strongly geared towards fighting, particularly single combat. Bearing this in mind, it would be natural to expect fighter-deities to be well represented in Romano-Celtic iconography. The limited evidence for pre-Roman Gaulish sculpture does contain war-god imagery, but in the Romano-Celtic phase, though frequent epigraphic reference is made to 'Mars', his images are not common on sculptural depictions except in limited areas of Britain. Indeed, we will see that Mars underwent a transformation from the war role in which he was exported by the Roman occupying forces, and seems, instead, to have been identified with indigenous tribal gods who were as much protectors of land and people as warriors *per se*.

Prehistoric war-gods

Images of war-divinities appear in free Celtic contexts of the southern Gaulish sanctuaries of the Lower Rhône Valley. A series of shrines – Roquepertuse and Entremont for instance – share recurrent features of stone porticos displaying carved or genuine severed heads and images of warriors, sitting cross-legged (Figure 47). The shrines probably date to the fourth or third century BC, part of the *oppidum* complex which flourished here at this time. The presence of sculpture indicates Greek influence from the colony of Marseille, but there is pure celticism in the style, spirit, and content of the sanctuaries.[175] Glanum,[176] Entremont,[177] and Roquepertuse[178] have all produced remarkably homogeneous images of warriors seated cross-legged, in the manner of Cernunnos. Entremont has, perhaps, the richest material. The sanctuary belonged to the *oppidum* of the Saluvii, sacked by Rome in about 123 BC. The warrior figures wear torcs and cuirasses (Figure 47), often with apotropaic signs such as double spirals or, more significantly, severed heads. Indeed, the symbol of the 'tête coupée' is a constant theme: Entremont has a pillar carved with lipless incised heads, and both it and Roquepertuse possess skull-portices, carved with niches in which were set the skulls of adult men, some evidently killed in combat. Moreover, many of the warrior-gods carry images of severed heads in their hands. All the head carvings are distinctive in having closed eyes, perhaps representative of dead men. The warrior/severed head association recurs in other contexts: at St-Michel-de-Valbonne (Var), still in southern Gaul, a pre-Roman menhir-shaped stone depicts a horseman with a huge head, riding over five severed heads.[179] Back at Entremont, a relief of a horseman carrying a severed head, eyes closed, suspended from the neck of his mount,[180] faithfully expresses classical commentators' remarks on the behaviour of Celtic head-collectors.[181] The theme recurs on Celtic coins[182] which display images of warriors with severed heads. Whilst the head-bearing horsemen may simply reflect human Celtic

Figure 47 Statue of cross-legged warrior-god: Entremont. Musée Granet, Aix-en-Provence. Height 80cm. Photograph: Miranda Green.

soldiers, the cross-legged figures are surely divinities. Their hands rest on their severed-head attributes in an attitude of benediction, and these warriors may well have been envisaged as lords of the dead.

The Lower Rhône Valley has produced other iconographic reminders of warfare. The two warrior images, at St-Anastasie/St-Chaptes[183] and Grézan,[184] both in Gard near Nîmes, may depict war-gods. A date of fifth or fourth century BC has been suggested for Grézan. The St Anastasie carving is interesting for the presence of a faintly incised frieze of animals, perhaps

horses, carved on the chest of the warrior. A not dissimilar sculpture from the *oppidum* at Nâges[185] possesses a frieze with alternating heads and horses, recalling the horseman and head-hunting theme looked at earlier. Far away, at Hirschlanden in Germany,[186] a stone statue of the sixth or fifth century BC represents a naked warrior with a torc, a conical helmet, a belt and dagger. His arms are crossed and he is ithyphallic; he once presided over a barrow-mound. That the image is of a god rather than of a dead soldier may be suggested by the torc; the ithyphallicism may indicate the resurgence of life after death, and it may be that human and divine concepts have merged and that a dead chieftain has perhaps been elevated to divine status. It is equally difficult to decipher the rank of warriors who appear constantly on Celtic coins.[187] The figures, often naked, reflecting the Celtic penchant for fighting unclothed commented on by Graeco-Roman authors, carry the carnyx (war trumpet), standards surmounted by boar or bird images (see again, for instance, on the Gundestrup Cauldron), sceptres, boughs, or torcs. Surely divine, though, are the crude little Iron Age chalk warrior-figures from Wetwang and Garton Slack in East Yorkshire.[188].

The Romano-Celtic warrior-guardians

There is an ambiguity in the role of war-gods identified with Mars in Romano-Celtic Gaul and Britain. A brief glance at the epigraphic evidence reveals that 'Mars' was by no means simply a god of war. The original Italian function of Mars was as a deity of agriculture and protector of land boundaries, and indeed the Celtic version of Mars adheres much more closely to this role. There is no doubt that, when the Romans occupied Celtic lands, they encountered tribal protectors who had a defensive (and offensive) war-role but who presided over all aspects of the tribe's welfare. The Celtic surnames given to 'Mars' reflect this identification with tribe or location. One of the Berne commentators on Lucan's Poem *The Pharsalia*[189] equates Mars with 'Teutates' – the name meaning god of the tribe; and Mars Teutates is recorded epigraphically at, for instance, Barkway, Hertfordshire.[190] Tribal guardianship is reflected in 'Mars Albiorix', a god of the little tribe of the Albici of Vaucluse in southern Gaul, and similar local protectors are exemplified by 'Mars Vesontius' at Besançon.[191] What is striking about the epigraphic evidence is the frequency of dedications to a Celtic Mars – in central and southern Gaul and Aquitaine – where there was little or no military presence after the initial occupation.[192]. We will see that a major part of Mars' function in Romano-Celtic contexts was as a defender against all forms of evil – barrenness, disease, and all misfortune. No doubt he retained the war imagery which persisted in the iconography, both because of the Roman Mars who appeared in Celtic lands as an unequivocal warrior, and because of the strong combative traditions of the Celts themselves.

The Celtic 'Mars' as a true warrior

Even where 'Mars' appears in specifically unmilitary, peaceful contexts, he usually retains some, if not all, of his military regalia. But two groups of iconography indicate the presence of a war-god who may have been worshipped principally as a simple martial deity. The first of these comprises the North British group; the second consists of the Celtic horsemen.

The British 'Mars' clusters in two main centres, the south-west, where his protecting role superseded his warrior function (below, pp. 114–15) and in the region of Hadrian's Wall, where he was a true war-god. Here, in the territory of the great confederation of the Brigantes, the war-god personified his people, flourishing in an unadulterated, indigenous milieu where the spirit of the fighting Celt had not been smothered by romanization, but where it lived on, stimulated by the conflict with Roman forces which never really disappeared. Images of warrior-deities abound in North Britain. Interestingly, despite the Roman military presence, these gods are native deities. The Roman Mars image plays a somewhat secondary role. Thus, the rock-cut warrior at Yardhope,[193] situated near a Roman marching-camp, is naked, in the fashion of a Celtic combatant, with a (? leather) cap, spear, and small round shield. With his jutting brows and elongated eyes, he is unequivocally local. The Yardhope image may actually be Cocidius, a local god who was identified variously with a woodland god adopting the Roman title Silvanus and a Celtic Mars. Cocidius appears at Bewcastle in Cumbria[194] where two embossed silver plaques dedicated 'deo Cocidio' were found with third-century material in the underground strong-room in the headquarters building of the Roman fort. Cocidius is depicted as a simple 'matchstick man' figure with a rectangular shield and spear. The North British gods possess two distinct features, often combined with such crude, 'simplistic' art-style as occurs at Bewcastle: one is the presence of horns, the other ithyphallicism. Both features can be seen, for instance, at Maryport in Cumbria, where schematized war-gods are both horned and ithyphallic.

The apparently crude, incised outlines employed by Celtic craftsmen to portray warrior-gods is a feature which recurs both in and outside Brigantia. In another relatively unromanized region, at Tre Owen near Newtown in Powys, a war-god image was associated with third-century pottery near the bottom of a pit or well.[195] The simple image is of an aggressive war-god with a round shield and brandishing a sword. Such images are very similar to warriors which occur elsewhere in Britain: stones re-used in villa foundations at Wall in Staffordshire display crude carvings of human 'pin-man' figures with shields;[196] the god at Stow-on-the-Wold (Gloucestershire) appears in similarly economically simple outline, with an oblong shield, spear and a *modius*-like head-dress.[197] One of the very rare warrior-images from the Pyrenees, at Galié (Comminges)[198] is of a stylized naked god with his lance, blade-down, in one hand – perhaps in reflection of a defensive rather than

offensive role. I examine the whole question of schematism and apparent crudeness in image-making in Chapter 7. Here it is necessary only to point out that such abstraction is a Celtic feature which would only find favour among an indigenous clientèle. Both patron/devotee and craftsman would have been operating in an entirely native milieu.

The war-god as a horseman refers to a specifically Romano-Celtic cult, even though the name of 'Mars' may be used. The Roman Mars was not generally equestrian, and the idea of a warrior-horseman may have originated from the existence of a ruling knightly class in Celtic society and the excellence of Celtic cavalry and horsemanship. We have evidence, too,[199] that the horse was extremely important in Celtic religion (Chapter 5), and we have seen also that the horse-goddess Epona was a popular deity among soldier and civilian alike. The suggested association between the Celtic Mars and the ruling elite is supported by certain epigraphic evidence. Mars 'Rigisamus' refers to a 'king of kings', and a high celestial role, usually reserved for Jupiter, is implied by 'Loucetius', meaning 'light', or 'Belatuca-drus', 'bright one'. That horses and sun-symbolism were closely linked in Celtic religion is evidenced, among other features, by Celtic coins bearing horses and sun-signs; by the association between horses and the Celtic Apollo;[200] and by the link between the horse and the Celtic sky/sun-god (pp. 123–9). On epigraphic evidence, the Celtic Mars was often worshipped in high places in Gaul, again usually the prerogative of sky-gods.

Gaul and Britain have both produced ample evidence for the cult of an equestrian warrior. We have already noted the prehistoric image of a horse-man at St-Michel-de-Valbonne (Var). Here and at two sites not far away in Drôme[201] in Romano-Celtic times, Mars Rudianus was venerated: this may be the horseman represented at St Michel.[202] Other Gaulish horsemen can be linked with god-names. At Bolards (Nuits St Georges) in Burgundy, a bronze horse or mule was dedicated to Segomo, a name which may mean 'victo-rious', and pipe-clay horses and horsemen come from the site.[203] Mars Segomo was known among the Sequani, so an association betwen Mars, a native conqueror and the horse may have been established. Other Gaulish links between the Celtic war-god and horses occur, for instance, with the important cult of Mars Mullo in north-west Gaul, at Rennes[204] and Allonnes (Sarthe).[205] We have no evidence as to the imagery with which Mars Mullo was expressed, but his Celtic surname refers to 'mule'. His high status is illus-trated by his links with the emperor in the Allonnes epigraphy, and by the official, public nature of his cult at Rennes in which town officials were involved. We know that statues (lost) and dedications were set up here in urban temples in the earlier second century AD. There was a sanctuary asso-ciated with horse imagery, dedicated to the Celtic Mars, at Sougères-en-Pulsaye (Yonne);[206] and a dedication to Mars Camulus (suggested by Ross as being a Belgic deity, later equated with the Roman god)[207] was made by a horseman from Reims in AD 200 and found in that city.[208] Camulus recurs at

Rindern in Germany[209] and in Britain at Bar Hill on the Antonine Wall.[210]

The British cult of a horsemen-warrior is of particular iconographic interest. Most of the evidence comes from eastern regions, notably the tribal territories of the Catuvellauni and the Corieltauvi. At Martlesham in Suffolk and Stragglethorpe (Lincolnshire), the horseman appears as a conqueror, perhaps of evil personified as an enemy. The Suffolk image is a bronze figurine dedicated to Mars Corotiacus, a local deity in classical guise but who, un-Mars-like, rides down a prostrate foe.[211] The image at Stragglethorpe is stone and the enemy, struck down by a spear, is a serpent.[212] The symbolism here is remarkably similar both to certain early Roman tombstones of the Rhineland, where cavalrymen ride down enemies,[213] and to images of the Celtic Jupiter who tramples a monster who is half-man, half-snake (pp. 123-9). A sanctuary to the Celtic horseman existed at Brigstock (Northamptonshire), a temple precinct containing many shrines and several bronze figurines of warriors on horseback,[214] similar to the splendid little statuette of a horseman at Peterborough.[215] A schematized stone image of a horseman, with spear and shield, at Margidunum (Nottinghamshire) is distinctive in its curious proportions: the horse is diminutive and could never have supported the weight of the much larger horseman.[216] The number of images of a Celtic equestrian god in eastern Britain must point to a local tribal preference, perhaps reflecting earlier, free Celtic, horse-cults. We know that ceremonies involving horse ritual and perhaps horse sacrifice were practised in south-east Britain,[217] and we should perhaps recall also the Iron Age chariot-burials of the Parisi where, on occasions, horses and chariots were buried with their owners.[218] Mounted war-gods are rare in Britain outside the eastern tribal areas but not entirely unknown: the Dobunni worshipped a divine horsemen depicted with a large circular shield and an axe at Bisley in Gloucestershire.[219]

'Mars' as a healer and god of prosperity

The non-military role of deities known as 'Mars' in the Romano-Celtic world may be observed in many regions of Gaul and Britain. As a healer, 'Mars' is a fighter against disease, and here the evidence is largely epigraphic rather than iconographic. Mars Lenus, the great Treveran healer of Trier and Pommern[220] was worshipped in Britain at Caerwent[221] and at Chedworth (Gloucestershire) where the name 'Lenus' was inscribed on a stone depicting a schematized war-god with a spear.[222] The retention of military imagery for a peaceful, beneficent healer recurs at Vichy where Mars Vorocius, presider over a curative-spring shrine, appears on a potsherd as a warrior with helmet and shield, and as a clay horseman with a free Celtic La Tène III shield similar to that possessed by the healing Mars at Mavilly (Figure 26) (Chapter 3). But the god's regenerative role as a god of renewal is illustrated by his horned snake,[223] a beast associated with the divinities of well-being, as

we have seen, and who recurs with the healers at Mavilly.[224] An interesting feature of Mars as a healer is his particular patronage of people with eye afflictions. He appears thus at Vichy, as Mullo at Allonnes[225] and at Mavilly, where one sculpture shows Mars with his healing canine companion and a raven, accompanied by a pilgrim with his hands over his eyes (Figure 25).[226] Far away, at Lydney (Gloucestershire), the local healer, Nodens, was equated with Mars and, again, cured eye disease. The only symbolism which may represent the god consists of dog images.[227] The appearance of the raven at Mavilly and a bone eagle at Lydney may reflect the bright eyes and sharp sight of birds of prey. The dog was a noted healing motif, and we have alluded already to the restoration of sight by the lick of a dog at a Greek sanctuary to Asklepios. That the 'Mars' at Vichy and at Mavilly were specifically Celtic gods is demonstrated by the occurrence, at both sites, of warrior images bearing the distinctive hexagonal late Iron Age shield.

The Romano-Celtic warrior could be a guardian of general prosperity, well-being, and fertility, in addition to his particular function as a healer. We have seen the presence of the ram-horned snake at Mavilly and Vichy, where it accompanies the warrior-healer. This hybrid beast, itself a symbol of fertility and regeneration, reappears with 'Mars', for instance at Vignory in Burgundy[228] where a god in cuirass and leather-thonged skirt holds a ram-horned snake in one hand. In Britain a bronze figurine from a hoard of bronzes at Southbroom in Wiltshire[229] depicts Mars in tunic and helmet, grasping two ram-horned snakes behind their heads. Elsewhere a god with some martial characteristics is associated with symbols of commercial success or of the earth's fruitfulness: the Le Donon (Vosges) shrine to Mercury produced an image of a god, naked apart from a cloak over his shoulders, a drawn sword and a pot or purse.[230] The purse may reflect Mercury's presence, but this Roman god is never associated with war. Here a local god is represented as a guardian of abundance and success. A Dijon 'war-god', again nude with only a cloak, appears with the sword of protection and a sheaf of corn-ears.[231] In Britain, among the Dobunni at Custom Scrubs (Gloucestershire), two curious 'Mars' figures represent the worship of a peaceful, bucolic prosperity-god. One image was dedicated to 'Romulus' by a Celtic devotee and depicts a male in tunic and cloak, a triple-crested helmet (recalling a triple-pointed diadem on the god at Vignory), a shield, spear, and sword, but with the alien symbol of a double *cornucopiae* surmounting an altar. The second, obviously the work of the same craftsman, is dedicated to 'Mars Olloudius' (a deity worshipped also at Ollioules in southern Gaul),[232] looking like a Roman *genius*, with no military attributes, and carrying a *patera* and double *cornucopiae*.[233]

An association between war imagery and fertility is implied by ithyphallicism on North British representations – at Maryport, for instance, and much earlier, at Hirschlanden. Aggression and virility are quite naturally linked. But the total transformation of a belligerent god of war to a peaceful

protector of crop-growth and abundance is a volte-face which is difficult to comprehend unless we recall the original identity of Mars in Italy as land-protector and god of agriculture. In Romano-Celtic contexts, Mars dropped his aggressive, offensive role, to become a guardian of all that peaceful worshippers wanted preserved and protected: health, fertility, and all that was good in earthly life.

The sun and sky god

In Chapter 5 we examine the symbolism associated with the sun itself. Here we are concerned most of all with the sun-god who, in the late Iron Age and, more particularly in the Romano-Celtic period, took the form of an anthropomorphic sky and solar lord of the heavens. The most prominent emblem of this god was the image of the sun as a spoked wheel.

There is little pre-Roman evidence for a solar god represented in human form. Sculptures depict warriors bearing talismanic wheel-pendants on their body-armour: the soldier at Fox-Amphoux (Var)[234] is one example; and Celtic cuirasses and helmets represented on the Arch at Orange[235] show similar solar amulets. But these are human images attesting the use by earthly warriors of the sun-talisman. More likely to be divine are the motifs depicted on Armorican coins which sometimes bear the image of a human head with a sun-wheel in the hair.[236] The most evocative evidence for a free Celtic wheel-bearing sun-god appears on the Gundestrup Cauldron,[237] where a small figure of an acolyte offers a large cart- or chariot-wheel to a divine being (Figure 48). An interesting point about this scene is that the sun-god's attendant wears a bull-horned helmet identical to those associated with solar amulets on the Arch at Orange.

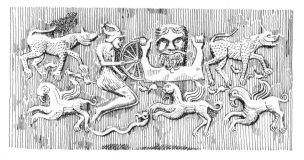

Figure 48 Silver plate from Gundestrup Cauldron (Figure 1), showing detail of wheel-god: Gundestrup, Jutland, Denmark. Nationalmuseet, Copenhagen. Illustrator: Paul Jenkins.

The Romano-Celtic lord of sun and sky

As a result of Roman and Celtic interaction, there emerged a hybrid sky-god, owing a great deal to the concept and imagery of the Roman celestial and father-god Jupiter but betraying the presence of a Celtic deity in partial Roman guise. Where an epigraphic dedication exists on these composite images, the divinity invoked is always called by his Roman name; there may, occasionally, be a Celtic surname attached to that of Jupiter – Taranis or Tanarus for instance,[238] but never associated with an anthropomorphic image. Two main types of iconography by which this complex god was expressed can be distinguished: the Romano-Celtic 'Jupiter' may be depicted as a sun-god, with his Celtic sun-wheel (but Jupiter never appears as a solar divinity in classical imagery). The other main type shows the god as a conqueror over evil, triumphing over the negative, chthonic forces. The link between the two groups of imagery is provided by the sun-wheel which occurs occasionally with the conquering sky-warrior. Even in instances where overt Celtic elements of symbolism are missing, images of Jupiter may still display celticism in the style of image. A bronze statuette from the Rouen area depicts the Roman god with his eagle, but with a stylized face and hair, and wearing Gaulish clothes.[239] Even more unclassical is the bronze figure of a Celtic peasant, in a heavy hooded coat, whose only attribute is a large thunderbolt, an emblem unequivocally tied to Jupiter.[240]

The image of the sun-god (Map 6)[241]

The solar god appears in a variety of guises, with two consistent features, of which one is his accompaniment by the sun-wheel, the other the mien and emblems of the Roman Jupiter. Frequently the god takes a very classical form and here the sun-wheel may be the only Celtic symbol. This motif is, however, utterly alien to the imagery of the Roman god, and the combination of symbols indicates the absolute conflation between Roman and Celtic divine power. It is the attribute of the spoked wheel, traceable as a cult-object long before the period of Roman influence (Chapter 5) which gives the god his indigenous identity. But some images of the sun-god possess other features which are foreign to the Mediterranean divinity and, in their most extreme form, bear no resemblance whatever to the Roman sky-god.

Before we examine the images in detail, we should consider the wheel itself as a symbol. It was undoubtedly solar, but there may be more to it than that. Many of the wheels possessed by the Romano-Celtic sky-god are realistically depicted, as if the imagery of a real wheel were important. It may be that, in addition to the solar symbolism, there is perhaps also the idea of a vehicle, the sky-god's chariot rumbling across the firmament inducing the growl of thunder. We will see later that the Celtic Jupiter was occasionally envisaged

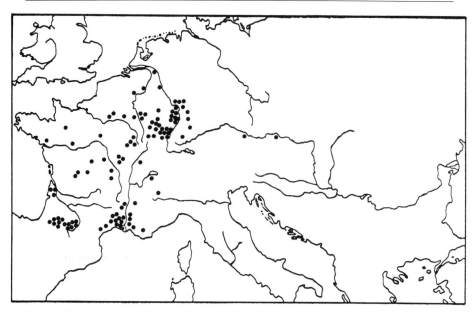

Map 6 Distribution of stone solar wheel and swastika monuments in Continental Europe: after M. J. Green, *The Wheel as a Cult-symbol in the Romano-Celtic World*, 1984.

as riding in a chariot, and the thunderbolt symbol was a recurrent associate of the wheel-sign.

The most romanized images of the Romano-Celtic sky/sun god include sculptures at Alzey (Rheinland-Pfalz)[242] and Alesia,[243] which both represent Jupiter, enthroned, in normal Roman attitude, with his usual motifs of a globe (symbolizing his dominion over the world) at Alesia and his eagle (his sky-emblem) at both sites. Here it is the decoration on the sides of the throne which betrays the god's hybrid identity; at Alesia both sides are carved with wheel symbols; at Alzey the Celtic wheel on one side is balanced by the Roman eagle on the other. An altar at Laudun (Gard) in Provence shows essentially similar imagery,[244] where Jupiter's sceptre and eagle are balanced by the alien presence of the wheel. At Séguret (Vaucluse) also in the south of Gaul, Jupiter appears as a Roman general, that in itself being a curious image for the god, with his eagle and the symbol of an oak, the Roman god's special tree. But these Mediterranean motifs are associated with a large wheel held by the god down by his side, like a shield at rest, and by a snake which, Eden-like, twines itself round the tree.[245] The warrior image is repeated in a small baked clay mould for appliqué decoration on pottery, at Corbridge in Northumberland, a military supply depôt just south of Hadrian's Wall. Here the Jupiter-identity really has disappeared; the solar wheel appears next to a war-god with tunic, helmet, the shield of a legionary, and a knobbed club.[246]

That the sun-god should take the form of a soldier at a military installation is appropriate; his appearance thus in peaceful Provence is less explicable unless he is seen as a conqueror and therefore supreme. But we will see later that there is a whole series of monuments depicting the Celtic sky-god as a fighter.

Small votive objects portraying the sun-god vary enormously between images which closely resemble Jupiter to those of an entirely native deity. But all carry the distinctive solar-wheel motif. Most akin to the Roman god are the bronze figurines from Le Châtelet (Haute Marne) (Figure 49) and

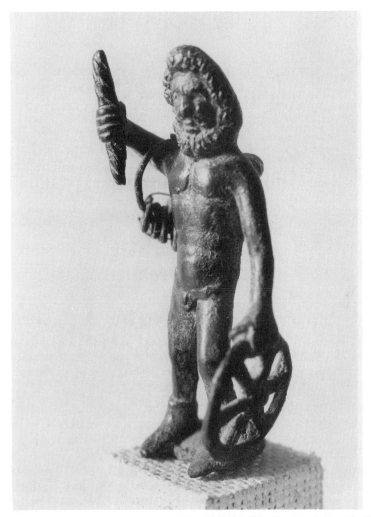

Figure 49 Bronze figurine of wheel-god: Le Châtelet. Musée des Antiquités Nationales, St-Germain-en-Laye. Height 10.3cm. Photograph: Miranda Green.

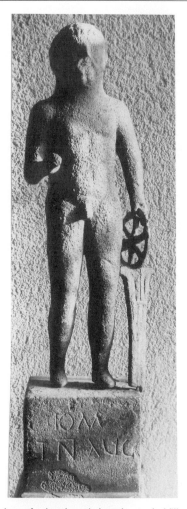

Figure 50 Bronze figurine of wheel-god: Landouzy-la-Ville. Musée des Antiquités Nationales, St-Germain-en-Laye. Height 22cm. Photograph: Miranda Green.

Landouzy-la-Ville (Aisne) (Figure 50). These images may either have been personal cult-objects or may have belonged to a shrine. The first figure[247] depicts a naked, mature male with curly hair and beard, reminiscent of Jupiter, with his thunderbolt in one hand. The two alien symbols are a wheel by his ankle and a curious motif of nine S-shaped objects hanging from a shoulder-ring. These may be spare lightning-flashes; they resemble the individual strands of which the god's thunderbolt is comprised. The association of wheel and S-motifs recurs on a pot at Silchester, decorated with alternate wheels and S-shapes,[248] and on a bronze wheel model from Grand-Jailly

120

(Côte d'Or), decorated with three S-symbols soldered onto the rim.[249] The figurine from Landouzy[250] is firmly identified with the Roman sky-god by a dedication on the base to 'Jupiter Best and Greatest and the Numen (spirit) of the Emperor'. The image is of a grim-faced, naked god holding a solar wheel over an altar. Cheaper votive objects are represented by pipe-clay figurines of the wheel-god mass-produced in central Gaulish manufactories.[251] Two main types may be distinguished: the sky-god may appear with either an eagle and thunderbolt or a wheel and thunderbolt. This may suggest that somehow the eagle and the wheel were interchangeable symbols, both celestial motifs but one (the eagle) sympathetic to a more romanized clientèle, the other (the wheel) appealing to a more pronounced Celtic taste. What is particularly interesting about this group is the presence with Jupiter of a small being crushed by the weight of the sky-god's hand on its head. We will return to this theme when considering the celestial fighter (pp. 123–9).

Two British bronzes were made for a liturgical rather than for personal use: both are sceptre-fittings, one from a fen site in Cambridgeshire, the other from a temple in Surrey. The first site, Willingham Fen, where there may have been a shrine, produced a cast bronze sceptre-terminal revealing complexities of Romano-Celtic mythology which are not generally apparent in the iconography.[252] A young naked god, brandishing a thunderbolt or club, is associated with a wheel, a dolphin, and the head of a triple-horned bull. A dolorous-looking individual is crushed into the ground by the god's foot. The imagery here is a balance or blend of Roman and Celtic symbolism: the eagle and the wheel may be seen, respectively, as classical and indigenous sky-signs: the dolphin[253] is frequently employed as a Graeco-Roman motif of death and the subsequent sea-journey to the Isles of the Blessed; the underworld monster, trampled into the earth, will become familiar when we look at the phenomenon of the Jupiter-Giant column sculptures as a symbol of negative forces. The bull motif is interesting in that this animal was traditionally associated with the Roman Jupiter, but it has been 'celticized' by the addition of a third horn (pp. 180–2). The imagery of the Willingham god himself is curious in that the usual mature deity is replaced by a young, clean-shaven, dancing being resembling Cupid rather than the dignified sky-lord. The other British sceptre-fitting is very different: the temple site at Farley Heath in Surrey produced a sheet-bronze strip, once wound around a wooden and iron rod, decorated with schematized 'matchstick' figures of 'humans' and animals.[254] The hammer-god is present; a smith-deity is represented by tongs, and there are ravens, boars, stags, and other animals. The Celtic sun/sky-god appears as a head associated with a sun-wheel sign. The imagery here owes little to classical tradition, either in terms of art-style or religious content. The mythology or cult displayed again implies intricacies which it is impossible fully to interpret. The association of the sky-god with animal imagery may suggest a seasonal, cyclical symbolism, with sky and earth motifs juxtaposed; the presence of smiths' tools may

represent iron and an earth-dimension; and the raven – as a carrion bird – frequently has chthonic associations, but its bright-eyed stare may invoke light and the sun. We have seen already that the hammer-god and the sky-god were linked (p. 81).

With the imagery at Farley Heath we have come a long way from the very Roman representations of the sky-god who resembles Jupiter in every respect but for the foreign wheel-motif. Two other British sites reveal further the separation between Roman and native celestial symbolism. From Netherby in Cumbria[255] come two reliefs of seated divinities bearing *cornuacopiae*, normal motifs of fecundity and well-being which we have met often in association with the goddesses, divine couples, and the gods of abundance. The *cornucopiae* is the emblem of Roman *genii* whose images are depicted holding *paterae* over altars. At Netherby, however, the *patera* is replaced by a large wheel, quite out of proportion to the diminutive altar beneath it. On one of the reliefs a boar and a tree accompany the wheel-god, enhancing the land-vegetation-fertility symbolism already present in the borrowed image of the *genius* with his horn of plenty. The Cumbrian evidence is interesting in that it introduces a fertility dimension to the cult of the sky-god. We will see presently that this role recurs in other imagery. The second site where indigenous motifs predominate in sky imagery is Caerleon, the Roman fortress of Legio II Augusta.[256] A number of clay antefixes (tiles covering the gable-ends of roofs) are decorated with crudely fashioned human heads and sun-wheel symbols. Whilst it can be argued[257] that this imagery is simply apotropaic, designed as a good-luck motif to ward off evil, it may be that the sky-god is here represented, in which case we are witnessing the curious phenomenon of a Roman garrison adopting a Celtic sky-god image to protect their military installation from Celtic aggressors.

Two seemingly curious associations for the Romano-Celtic sky/sun-god deserve comment – fertility and death. The fertility link noted at Netherby is supported by other symbolism: at Naix (Meuse)[258] a seated wheel-god is associated with two *cornuacopiae*; and at Clarensac (Gard) a wheel-sign is accompanied by a dedication to Jupiter and Mother Earth.[259] Sky and fertility are again linked at Köln where Jupiter Best and Greatest and the Mothers were invoked.[260] Perhaps most evocative is evidence for a solar dimension to the Celtic mother-goddess cult seen, for instance, on clay figurines where a goddess is associated with wheels and circles (pp. 38–9).[261] The link between sun/sky and fertility is appropriate in that the sun was clearly responsible for crop-growth and that the Roman sky-god with his thunderbolt had a role in summoning rain to fertilize the land. Less clearly explicable is the death role of the sun-god. This is seen at its most prominent in Alsace, among the Mediomatrici, where tombstones are recurrently decorated with wheels and circles (p. 167). But that there was a specifically chthonic dimension to the sky-cult in western Europe is seen most clearly in a group of monuments which are occasionally, but not usually,

associated with the solar wheel, where the god appears in the image of a celestial warrior.

The sky fighter (Map 7)[262]

In looking at certain small cult-objects depicting the sun-god, notably the Willingham Fen bronze and the Allier clay figures, we noted the phenomenon of the subservient individual, bowed down by the weight of the wheel-god's hand or foot. At Willingham this is represented by a head driven into the ground; the clay figures show a wheel-god with his hand resting heavily on the head of a small humanoid being whose diminutive size clearly indicates a lower status than that of the god. In the monuments depicting the sky-god as a conqueror, this down-trodden person is a major feature. That the sky-god here is at least closely linked with the sun-god is suggested not

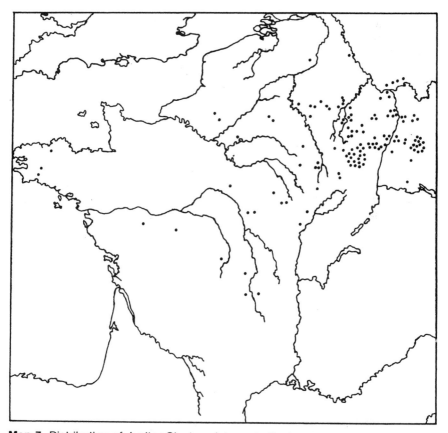

Map 7 Distribution of Jupiter-Giant sculptures in Gaul and the Rhineland: after P. Lambrechts, *Contributions à l'étude des divinités celtiques*, 1942.

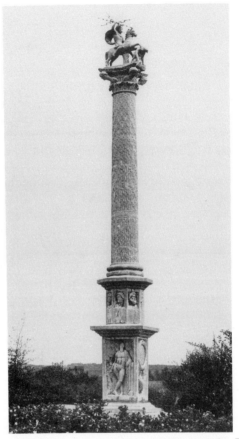

Figure 51 Reconstruction of Jupiter column: Hausen-an-der-Zaber. Württembergisches Landesmuseum, Stuttgart. Height approx. 13–14m. Photograph: Württembergisches Landesmuseum, Stuttgart.

only by the epigraphic dedications which, where they occur, are to Jupiter or his Roman consort Juno, but also through the occasional use by the sky-fighter of a wheel, held as a shield. We will return to this, but first we should introduce the general iconography of the celestial conqueror.

The most common form in which the Celtic sky-god appears as a warrior is on horseback (Figures 51, 52). He is in the guise of a Roman general, driving his horse at a gallop over a hybrid creature, half-man, half-serpent, with a human head and torso but whose legs are in the form of snakes. We know that the god thus portrayed was identified with a sky-god. The sculptured group is only one component of an elaborate, composite monument set up in honour of a celestial deity in the western Roman provinces. Such monuments, about 150 of which are documented, consist, in their complete form,

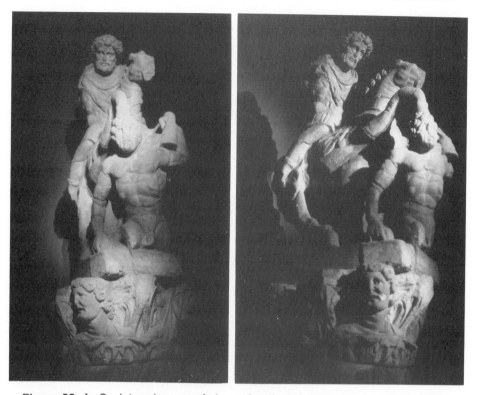

Figure 52a,b Sculptured group of sky-god and earth-giant, from Jupiter column: Merten. Musée Archéologique de Metz. Height approx. 1m 50cm. Photograph: Miranda Green.

of four- and eight-sided bases adorned with Roman divine images and a Roman invocation. Above these, tall pillars, often decorated with foliage or scale-ornament, are clearly tree-skeuomorphs. The scale-pattern, on analogy with iconography on Trajan's Column, imitates tree-bark, and on the column at Hausen-an-der-Zaber near Stuttgart (Figure 51)[263] acorns and oak-leaves specifically proclaim Jupiter's oak as the particular tree represented. The columns are surmounted by Corinthian capitals and it is above these that the horseman rides. A complete monument, as is the case with a pillar from Merten near Metz (Figure 52),[264] may have stood up to 15 metres high. The whole composite structure is a paean of triumph to the sky-god. The deities of the lower stones are often the planetary Roman gods; the column itself not only represents Jupiter's tree, but stretches towards the sky, projecting the image of the sky-god as high into his element as possible. So far, balance and conflation between Roman and Celtic influences may be observed: the dedication and the lower images are Roman; so is the idea of

the oak; but the pillar may have been represented iconographically partly because of the Celtic reverence for sacred trees. None the less, the horseman-group is a symbol which is less familiar to the Roman world. The Roman sky-lord is not equestrian and this horseman, though he may bear Jupiter's thunderbolt, may also carry the Celtic solar wheel.

Before we examine the precise iconography of the sky-conqueror in more detail, we should note the distribution and context of the Jupiter columns. In tribal terms, they appear especially among the Lingones, Mediomatrici and Treveri, in central and eastern Gaul, along the Moselle and both banks of the Rhine. Frequently thought of as monuments pertaining particularly to the military areas, they in fact occur comparatively rarely in the actual frontier area[265] and are infrequent in the forts of the German *limes*. In the Vosges region, the columns often appear on farms and no less than four were erected in the high Vosges sanctuary of Le Donon. They are frequently associated with springs; Cussy in Burgundy is but one example.[266] Where there is dedicatory evidence, Jupiter columns were set up not by soldiers so much as by members of the native population.[267]

Jupiter as a Celtic sky-conqueror appears in two main forms: one is as a horseman, the other depicts a non-equestrian sky-god.[268] In both types, the juxtaposition of sky-god to subservient being is present. The artistic style of the sky-fighter groups may be seen to vary enormously from the very classical to the schematic and Celtic.[269] But in general, they share the feature of the influence of Greek mythology. It seems to have been the Greek theme of the 'Gigantomachy', or the battle between the gods and earth-giants which inspired the iconography of the Romano-Celtic sky-groups. The monster of the equestrian sculptures, with its snake-limbs, appears to represent chthonic forces (Figures 52, 53). But the sky-god himself is equestrian where the Olympian gods are not, and, indeed Lambrechts[270] has questioned the presence of direct conflict between the two elements, observing the detached, uninterested attitude of the god towards his monstrous companion and the usual lack of weapons held by the giant or the god. What seems to have happened here is that the classical iconographic theme was taken and adapted for a Romano-Celtic religious milieu. A further influence on the art-form may have been the auxiliary Rhineland tombstones of the first century AD where a horseman rides down an enemy.

We need, now, to examine the precise symbolism of the Jupiter-Giant groups. The rider himself usually appears in armour, proving his identity as a warrior. He often appears with cloak flying,[271] emphasizing the notion of movement and the speed of his charging mount. His thunderbolt, often of metal to catch the light, is the god's only weapon and proclaims his identification with the Roman sky-god. Unfortunately the sculptures are so often badly damaged and incomplete that it is impossible to judge how frequently the solar motif of the wheel appears. But we know of some sculptured horsemen where the wheel does survive.[272] In all such depictions the

Figure 53 Stone group from summit of Jupiter-Giant column: Neschers. Musée d'Epinal. Height 91 cm. Illustrator: Paul Jenkins.

sky-god carries the wheel as if it were a shield. At Quémigny-sur-Seine (Côte d'Or)[273] the wheel/shield is oval, more like a true shield, but with spokes radiating from a central nave or shield-boss. In a variant on the horseman image, at Weissenhof[274] the sky-god rides over a giant in a *biga* (a two-horse chariot) rather than a horse. The rider himself is frequently in classical style, well-proportioned and realistically portrayed. But there are exceptions: at the remote Donon sanctuary, the sky-god has a Celtic face with almond eyes and shuttered expression;[275] and at Pforzheim in Germany, the rider is carved with an overlarge head and small body, in true Celtic tradition (pp. 206–23).[276] At the other extreme, the Tongeren group[277] shows that the Celtic artist underwent Hellenistic influence in the lively and realistic style.

The group is distinctive, too, in the provision of two giants, back-to-back, who writhe beneath the horse's hooves.

The giant under the rider is iconographically very interesting: its snake-limbs endow the being with a chthonic, earth-linked imagery. The portrayal of an uncouth, earthbound strength is frequently suggested by the massive head and shoulders, braced against the sky-horseman's weight; and the strained, aghast expression of its face demonstrates how intolerable was its burden. We can see this at Köln, on a third-century group,[278] where the giant consists merely of a hunched head and two snakes; at Châtel Portieux (Vosges) and, again, at Neschers (Puy-de-Dôme) (Figure 53),[279] the giant's head is again huge and dolorous. Though the monster is rarely armed, he does occasionally bear a club.[280] What is characteristic of the giant is its relationship to the horse. Certainly in some cases, the monster seems to be flattened or crushed: the Neschers giant is driven into the earth and the Butterstadt rider tramples a giant which is turned to face the thrashing hoofs. But the attitude seems sometimes to be that of support, and at Grand (Vosges)[281] the horse rests heavily on the bowed back of the monster who holds it up. Another group from the same place has a naked *genius*-like figure placed between the front hooves, in place of the giant,[282] and this creature definitely has a supporting role. It holds a sinuous object in one hand, which has been interpreted as a lightning-flash but which could equally represent a snake, thus retaining the serpent element usually associated with the conventional giant.

There are variants of the image of the sky-horseman of the columns, but the two elements of sky-god and chthonic monster remain constant. In a central Gaulish subgroup the horse is missing: at Champagnat (Creuse)[283] and Dompierre (Haute-Vienne)[284] the sky-god has a wheel and monster, but is standing, with no horse present. At Mouhet (Indre)[285] and Tours (Indre-et-Loire)[286] the god, too, has vanished and only the wheel and monster are present. The Mouhet giant kneels, like Atlas, with the weight of the wheel, like the world, on his shoulders. It may be that on these horseless images, the sun-wheel replaces the equestrian motif. There is good evidence[287] that the horse was itself solar, and thus, even without the beast, the celestial element is still present in this central Gaulish group.

The other main group of sky-conquering images consists of depictions of the sky-god dominating a smaller, sometimes snake-limbed, being. An interesting link between this group and the horseman occurs at Luxeuil[288] on a lost relief, where a wheel-bearing horseman holds a small being, thus displaying all possible elements in the sky-fighter's repertoire of imagery. Usually the sky-god stands with his hand on the monster's head: one example is a stone at Merkenich[289] where the sky-god, in military uniform and brandishing a thunderbolt, rests his hand in a dominating, yet paternal, gesture on the head of his earthbound associate who carries a club,[290] like the monster at Dalheim. Some of these sky-gods carry wheels; a stone at St-Georges-de-

Montagne (Gironde) exemplifies the association of sky-lord, small earth-being, and sun symbol.[291] This iconography is of particular interest in that it recalls quite precisely the imagery on the small pipe-clay figures of the wheel-bearing sky-god with small, scroll-legged being by his side.[292] The strain and anguish on the faces of the little beings exactly imitates the sad expression of their stone counterparts and indeed that on the faces of the horseman-giants (Figure 53). But here, the submission of earthly forces is clearly expressed by the small size of the sky-god's companion (in direct contrast to the massive chthonic giant). Seen in this context, the Willingham wheel-god, with his foot on a monster's head (p. 121), springs into sharp focus.

The relationship of the sky-god to the monster is perhaps best interpreted as one of mutual dependence. On the equestrian groups, the horse rides down the giant, a symbol of the dominance of the sky over earth and chthonic forces. Where the horse is absent, this dominance is expressed by the sky-god's hand on the head of his earthbound companion. But the giant or monster has a role to play as an underworld, dark, negative, death-image without which the forces of good, light, and life could not flourish; thus an antithesis of heaven and earth, life and death is expressed. The ambiguity in representation is, I believe, deliberate. Likewise the pillar itself, tree-like, may represent the link between the upper and lower worlds, its roots deep in the earth, its summit reaching towards heaven. What we should remember is that this antithesis and interdependence of positive and negative, life and death, recurs on other sky symbolism. The snake and warrior elements appear at Séguret (p. 118), and the chthonic dimension to the sun-cult may appear on the wheel-decorated tombstones of Alsace (p. 167). The recognition of a deliberate ambivalence between sky-god and earth-being is, I think, crucial in interpreting the exact nature of the association between the two images in the Jupiter-Giant groups.

The theology of the sky-god

The number and variety of stone monuments and small cult-objects which express the popularity of the Romano-Celtic sky-god indicate also the breadth of functions which his cult spanned. The divine entities recognized in such natural phenomena as sky, sun, and storms were given flesh and visual imagery by the adoption of a basically Roman art-form and by equation or conflation between the Roman Jupiter and the previously amorphous Celtic sun- and sky-power. The two main images of sun-god and sky-conqueror suggest that the cult was involved not only with the solar and celestial elements and emanations but with fertility, war, the underworld, and with death. The solar aspect was dominant, and the wheel-sign provided a link between the sun-god and the fighter against darkness. Where the sky-deity is a warrior, he is defending the positive, good, life-force against the powers of darkness, in a manner similar to the struggle of the Celtic Mars

129

against disease and barrenness. We have observed a few cult-objects – the Gundestrup Cauldron, the Willingham and Farley Heath sceptres (pp. 121–2) – which hint at complexity which can never be fully explained. But the elements of sun, sky, weather, fertility, and death imply a seasonal mythology involving the germination, florescence, and apparent death of the seed in the ground: the sun's rays – phallus-like – penetrated the ground, and the rain – the divine semen – fertilized the earth. But most often the imagery is of a flamboyant, high divinity, exulting in his dominance over terrestrial matters, whilst there is recognition that the dark side to life is an essential and interdependent dimension. Like the Roman father-god, the Romano-Celtic celestial image expresses power – to bring to life or to destroy, and to wield the sun, lightning, and storms.

The conflation of Roman and Celtic cult-imagery perhaps reaches its apogée in its expression of the sky-cult. Interestingly, too, the whole spectrum of society is represented: rich and poor; higher and lower echelons; military and civilian. Perhaps more than any other cult, that of the solar/sky-god penetrated and pervaded all aspects of Romano-Celtic society and culture.

Conclusion

The images of male deities in Romano-Celtic Gaul and Britain embrace a wide range of types and functions. The imagery depended, to a very large degree, on Roman art-ideas. Thus, at one extreme, Mercury and Apollo tended to retain their Roman visual symbolism and attributes (themselves, in turn, dependent ultimately upon Greek prototypes). But there were also gods whose identity was born of a true mixture of ideas and art-forms. Thus the Celtic warrior may have had the imagery of Mars, but with alien features and an unwarlike function. The sky-god was perhaps even more of a true blend of Celtic and Roman influences. Some divinities, like Sucellus, swing towards the indigenous element as the main source of inspiration in visual expression, with the principal identifying attribute belonging to native rather than intrusive imagery. Least influenced of all by Mediterranean symbolism was Cernunnos, a native deity through and through, who even transcended the norm of anthropomorphic god-depiction and showed his Celtic bond with nature by his assumption of antlers. The popularity of distinctive and recurrent images – the hammer-god, the wheel-god, Cernunnos – indicates that there was some kind of unity in recognition of the divine, and perhaps in religious observances and ritual as well. What is very striking is the association, in some measure, of virtually all the deities expressed iconographically, with all the basics of human life, human expectations, protection, fertility, and, finally, death and comfort in the afterlife.

5

The symbolism of the natural world

The religious beliefs of the Celtic world had their roots firmly within the concepts of animism and the sanctity of the natural world in all its manifestations. We have already seen – notably in discussions of male and female divine images – that deities were often represented accompanied by animals. Indeed the gods themselves could on occasions be semi-zoomorphic and some, like Epona, depended on beasts for their very identity. Divinities were associated not only with animals but with natural phenomena such as the sun, thunder, water, and trees. We know from inscriptions that divine entities could be identified with places – every mountain and stream was numinous and this is demonstrated by the topographical names of some spirits. This chapter is concerned with the iconography of these natural phenomena for themselves rather than their appearance in direct association with anthropomorphic images. There are two main groups of evidence: the first is animal symbolism; the second is concerned with inanimate phenomena – water, trees, and celestial emanations of which the most dominant is the sun.

The symbolism of beasts

It is certain that animals, whether wild or domesticated, played a crucial role in Celtic beliefs. They appear consistently in imagery from before the Roman period in Celtic lands, either with anthropomorphic divine representations or alone. The status of beasts in terms of divinity is arguable. Some scholars, like de Vries[1] and von Petrikovits[2] believe that some anthropomorphic deities may first have been represented by animals and only later took on human guise. They point particularly to divinities like Epona and Cernunnos, who had very close and specific zoomorphic associations. But I would agree rather with Duval and Thevenot[3] who argue that certain beasts were sacred but were not themselves gods. But the boundary is very blurred: Duval would admit of the divinity of 'unnatural' animals such as the three-horned bull,

and Thevenot[4] makes the point that 'Tarvostrigaranus', the bull with three cranes on the sailors' pillar at Paris (pp. 183–4), must be divine since all the other dedications on the monument are to unequivocal deities.

We need to ask why animals were so frequently depicted in sacred iconography. In the classical world gods were accompanied by animals because of their mythological/legendary or symbolic associations. Thus for the Greeks and Romans animals were seen as a means of extending and enhancing a deity's symbolism. In the Celtic world the iconographic function of animals, whilst similar to an extent, was more far-reaching. The classical Mercury possessed his own identifying imagery (winged hat, *caduceus*, purse) and his accompanying zoomorphic images reflect aspects of his mythology and his function. Thus his tortoise refers to the legend in which Mercury-Hermes invented the lyre using a tortoise-shell; his ram or goat are fertility symbols. But beasts are not essential in identifying Mercury nor, indeed, any Mediterranean god. The Celtic situation was rather different: some Gaulish or British entities relied on their zoomorphic imagery for their identification. The goddesses in particular could be divine 'patrons' of specific animals: deities like Epona, the horse-goddess; Artio, the bear-goddess, and Arduinna, the boar-goddess of the Ardennes. Some male deities, notably the antlered and horned gods, went further and were inextricably intertwined with animal images. Their part-zoomorphic state may reflect transmogrification, the ability of deities (documented in early Irish and Welsh literature) to shift at will from human to animal form.[5]

What seems indisputable is that animals were revered and admired for their particular qualities – whether it was ferocity, speed, sexual vigour and fertility, or simply their beauty and usefulness to humankind. Apart from the closeness of the link between gods in human form and beasts, the frequent occurrence of animals on their own in iconography may mean that they attained greater sanctity than in other contemporary belief-systems. It may mean that beasts alone could represent a god without the presence of the human image always being necessary. The bronze horse at Neuvy-en-Sullias (Figure 63)[6] bore an inscription 'sacred to the god Rudiobus'. The horse was not Rudiobus but it belonged to him and was a suitable image with which to honour him.

The vast majority of Iron Age depictions of animals, for example on metalwork, form part of an integral and essentially abstract design. Their presence may be religious or decorative or both. An exception is the imagery on rock-carvings which we will look at in more detail presently. Here, whilst beasts are schematized, they are represented for themselves. Some metal figurines, too, are animal images *per se*; examples like the seventh-century BC bronze bovid with huge upcurled horns from a cemetery at Hallstatt,[7] or the little stags with immense antlers on the cult-wagon from Strettweg (Figure 56)[8] show a genuine rapport on the part of Celtic craftsmen with their subjects. At the same time, emphasis on horns and antlers demonstrates

that, whether artistically or symbolically, these features were significant. By far the commonest motifs on the reverse of Celtic coins[9] are those of animals – horses, boars, bulls, stags – precisely those beasts which figure most prominently in Celtic cult-imagery. Very occasionally[10] there may be direct links between coin motifs and other religious art; we will see this in examining the symbolism of specific animals.

We are concerned here with the function of animals in religious imagery. Accordingly, it is not appropriate to discuss in detail other evidence for the use of beasts for cult purposes, such as animal sacrifice. This was, in any case, so universal within ancient religions, both in Europe and elsewhere, that examination of the practice in the present context would serve no useful purpose. However, there are one or two specific points which may increase our understanding of how animals were regarded in religious terms. Recent work on animal-bone assemblages in Britain and Gaul[11] has indicated certain patterns and complexities in sacrificial behaviour which may suggest the relative importance of certain animals or particular god-types. Gournay-sur-Aronde was a sanctuary within an *oppidum* of the Bellovaci which yielded enormous quantities of animal debris which falls into two main categories. One consists of the complete skeletons of horses and elderly cattle, with no evidence of butchery; the other of young butchered pigs and lambs. The cattle were interred in pits and Brunaux[12] interprets these deposits as sacrifices to the underworld gods. It is his view that the horses were buried with honour as and when they died naturally. Neither horses nor cattle were eaten. But sheep and pigs were killed and consumed – sacrifices to the gods (but the best portions eaten by the humans). This deliberate choice of pig and sheep for sacrificial feasts is reflected in such other Gaulish sanctuaries as Ribemont and Mirebeau,[13] and in Britain at Hayling Island (Hampshire).[14] In looking at Celtic sacrificial activity from a socio-ethnographic viewpoint, Wait[15] has studied both the purpose and significance of animal sacrifice and has pointed out that, although such practices are common to both ancient and modern peoples, they should be viewed within the context of all kinds of religious offering. To sacrifice an animal is expensive for rural peasants; it represents a loss of valuable material (in terms of meat, hide, bone, milk, and sinew) and is therefore to be regarded as an important activity, perhaps the response to a special event or crisis within the community. Whilst it would be inappropriate to pursue this kind of religious evidence further, it does support the iconographic indications that animals were highly valued. Some were sacrificed, but not lightly, and there would have been a certain interdependence between man and animal. In terms of ritual, the victim of the deity supposedly represented by a beast would have to 'assent' to the killing; propitiation would have to be made. There would be a similar situation in hunting rites. Animals had high status, and because of this their sacrifice in times of need greatly benefited the community. Conversely, it was the duty of both man and the gods to protect and foster their animal companions.

Wild animals and the hunt

For many Celtic cults, the imagery of wild and hunted beasts was important. Thus the characteristic animals of the chase – stags, boars, and bears – are depicted, as well as such creatures as snakes and birds, only a few species of the latter being snared for food. Arrian[16] makes the comment that the Celts never went hunting without the gods. In discussing the male image (Chapter 4), certain deities were noted who were associated with hunting and who seemed to have a dual attitude to animals, as guardians and hunters, in an intimate and mutual bond. The same may be true of such goddesses as Artio the bear-goddes (Figure 10) and Arduinna, patroness of wild boars (pp. 27–8). Like warfare, hunting was, in a real sense, a ritual activity requiring divine aid; religion and hunting are naturally associated. This is illustrated by descriptions in vernacular Celtic literature of the Divine Hunt, where a supernaturally large stag or boar lured hunters into the otherworld;[17] hunters needed the protection of the gods in what was a perilous activity.

Stags and stag-hunting

The Valley of Camonica in the Alps of northern Italy is famous for its sacred rock-carvings, which began in the later Neolithic and continued through the Bronze Age and into the Iron Age Celtic Camunian period.[18] During this last phase, carvings representing stags and stag-hunting predominated, superseding the older Bronze Age cults where the bull and the sun were paramount. The Camunians were great hunters: Camonica Valley is a natural corridor in difficult, mountainous terrain, a pass used by herds of wild beasts in migration or harsh weather. So it was a rich kill-site and consequential source of food for the Camunian Celts.[19] Hunt scenes proliferate on these rocks, and it is clear that wild animals and their capture and the magic of the chase were important in Camunian religion. The hunters themselves are represented as aggressively male, sometimes ithyphallic,[20] and with huge muscles and enormous weapons. Birds are shown snared and animals were trapped and netted or run down by dogs; once caught, the beasts were despatched with spears or axes. On one seventh-century BC stag-hunt, on the great Naquane Rock, an ithyphallic hunter is accompanied by a being who is half man, half stag (Figure 54).[21] This, like the fourth-century portrayal of the antlered human figure from the same place (Figure 35),[22] demonstrates the very intimate link between the hunter and his quarry.

The stag at Camonica Valley is not always depicted as a hunted beast, but is frequently portrayed in association with another powerful Camunian cult-image, that of the sun; indeed over the whole Camunian period, the two themes of stag and sun constitute more than three-quarters of the religious scenes on the rocks.[23] In the Iron Age iconography, there is even ambiguity in stag-sun imagery, where the sun's rays sometimes resemble antlers. Nearly

Figure 54 Rock-carving, perhaps seventh century BC, depicting half-man, half-stag figure with huge antlers: Val Camonica, Italy. Illustrator: Paul Jenkins.

all the stag images at Camonica are of Iron Age date, and the beast may be depicted with enormous spreading antlers like the branches of a tree in the forest which clothed the slopes of the valley. Sometimes the stag is enclosed within a circle of praying or dancing human figures, indicative of the reverence of the community for the stature, speed, and sexuality of their prey.[24]

For its hunters, the stag with its tree-like antlers symbolized the spirit of the forest. It was imbued with fertility symbolism, not only because of its virility, but because the autumn shedding and spring growth of its antlers – again reflecting trees with their falling and reappearing leaves – gave the stag a seasonal imagery. We may recall (pp. 86–96) the antlered god with his removable antlers, perhaps inserted in summer and taken away in winter. Indeed, a large and beautiful bronze stag from a late La Tène hoard (Figure 55), buried at the time of the Roman conquest at Neuvy-en-Sullias (Loiret),[25] has antlers in velvet, demonstrative of its spring image.

Pre-Roman and Romano-Celtic stag images, apart from the Camunian iconography, may imply hunting symbolism. What is probably a ritual stag-hunt is depicted on the seventh-century cult-wagon at Strettweg in Austria (Figure 56) where horsemen and foot-soldiers accompany two small stags, with a centrally-placed goddess presiding over the scene.[26] A third-century bronze group at Balzars in Liechtenstein (Figure 57) comprises two warriors, a boar and a stag.[27] Again we see the over-emphasis on the antlers, noted already at Strettweg, the identifying and important feature of the animal.

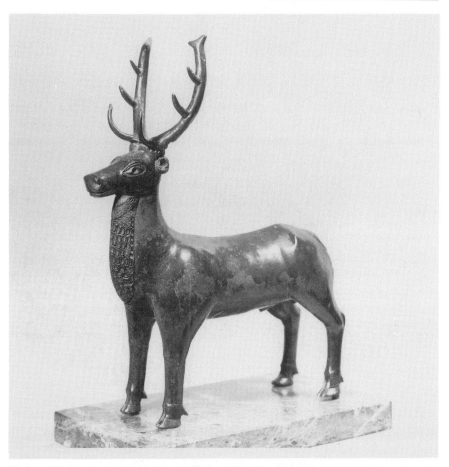

Figure 55 Bronze stag: Neuvy-en-Sullias. Musée Archéologique, Orléans. Height 34cm. Photograph: Bulloz, Paris.

The bronze stag, made in about 100 BC at Saalfelden near Salzburg,[28] may have been portrayed as a hunted beast. On certain Celtic coins the animal appears: thus a stag-head is the main reverse-type on the coins of the Boii,[29] and a Gaulish coin found near Maidstone[30] once again shows huge antlers and an association with the other main animal hunted by the Celts, the boar. In view of the Camunian connection between the stag and the sun, the imagery on a sixth-century gold bowl at Altstetten, Zürich, is interesting (Figure 58): the vessel is decorated with sun and moon motifs accompanied by beasts of which the only identifiable one is a stag.[31]

Romano-Celtic stag-iconography forms two main groups, that associated specifically with woodland and hunting, and images linked to fertility

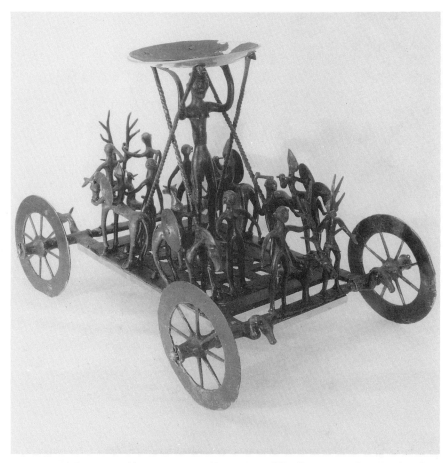

Figure 56 Bronze cult-wagon; seventh century BC: Strettweg, Austria. Landesmuseum Joanneum, Graz. Height of goddess approx. 22.5cm. Photograph: Landesmuseum Joanneum.

symbolism. In North Britain the hunter-god Cocidius was associated with deer and forests (above, pp. 100–3) and, at Castlecary in Scotland, a relief of a stag and three trees[32] evokes similar symbolism. Silvanus Callirius ('woodland king') had a stag figurine dedicated to him at a shrine in Colchester.[33] We have already discussed the Gaulish gods of hunt and forest (pp. 100–3). The larger group of stag images concerns the fertility and prosperity aspect of the stag-cult, seen very clearly (pp. 89–96) in its association with the antlered anthropomorphic god Cernunnos, where it may drink coins from the god's purse at Reims (Figure 38)[34] or vomit money in Luxembourg.[35] We have seen that at Le Donon, the hunter-god armed with the means of killing his companion none the less lays his hand on its head in

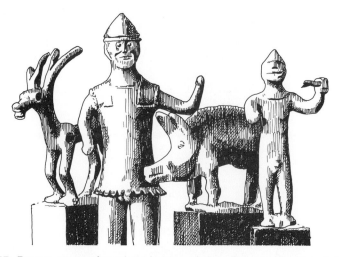

Figure 57 Bronze group of warriors, boar, and stag: Balzars, Liechtenstein. Vaduz, Liechtenstein Landesmuseum. Height of largest figure 12.8cm. Illustrator: Paul Jenkins.

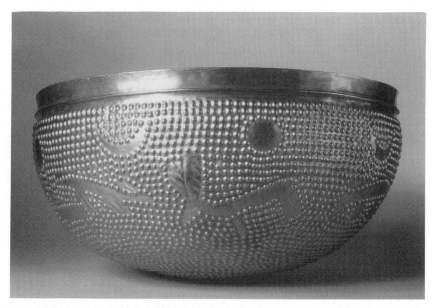

Figure 58 Chased gold bowl decorated with suns, moons, and animals, including stag; sixth century BC. Altstetten, Zürich. Diameter 25cm. Schweizerisches Landesmuseum, Zürich. Photograph: Landesmuseum, Zürich.

blessing: indeed, the god himself is a fertility-god shown with the fruits of the forest he has garnered, as well as the skin of the beast he has slaughtered (Figure 43). The stag embodies a dualistic hunting-prosperity symbolism where the two concepts marry in an interdependent relationship. The divine hunter has a strong bond with his quarry and through the link comes prosperity and well-being for the fertile earth. The Celtic stag epitomized the vast areas of west European woodland in which it roamed. Its image was reproduced in reverence by its hunters, but its qualities of potency and virility gave it added significance as a symbol of the florescence of the forest itself of and abundance in general.

Boars and bears

Both of these creatures were hunted by the Celts. We have little bear-imagery apart from that of the bear-goddess Artio herself (Figure 10),[36] whose image appears with that of her bear on a Romano-Celtic bronze group dedicated to the goddess at Muri near Berne (pp. 27–8). Artio protected bears against hunters and hunters against bears in a dualistic symbolism similar to that of the divine stag-hunters. That Artio was a goddess also of plenty is indicated by her bowls of fruit, one of which she offers to her fierce companion. Artio is known also among the Treveri;[37] and Mercury Artaios – a male patron of bears – was venerated at Beaucroissant (Isère).[38]

Boars possessed prominent and dual symbolism in the Celtic world. They were adopted as images of war, because of their ferocity and indomitability; and they were symbols of prosperity, because pork was a favourite Celtic food and played an important part in feasting. The two images come together in Celtic warrior-tradition, where hero-knights, bragging of their bravery, squabbled over to whom should be awarded the champion's portion of pork at the feast. This tradition is recorded both in vernacular Celtic literature[39] and in the comments of classical writers.[40] The aristocratic link with pork is clear from the rich Celtic graves attesting feasting in the otherworld;[41] and there is abundant evidence for the eating of pork on Iron Age settlement sites,[42] borne out by such Mediterranean observers as Strabo who comments[43] that the Celts loved pork and that Celtic pigs were large and fierce. In Irish legend[44] pork was an otherworld food capable of constant replenishment, like the loaves and fishes of the New Testament parable.

The foregoing indications that the boar possessed a ritual/culinary role is matched by the evidence for the beast as a combative war and hunting symbol. In Celtic vernacular mythology[45] boars were described as a huge, fierce and destructive quarry, luring hunters to the underworld. Helmet-crests in the form of boars, and the boar motifs on war-trumpets and standards proclaim the beast as an admired battle emblem. On the Gundestrup Cauldron,[46] Celtic soldiers appear with just such boar-motifs.

The ubiquity of boar iconography in Iron Age and Romano-Celtic

Figure 59 Bronze boar-figurine: Neuvy-en-Sullias. Musée Archéologique, Orléans. Height 68cm. Photograph: Bulloz, Paris.

contexts suggests its importance as a sacred animal. On its images, the dorsal bristles were frequently exaggerated (Figure 59), in the same manner as antlers on stag images (Figure 56), presumably to emphasize ferocity. We can see this on the Maidstone coin alluded to earlier[47] where boar and stag occur together. The boar, indeed, is a very common motif on Celtic coinage; sometimes it appears as a real beast, but the motif may instead represent a boar-standard carried into battle.[48] The religious significance of Celtic coin motifs is often challenged, but occasionally there may be direct links between coins and other, indubitably religious imagery. This occurs on coins of the Aulerci Eburovices of northern Gaul, where on the obverse is a human head on whose neck is a boar[49] (pp. 104–5). This must surely reflect the same symbolism as that on the image of the late Iron Age boar-god from Euffigneix (Figure 46), a block-like statue of a man wearing a torc, a bristled boar marching along his body (pp. 104–5).[50]

Several bronze boar figures of the Iron Age demonstrate the reverence of the Celts for the wild boar. Typical Celtic features include large ears and elaborate bristles, the latter often in the form of ornamental openwork crests, showing La Tène abstract scrollwork patterns (Figure 60).[51] As Foster comments,[52] the three little boars from Hounslow are 'essential' boar, the image being reduced to essentials – crest, ears, snout, but no tusks. The exaggeration of parts of the image may sometimes be for artistic effect as well as for religious purposes, in the case of the bristles combining ferocity imagery with enhancement of design. Foster believes that most British Iron Age boar-figures are standard-fittings, war regalia rather than cult-images. But my view is that boar symbolism is too important for such iconography to

140

Figure 60 Bronze boar figurine; second or first century BC: Luncani, Romania. Length 10.5cm. Illustrator: Paul Jenkins.

be entirely devoid of religious significance, and in any case, I do not think that one can fully separate the two concepts. The three bronze boars from Neuvy-en-Sullias[53] (Figure 59) are certainly not mere fittings, one is nearly life-size, and they were found in a hoard with a bronze horse dedicated to a god and a large stag-figurine, all buried perhaps to save them from looting at the hands of Roman conquerors and hidden near to a later Romano-Celtic shrine.[54]

The boar remained an active religious symbol during the Romano-Celtic period; indeed its ferocity caused the Romans to adopt it as an emblem for Legion XX, stationed at Chester. The Romano-Celtic boar, in civilian contexts, became perhaps less of a war motif than a hunting image. The bronze depiction of a dying boar from a shrine in Sussex[55] may suggest it was killed by a hunter's hand; and Arduinna of the Ardennes was a huntress.[56] The images of boars and trees on a relief at Netherby[57] and on a British coin of Cunobelin[58] may indicate the forest and the hunt. Apart from Arduinna, we know of other deities associated with the animal: Mercury 'Moccus' (pig) was worshipped among the Lingones,[59] and the Gauls of the Chalon-sur-Saône region[60] revered a god named 'Baco'.

Snakes

These creatures do not generally appear in Celtic iconography on their own but as companions to anthropomorphic divinities. Since this is the case, they were considered in some detail in discussions of male and female divine imagery (Chapters 2 and 4). Nevertheless, it is worth referring briefly to snake imagery in the Romano-Celtic world. Snakes, which possessed a complex symbolism, were generally considered beneficent creatures even though, presumably, poisonous varieties were feared and avoided. In Roman contexts, serpents were protective house-*numina*, and they seem to have had a similar function in Celtic religion. They occur on Celtic coins,[61] sometimes

ram-headed, reflecting later sacral imagery (pp. 92–3), but the bulk of iconography is of Roman date. On stones dedicated to the mother-goddesses in the Rhineland, a snake sometimes appears curled round a tree.[62] It may be that the imagery is that of a sacred tree guarded by a benign but watchful serpent; both emblems have a mutual affinity, since both emerge from the ground and from darkness into light. This dual role of protective beneficence and chthonic symbolism is repeated in the snake's companionship with other Romano-Celtic divinities. Where the snake is associated with the sky-horseman, it is chthonic, but at Séguret near Vaison in Provence[63] the beast is again twined round a tree, in company with the solar warrior. Serpents were health-givers, accompanying such healer-deities as Sirona, Borvo, and Damona;[64] and the ram-horned snake-companion of the Celtic Mars, Mercury, and Cernunnos (pp. 92–3) combines fertility and prosperity imagery with the symbolism of good luck and eternity. The serpent's function as an emblem of well-being may, in part, be due to its practice of sloughing its skin, analogous to rebirth. This may have given rise to its healing and regenerative symbolism. But in its quality of beneficence and chthonicism, the snake in a Celtic milieu performs a very similar role to that of its Mediterranean counterpart. In the classical world, for instance, Mercury was not only a herald and a god of commerce, but he had also fertility associations (hence his ram or goat attribute) and possessed also a function as a leader of souls in the underworld.[65] His *caduceus*, formed of two snakes entwining a rod, was his herald's staff with which he also guided souls to the otherworld after death. Asklepios-Aesculapius, the great healer god of Greece and Rome, had a snake as a regenerative healing but also perhaps as a chthonic symbol.[66]

The birds

The power of free flight gave birds a cult-significance in both Mediterranean and Celtic Europe. In Roman religion, specific birds were adopted as suitable companions for their divinities – Minerva with her owl, Mercury with his cockerel, and so on. Such birds as ravens and doves were considered to possess oracular powers, perhaps because of their distinctive 'voices'. In Celtic contexts, certain birds seem to have been imbued with particular symbolism, a feature which goes back into the pre-Roman Iron Age. Thus Celtic coins frequently depict bird motifs: cranes, ravens, water-birds or cockerels;[67] and a curious type occurring widely in Gaul and found also in Britain depicts a horse with a crow or raven on its back.[68] Whatever the status of animal figures on Celtic coinage, this imagery must surely be religious, and it is suggested that it may represent Badb Catha, the war-goddess of early Ireland, who could change shape from woman to death-crow in battle. Birds play a role in Iron Age Camunian rock-imagery, perhaps possessing an oracular function: sometimes they are depicted in front of a person apparently speaking to the bird, and birds are often associated with temple

images.[69] In the Romano-Celtic period, geese were connected, as aggressive guardians, with the worship of war-gods. But even before the Roman period, the military link was present: goose-bones have been found in Iron Age warriors' graves in Czechoslovakia;[70] and a huge stone goose stood on the temple lintel at Roquepertuse in southern Gaul, a sanctuary which, with its skulls of young adult males – perhaps battle victims – may well have been associated with war-cults. The bronze Celtic war-goddess from Dinéault in Brittany was adorned with a helmet-crest in the form of a goose.[71]

Whilst many different kinds of bird occur in Romano-Celtic iconography, two stand out in terms of their wide-ranging appearance: the dove and the raven, both of which may have possessed oracular symbolism, but only one – the raven – as a carrion bird, has a death-image as well. Depictions of doves occur in many Gaulish thermal-spring shrines, especially in Burgundy. They appear in groups of two, four or six at, for instance, Nuits St Georges;[72] Beire-le-Châtel;[73] and at Alesia.[74] At Forêt d'Halatte (Oise) a human hand holds a dove,[75] and images of birds which may be doves were carried by the stone pilgrims as offerings to Sequana at *Fontes Sequanae* near Dijon.[76] At the healing shrine to Apollo Vindonnus at Essarois (Côte d'Or), two images of pilgrims carry doves as gifts for the god;[77] and far away, at Trier, images of young children hold birds as offerings to Lenus, the healer-god who was especially protective of youth.[78] So in Romano-Celtic sacred contexts, doves were particularly associated with healing. It may be that the link with the healing god Apollo is the reason. He was the classical god of prophecy as well as a healer and, as such, doves may have played a part in this oracular ritual. But as peaceful, loving birds, doves may simply have appeared at these Gaulish sanctuaries as images of love, harmony, peace of mind, and good health. The Roman goddess Venus had the dove as an emblem of love.

Ravens have a reputation, not only as scavenging carrion birds, but as deceitful, cruel, and dangerous creatures.[79] Certainly in early Irish mythology, ravens were associated with goddesses of war and destruction, who had the unpleasant habit of appearing in battle as death-signs.[80] It is demonstrable that ravens and crows possessed chthonic symbolism in the Celtic world, but iconographically they were linked with a number of deities, not necessarily always in a death-role. A raven accompanies the Celtic healer Mars at Mavilly (Figure 25), on a relief depicting a pilgrim with eye-trouble;[81] and it may be that the bright-eyed raven represented clear vision. Alternatively, as an oracular bird, it may have predicted the success (or failure) of the bid for a cure. It seems likely that ravens possessed a dual symbolism of death and rebirth, perhaps because of their ability to 'speak', and were thus considered as 'possessed' by the gods. Thus the raven's appearance with Nantosuelta, Epona and the mothers[82] may reflect this dual role, already observed as typical of the goddesses.

In iconography, it is frequently difficult to distinguish different types of bird and this is especially true of doves and ravens which occur in company

with Celtic deities. Thus the gods with birds on their shoulders at Moux (Figure 45), Alesia and Compiègne[83] could either be ravens or doves. The same ambiguity can be observed in Luxembourg, where goddesses are associated with birds.[84] Birds may have had a complex symbolism in the Celtic world. Their power of flight and their ability to escape from the bonds of earth gave them a mystique which perhaps led them to be regarded as representative of the spirit freed after death and thus linked to the gods and the otherworld. Apart from their association with death, rebirth, healing, and light, there may well have been a seasonal aspect to their imagery: the migratory habits of certain birds may have been recognized, heralding the arrival of summer or winter.

The cults of domesticated animals

Three genera of domesticated beast dominate the imagery of the Celtic world during the Roman period: the dog, horse, and bull.

Dogs

In religious terms, dogs had a complicated role which embraced the three concepts of hunting, healing and death, sometimes inextricably linked one to the other. All three images were closely associated in Celtic, as indeed in Graeco-Roman, religion. Celtic hunter-gods possessed dogs – to aid them in the hunt itself, and as guardian-companions. There was underworld symbolism, presumably deriving from the Mediterranean myths of Cerberus and Hecate. The burial of dogs in archaeological contexts[85] suggests chthonicism, and it is possible that dogs accompany such divinities as Sucellus, Epona and the mothers in an underworld role. Gaulish cremation-graves often contain pipe-clay dogs resembling Anubis – the Egyptian underworld jackal-god.[86] But the imagery of dogs suggests that healing and life may play as important a role as death. Indeed, if we examine the symbolism of the Greek healer-god Asklepios (who had a canine companion), we see that he combined the roles of healer and chthonic deity.[87]

It is as a healing image that the dog appears to have been most prominent in Romano-Celtic symbolism. A number of known healing-deities were associated with the animal. In Britain, the water-goddess Coventina was given a bronze dog as a votive offering;[88] and the healer Nodens, whose great sanctuary was on the Severn at Lydney, was represented by numerous images of dogs, but with no human depiction of the presiding god.[89] The animal appears at many of the great Gaulish healing shrines: at the sanctuary of Apollo and Sirona at Hochscheid, a dog is the companion of a seated goddess represented by small clay figures;[90] and a dog accompanies the Celtic healing Mars and his blind pilgrim at Mavilly.[91] At Sequana's shrine, images of pilgrims bear dogs as offerings,[92] and this is repeated at Tremblois in the

Figure 61 Stone sculpture of infant in cot, with dog curled on top: curative sanctuary at Sainte-Sabine. Beaune, Musée des Beaux-Arts. Length 25.5cm. Photograph: Miranda Green.

same region.[93] A charming image of a baby in a cot at the curative temple of Ste-Sabine in Burgundy portrays the child with a small pet dog curled up on its body (Figure 61).[94] This association between dogs and healers is very close to Graeco-Roman religious concepts: live dogs sacred to Asklepios were kept in temple precincts, and inscriptions at the god's shrines both at Epidauros and Rome attest miraculous cures by the sacred beasts. Their saliva was considered highly beneficial in the curative process[95] (and it might be recalled from the New Testament that Christ healed eyes with his own spittle, as if saliva itself was efficacious in therapeutic ritual activity).

The animals which accompany many deities, such as the hammer-god, Nehalennia (Figures 2, 4) and the mothers, are probably to be considered as house-dogs, man's faithful companion and protector in the home or on the

hunt, like the hound of Odysseus. Von Petrikovits[96] points out that such dogs are benign, alert, and friendly creatures, not the hell-hound of Hades. He comments that some canine companions of the mothers have a small bell or *bulla* round their necks, similar to that worn by Roman boys to signify their youth. It may be that dogs particularly guarded women and children; some of the pilgrims carrying dogs at Gaulish thermal shrines are young. If dogs do possess chthonic symbolism in Celtic contexts, then they are probably beneficent images of rebirth, allied to their healing role, rather than sinister guardians of the underworld.

Horses

The horse was revered by the Celts as a precious animal in daily life. It was crucial to the Celtic way of life, being important as a prestige animal associated with the nobility. It was a warrior's beast, used in cavalry and chariot-fighting; and it played a prominent role in the civilian economy. Thus the creature's secular importance endowed it with reverence, sanctity, and supernatural symbolism, it was admired for its beauty, strength, speed, and sexual vigour.[97] So it is appropriate that the horse should have found a significant niche in religion and in iconography.

There is substantial evidence for horse imagery in Iron Age contexts. Its occurrence at the pre-Roman sanctuaries of southern Gaul is probably as a war-symbol: at the shrine of Mouriès (Bouches-du-Rhône), schematized incised figures of horsemen and horses form the bulk of the imagery. The supernatural character of the horse here is suggested by one image of the animal with horns – and three of them at that.[98] Roquepertuse, another sanctuary in the same group, has produced a frieze of four incised horse-heads in profile (Figure 62).[99] A lintel at the Nâges (Gard) sanctuary is decorated with alternate trotting horses and human heads;[100] and at nearby St-Anastasie a third-century BC helmeted stone bust of a warrior bears a frieze of incised horses below his neck.[101] These Celto-Ligurian shrines, with their evidence for warrior-figures and for ritual involving the severed heads of adult men,[102] are indubitably war sanctuaries, and the horse image is present as a fighting animal.

Other pre-Roman Celtic iconography features horses: at Val Camonica, a fourth-century rock-carving portrays an ithyphallic horse;[103] and horses are the most common animal on Celtic coins. Where the sex of the animal may be distinguished on coinage, the representations are generally of mares, though stallions do occur,[104] and this may reflect later symbolism where the horse, in company with Epona, is a fertility-cult animal and a mare. The choice of the horse on Celtic coins, in my view, is only in part due to the copying of iconography from Macedonian prototypes; the horse remained as a dominant image over three centuries, and this may reflect its significance.[105] Occasionally the horse depicted on coins has horns,[106] mindful of the beast's elevation to the same overt supernatural status seen

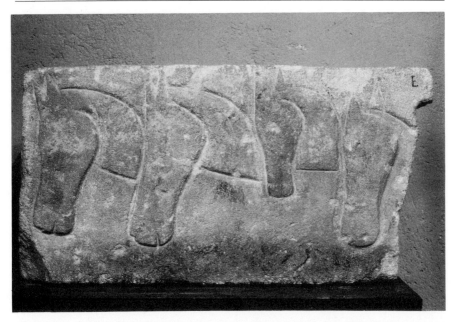

Figure 62 Stone with incised horse-head profiles; sixth century BC: Roquepertuse sanctuary. Marseille, Musée Borély. Height 32cm. Photograph: Miranda Green.

at Mouriès. The later Romano-Celtic cult-association between horses and the sun is perhaps reflected earlier on Celtic coinage where the sun and horse are prominent.[107]

Iron Age ritual often involved horses: at Gournay, complete horses were interred, perhaps simply representing similar honourable burial to that accorded human beings.[108] Quartered horses formed part of the ritual at the sixth-century BC cave-site known as Býčiskála in Czechoslovakia;[109] and there is abundant Iron Age and Romano-Celtic ritual involving the bodies of horses.[110] A possible aspect to horse-ritual concerns the heads of horses which have been found in rivers at the same places as weapon-offerings,[111] maybe reflecting the war imagery of southern Gaul.

The iconography and ritual of horses becomes more prominent in the Roman period where they were associated with several divinities, particularly those with solar, healing or war functions. Indeed, sometimes these concepts became intertwined. Horses, like other animals, were revered for their qualities and were adopted as sacred to certain gods. A bronze figure of a horse from Neuvy-en-Sullias (Loiret) (Figure 63) was dedicated to 'Rudiobus', with an inscription 'Augusto Rudiobo sacrum. . .',[112] indicating that the image was an offering appropriate for this deity; but we have no image of Rudiobus himself. The Celtic war-god was frequently represented as a horseman; and the Celtic sky-warrior also appeared on

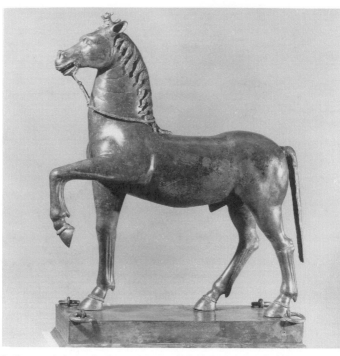

Figure 63 Bronze horse, dedicated to Rudiobus: Neuvy-en-Sullias. Musée Archéologique, Orléans. Photograph: Bulloz, Paris.

Figure 64 Relief of mare and foal: Chorey. Beaune, Musée des Beaux-Arts. Maximum width 30.5cm. Photograph: Miranda Green.

horseback. A small horse or mule dedicated to 'Segomo',[113] from Nuits St Georges, may be associated with a Celtic Mars: Mars Segomo is recorded at Lyon[114] and elsewhere. The link between horses and Celtic warriors and sky-gods may be solar: the sky-fighter was often depicted as a solar horseman, and we may recall the pre-Roman association between the sun-god and horses on Gaulish coins. The site at Nuits which produced the Segomo horse also produced pipe-clay images of horses and horsemen, similar to the Belgian examples at Assche-Kalkoven,[115] of which some have moon-signs or *lunulae* suspended from their collars, indicative of celestial imagery. But Nuits was a curative-spring sanctuary, and there is abundant evidence for a connection between horses and healing, maybe because of the involvement of the Celtic Apollo, a great healer, but also a charioteer and a sun-god. One Burgundian thermal sanctuary at Sainte-Sabine was dedicated to Apollo Belenus – a Celtic surname meaning 'bright' or 'brilliant',[116] and here the image of the god is associated with clay horse-figurines.[117] Horse figures appear at the healing shrines of Forêt d'Halatte (Oise)[118] and at *Fontes Sequanae*, where wooden effigies of horses[119] may have been offered to Sequana either in hopes of a cure for real animals or as an offering appropriate for the goddess. Closely linked with healing and regeneration was fertility, and the Burgundian reliefs of mares suckling foals at Cissey and Chorey[120] show horses in direct reflection of fertility imagery (Figure 64). These portrayals are themselves linked to the cult of Epona the horse-goddess whose Burgundian iconography often consists of the deity seated on her mare who suckles a foal. The importance of horses in secular life is amply reflected in its religious symbolism: it was sacred to sun-gods and divine warriors; and it was an image of fertility and healing.

Bulls

There are two major strands to the symbolism of the bull: one is the strength, ferocity, and virility imagery associated with the untamed (and uncastrated) bull itself; the other is the sheer power and agricultural importance of oxen. The European iconography of bulls goes back before the Celtic era: at the Bronze Age sacred site of Mont Bego (Alpes Maritimes) near the Italian-French frontier[121] bull or ox motifs were the dominant images in a cult involving both the docile working ox and the savage bull, perhaps linked with weather-cults, as is the case with other ancient (notably oriental) religious systems.[122] Oxen are also the dominant symbol in the Bronze Age phases at Camonica.[123] Later Bronze Age Urnfield cultures of central Europe and the succeeding Hallstatt phase made extensive use of bull iconography;[124] and it continued into the European Iron Age (Figure 65). Apart from such isolated bull-figures as that at Weltenburg near Munich, dating to the late first millennium BC,[125] bulls appear on Celtic coins, and the celestial symbolism associated with bulls in the East is perhaps reflected in coin images of bulls with moon-signs between their horns.[126] The horns of a bull are in themselves

149

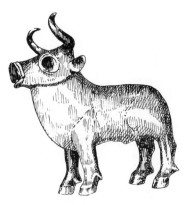

Figure 65 Bronze bull figurine; (?) sixth century BC: Býčískála Cave, Czecho-slovakia. Naturhistorisches Museum, Vienna. Height 11.4cm. Illustrator: Paul Jenkins.

reminiscent of the crescent moon. Bull-head bucket-escutcheons of the Iron Age and Roman period are not simply decorative but, like fire-dogs with their bull-head terminals, have a symbolic meaning, perhaps linked to concepts of hospitality and ritual feasting.[127] There is substantial evidence for Iron Age ritual involving cattle burials and sacrifice. Brunaux[128] suggests that, at the Bellovacan sanctuary at Gournay, cattle were buried in old age as offerings to the chthonic gods. The entrance to the shrine was guarded by flanking bull- or ox-heads (found in the ground, but perhaps originally nailed to gate-posts), as apotropaic symbols. There is plenty of other evidence for the sacrifice of bulls.[129]

In the Romano-Celtic period, bulls became associated with specific cults and divinities. In Graeco-Roman religion, the sky-god Zeus/Jupiter was traditionally associated with bulls,[130] perhaps as weather symbols reflecting the roaring and stamping of an angry beast. In a Celtic context, the sky-god on the Willingham Fen sceptre-terminal, with his solar wheel and Jupiter's eagle, is accompanied by the head of a bull, its Celtic character demonstrated by its third horn.[131] The Celtic bull as a fertility and prosperity image is seen in Gaul at Reims (Figure 38)[132] and at Saintes,[133] where Cernunnos is accom-panied by bulls; and at Turbelsloch, where a stag coughs up money, joined on the relief by a bull and a god bearing a *cornucopiae*.[134] Bulls are linked with healing in such curative shrines as Tremblois;[135] Forêt d'Halatte;[136] and *Fontes Sequanae*,[137] where wooden bull figures were offered to Sequana.

That the bull was admired and revered, both on account of its savagery and its usefulness in economic terms, is suggested not only by the appearance of bull images *per se* but also by the adoption of bull-horns for deities (pp. 96–9). Magico-divine bulls run rampant through early Irish mytho-logy,[138] where they indulge in the transmogrification activities so beloved of

the divine beings of early vernacular Celtic literature. Indeed such shape-changing may be reflected iconographically in such composite objects as the bucket-mount at Thealby (Lincolnshire) where a bull's head is surmounted by that of an eagle; and a similar escutcheon from the river Ribble (Lancashire) where bull, eagle, and human head are combined.[139] The association of bull and eagle imagery recalls the link with the sky-god alluded to earlier. The magic and power of the bull pervaded the Celtic conscious-ness. The Ulster Cycle of early Irish prose-tales[140] informs us that cattle-rearing and raiding were endemic to Celtic society; and in Gaul, tribal and place-names[141] reflect the significance of the animal in the Celtic world.

Trees, water, and the sun

A feature of Celtic beliefs, held in common with those of many ancient and modern pre-industrial societies, was an intense awareness of and and reve-rence for the powers of the natural phenomena which surrounded them. There were literally hundreds of topographical spirits bound to particular localities, evidenced by epigraphic dedications. Usually these are not represented in imagery though, as we have seen, certain mother-goddesses could possess epithets linking them to specific places. We do have some iconographical evidence for tree symbolism and for cults associated with water; linked to the latter was a deep veneration of the firmament of which the most dominant feature was the sun.

The sanctity of trees

The Celtic word 'nemeton' refers to the presence of a sacred grove. The term appears in derivative form in Celtic place-names: 'Drunemeton' was a sacred oak-grove in Galatia (an area of Asia Minor settled by the Celts in the third century BC).[142] Tacitus[143] speaks of the groves of Anglesey as the last Druidic stronghold against Rome; and Dio comments on the sacred wood in which sacrifices to a British war-goddess Andraste were perpetrated.[144] There were grim sacred forests in southern Gaul, sprinkled with the blood of human sacrifices.[145] There was a Celtic goddess Nemetona ('goddess of the grove'), worshipped in Britain at Bath[146] and in Gaul.[147] Tribal names, too, indicate the close rapport between Celtic peoples and trees: the Eburones derive from the word for yew-tree, and the Lemovices were the people of the elm.[148] We know of a place called Biliomagus which may mean 'the plain of the sacred tree'.[149] Incidentally, we should note that sacred groves were not confined to the Celtic world; they were present in Italy as well; Cicero[150] in a Roman context comments that there should be shrines in the cities and groves in the countryside.

There is archaeological verification for ritual involving trees. Two large sacred enclosures, the Goloring and the Goldberg in Germany,[151] both date

to the sixth century BC; in the centre of each was erected a huge central post, the cult-*focus* and maybe imitative of a living tree. The same pattern of pre-Roman ritual activity can be observed at a third-century Czechoslovakian enclosure at Libeniče;[152] and at the La Tène site of Bliesbruck (Mosel), over a hundred sacred pits filled with votive objects had been planted with tree-trunks or living trees.[153] In Britain, at the pre-Roman temple of Hayling Island,[154] a central pit held a ritual post or stone; and a similar feature was observed at Romano-Celtic Ivy Chimneys in Essex.[155] In fact there is abundant archaeological evidence for the use of timbers, upright stones (perhaps skeuomorphs of trees), or trees themselves as cult-*foci* in Celtic sanctuaries.

In Celtic iconography, trees very frequently accompany other images, often those of identifiable divinities. Plants and trees are common motifs on Celtic coins, though they are generally formalized and may possess no specific religious symbolism. The concept of wild forest is perhaps reflected on a British coin of Epatticus which figures a boar beneath a tree,[156] recalling a Romano-Celtic relief at Netherby in Cumbria;[157] and trees may often be found as background to Celtic religious reliefs. The bear accompanying Artio stands under a tree,[158] and the Romano-Celtic solar warrior-god appears with a tree, snake, and eagle at Séguret in Provence.[159] The cult of the mother-goddesses, especially in the Rhineland, has a tree association: here the sacred precinct of the Matronae Vacallinehae at Pesch had a sacred tree as a cult-*focus* and, on a number of reliefs of the Germanic mothers, trees are present, sometimes (as at Köln and Bonn) with a snake curled round the trunk (Figure 66).[160] It is suggested that the snake guards the tree, which is therefore itself numinous, and von Petrikovits cites Mediterranean imagery where snakes protect trees. Where the trees on this Rhineland imagery are distinctive, they are usually oaks, as are those on the British boar/tree iconography alluded to earlier (pigs love acorns, and Polybius[161] mentions the importance of oaks and acorns in animal husbandry). The sky-god at Séguret is a Romano-Celtic version of Jupiter, to whom oaks were sacred; and the Jupiter column at Hausen near Stuttgart was clearly a skeuomorph of an oak, being decorated with oak-leaves and acorns.[162] Allusion has already been made to the tree imagery of the Jupiter columns.

The oak seems to have possessed a special sanctity in Celtic belief: most of the immediately pre-Roman wooden images at the sanctuary of *Fontes Sequanae*[163] are made of oak heartwood, though other trees on the Châtillon plateau were available. The Druids had an especially close link with oaks, and we know from Pliny[164] that they were involved in a feast ritual which concerned oaks, mistletoe, and the sacrifice of white bulls. The parasitic growth was considered especially efficacious for curing barrenness and disease when found on oak-trees. We must remember, too, that the very word 'druid' is derived from the Celtic word for oak. The prominence of oaks in religion – whether of Mediterranean or Celtic origin – is entirely

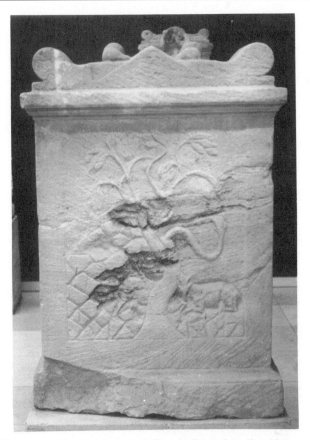

Figure 66 Tree carved on reverse of altar dedicated to the *Matronae Aufaniae*: Bonn. Rheinisches Landesmuseum, Bonn. Base width 1m 1cm. Photograph: Miranda Green.

understandable: often huge and of great age, they must have epitomized life itself. As towering giants, they were appropriate as trees belonging to Jupiter and Zeus or their Celtic celestial counterpart. Oaks typified the forest with its rampant growth and were thus the trees of hunters and of the fertility deities.

But other trees were sanctified in the Celtic world: people living in the Pyrenees dedicated altars to 'Fagus' (beech-tree),[165] and at Croix d'Oraison in the same area, a crude incised bust of a man may possibly represent Fagus personified.[166] This mountainous region produced also a cult of a god of 'six trees'.[167] In southern Gaul the most sacred trees appear to have been conifers, perhaps the most dominant species in that area: at Glanum in Provence an uninscribed altar was carved with the image of a conifer or palm (Figure 67).[168] But it is again the Pyrenees further west which have produced the most abundant evidence for conifer imagery: a number of small,

153

Figure 67 Altar decorated with tree symbol: Glanum. Musée des Alpilles, St-Rémy-de-Provence. Photograph: Miranda Green.

locally-made altars were ornamented with conifers, often combined with such images as swastikas, usually taken as being sun-wheel derivatives, or concentric circles, which were also solar.[169]

This kind of tree imagery is probably present, at least partly, as fertility symbolism. We have seen that the Germanic mother-goddesses were sometimes associated with trees; and we have the British link between mother-deity and conifer at Caerwent, where a seated goddess was depicted grasping a conifer (Figure 14).[170] With their roots deep underground, drawing up nourishment for their flamboyant growth, the florescence of trees would be a natural symbol of the earth's abundance. But tree symbolism was perhaps more complex: there may have been a seasonal imagery in the behaviour of deciduous trees in winter and summer. Even more powerful, perhaps, was the observed link between the upper and lower worlds. Trees have their roots

deep below earth, and their trunks soar skywards, their topmost branches apparently brushing against heaven itself. Just as mountains were sacred to many ancient peoples[171] because of their height and their underground beginnings, so trees likewise bridged the space between the firmament and the underworld. This may, indeed, be the significance of the image of a large tree carried by soldiers on the Gundestrup cauldron. Here, maybe, the Tree of Life was carried into battle for good luck and to pave the way into the otherworld.

The symbolism of water

Water in all its forms was venerated in the Celtic world. The special properties of rivers, lakes, springs, and rain were acknowledged as resulting from their sanctity and numinosity. Water is a life-source and a means of cleansing. Pure spring-water could heal disease, and the genuine mineral, curative qualities of some springs were recognized and revered then as now. Water symbolized the means of both physical and spiritual purification. There was a cyclical image of water falling from the sky as rain (the gift of the sky-god), being absorbed by the earth and emerging as springs; thus there was an immediate link between upper and lower worlds, sky-deities and fertility and chthonic powers. Water could cause life or death; it could heal or destroy. In its ability to reflect light, it seemed to glow with its own luminosity. In its flowing, bubbling or cascading movement, its murmuring, chuckling, or roaring, it was apparently possessed of independent life and spirit.

The main *foci* for Celtic water-cult practices in the Romano-Celtic period were provided by springs. There is some evidence for pre-Roman cult-activity. Thevenot[172] noted the probability that Gaulish springs were venerated in the Neolithic and Bronze Age; and some spring sites, like Duchcov in Czechoslovakia,[173] belong to the very early Iron Age. But the end of the free Celtic era and the onset of the Romano-Celtic phase saw a great upsurge in religious practices centred on sacred curative springs. Substantial shrines were established and visited by huge numbers of pilgrims.

Allusion has been made elsewhere to some of the healing-spring deities. Here it is interesting to look at the divine beings who were specific personifications of the thermal sanctuaries. We should bear in mind that such personification of water was something common to the Mediterranean and the Celtic world. In Britain, the major shrine of Sulis Minerva at Bath produced a great deal of iconography, but the presiding goddess appears in Roman guise as Minerva. Only the temple pediment with its male, very Celtic 'Gorgon' head[174] and its long flowing hair could be taken for a definite water symbol, and the physical expression of this being owes something to solar as well as to aquatic imagery. At Carrawburgh in Northumberland, the personification of the holy spring was called Coventina, an indigenous Celtic spirit who, curiously, turns up very occasionally elsewhere, in Gaul and

Spain. At her north British sanctuary, Coventina was represented both as a single water-goddess and as a triple nymph, appearing in the semi-nude guise common to water-nymphs throughout the Roman empire. But the style of her images is Celtic, with little attention paid to realistic proportions or anatomical accuracy; her physiognomy is rudimentary and her hair depicted in stylized strokes. In the triple image, Coventina's water symbolism is indicated by her beaker and her overturned pitcher with water pouring from it. On the single image, the goddess waves a water-lily leaf and reclines on waves; her left arm rests on an upturned jug of water.[175] This triplism recurs at Unterheimbach in Germany, where three half-naked nymphs, perched on rocks, hold reeds, the symbolism here enhanced by a frieze of sea-horses above them.[176] We have no name for the German nymphs, and it is possible that they are classical water-spirits rather than local Celtic entities. The thermal establishment at Fumades (Gard) in southern Gaul produced similar triple images of semi-clad nymphs. Their long flowing hair simulates water and the goddesses hold vessels in the shape of scallop shells.[177] On one altar[178] they are accompanied by the goddess of the spring, reclining – like Coventina – with her elbow on an urn pouring water. The fertility symbolism of the sanctuary is suggested by an image of three goddesses of whom one has a *cornucopiae*, and the two flanking women dip their hands into a bowl of water held by their central companion.[179] With all these water-spirits, it is difficult to interpret them as specifically Celtic rather than Roman divine beings from their imagery alone. There is strong Mediterranean influence in their iconography, but the chances are that, as is definitely the case with the Celtic Coventina, they are indigenous personifications of local holy springs.

There were other divinities whose imagery links them directly with spring-water. The sanctuary of *Fontes Sequanae*, situated in a valley within the Châtillon plateau north of Dijon in Burgundy, produced a bronze image of Sequana, goddess of the Seine, sailing on a duck-prowed boat (Figure 16).[180] At the curative thermal sanctuary of Néris-les-Bains (Allier) a god with a ram-horned serpent is accompanied by a nearly-nude goddess, the Nymph of the spring (Figure 21);[181] and in the ruins of the baths at Vertault[182] an altar depicts a bearded god of the spring with a flowing urn held over an altar, associated with the symbolism of the hammer-god; we have noted already that Sucellus was linked with the curative water-cult.

The iconography associated with the Celtic spring sanctuaries of Gaul tells us more about the pilgrims who visited them in hopes of a cure from their afflictions than about the presiding deities. Many Gaulish thermal shrines produced wooden or stone votive images of whole pilgrims or of parts of their bodies needing to be healed, that were offered to the spirits of the spring (Figure 68). Examples of such offerings include those from Chamalières;[183] Luxeuil;[184] Pré-Saint-Martin[185] and Essarois.[186] But one of the richest and most informative sites is at the Sources de la Seine sanctuary (*Fontes*

Figure 68a,b Altar with incised votive limbs: Glanum. Musée des Alpilles, St-Rémy-de-Provence. Height approx. 17cm. Photograph: Miranda Green.

Sequanae) dedicated to Sequana the goddess of the Seine at its source.[187] Here pilgrims and their ailments were first represented in wood in the immediate pre-Roman period, when the shrine was initially established, and it is these two hundred oak images which provide a fascinating insight into the hopes and fears of a simple rural population (Figures 69, 70). In the succeeding Roman phases, the shrine was substantially expanded, and stone took the place of wood as the main medium for iconography. The name of the goddess, Sequana, is recorded on dedications and votive objects.[188]

The images of Sequana's suppliants give us an idea of how Celts represented themselves and of the diseases which plagued them. Many pilgrims were dressed in a distinctive heavy-weather hooded cloak (Figure 69), the 'bardocucullus',[189] perhaps reflecting the outdoor livelihood of ordinary people – hunting, travelling, mule-driving, or farming. The devotees were frequently portrayed carrying symbolic offerings – a

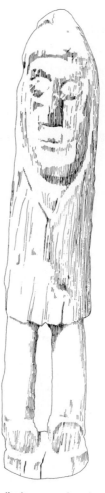

Figure 69 Wooden image of pilgrim, wearing *bardocucullus: Fontes Sequanae.* Musée.Archéologique de Dijon. Height 47cm. Illustrator: Paul Jenkins.

favourite dog (a dualistic image of both gift and healing-symbol) or a purse of money. Images reflect the presence of children and babies as well as adults; and even horses and cattle are represented. In addition to the complete images of supplicants to her shrine, Sequana was offered depictions of parts of bodies: limbs, eyes, internal organs, and genitals – all in the hope that such symbols of suffering would generate reciprocal healing of the part portrayed. Eye-troubles are recorded in the numerous eye models dedicated to the goddess (Figure 74), and some of the carved heads also indicate eye-disease and blindness (Figure 72). Interestingly, we know that

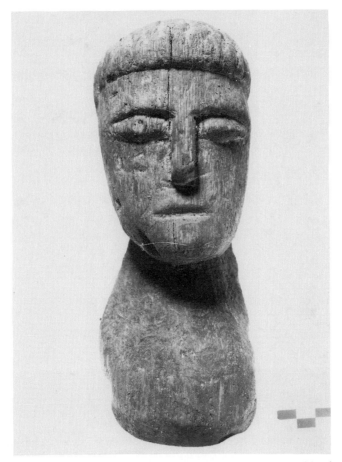

Figure 70 Image of (?) blind pilgrim, wood: *Fontes Sequanae*. Musée Archéo-
logique de Dijon. Photograph: Musée Archéologique de Dijon.

empirical eye-medicine was practised here: the presence of occulists' stamps
attests that doctors as well as priests helped the sick – or perhaps the two
professions were sometimes combined. The small bronze plaques represen-
ting eyes or breasts are interesting in that it is often impossible to tell which
are which, as though they were made to be interchangeable, depending on
the pilgrim's particular problem (Figure 74).

There are some curious and distinctive features in the iconography.[190]
Multiple heads or limbs express the hope that the intensification of an image
might make the plea for help more effective. Stone feet are represented with
a sponge full of water pressed against the heel, as if to reflect damage to the
Achilles tendon which could be cured by the touch of sanctified water. There
are strange images of thoracic cavities, open or closed, which perhaps record
the presence of respiratory diseases – asthma, bronchitis, or pneumonia. On

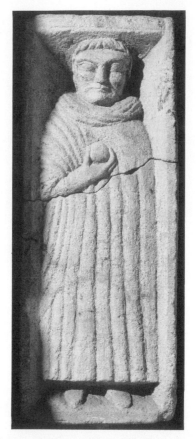

Figure 71 Stone sculpture of pilgrim with fruit offering: *Fontes Sequanae*. Musée Archéologique de Dijon. Width 30cm. Photograph: Miranda Green.

the wooden offerings particular attention was paid to the head, either because of the need to represent eye afflictions accurately or because the identity of the suppliant was important – but devotees were rarely named.

When a pilgrim entered the precincts of the sanctuary, he performed his primary ablutions in order to purify himself at one of the canalized springs. He stopped before the little shrine at the edge of the precinct, praying to Sequana to accept his supplication. Either at this point or later on he deposited the image of himself or his illness which he had purchased at a temple shop. Some offerings were found grouped in a semi-circle around a sacred pool. It is likely that the offerings were periodically cleared to make room for new ones. After the pilgrim had washed himself and had dedicated his image, he went to the sacred pool near the main temple to immerse himself and thus be further purified. Then he proceeded to a long portico or

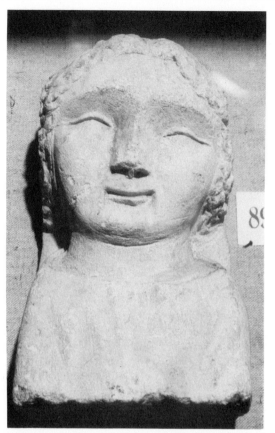

Figure 72 Stone image of blind girl: *Fontes Sequanae*. Musée Archéologique de Dijon. Height 19.5cm. Photograph: Miranda Green.

dormitory for the healing sleep during which he hoped for a dream, vision or revelation, the moment when the goddess inspired and healed him. It says much for Sequana's power that *Fontes Sequanae* grew up and flourished round a spring whose water possessed no genuine medical properties but was only a source of fresh pure water.

Rivers and lakes were also venerated and were the centres of cult-activity, though not specifically associated with healing. Rivers gave life along their route. Confluences were especially sacred: the conjunction of two waters was especially efficacious and full of the life-force.[191] The names of rivers may reflect their sanctity: the Marne means 'mother';[192] and we know of many rivers which were venerated: Verbeia – the river Wharfe in northern Britain; Souconna – the Saône at Chalon;[193] Ritona – a Treveran goddess of fords,[194] and many more. Rivers, like the earth, played the role of receptacles

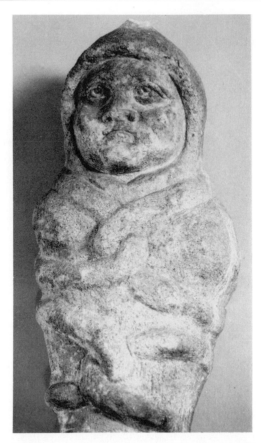

Figure 73 Stone image of hooded infant: curative sanctuary at Ste-Sabine. Beaune, Musée des Beaux Arts. Length 33cm. Photograph: Miranda Green.

for offerings.[195] The cult of the Thames, into which rich goods were cast as offerings as early as the Bronze Age, was probably centred on regular crossing-places.[196] In terms of images of river-gods, indigenous Celtic spirits were represented in a manner very similar to Mediterranean water-deities. The seated stone goddess at Gissey-sur-Ouche[197] is a naturalistic river-spirit who would be as much at home in Italy as in Celtic Gaul. More native in iconography is the relief at Autun[198] where a god with a trident stands on a water-like surface, accompanied by a spear-bearing goddess. The presence of a dog and a snake may represent the chthonic origins of the river or stream personified by the divine couple, though the snake may itself reflect the sinuous, rippling surface of running water. Though lakes were very sacred to the Celts, they were not generally personified iconographically. Like rivers, they were places in which offerings were made to the gods. Deep water

Figure 74 Bronze eye/breast plaques: *Fontes Sequanae*. Musée Archéologique de Dijon. Length of middle plaque 4cm. Illustrator: Paul Jenkins.

provided access to the lower world, and offerings cast in were thus rendered inaccessible to mortals and became inviolable.[199]

Before leaving water symbolism, we should look at the apparently curious association between water and the sun, a natural power perhaps even more sacred than water, as we will see presently. There is a natural, visual link between the sun and water, in terms of light itself and the light-reflective properties of a water surface. But there was a deeper symbolic association between the sun and the healing thermal shrines. The link is a complicated and interactive one: the classical Apollo was both a healer and a god of bright light and the sun; he took both these characteristics with him to the Celtic world, for instance as Apollo Belenus ('brilliant Apollo') at such healing sanctuaries as Ste-Sabine.[200] At Essarois also in Burgundy, the healing shrine was dedicated to Apollo Vindonnus, whose Celtic surname reflects clarity of light and whose image on his temple pediment was that of a radiate sun-god.[201] Votive figures and model eyes indicate the presence of eye-troubles, and it is probably no accident that appeal was made to a god who symbolized both clarity of light and vision and of pure translucent water. A similar juxtaposition of healing water and sun symbolism occurred at Luxeuil[202] where Luxovius, a god of light by his name, presided over a spring-shrine where the solar sky-horseman was also venerated.[203] Sun and water are again linked at Lhuis (Ain) where healing mother-goddesses, personifications of a local stream, shared a sanctuary with the solar god represented by a wheel-decorated altar.[204] Solar-wheel models were cast as offerings into such rivers as the Oise and Seine, and were dedicated to the gods of such therapeutic establishments as Bourbonne-les-Bains.[205] Two points serve to clarify

this association between the sun and thermal curative sanctuaries: one is that the sun and water both promoted fertility and thus regeneration – a concept close to healing, and an association which we find with the mother-goddesses (pp. 32–8). The other concerns heat itself; the sun is the source of all warmth, and many of the Celtic sacred springs were hot.

Finally, in alluding to the religious connection between the sun and water, it is interesting to note the observations of St Vincent, a martyr who commented upon pagan cults in Aquitaine at the beginning of the fourth century AD.[206] He apparently witnessed a custom which involved rolling a flaming wheel down to a river, where it hit the water and was then removed and reassembled in the temple of the sun-god. There is cyclical imagery here: the solar sign is sent to fertilize the earth and is taken back into the sky to light and warm the world.

The power of the sun (Map 6)

Long before the Roman occupation of north-west Europe, the Celts and their ancestors worshipped the power of the sun, considered to be super-natural and acknowledged as being essential to life and fruitfulness. Its habit of seeming to travel across the sky, to disappear at night and, miraculously, to appear again the next day, imbued it with mystery, and there must always have been the fear that one day it might not return. During the later Bronze Age and the Celtic Iron Age, the veneration of the sun took the form of small votive models in the image of a spoked wheel. The central sphere, the rays and the nimbus of the solar orb were observed to resemble the nave, spokes, and felloe of a wheel. In addition, the element of movement provided a link: the sun was seen to travel through the sky in a manner similar to a rotating wheel on a moving vehicle.[207] Solar-wheel models abounded in later pre-historic Europe, sometimes found without associations, but they were often thrown into rivers or placed in graves or shrines.[208] One such sanctuary was Villeneuve-au-Châtelot (Aube)[209] which produced large quantities of silver and bronze wheel-models in association with structures and with Gaulish and early imperial Roman coins, which fix the date of the shrine to the very beginning of the Roman empire. Another important cult-site was at Alesia in Burgundy[210] where numerous miniature bronze sun-wheels were associated with deposits of more than two hundred tiny pots set in groups of nine. Here a wooden temple was probably erected in the late free Celtic period; pottery dates it to the end of the Iron Age.

At Val Camonica in northern Italy, the sun-cult mingled with other beliefs in a complex series of religious conceptions. The Camunians linked the sun with fertility, with cults involving animals and the dead. The sun was venerated here from the later Neolithic and reached its apogee during the Bronze Age. Celtic Camunians portrayed the sun image as an arbiter between fighters (Figure 75) and temples were depicted ornamented with

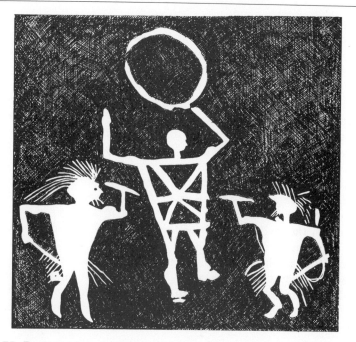

Figure 75 Rock-carving of warriors and solar deity as arbiter: Val Camonica, Italy. Illustrator: Paul Jenkins.

solar motifs.[211] The rings, wheels and rosettes on Celtic coins were probably solar, and Allen[212] believed that wheels on coinage are both chariot-wheels and sun-signs. Celtic armour was frequently decorated with wheel motifs, perhaps as apotropaic, good-luck talismans.[213]

We saw earlier (pp. 116–30) that the Romano-Celtic sky-god was often associated with a solar wheel. But the sun possessed sufficient power, even in the anthropomorphic Roman phase, frequently to appear as an image by itself and to represent the god, reflecting Iron Age cult-practice. In many instances, the link with the Roman Jupiter, seen in humanoid imagery, is maintained either epigraphically or by symbols traditionally associated with the Roman god. The style of visual cult-expression varies from the totally classical to the wholly indigenous, representing the devotion of the complete spectrum of Romano-Celtic society. All stone images have in common the intense conflation between Roman and Celtic elements, both of which were necessary for the iconography of the sky-sun cult. The miniature bronze, silver and lead wheels, so prevalent in the free Celtic period, continued to be dedicated to the sun-god as votive offerings;[214] and at a Romano-Celtic temple at Wanborough, clerical regalia in the form of head-dresses topped by solar wheels suggests the presence of priests of the sky-cult.[215]

Most romanized of all the iconography are the altars which occur in areas

associated with Roman military settlement. Stones from northern British frontier forts, like Maryport and Castlesteads,[216] depict symbols of Celtic sun-wheel and the thunderbolt motif of the Roman Jupiter, and they all bear military dedications to 'Jupiter Best and Greatest'. The Romano-Celtic sky-god was similarly represented in the Rhineland frontier region.[217] All this material belongs to a Roman army milieu and is Roman except for the native Celtic sun-symbol. The appearance of these altars in such contexts as North Britain begs the question of whether auxiliary troops encountered the sun-god when they arrived or whether they brought him with them from Europe. The cohort at Castlesteads originated among the Belgic Tungrians, belonging to a region whose inhabitants worshipped the sun-god.

The same conflation between Roman and Celtic sky symbolism can be observed in the balance of images present in a homogeneous group of material from the civilian region of the Lower Rhône Valley, centred on Nîmes. Epigraphic dedications to a sky-god called by his Roman name may accompany Celtic solar wheels and Roman thunderbolts, or symbols may appear on anonymous votive stones. An altar at Lansargues (Hérault) is dedicated to Jupiter and decorated with a wheel between two thunderbolts;[218] and the juxtaposition of motifs recurs on an anepigraphic altar from Castelas de Vauvert (Gard).[219] The stone at Collias near Nîmes is interesting in that the sun and thunderbolt are accompanied by a dedication which alludes to two local clans, the 'Coriossedenses and Budicenses'.[220] The balance of motifs on these Provençal altars – Celtic sun and Roman thunderbolt – suggests either true conflation or the blending of Roman and native imagery in the worship of a hybrid divinity; or maybe devotees were covering all eventualities in propitiating native and intrusive sky-gods together. Alternatively, the sky-god's followers wanted as many images as possible depicted to maximize the potency of the symbolism. To my mind the sky-cult in the Lower Rhône was an inextricable merger of two ethnic elements, owing its physical expression equally to Graeco-Roman and indigenous influences.

The sky-cult in the Pyrenees of south-west Gaul was again expressed by symbols rather than by images of the god himself. The Pyrenean altars are distinctive in being small with simple incised outline decoration and, more importantly, in their introduction of a new symbol related to the sun-wheel, namely the swastika. Roughly inscribed dedications to Jupiter, wheels and swastikas were presented in varying combinations and the symbol of the conifer, to which allusion was made earlier in this chapter (p. 153), forms an additional dimension to the cult-imagery. At a high mountain-sanctuary to the sky-god at le Mont Saçon (Hautes-Pyrénées) worshippers dedicated altars with swastikas, conifers, wheels, and invocations to Jupiter;[221] and a shrine attached to the large Roman Villa of Montmaurin (Haute-Garonne) produced an altar with wheel and swastika and another of identical type dedicated to the Roman sky-god.[222] Nearby, at Valentine, an elaborate

temple housed altars to Jupiter and a stone ornamented with a bush and swastika on the front and a wheel symbol on the reverse.[223] The swastika was endemic as a cult-motif associated with the sky-god only in this area. It clearly had a symbolic function similar to, though not identical with, that of the solar wheel itself. Well-known in the ancient world as a 'good luck' sign, here I think that the motif had a specific function akin to that of the wheel, perhaps emphasizing the element of movement. The link with tree motifs may point to an association with fertility, which is traceable in the imagery of the sun-sky god (pp. 116–30). It is natural that sky-deities should be venerated in the high mountains of the Pyrenees: there is epigraphic evidence that the Celtic Jupiter was a lord of high places.[224] The schematic icono-graphy of these Pyrenean cult-sites argues for a less romanized sun-sky god worship than was practised further east in Provence. Such sky motifs as thunderbolts are absent, but the balance and conflation are maintained in the juxtaposition of epigraphic dedications to the Roman god and Celtic solar signs.

It remains for us to look at the apparently curious association between sun-wheels and the underworld. We have seen that other natural elements – water, trees, and animals – have chthonic symbolism, but perhaps the link between the sun and the regions of darkness requires most investigation. We saw that the Celtic sky-fighter opposed the negative forces of death. Inanimate sun-symbols demonstrate a further dimension to the association. Miniature solar wheels were buried in Celtic graves, as at the Dürrnberg,[225] but even more spectacular is a distinctive group of Romano-Celtic house-shaped tombstones from the Mediomatrician region of Alsace, which are decorated with sun-wheels, circles, and rosettes.[226] The sun may be present in sepulchral contexts as a symbol of light in the dark places of death, and as a reassurance that there would be rebirth and a new life after death.

The sun had domination everywhere, not just in the sky and the upper worlds. Like water, it had links with the earth and the underworld. The sun's rays, like the rain, were seen to penetrate the earth and fertilize it in an alle-gory of human and animal procreation; and it reigned triumphant even in the world of death.

Conclusion

The sensitivity of the Celts to their natural environment is striking and mani-fests itself in the amount of religious imagery which is associated with the natural world. The numinosity of all natural phenomena – of the sky, sun, water, mountains, and trees – demonstrates the close alliance existing between humankind and its surroundings. The suddenness of storms, the occurrence of drought, the capriciousness of water, the healing properties of springs and the daily reappearance of the sun, were all explicable only if these phenomena were controlled by the gods. The relationship of the Celts to

animals is related but more complicated: an animal's particular qualities were revered, so those qualities were adopted as being appropriate to represent an aspect of divinity. Animals were not generally deities *per se*, but on occasions the boundaries between god and beast were blurred. Hunter and hunted had a peculiar, symbiotic interdependence; and certain gods relied so heavily on beasts that their very identity was inextricable from animal imagery. The rural basis of their society meant that the Celtic peoples were intensely aware of and at one with their natural habitat. The gods were everywhere and the natural spirits had to be harnessed and their power used for good, whilst their capacity for destruction was equally acknowledged.

6

Triplism and multiple images

Celtic imagery is distinctive in that it was frequently used to make a positive statement concerning the extreme potency of a divine concept. Such visual evidence of devotion was not hidebound by the rigid framework of realism: thus the image itself, however bizarre and unnatural it appeared in earthly terms, could function as a direct acknowledgement of power. Thus, if a deity were represented iconographically, it was frequently so depicted with its power visually expressed. This could be achieved in a number of ways. Most important, perhaps, was the multiplication of all or part of the image. This is a complex form of religious symbolism: sometimes, one may argue for simple intensification by the repetition of the image, with the number of depictions in direct correlation to the level of power portrayed. But in the Celtic context there is no doubt that, whilst two, four and more replicated images were on occasions represented, the number three transcended all. Indeed, it is indisputable that, over and above mere intensification, threeness, triplism or triadism had a very special symbolic significance, though it could be argued that threeness could perhaps be symbolic of all multiples in general, not just three, and that three was chosen as a pleasing artistic composition.[1] The concept of triadism will occupy the major part of this chapter.

The symbolic use of number runs as a constant thread through much of the vernacular literature of Ireland and Wales. In this context, it is the odd numbers which are significant, notably three, five, seven, and nine. Wholeness was important and thus five – the four cardinal points and the centre – could represent totality.[2] In Irish legends counting was frequently by fives; seven and nine could substitute for five, and we find numerous instances of these groups of numbers: the Irish hero Cú Chulainn possessed nine weapons of each kind – eight small and one large. An Irish leader or war-hero often had eight companions, thus making up the magic number of nine. The 'nine' concept has an interesting archaeological counterpart in

Romano-Gaulish evidence, if we recall the temple at Alesia (p. 164) with its miniature pots in groups of nine.[3]

But it is three that stands out in the iconography; and this is endorsed by the importance of the number in the Irish and Welsh literature. The 'triad' is a literary formula used for traditional learning which combined three concepts and which dominated much of Celtic vernacular literature.[4] More than that, however, trios are exceptionally prominent within Celtic literature. Groups of three beings appear constantly, as triplication of a single individual:[5] thus the three eponymous goddesses of Ireland were Ériu, Banbha, and Fódla. The triple Brigit or three sisters Brigit was worshipped respectively by poets, smiths, and doctors; she was at the same time a mother, a guardian of childbirth, and a goddess of prosperity. As a seasonal deity associated with the early spring feast of Imbolc, Brigit was propitiated by the sacrifice of a fowl buried alive at the meeting of three waters.[6] We have the Irish legend of the threefold death of the king – by wounding, burning, and drowning.[7] And we cannot help linking this with the archaeological evidence of the triple-killing of the late Iron Age bog-body, Lindow Man, who was successively hit on the head, garrotted, and his throat cut.[8] The Ulster hero Cú Chulainn possessed much imagery abounding in the number three – tri-coloured hair which was triple-braided; he killed warriors in threes; the symbolism is endless.[9] Triads of deities were also important: the three craftsmen Goibhniu, Luchta, and Creidhne;[10] or the three war-mothers, the Mórrigna and the Machas.

In all these instances of epic poetry the repetition of number has the dual effect of exaggeration and intensification added to the symbolism embodied in threeness itself. Three may be seen as a sign of totality or trinitarianism; thus, Lambrechts would believe[11] that triplism is in a sense the exaltation of the forces of nature, an expression of extreme potency. For whatever reason, multiplication and, in particular, triplism, possessed powerful symbolism both in post-Roman vernacular literature and in Romano-Celtic iconography. In the latter, triplism may take several forms: the whole image may be triplicated – the three mother-goddesses, for instance. Or the head alone may be tripled, or the horns of a bull. Triplism is not specific to a particular deity. The *Matres* are defined by their triple form, but there are single mother-goddesses as well. Indeed, the *Matres* as a multiple concept belong to certain parts of the Celtic world. Likewise, the triple-faced image was popular in certain areas. But occasionally we find triple deities whose multiplication is uncommon and sometimes very rare, as with the triple warrior-god at Lower Slaughter in Gloucestershire.[12] The *genii cucullati* (pp. 185–8) are curious in that they occur in single form on the Continent but as triads in Britain. We shall see in studying iconographic types that triplism in imagery seems to have several functions. Where the tripled image is identical in all three depictions, sheer intensification appears to be the intention, but often the images may differ slightly. For instance, the mothers

may differ in age or may bear varying attributes; and the Remic triple heads may also reflect youth and maturity. In these instances, different seasons or times of life may be represented; where the emblems vary, different aspects of prosperity may be portrayed.

The triple-faced image (Map 8)

The human head possessed a very special significance for the Celts (Chapter 7). So it is quite natural that iconography should reflect this importance, by endowing this element of the human body with the mystical intensity of triplism. A number of gods in Gaul (and to a much lesser extent in Britain) were represented with the triple-headed or triple-faced image in

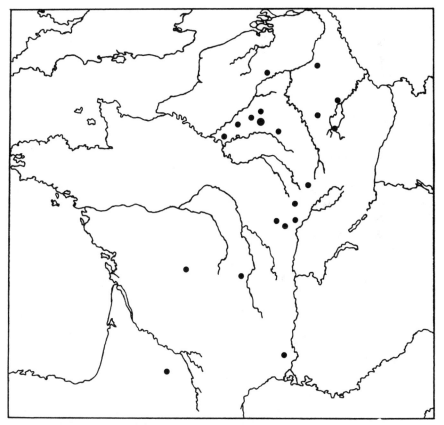

Map 8 Distribution of triple-faced monuments in Gaul:
● single monuments
● Reims cluster
After P. Lambrechts, *Contributions à l'étude des divinités celtiques*, 1942.

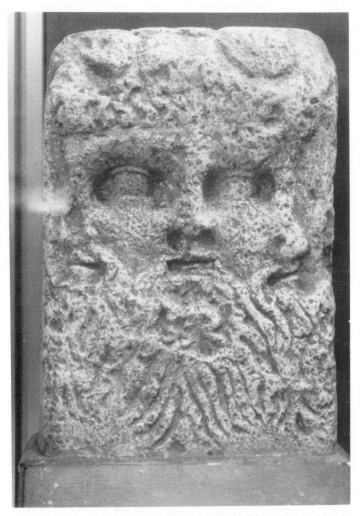

Figure 76 Stone triple-faced head: Reims. Musée St Rémi, Reims. Height approx. 27cm. Photograph: Miranda Green.

certain areas and on specific cult-objects. A particular concentration of this type of image occurs among the Remi in north-eastern Gaul, around modern Reims (Figures 76, 77). There is a scatter of such depictions, too, among such other eastern Gaulish tribes as the Lingones and the Treveri, and further odd outliers are known, as at Nîmes (Provence) and Condat (Dordogne) in the south and west of Gaul. British triple-faced images are rare but they occur in the south[13] and west.[14] Other examples are known in the north, and even in the far north of Scotland,[15] and in Ireland.

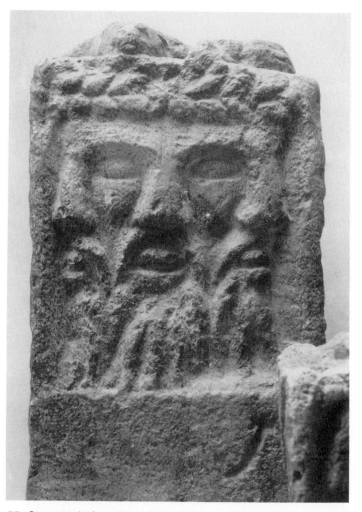

Figure 77 Stone triple-faced head, with olive wreath and with ram's head and bird on top surface: Reims. Musée St Rémi, Reims. Height approx. 27cm. Photograph: Miranda Green.

Triple-faced images may take several forms. They may appear simply as three-faced heads, with no attached body. Alternatively a single body may be surmounted by three faces or heads. The image may appear on its own or associated with attributes or other images which may give a clue to its identity. The triple-faced god of the Remi (Figures 76, 77) is a distinctive and homogeneous type.[16] Somewhat before the full Roman phase, pre-Roman coins of the Remi sometimes portray the three-faced image.[17] This is important since it shows that this type was recognized as a concept before the

burgeoning of Celtic religious art during the Romano-Celtic period. Triple heads occur also associated with solar symbols on pre-Roman Urnfield and La Tène metalwork in Europe.[18]

The main three-faced god-type of Reims and its environs is characterized by the portrayal of an often bearded head with three blended faces, one full-face and the others in profile, so that there are shared features. The head is normally in the form of a quadrangular block, fairly stylized, with a bay-leaf crown. Two variants from Reims itself consists of small pillars topped with three faces.[19] The tops of many of the Reims blocks bear images of a ram's head and a bird, generally interpreted as a cockerel.[20] On a relief from Soissons[21] the portrayal is essentially similar but with a definite depiction of a ram and cockerel beneath the head. A carving of related form comes from Entraigne (Loiret).[22] The association of symbols is interesting because the two beasts are the normal attributes of the classical Mercury. This link is further enhanced by one Reims stone[23] where Mercury appears in full Roman guise on one surface and on another is the three-faced image. That three was a definite association between Mercury and the Celtic triple-face in northern Gaul is indicated by a relief from Paris where a triple-faced god[24] holds a ram's head in one hand and Mercury's purse in the other, and is accompanied by the classical god's emblems of goat and tortoise. Even more interesting in this context is a stone from Malmaison where a depiction of Mercury and his Celtic consort Rosmerta is surmounted by a bearded triple-faced image,[25] the relative positioning perhaps implying the pre-eminence of this multiple form in this region. So in certain instances in north-east Gaul, the triple-faced god is linked with Mercury in his Graeco-Roman or Celtic form, thus allying the Celtic triple-deity with the role of prosperity assumed by the Celtic Mercury. It would be misleading to take it for granted that the image was itself that of a Celtic Mercury.[26] The fact that the Malmaison iconography portrays Mercury and a separate triple-faced image shows their distinct identities. What we appear to have is an acknowledgement that in some instances there were links between two deities, that the three-faced form sometimes merged with and took on the two functions of the Celtic Mercury and on another occasions was simply an associated divine form.

Before we leave the Remic triple-headed images, two very significant points specific to the group should be noted, namely the representation of youth and old age and the association of male and female heads. Several sculptures show the juxtaposition of an older, bearded head with a young clean-shaven one: a stone at Broussy[27] has one old and two young heads, and another at Aij[28] has two older and one younger head. Linked to this iconographic type are images where male youth and old age are accompanied by a female head.[29] The Mercury imagery already alluded to is very strong on a stone at Reims where Mercury's winged head is accompanied by that of a female (? Rosmerta) and a young head associated with two rams' heads.[30] These related phenomena are interesting since the youth/old age imagery is

reflected in portrayals of the Ubian mother-goddesses (below, pp. 194–8). It may be that here two concepts only are needed in specifically religious terms, the third being added only for aesthetic balance and because of the general sanctity of 'three'. A further point of interest is the female element, which echoes the presence of a goddess associated with the triple-headed males in Burgundy (below).[31]

The triple-faced god represented by a head is likewise associated with other divine images, notably the three mothers. This link between the two god-forms is especially significant because in two instances, at Trier and Metz, two triplistic images share the same stone. At Trier[32] the Treveran mothers appear to trample the *tricephalos* (triple-head) underfoot. The attributes of the goddesses – spindle, distaff, and scroll – perhaps denote their role as Fates measuring out men's lives. The relief from Metz[33] is very similar: here, the three goddesses stand, the central one on top of a triple-faced head, and again the Fates imagery recurs. We will return to this symbolism in consideration of the triple mothers; here the interest is the association between the two triple forms, thus intensifying even further the power of three and, in addition, the subjugation of the *tricephalos* to the dominance of the mothers. A final find of interest here is the bronze *female* triple-face at Cébazat (Puy-de-Dôme),[34] which may endorse the link with the mother-goddesses.

The three-faced god occurs again on some of the so-called 'planetary' pots of Belgic Gaul.[35] These vessels were mostly made in the valleys of the Sambre and Meuse, and include tricephalic images among the deities depicted (Figure 78). Before we leave three-faced images, we should turn our attention to some of the British and Irish examples. These appear with a scattered distribution and are generally unassociated. The Irish heads are significant in that, of course, Ireland was entirely uninfluenced by Roman iconography. The clean-shaven triple-face from Corleck[36] may date to the first century AD; and another head, found near Raphoe, Co. Donegal, has huge eyes and a cowl-like head-dress.[37] A Scottish example, possibly from Sutherland, made of granite foreign to the area[38] has been dated between the third century BC and the first century AD. A *tricephalos* from Bradenstoke in Wiltshire has three identical faces with thin mouths, wedge-shaped noses and jutting brows,[39] but perhaps the most interesting British example is that from the northern Roman fort at Risingham. Here, a dedication-slab to the spirits of the emperors depicts Mars and Victory, a small isolated head accompanying Victory being triple.[40] Even in such a Roman context, the *tricephalos* is not the only Celtic iconographic image, for Victory has a Celtic crane beneath her.

A Burgundian phenomenon, appearing especially among the Lingones and Aedui,[41] is the association of the three-faced god with another very specific god-type. Here the *tricephalos* is represented with a complete body rather than just a head, and his identification is with the antlered and torced,

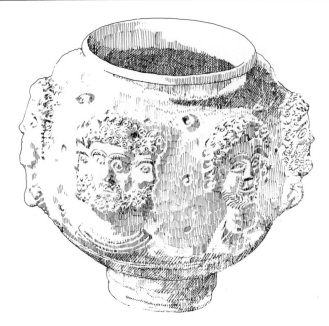

Figure 78 Three-faced image on pot: Bavay (Nord). Cabinet des Medailles, Bibliothèque Nationale. Illustrator: Paul Jenkins.

often cross-legged god form (pp. 86–96). The bronze god from near Autun, with his antlers, crossed legs, and ram-horned snakes, is triple-faced (p. 90);[42] a non-Burgundian parallel is from Condat (Dordogne) where the bust of a three-headed deity wearing the Gaulish *sagum*, is depicted, once again, with sockets in the middle head for antlers. The stone[43] has been dated to the later second century AD because of the 'Severan' treatment of the bearded heads, recalling the characteristic depictions of the emperor Septimius Severus. Other Gaulish reliefs reflect this association with the antlered god Cernunnos. At Langres,[44] a triple-faced god, with all three faces bearded and with very prominent eyes (a Celtic feature), bears spiral horns or antlers on the central head. Stelai from Beaune[45] (Figure 79), Dennevy[46] (Figure 80) and Nuits St Georges,[47] all in Burgundy, are interesting in that the triple-faced god appears in company with two other deities. At Beaune and Nuits the antlered Cernunnos is closely linked with the triple-faced images. Indeed at Nuits, the stag-god is himself triple-faced. The triad here consists of a mother-goddess; a hermaphroditic figure with *cornucopiae* and mural crown, and the three-faced antlered god, all seated. All the gods have footstools and are accompanied by a complex series of attributes. The goddess has a pot or basket of fruit by her feet; a snake reposes between her and her bisexual companion. Between this central figure and the antlered *tricephalos* is a purse, and the latter has another purse on his lap. Below the

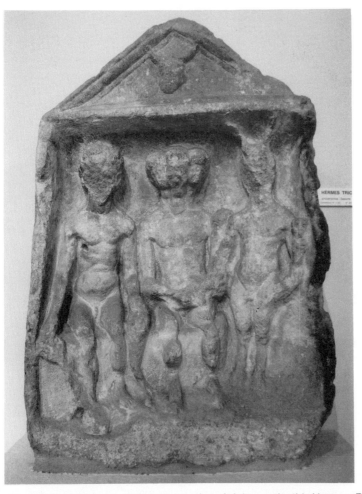

Figure 79 Relief with triple-headed god, antlered deity, and a third image: Beaune. Musée des Beaux Arts, Beaune. Width 51 cm. Photograph: Miranda Green.

triad are a bull, stag, dog, hare, and boar. The imagery is intensive of fecundity and prosperity in all its forms. The relief at Beaune (Figure 79) is essentially similar but simpler: here it is the central deity who is triple-faced, naked and seated with a fruit-filled *cornucopiae* in both hands. Next to him is another naked seated god, resting one hand on a *cornucopiae* and offering the contents of a *patera* to his dog. On his other side is an antlered god with goat-legs and a third horn of plenty. On this carving, antlered god and *tricephalos* are associated but not conflated. But again, prosperity symbolism, demonstrated this time by the repeated *cornucopiae*, is prominent. The final triad to be considered is that from Dennevy near Autun

177

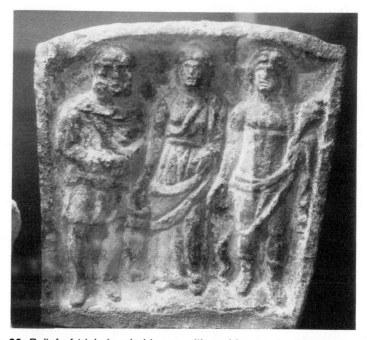

Figure 80 Relief of triple-headed image with goddess and a third figure, accompanied by *patera, cornucopiae*, and snake: Dennevy. Autun, Musée Rolin. Width of top approx. 20cm. Photograph: Miranda Green.

(Figure 80). Here, as at Nuits, the three-faced god is associated with fertility and florescence: in the centre of the trio is a goddess holding a cake or *patera* over an altar; she is flanked by a semi-draped being with long hair, *cornucopiae* and another cake/*patera* held out towards a snake; and on the other side is a bearded three-faced god, perhaps holding a basket of fruit.

So the triple-visaged god can occur in many forms. Where he is by himself, there is little clue as to his symbolic significance or identity. We can only say that the three-faced element must be meaningful. But the picture begins to develop in cases where there are attributes or associated divinities. First we have to consider the aspect of multiplicity, particularly as regards the question whether there is more to plurality of face or head than the magic number three. There is, I think, an element of potency not only in threeness itself but also in the ability of a god to look in several directions at once. Thus, the four-faced bronze Mercury from Bordeaux[48] could look all round him. The same is true of the janiform beings, for instance, in such pre-Roman contexts as Roquepertouse where, in a southern Gaulish Iron Age shrine, maybe as early as the third century BC, two conjoined heads divided by the beak of a bird gazed out from the gateway of the temple in opposite directions.[49] Other 'Janus' heads are known in the Iron Age: a fifth/fourth-

century BC stone pillar at Holzerlingen in Germany had two opposing faces;[50] and coins, too, reflect similar imagery.[51]

Apart from triplism itself and the concept of omniscience gained from an all-round view of the world, there is some evidence that three-faced deity-forms may belong to the beneficent group of Celtic divinities whose main function was to bring the blessings of prosperity in this world and the next. Thus they were linked to the mothers, to Cernunnos, to emblems of well-being and fertility. The presence of snakes on some reliefs may introduce an underworld dimension to the cults, seen also in two reliefs, at Varhély in Dacia and Unterseebach (Bas-Rhin) in Gaul, where the hammer-god is accompanied by a three-headed dog.[52] The dog had associations with the underworld in both classical and Celtic religion, and the fearsome three-headed Cerberus, guardian of the entrance to Hades,[53] is well known. But the dog is also merely a benevolent companion of deities like Sucellus and the mothers. It should be remembered that not only the Celts and the classical peoples employed triplistic images; we may point, for instance, to the cult of the Thracian Rider – essentially a cosmic god, of whom a triple-faced version is recorded.[54]

A three-faced image, in any culture, is a strong symbolic acknowledgement of predominance, power, and sanctity. The image is unreal and therefore supranatural. It can stand on its own, gazing out in all directions, or it may be associated with other divine entities. It can represent one god or several, the latter more likely since, albeit rarely, a female version is known. The Remic deity, whose image is repeated identically so many times, is a serene, mature male, a venerable being with a laurel crown, indicative perhaps of kingship. The symbolism of the Burgundian god is more complex and his association with the nature gods is very prominent. Yet the British ones need not be part of the same phenomena: the Irish examples, indeed, may be quite early and certainly were not born of Romano-Celtic hybrid imagery. Here, on the periphery of the Celtic world, triple heads may simply reflect a common Celtic belief in the powerful symbolism of three combined with the equally potent symbol of the human head.

Triplism: the animals

Triplication in animals has close links with the three-faced head just examined. Indeed we have seen that an occasional triple-headed dog is present. Triplism in animal iconography is again, like the *tricephalos*, often an example of the multiplication of part of the body. Most important in this category are the triple-horned bulls, who are represented by a substantial iconography. But on Celtic coins of the Britons, for instance, a triple-tailed horse is depicted;[55] and on a Czechoslovakian coin, a horse is triple-phallused or triple-teated.[56] A pre-Roman horse-carving at Mouriès[57] has three horns; and a triple-horned boar-figurine is recorded from

Burgundy,[58] thus adding monstrosity to the triplism. Interestingly, Irish literary tradition has produced a three-horned image.[59].

The triple-horned bull

The bull regularly undergoes triplication in Romano-Celtic iconography. Nearly forty examples of three-horned bull-figures – of bronze, stone, and, exceptionally, clay – are known in Gaul (Figures 81, 82), with a few British figures. Their distribution indicates that they are indigenous to the Gaulish provinces, occurring most frequently among the Lingones, Sequani, and the central-eastern tribes in general.[60] Outliers include the British examples, and one each from Yugoslavia and Holland.[61] These bulls have unequivocally sacred character, shown beyond doubt by their occurrence in shrines, by their associations and by occasional votive dedications. In one case, the sheer size of the bull-figure from Martigny-en-Valais (Switzerland) implies its divinity.[62] The derivation of the imagery is interesting: Boucher suggests[63] that the basic form of the bull is of Mediterranean origin and that there may

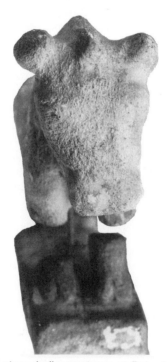

Figure 81 Triple-horned stone bull: sanctuary at Beire-le-Châtel. Musée Archéologique de Dijon. Height 16cm. Photograph: Miranda Green.

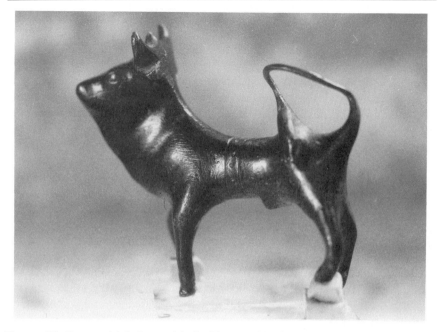

Figure 82 Bronze triple-horned bull: Glanum. Musée des Alpilles, St-Rémy-de-Provence. Max. height 5.3cm. Photograph: Miranda Green.

have been artistic transference of the Pompeii-Herculaneum type of Italian bull-figurine with a bird between its horns to a triple horn in a Celtic milieu. There may also be an association between the three-horned bull and the 'Tarvostrigaranos' or 'bull with three cranes' (below).[64]

It is worth looking at a few specific examples whose context or association is of especial interest. The votive nature of a bronze bull from Auxy (Seine-et-Loire) is demonstrated by its dedication to the emperor.[65] Again, a bronze bull from Moulins[66] is associated with a deity carrying a *cornucopiae*, suggesting the beneficent nature of the animal; and in Langres Museum[67] a bronze image of a god is flanked by two triple-horned bull-heads and rams' heads, both beasts symbolic of fertility in the Romano-Celtic world. It is evident from close study of occurrences of triple-horned bulls as bronze figurines that they were benevolent animals. Sometimes serene, sometimes dancing, they certainly do not appear as fighting, menacing creatures.

Whilst the triple-horned bull image normally occurs alone and without other symbolism, there are occasionally clues as to the nature of the cult. The stone bulls (Figure 81) from the sanctuary of Ianuaria at Beire-le-Châtel are associated with a radiate god who may be the Celtic Apollo, god of sun and healing.[68] Stone carvings from the temple indicate that devotees worshipped a number of deities. Here, the presence of depictions of doves supports the

notion of a beneficent series of divinities, perhaps with oracular powers. Other evidence endorses the solar association: the bronze bull at Glanum in Provence (Figure 82) bears a girth-belt decorated with concentric circles, often interpreted as sun symbols.[69] More powerful evidence, though, comes from Willingham Fen (Cambs) where a bronze sceptre-fitting portrays complex iconography but links the Celtic solar-wheel god with the three-horned bull.[70] The bull is a frequent associate of the Mediterranean sky-gods; here it is made Celtic by the additional horn. Underworld symbolism for the image is suggested by two grave-finds, a pipe-clay bull-figurine from a child's tomb at Colchester, and another a recent discovery in a cemetery in France, at Cutry.[71]

Two final features of three-horned bulls need consideration: the first is the occurrence of the image as a head alone, seen at Willingham Fen, in a recent find from near Cookham in Berkshire,[72] and in France at Besançon.[73] These depictions may be partly for convenience. But within the context of the human triple-faced head considered earlier, it is interesting to note that once again the head may be stressed as of importance. Thus use of the head to symbolize the whole – *pars pro toto* – makes sense, in any case, since it is the tripling of the horns which is symbolically significant. The second point concerns the silvered bronze triple-horned bull from a fourth-century AD shrine at Maiden Castle in Dorset,[74] a figurine unique in that it bears the busts of three females on its back. Taken alone, the symbolism of this imagery is totally obscure, but it does make some iconographic sense if looked at within the context of another form of triplism associated with the bull – the bull with three cranes (below).

Before we examine the specific phenomenon of the bull-and-birds imagery, we should consider the triple horn on the bull-figures. Triplication of the horn may have more than one function. There may be simple intensification; horns were potent symbols both of fertility and of destruction, and the multiplication of the essence of a creature and its force is a natural way to augment its symbolic potency. In this connection, the Burgundian three-horned boar is significant. Even more unnatural than the bull, in possessing horns at all, it is a fierce, indomitable creature with the imagery of the fantastic and supranatural. Again, we need to recall the sacredness of 'three' for the Celts: thus we do not have a proliferation of horns beyond three. Also to be borne in mind here is the visual symmetry of three: if Boucher is right[75] – that on the Celtic beast the middle horn replaced a bird on the Italian bull-images – then artistic considerations are not entirely irrelevant. Finally, if we look at the symbolism of the bull itself (pp. 149–51) we see that it was revered as a creature of great power, virility, and invincibility but, paradoxically, also as a blithe creature of good fortune, often depicted in his triple form as a prancing beast, who appears with the good things in life – sun, plenty, and healing symbols. But the bull has a sombre side, and may protect the dead in the journey to the otherworld.

The triple bull and 'Tarvostriagaranos'

Occasionally in Celtic iconography, it is not the bull's horns that are tripli-cated but the animal himself: on a stele at Saintes in Aquitaine, a double set of images appears on the front and back; on the front are a pair of deities; and on the reverse the stag-god Cernunnos appears with a goddess and a small club-wielding figure, all supported on the heads of three bulls:[76] the bull (pp. 86–96) was a recurrent companion of Cernunnos. This triplism is reflected on the imagery of the Gundestrup Cauldron where, on inner plate D,[77] are three divine bulls about to be slaughtered by three sword-bearing warriors. These animals are huge in relation to their killers and this must surely reflect their divinity. The triplication of the bull itself is intensification of the whole concept of the animal rather than the specific element of the horn. It is interesting, indeed, to speculate whether the horn-multiplication could perhaps be an ideogrammatic representation of the animal itself in triplicate.

Two stones, at Paris (Frontispiece) and Trier respectively, portray the curious image of a bull associated with three wading-birds – cranes or egrets. The Parisian monument consisted originally of several blocks forming a pillar dedicated to Jupiter by a group of Parisian sailors during the reign of Tiberius.[78] Two panels concern us here: on one surface a woodcutter named 'Esus' hacks at the branch of a willow tree (Figure 44); on another a bull is depicted with three cranes perched two on his back and one between the horns. This animal is named 'Tarvostrigaranos'. The stone at Trier shows virtually the same set of images. Here the first-century AD stone is dedicated to Mercury by a Mediomatrician, perhaps a shipper on the Rhine, called Indus.[79] On one surface of the stone is the image of the Celtic Mercury and Rosmerta, on another a woodcutter chopping at a willow tree in which are a bull's head and three cranes or egrets. The symbolism on the two stones is identical and surely Esus and Tarvos must be depicted here at Trier, though not named. We have looked at the iconography in connection with Esus as a male image (pp. 103–4), but it is worth recalling one or two features of the bull element. If the birds are egrets, then their association with willows and bulls is appropriate: egrets have a symbiotic relationship with cattle, and they are fond of the water-loving willow.[80] But there are the added dimen-sions of triplism and of the destruction of the tree by Esus. It is interesting that in Irish vernacular tradition, cranes can represent women and, in that context, the Maiden Castle bull, with its three female riders, may spring into clear focus. Here, perhaps, in good Celtic literary tradition, the birds have transmogrified into human females.[81] Irish and Welsh literature tells of magic birds, sometimes in threes. The Irish goddess Cliodnu had three brightly coloured birds, nourished by everlasting apples, who sang sick people to sleep. This is a story parallel to the Welsh tale of the birds of Rhian-non who gave joy and forgetfulness for seven years.[82] The symbolism

of the tree and the woodman is curious. There is a water element in the imagery, given by the willow and the marsh birds. It may be that the Tree of Life, with its ever-regenerating force, may be represented.

Triplism and the male deities

Certain images, like the triple-faced head, *genii cucullati* and the mothers occur repeatedly in triplicate and indeed this triplism may often be a clue to their identity. However, occasionally, deities who are usually represented in single form may appear as triple images or with a triple element. An example is the triple *genius*-like figures, all identical and all carrying fruit at Tours,[83] or the triple *genius* from Symonds Hall Farm, Gloucestershire.[84] A unique triple warrior-god comes from a well at Lower Slaughter, also among the Dobunni:[85] here the middle triplet is slightly bigger than his companions, but this may be due to artistic symmetry following the arch of the stone; otherwise the triplets are identical, with long curly hair, round shields, and swords. Three very stylized, identical but enigmatic figures come from Burgundy;[86] they are schematized to the point of childlike matchstick-man simplicity, with geometric bodies and 'pin-man' faces. Their only distinction is the three deeply-grooved diagonal crosses on their torsos. In all these cases, the triplets are clearly meant to represent triplicated images of the same divine concept. Differences between them are negligible, and intensification to the power of three seems the intention. Sometimes, though, there are differences in size or treatment. Thus the Wycomb triad, where a central male rests huge arms on the heads of two diminutive beings,[87] may represent a deity and two acolytes, or a senior god and two junior spirits. This is similar to a relief built into Chepstow Castle in Gwent.[88] Where there is variation in size, it may be that mere intensification of the triple image is not the only symbolism. There is a new dimension in that a relationship between the three is evident, with superior and subordinate roles.

Sometimes it is an attribute or element that is triplicated rather than the being himself or his worshippers. At Vignory in the land of the Lingones, a young god is crowned with a three-pointed diadem,[89] similar to the triple-horned or triple head-dressed figure at Beire-le-Châtel, in the same region.[90] Unequivocally evocative of fertility symbolism is the bronze figurine of Mercury, from a cemetery at Tongeren in Belgium; the god once boasted three phalli (one in the normal place, one on top of his head and a third replacing his nose).[91] The image is partially paralleled at Mas-Agenais (Lot et Garonne) where a bust of the god has a phallus on its forehead; and a polyphallic Mercury is recorded in Naples,[92] demonstrating that this multiplication is not only the prerogative of Celtic devotees. Perhaps most curious of all is an altar from St-Gilles (Gard) in southern France, which was dedicated to the Gaulish Silvanus-Sucellus; the stone is inscribed to the Roman woodland god and bears the appropriate iconography of a jar and a

long-shafted hammer.[93] Here the hammer itself is surmounted by three tiny hammers, all identical and replicas in miniature of the main one, thus demonstrating that intensification to the power of three may be represented in many forms.

Genii cucullati

A *cucullus* is a hood fastened to a coat or cloak. In a Romano-Celtic temple at Wabelsdorf in Carinthia (Austria) were set up two large altars inscribed 'Genio cucullato' or 'to the hooded genius'.[94] This term *genius cucullatus* has been adopted to describe figural representations of deities typified by being dressed in hooded cloaks. For present purposes, their interest lies in the fact that they always occur as singular beings on the Continent[95] whereas in Britain the vast majority of *cucullati* appear in threes, usually identical one to the other. In continental contexts, they may appear as dwarfs or giants; they may carry eggs or rolls of parchment; and they may have overt phallic imagery. In the Moselle region, at Dhronecken and Trier[96] they appear as moustached dwarfs wearing cloaks and hoods and carrying parchments. A clay example from Trier has fruit and a scroll or money-bag; it was found in the sanctuary of the Xulsigiae (a local mother-goddess triad), beside the temple of the Celtic healer Lenus[97] Sometimes[98] the *cucullus* can be removed to expose a phallus; and *cucullati* appear as parts of lamps, the holder of which is formed by the god's phallus;[99] at Geneva the god is an oaken giant carrying an egg.[100]

The British *genii cucullati* are rather different. They are characterized by their triplicate form (Figure 83), though single ones occasionally occur; they are invariably dwarfs and their phallicism is not stressed. However, there are overt fertility associations. Thus, the gods are frequently in company with the mother-goddesses, especially in the tribal area of the Dobunni, and they often carry eggs. In addition, their hooded shape could be interpreted as itself phallic. It is interesting that British *cucullati* occur in triads precisely where the triadic mother-goddesses are dominant – Gloucestershire and the area of Hadrian's Wall – though among the Dobunni they are usually linked in iconography with just one mother. At Housesteads the trio, who come from a small, perhaps third-century shrine in the *vicus* of the fort,[101] are swathed in heavy cloaks reaching to their feet. Whilst they bear no discernible attributes, one feature is interesting in that the face of the central god is masculine, but those of the other two may possibly be feminine. But maybe, instead of sexual differences, the faces could reflect age – an older god flanked by two youths, a phenomenon which we have seen in the Remic three-headed god-form, and which is repeated with some of the mothers.

The southern British godlets are more varied and interesting in their associations. They are linked with healing springs at Springhead, Kent (where a single bone figure is recorded) and at Bath.[102] The latter example is

triadic, but here the dwarfs take a subordinate role: the group occurs as a tiny trio at the base of a relief of Mercury and Rosmerta. Healing may, again, be their function at Lower Slaughter[103] where two schematized groups of *cucullati*, one with a worshipper, are depicted and where the context of the well may imply a curative-water association. But the group with the devotee are associated with the symbols of a rosette and two ravens, which may denote otherworld significance; healing is associated with a Gaulish *genius cucullatus* from Trier, as we have seen. The Dobunnic *cucullati* are characterized by their firm link with the mothers. Thus, one of a triplet of hooded dwarfs offers or receives something from a goddess called 'Cuda' (a name denoting prosperity) on a relief from Cirencester.[104] Another relief from the Dobunnic capital depicts the trio in company with a mother nursing a cake or

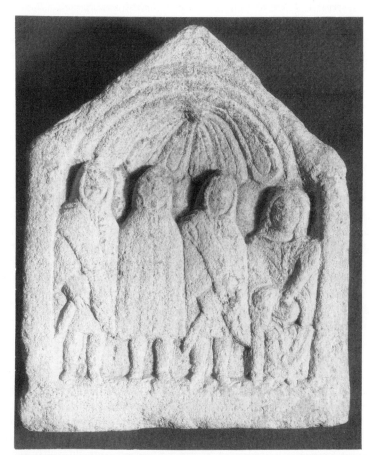

Figure 83 Relief of three *genii cucullati* (two bearing swords) and a mother-goddess: Cirencester, Gloucestershire. Corinium Museum. Height 27 cm. Photograph: Rex Knight, for Corinium Museum.

fruit; and two of the godlings carry swords, as if to defend her (Figure 83). On a third stone a mother-goddess bears fruit and the accompanying *cucullatus* an egg; and two triads at Wycomb in the same area also bear these fertility emblems.[105]

Regarding the interpretation of the imagery of *genii cucullati* and their cult, I think it is necessary to consider together singular and multiple depictions, since both obviously form part of the same symbolic concept. Where three occur, they are usually virtually identical apart from, say, the absence of a sword on the Cirencester group, or the possible age/sex difference in north Britain. The associated symbolism is complex, illuminating, and puzzling. There is obvious fertility imagery: phallicism, eggs, and a connection with the mothers. The Dobunnic sword-bearers seem curious at first glance, but we may see here the *cucullati* in a protective role, maybe guarding against barrenness and disease. Certainly healing and regeneration may well be present; the two concepts of fertility and healing are closely linked in the regenerative, seasonal theme of much of Celtic iconography. In this context, a connection with the otherworld is not inexplicable: the Lower Slaughter group comes from deep underground in a well, and Ross[106] interprets the birds on the pediment as ravens. If that is so then the chthonic imagery is plain. The parchment scrolls borne by some of the continental gods may be interpretable, then, in terms of their representation as guardians of the story and span of men's lives. We will see this developed in the iconography of the Burgundian mothers. The chthonic aspect could be represented also in the shrouding garments of the gods which give them an attitude of mourning and perhaps the hidden mystery of death.

The cult of the *cucullati* would appear, then, to be sophisticated, embodying elements of fertility, healing, death and renewal. The consistency of dress is of interest here. Hoodedness is the essential attribute, and we see at Cirencester[107] (Figure 92) that on a very abstract image, the necessary elements of hoodedness and triplism are not lost; and on a Birdoswald carving, the hood of a *cucullatus* is emphasized.[108] But we should make the point that non-divine images were frequently represented in the Gaulish hooded cloak. Humble pilgrims at, for instance, *Fontes Sequanae*[109] are depicted wearing this heavy-weather garment, and it maybe that the choice of clothing for the *genii cucullati* may have been a deliberate attempt to identify them with the needs of simple rural communities. Triplication was important only to the British worshippers, and this is curious when it is considered how favoured was triplism in other continental portrayals, for instance, of the mothers. For the *cucullati*, though, the potency of their symbolism was seen to be particularly enhanced in Britain by triadism. This added to their magic and emphasized whatever symbolic role each particular group enacted.

The goddesses

Triplism may be said to have reached its peak in the imagery of the Celtic goddesses. The pattern of iconographic selection for triplication is similar to that pertaining to the male deities: certain goddesses were represented very rarely as multiple images. But others, namely the ubiquitous and homogeneous group of the *Tres Matres* or three mothers, are actually identified by their triadic form. It may be significant that the goddesses who appear, albeit rarely, in triplicate – Epona and Nehalennia – are associated symbolically with the mothers. Both goddesses (Chapter 2) share prosperity and fertility attributes with the maternal triad, and each may be regarded as possessing some of the functions of the mothers. Epona appears in triple form at Hagondange,[110] and the dedication to 'the Eponas' on one inscription[111] may also imply triplism. Two reliefs of the horse-goddess show further indications of plurality: at Strasbourg, Mercury is flanked by two Eponas;[112] and a relief at Beihingen near Stuttgart portrays Epona flanked by a number of horses.[113] Of the several hundred representations of the Dutch seafarers' goddess Nehalennia, one only is triple, on a stele from the Domburg temple.[114] This is particularly interesting since, although Nehalennia was worshipped by voyagers in response to or appeal for safe passage across the North Sea, the goddess's symbolism has much in common with the mothers. *Cornuacopiae*, fruits, and animals are Nehalennia's commonest attributes, and she was a protectress and goddess of prosperity in this world and the next. The triplicated depiction is notable in that Nehalennia is represented identically as triplets seated side by side and, significantly, the accompanying dedication is to 'Nehalennia' in the singular, not 'the Nehalennias'. So here we have an example of simple intensification: the goddess is regarded as a single entity, but her portrayal as three beings gives intensity to the imagery and the power of the dedication.

The literary evidence for multiple goddesses

Early post-Roman vernacular Irish literature abounds in references to triads of female divinities, for the most part territorial deities, with a maternal function born of their identification with the land. Thus the eponymous symbols of Ireland – Ériu, Fódla, and Banbha – ruled Ireland as land-goddesses at the time of the coming of the Gaels.[115] The Irish triadic goddesses have a complex and sometimes paradoxical symbolism and identity: they frequently combine the functions of mother-goddesses with that of war. Thus the three Mórrigna and three Badhbh were deities of slaughter, achieving havoc and confusion on the battlefield by means of magic. The three Machas, too, had a war element. One of them combined propensities for sexual activity and war, another maternity and the third land-protection.[116] Both the Machas and the Mórrigna were at the same time

regarded as one entity with three aspects and with three identities. We need to bear in mind this plurality in considering the iconographic evidence for the mother-goddesses.

The Romano-Celtic mother-goddesses

Most of the imagery concerns triplication. All over Romano-Celtic Europe, a homogeneous iconographic type consisting of three more or less identical goddesses, referred to on dedications as mothers, can be identified. The three mothers occur in various forms, represented either epigraphically or iconographically (or both) as far north-west as Scotland and as far east as Hungary. But there are particular concentrations in the Rhineland; the Rhône Valley from Lyon to Narbonensis; and the Burgundy region, particularly around Autun and Beaune; and they were worshipped, too, in north Italy and Spain.[117] I intend to study the imagery of the mothers by looking at their appearance in the main geographical areas in which their iconography is clustered, and then by considering the cult as a whole. First, I should like to examine the discrete phenomenon of the 'double' mothers.

The dual mothers

In the central west of Gaul the tribe of the Santones, centred on the town of Saintes, worshipped a mother-goddess whom they depicted not as a triple but as a double image. Duality is known elsewhere; we have already referred to janiform heads (p. 178), but there is a recurrent double iconography here which argues for a particular preference in this region of Aquitaine. Most double mothers occur at the tribal capital of Saintes itself, where there must have been at least one shrine dedicated to them. The images consist, for the most part, of two seated female figures, side by side, with such emblems of prosperity as *paterae* and baskets of fruit. These goddesses may have identical attributes[118] or may vary one with the other. A variant consists of a single goddess with a smaller figure by her side.[119] Here the presence, perhaps, of a goddess and acolyte, fulfils the requirements of duality, but the symbolism is different. Adherence to a specific number of images is repeated when we examine the triadic groups. What is also interesting about the Charente dual goddesses is the age-differentiation frequently observed: often the goddess seen to the left, carrying a *patera*, is younger, with long hair and a sweet expression, whilst her sister appears graver and more mature.[120] Once again, this is a phenomenon which pertains to many triple mothers, especially the Ubian goddesses of the Rhineland, and we have seen it already in the Remic triple images. There are other scattered examples of double mother-images in Gaul.[121] At the site of La Horgne-au-Sablon near Metz, an interesting relief reflects the close links between the 'twins': each goddess carries an apple or pomegranate in her right hand and has other fruit

on her lap, and one goddess places her hand on her sister's shoulder.[122] This, I think, demonstrates that we are not seeing here mere duplication of the image; rather, there are two goddesses each with a specific entity and with an overt sisterly relationship. A final example of duality which is worth looking at is a Burgundian group at Essey[123] where two mothers sit together in a two-horse chariot, as if reflective of the Irish legendary queen-goddess Medb who drove around her battlefield, or the Germanic goddess Nerthus who rode in procession through her cities.[124]

The twin mother-goddesses are both rarer and less well documented than the more familiar triple goddesses. Their imagery is interesting because, whilst plurality is involved, there is a definite preference in these instances for two rather than three. Thevenot[125] has suggested that the idea of two mothers is a phenomenon similar to that of divine couples (Chapter 3), where the male and female principles of a given religious concept are represented. Here, however, we have two females, often with different prosperity attributes and sometimes of different ages. This last feature could be quite meaningful, perhaps representing different stages of womanhood – nubile youth and experienced maturity. It is worth noting that these double goddesses do not carry children, so it is not overt human fecundity that is symbolized, but the passage of life and earthly and otherworldly well-being may, instead, be reflected by the imagery of these sister-goddesses.

The triple mothers

The triadic mother-goddesses are a very specific type, represented both epigraphically and iconographically. We should not forget that the Roman world knew triple goddesses – the three Fates and three Nymphs are examples. The imagery of the Celtic concept of the *Deae Matres* itself owes a great deal to Roman influence: the mothers are in origin a form of *Iunones*, the *Iuno* being the female spirit, just as the *Genius* was the essence of a male being. The Roman *Iuno Lucina* – the nursing goddess – associated with birth and lactation embodied principles which were very similar to the Celtic mothers; and indeed numerous Mediterranean representations of nursing spirits are documented.[126] The threeness in the iconography is an intensification of the original Mediterranean *Iuno* concept, whose function was to retain or disclose the native Celtic element by means of triplication. These triadic goddesses were widely worshipped in the Romano-Celtic world. In southern Gaul, North Italy, Spain, and Britain, their dedicants were often humble people; the lower ranks of the military, freedmen, and slaves. Only among the Ubii of the Rhineland were their worshippers consistently and demonstrably high-ranking military officers, officials, landowning farmers, and prosperous craftsmen. It was not inappropriate to a maternal cult that a fair proportion of the dedicants were women.

The Burgundian and Rhône Valley groups

The cult of the triple mothers in Burgundy shows a complexity and ambiguity which is unique. The iconography is varied and the symbolism expresses a profundity of religious thought which is only hinted at in many other cults. There is one specific Burgundian group which stands out: here, the mothers perform differing but interrelated roles which at first glance appear to be entirely connected with human fertility, but with perhaps a much deeper significance. The Roman settlement of Vertillum (modern Vertault) has produced a number of mother-goddess triads.[127] Two of them depict the triplets standing, which in itself is fairly unusual for these deities. On one relief[128] the main symbolism is concerned with *cornuacopiae*; all the goddesses carry these and the two flanking ones curve in graceful symmetry towards the central figure. The *cornuacopiae* themselves are large and brimming with fruits. The central goddess also holds a *patera* and this, plus the attitude of the flanking *cornuacopiae*, may suggest deference to and the seniority of the middle goddess. The other two Vertault reliefs both portray

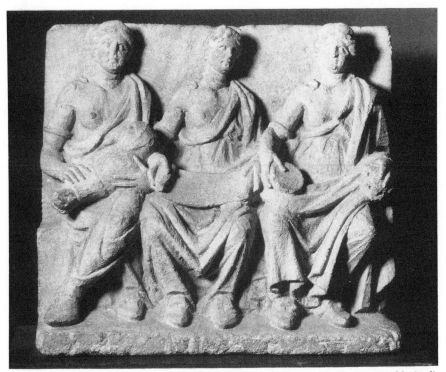

Figure 84 Three mother-goddesses with baby, napkin, and bath sponge: Vertault. Musée de Châtillon-sur-Seine. Height 38cm. Photograph: Christian Labeaune, for Musée de Châtillon-sur-Seine.

the mothers with imagery associated with babies: one[129] is fragmentary, but the middle figure may be seen to hold what appears to be a swaddling napkin which she unrolls. The other[130] is a very fine carving, with complex iconography (Figure 84). All three goddesses are seated; one carries a large swaddled infant; the central one unrolls a napkin; the last bears a wash-basin and sponge. All the mothers have their right shoulder and breast bared as if about to suckle a child. This stone shares the same symbolism with a relief found near Beaune,[131] where once again the attributes of the three seated matrons are a baby, napkin, sponge and wash-basin. The child-and-napkin imagery recurs on several stones local to this area: four representations from Autun depict the triad thus;[132] two are fragmentary, but the group as a whole appears to combine the symbolism of human fertility (child and napkin) with that of prosperity, as portrayed by *cornucopiae* and cake or *patera*. Autun is interesting in that, in addition to the stone group, it has produced a cheap domestic cult-object in the form of a small pipe-clay mothers group.[133] Imagery which is overtly similar to the Vertault/Autun groups recurs on stones from Nuits St Georges, the Roman settlement of Bolards. Once again, on three reliefs, we have the combined imagery of baby and napkin. On one[134] the triad sit together, one with a child on her lap, another with a napkin, the third with a *cornucopiae*: this last figure rests her foot on a stool – perhaps she is the senior mother. Another Nuits relief[135] depicts the three in similar attitude, but here the goddesses are of different ages, and it is the central figure who holds the napkin and is older, with creased cheeks and withered neck, whilst her companions are younger with round cheeks. So far the symbolism seems obvious and straightforward. But two other Burgundian triads call into question the simple 'napkin' interpretation of the imagery looked at so far. Again from Nuits St Georges,[136] a relief shows the central goddess, with her head covered, seated and unfolding a 'napkin'. The left deity has a *cornucopiae* and the one on the right has a swaddled child, but her right hand grips the beam of a balance. To the right of the central figure is the prow of a boat and a steering oar, to the left a globe. The stone from St-Boil (Saône-et-Loire) is unfinished and worn,[137] but the middle goddess has a 'napkin' and balance-beam; the left goddess also holds a 'napkin' and the third goddess a *cornucopiae*. The more complicated imagery of these two stones has led some scholars to re-interpret the napkin as, instead, a parchment or scroll, the Book of Life. Thevenot[138] would interpret the goddesses as representative not simply of human fecundity but also of the passage of life and death. The balance belongs to the Roman Fates (the *Parcae*), and Fortuna's attributes of rudder and globe enhance this imagery. Thus the idea may be that the mothers watch over the newborn baby and protect it; the *cornucopiae* symbolizes earthly riches; the parchment shows the inevitable one-way direction and limit of life; and, when the scroll runs out, the boat carries the soul to the otherworld. If a scroll is intended, the other Nuits relief, with the central older goddess

holding the Book of Life, makes sense. However, I consider it unnecessary to opt for either napkin or scroll as mutually exclusive. Rather, I would consider this as an example of deliberate Celtic ambiguity. Thus, napkin and parchment are similar images, especially when necessarily stylized for stonework, but, in some instances, straightforward fertility symbolism is uppermost; in others the deeper philosophical imagery of life and death and the goddesses' protective role are indicated.

The other maternal triads in this general area of east-central France are more diverse: symbols of earthly well-being are suggested by such attributes as fruit, goblets of wine, and *cornuacopiae*.[139] But at Langres[140] and Alesia,[141] it is human fertility that is again emphasized: the Langres stone does not display a triad of goddesses but retains the triplistic element in the grouping of mother with two children, whose involvement with a *cornucopiae*, purse, and *patera*, stress the symbolism of florescence: one of the children grasps at the *cornucopiae* and plunges his hand into a purse; the other seizes the *patera*. At Alesia the symbolism is again complex and may encapsulate several levels of religious meaning: the three mothers, each holding a *patera* and *cornucopiae*, are accompanied by three naked toddlers. There is again age-variation; the left-hand goddess is older, with a high-necked tunic and mural crown (symbolizing her protective role towards the town). The other two are nursing mothers with right breast bared; one has a particularly youthful face. But the imagery takes on a deeper symbolism with the presence, on the extreme right of the stone, of a nude child seated in a boat accompanied by a swan. Bearing in mind the boat symbolism already looked at, it seems that here again the journey to the otherworld may be represented; the water bird endorses the aquatic imagery, and the child may serve to remind us that there is death even in youth. But we should remember also the combined boat-bird imagery of Sequana at *Fontes Sequanae*. Could the symbolism at Alesia embody healing and renewal as well as death, the child referring to the notion of rebirth after death?

The mother-goddesses of the Lower Rhône form a separate subgroup. At Lyon the triad bear a child, fruit, and *cornucopiae*[142] The presence of a shell canopy above their heads has been interpreted by some as a symbol of high divinity[143] and may imply the exalted position of the mothers in the divine hierarchy, but Hatt[144] prefers to see this as reflective of water symbolism, and the head of a griffon present above the central figure he would see as a further piece of water imagery, with the added dimension of an association with Apollo, implying a healing role for the mothers here. This seems possible, especially in looking at another relief at Lyon which was actually dedicated by a Greek physician:[145] here the mothers again sit beneath a shell canopy, bearing *paterae* and fruits. A relief from Vienne, further south,[146] was found in the vicinity of a dedication referring to the presence of a temple. On the carving, the middle goddess is definitely the senior: she sits, feet on a stool, a basket of fruit on her lap, whilst her companions stand. The relief

found at Allan (Drôme) is of interest because, again, the central goddess is different: her sisters hold plates of fruit, but she has a *patera* in which is a knuckle-bone.[147] Near by was found a bronze plaque dedicated to the 'victorious mothers'. The triumph referred to probably means not in war as such but over illness, poverty, or barrenness. We will see a similar role for some of the British mothers. The significance of the knuckle-bone is obscure, but in view of the very ancient game of knuckle-bones (our own fivestones), which was played during the Roman period at Herculaneum, its presence here could imply life's game of skill and chance, again reflecting the symbolism of the Fates and Fortuna. The overt crop-fertility symbolism seen on these reliefs is repeated lower down the Rhône Valley at Vaison.[148]

The Treveran group

Triadic mother-goddesses are uncommon among the Treveri of north-east Gaul and their Mediomatrician neighbours. But at two important Roman towns in these areas – Trier and Metz – there appears important triplistic imagery embodying virtually identical symbolism. The Trier mothers are fragmentary, but enough survives of the sculpture to distinguish their attributes: the flanking mothers carry a spindle and distaff respectively; and the central one bears a napkin or scroll.[149] At Metz the three ladies stand with their upper halves naked, but wearing diadems. One bears a palm-leaf (a victory symbol) and a *patera*; another has a distaff and spindle; the third a goblet (of Moselle wine perhaps).[150] We may see immediate similarities between the imagery on both these stones and those of Burgundy where the goddesses' role as Fates spinning out men's lives is represented. Here the association with the span of life is even clearer. The palm-leaf, *patera*, and goblet represent earthly prosperity and perhaps triumph over misfortune; the scroll and spinning equipment remind the worshipper that life is short and at the whim of the gods. But what makes both the Trier and Metz mothers supremely interesting is the presence on each stone of a *tricephalos* (three-faced head) of Remic type beneath the feet of the central goddess. Here, then, there is conflation of two triplistic divine concepts, the mothers and the three-headed god. Whilst among the Remi the deity represented by the *tricephalos* reigned supreme, here among the Treveri he is subordinate to the mothers.

The Germanic mother-goddesses

The maternal triads of Upper and Lower Germany – which remained a military frontier region throughout the Roman occupation – form a very specific and homogeneous group, very different from the Gaulish mother-goddess type. On epigraphic dedications, in most of Romano-Celtic Gaul and Britain, the goddesses are referred to as *Matres*. In Germany they are *Matronae*. Several features distinguish the German mothers from their

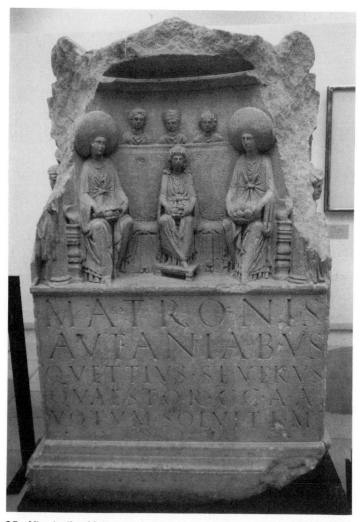

Figure 85 Altar to the *Matronae Aufaniae*, dedicated by a Quaestor of Köln: Bonn. Rheinisches Landesmuseum, Bonn. Base width 87cm. Photograph: Miranda Green.

counterparts in the western Celtic provinces. First, their surnames or epithets proclaim them as territorial deities, defined by locality. But whereas there is a bewildering variety of names, the imagery is consistent and varies little. Second, the monuments are often superbly carved, clearly by military stonemasons (Figure 85). Third, the dedicants were often high-ranking officials within the Roman administration or high officers in the army. Fourth, the imagery of the goddesses themselves had no overt concern with human fertility. Finally, the triad is distinctive in the iconographic treatment

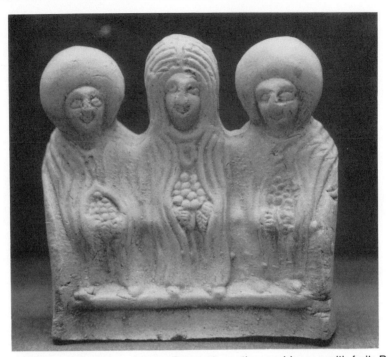

Figure 86 Pipe-clay group of three Germanic mother-goddesses with fruit: Bonn. Rheinisches Landesmuseum, Bonn. Height approx. 10cm. Photograph: Miranda Green.

of the divinities themselves. Indeed, in all of the triadic images, the pattern consists of a young central goddess with long flowing hair flanked by two older women with huge, nimbus-like circular head-dresses or hats, seemingly made of reinforced linen and held in place by a willow twig fastened with knots on the forehead and neck (Figure 86).[151]

The Germanic mothers have a number of different local names which may reflect either the birthplace of the dedicant or the place where the monument or temple was erected. The cult was popular in both town and countryside and the massive nature of many stones must imply the presence of temples and corporate worship. Indeed, several inscriptions mention temple precincts, and the practice of public worship in shrines is displayed at Pesch, where there were assembly areas. A relief at Bonn shows a procession of women,[152] again expressing an organized cult. Whilst several of the names of the goddesses occur only once or twice, others recur within specific locations. Yet from the iconography it is clear that, whatever the surnames, the goddesses were envisaged as being essentially the same deities throughout the German provinces.

The *Aufaniae* were a particular forth of triadic mother-goddess to whom

several monuments were dedicated in the Bonn area during the second century AD. Their imagery is of normal Germanic type, with two mature, nimbus-headed mothers flanking a younger one with free-flowing tresses. All three bear baskets of fruit and wear long garments. The side panels generally depict scenes of sacrifice to the mothers[153] or stylized foliage. A temple at Nettersheim near Bonn contained a number of images of the *Aufaniae*:[154] on one [155] the triad carries boxes and the central goddess has a distaff. Once again we may have here the homely domestic image of the traditionally female pursuit of spinning, but with the underlying more sinister symbolism of spinning out life's thread. On a relief from Bonn[156] the three *Aufaniae* appear below the busts of three young women, perhaps acolytes or novice-priestesses.[157] On the side panels are women with fruit-baskets and garlands of flowers. The stone was dedicated in AD 164 by a Quaestor (a financial official) of Köln (Figure 85). On another,[158] set up by a Decurion (town official) of the city, the mothers appear between two Victories on globes. The idea of triumph occurs again at Bonn where there is a combat scene of a legionary versus an Asiatic who pleads for mercy.[159] Worshippers, acolytes, and suppliants appear on many of these stones. On one Bonn relief[160] the *Aufaniae* sit flanked by two groups of female worshippers who, like the mothers themselves, carry baskets of fruit to offer to the goddesses. Some of the floral and faunal imagery is interesting: often trees or boughs of laurel and bay are present; there may be birds perched in the branches[161] or guardian snakes entwined round tree-trunks.[162] One military stone has no depiction of the goddesses but on the reverse are a tree, a twining snake and a triple-bodied goat[163] – so even here triplism is present. On one sculpture, a Medusa mask (a potent apotropaic symbol) is shown above the heads of the mothers,[164] as if enhancing their protective powers.

The area around Rödingen has produced local versions of the Germanic mothers, called the *Gesahenae*, *Gavadiae* and other territorial names. The imagery is virtually identical to that associated with the *Aufaniae*. Foliage, birds, and *cornuacopiae* are the associated prosperity images usually present, and the mothers sometimes hold flowers or branches as well as their fruit-baskets.[165] An important temple complex dedicated to one local variant – the *Vacallinehae* – was present at Pesch[166] where, within a temple precinct, several shrines held more than 160 altars to the goddesses; the dedicants were mostly soldiers, and bread – standard legionary fare – was the main attribute of the mothers. Another temple, at Gripswald, was dedicated to the mothers and the Celtic Mercury Arvernus.[167] One of the stones here links the German *Matronae* with some of the Burgundian imagery, for they are associated with the rudder and globe of Fortuna;[168] and they wear crescent-shaped amulets which may link with the essentially feminine cosmic symbol of the moon, a connection made, in the classical world, with Diana the lunar Huntress.

The mother-goddess reliefs of Köln possess many of the same

characteristics of the other German goddesses: the shell canopy on some[169] may reflect high status or water-imagery, like the Lyon reliefs. Once again, sacrificial scenes are common, and on one relief[170] a female devotee carries a napkin, again maybe linking the imagery with the Burgundian triads. At Köln, the surnames of the goddesses[171] are varied and rather weird, as if personal to particular families. One, to the *Boudunneihae*, was dedicated by a woman, Dossonia Patera, in the second century AD[172] and repeats the triumphal imagery noted on a relief from Bonn dedicated by a Köln official,[173] with Victories flanking the mother-goddesses.

The imagery of the Germanic mothers is remarkably consistent, though the associated symbolism may be diverse. First, the German linen and willow head-dress is almost exclusive to the Germanic provinces, though there is a single goddess with 'nimbus' at Dalheim among the Treveri.[174] Second, the age-differentiation is extremely recurrent: it is interesting, too, because the same phenomenon has been observed among other triple-images – the Remic triple-god, for instance, and on other mother-goddess imagery. A single mother-goddess at Naix is grim and wrinkled, while her flanking attendants are small and youthful; and on the stone at Vendoeuvres[175] the stag-horned Cernunnos appears as a child between two older deities. The imagery itself is little concerned visually with human fertility. The floral and faunal associated symbolism is reflective of earth's bounty. But there is otherworld significance too, perhaps, in the presence of birds and snakes. The triumph of life and good over evil may be represented by the Victories, but, conversely, the inevitability of death is seen in the distaff. The chancy nature of life is seen also in Fortuna's rudder and globe. But the *Matronae* are beneficent: their suppliants offer them the fruits of the earth, and they sit serenely gazing benevolently at their devotees. But what do the older matrons and youthful girl signify? Is it the passage of life? Who is the most important – the girl or her middle-aged companions? We noticed some evidence of age difference between some of the Gaulish triads. Perhaps the best explanation is that of the varying virtues of divine womanhood, where youth is nubile, attractive, and itself represents fecundity and renewal; middle-age is, on the other hand, experienced, mature, and far-seeing. The goddesses were far more than simple domestic protectresses; what attracted army officers and high urban officials must have been a cult which offered a deep satisfaction and comfort in both this world and the unknown of the underworld, qualities which make the appearance of single mothers in *mithraea* relevant as associates with the profundity of the Mithras-cult.

The British triple mothers

The iconographic evidence for the mothers cult in Britain is scattered, sparse and relatively poorly preserved. The paucity and low quality of stone-carvings suggests that in the western Celtic provinces at least the worship of

the *Matres* was usually neither fashionable nor upper-class, unlike the German situation. Epigraphy endorses this: where there is evidence, the most common dedicants were ordinary soldiers, though there are exceptions:[176] in London there was a relatively prosperous mother-goddess cult. The lack of topographical surnames here implies the introduction of the cult from outside Britain.

The poor representation and preservation of the British iconography means that it is not possible to study the imagery in as much detail as is possible for Gaul and Germany. But a number of geographical groups may be distinguished corresponding to different tribal or urban areas. In the south, the two main centres for the cult of the mothers appear to have been London and Cirencester, although outlying examples occur also, as at Bath (Figure 88). Three of the London images take the form of monumental stone carvings, presumably from temples, and part of an inscription supports the evidence for at least one major shrine.[177] One relief shows the mothers with the conventional attributes of baskets of fruit;[178] but a much more interesting find[179] depicts what at first glance look like four mothers; one holds bread and grapes (note the parallel symbolism to the Christian bread and wine), balanced imagery of the earth's fruitfulness; another is representative of human fertility, nursing a child; a third carries a dog, perhaps symbolic of healing and otherworld regeneration; the fourth carries a basket. This, then, is either a rare example of four mothers, intensifying the imagery even more than usual, or, as Merrifield suggests, three mothers and a representation of the deified empress as a *dea nutrix*. The other notable London find is a silver feather-shaped plaque on which the mothers are depicted, one of a group of such votive objects frequently found in British sacred contexts. Here the appearance of the mothers as victors over death, barrenness or disease seem to be the main theme; each goddess holds a reed or branch, perhaps a victory-palm. It has even been suggested that the leaf/feather-shape of the plaque itself represents a stylized palm.[180]

Human fertility is the main overt imagery of the Cirencester mothers (Figure 87). The tribe of the Dobunni produced a rich and varied cult-iconography, including several triple-forms – *genii cucullati*, warrior-gods, and mother-goddesses. Indeed the mothers appear quite frequently as single females but in company with the triadic *cucullati* (above). Their predilection for triple associations even when they themselves are not multiplied is demonstrated by the Cirencester image of a single mother but with three large apples in her lap.[181] Three triple-mothers reliefs come from Cirencester itself: one shows the goddesses in relaxed, naturalistic attitude grouped in a semi-circle on a bench.[182] Each is accompanied by a male toddler, one of whom reaches up towards the breast of his mother. The central goddess holds a dachshund-like lap-dog. Here the symbolism is at one level simply that of human maternity. But the dog perhaps introduces another, maybe otherworld, element, and regeneration and life after death may be

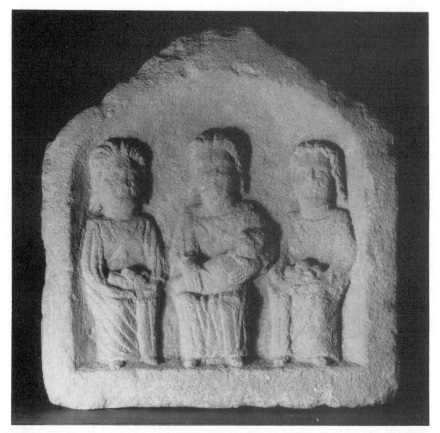

Figure 87 Three mother-goddesses with fruit and baby: Cirencester. Corinium Museum. Photograph: Betty Naggar.

represented. Unlike the other Cirencester triples, these women sprawl happily, in carefree attitude on their bench, chatting together as if at a mothers' meeting. The other reliefs are more formalized: one is stiff in style but charming, with three mothers in long schematized robes. The flanking goddesses carry trays of fruit, but the central one carries a swaddled infant (Figure 87). That three separate entities are depicted is suggested by the slightly different hairstyles of all three.[183] There is warmth and beneficence which seems to speak of the goddesses' imagery as representative of real-life mothers: this is compounded by the benign smile on the face of one of the deities who glances fondly at her sister-goddess's child. The central goddess is slightly larger than her companions; that and her possession of a baby may accord her the highest status. The final sculpture from the Dobunnic capital shows three matrons, again each with different hair-styles denoting their individual identity. Here the earth's bounty is expressed by trays of fruit and

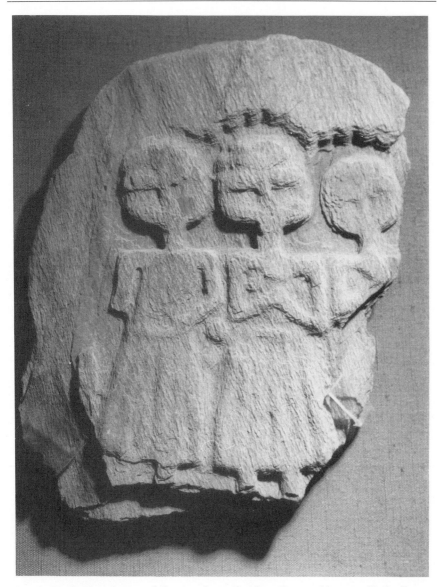

Figure 88 Schist plaque of three schematized mother-goddesses: Bath. Roman Baths Museum. Height 24.8cm. Photograph: Betty Naggar.

loaves held in the mothers' laps.[184] But once again the overt symbolism may hide a deeper meaning: the lower folds of the goddesses' clothing form dolphins, and it may be that here is reference to death and the mothers' protection in the journey to the Blessed Isles – the classical significance of dolphin imagery. A Midland group of images is not dissimilar in overall

symbolism to the Gloucestershire imagery, in that dogs and fruit are combined, perhaps to balance ideas of earthly florescence and otherworld comfort.[185]

The other principal area of British where the mothers' cult was popular was the North, which, throughout the Roman period, retained a military presence similar to that pertaining in the German frontier region. Epigraphic dedications, frequently by soldiers, attest to the popularity of the cult for men, a feature reflected also in the German provinces. The iconography demonstrates that the emphasis was on general prosperity rather than human fertility but, once more, there must have been a deeper meaning and comfort for their devotees, which may have come from the goddesses' role as protectors in all aspects of this life and that to come, but also from the efficacy of propitiating deities of foreign territory. York must have been one centre for the cult: altars were dedicated to the *Matres Domesticae*; and one image is of the three goddesses seated, their right hands across their breasts, with worshippers and sacrificial offerings.[186] Another centre was at Carlisle where, interestingly (bearing in mind some of the Burgundian and Germanic imagery), they were associated epigraphically with the Fates;[187] and some dedications were to the Overseas Mothers, known also elsewhere in Britain.[188] Of the many images at Carlisle, the most varied shows the triad carrying a knife, a cake and a flower respectively, and each with bowls on their laps; the seniority of the right-hand goddess is suggested by her more elaborate costume. Netherby nearby may have had another shrine to the veneration of the mothers, depicted with symbols of earthly well-being – *tazzae* of fruit and pitchers of wine.[189] Everywhere in the region of Hadrian's Wall, the imagery is generally simple, indicative of abundance and crop-growth. One final piece of iconography is remarkable in that it is the only Scottish representation of the *Matres*.[190] The relief was found built into a garden wall, the original provenance unknown. Here the mothers sit close together on a bench under a shell canopy; they are identically attired in fine-pleated robes; their large heads and thick necks may imply head-dresses; each goddess holds a round fruit; one has a basket of corn; the middle mother has a large bunch of grapes; the right figure holds a basket. The symbolism is of the fruits of the earth; the presence of the grapes and corn is interesting since they recall the attributes of the London goddesses. That the right goddess has her hand across her breast, thereby cramming her basket and her fruit in the other hand, must be significant; otherwise the awkwardness of the imagery seems unnecessary.

The triple mothers: summary and significance

The foregoing evidence demonstrates at the same time the homogeneity and complexity of the mother-goddess cult within western Europe. It was a widespread and popular form of worship, reaching its maturity only in the

Roman period yet being a specifically Celtic cult. The imagery, in its triadism, was foreign to the Roman world, though the goddesses may owe much of their original concept to Roman ideas of a fertility image. Syncretism is shown not only in the Latin name of *Matres* or *Matronae* (*Matrae* is another variant), but also by certain attributes – *paterae* and *cornuacopiae* for instance – which are of classical origin. The symbolism is interesting since it is maternal rather than sexual: the goddesses are clothed and their sex not emphasized except in the imagery of the nursing women. The symbolic power came from repetition or multiplicity of fertility and prosperity images and from the plurality of the goddesses themselves. The cult appears to have developed from a simple fertility religion to a much deeper concept of protection and well-being in all aspects of life and, indeed, of death.

The epigraphic evidence is peripheral to our main concern, which is visual imagery. But it is interesting that written dedications add further dimensions to the cult which are not always brought out in the imagery alone. We have seen that the names of the mothers may denote locality. Of these, some show an association with water, especially healing springs: the *Nemausicae* at Nîmes and the *Glanicae* at Glanum combine territorial with spring-water symbolism. The name of the *Comedovae* at Aix-les-Bains clearly refers to health and healing at this important thermal spa.[191] This water imagery is rarely expressed iconographically, except where boats, dolphins, and maybe the shell canopies imply aquatic associations. But context – for instance at Bath – also shows the importance of water, acknowledged as crucial as a life-source, with properties of healing and regeneration. The iconography itself shows the many levels of significance of the cult. Most overtly important were the blessings of earth and nature. Children, crops, beasts, trees, and flowers were all seen as the responsibility and bounty of the mothers. But the more profound symbolism of renewal, regeneration, and protection in the otherworld is also present, and there is the more sinister symbolism of the mothers as Fates, warning humankind that life on earth is short. Dogs and snakes may be suggestive of death, healing and rebirth; trees may represent not simply fertility but the Tree of Life, which dies and is reborn every spring. The association of the mothers with trees epigraphically is indicated at Grenoble, where the goddesses are named 'Nemetiales' or 'goddesses of the Grove'.

Finally we should look at the triplism itself: sometimes the mothers are identical – true triplets – and sometimes they carry different attributes, have varying hair-styles or, as often happens, one may be distinctive as the senior goddess. Intensity of symbolism, enhancement of the power of devotion and the augmenting of the value of the homage rendered must be the main reasons for multiplication. Triplication may have had a separate significance based on number. But are we seeing here one goddess or three? It is impossible to be dogmatic about this but certainly sometimes the goddesses

are all individuals and care is taken to portray them as such. In instances where the ages differ, then youth and maturity, with their particular qualities, must be represented. In the case of the German mothers, there is a consistent image of a young goddess flanked by two older ones. Here it seems that two mature images are symbolically unnecessary. Do we in fact have two goddesses, the third added simply because of balance, symmetry, and the magic number three? Like most Celtic symbolism, the interpretation of the triple image may embody several concepts and involve fluidity, ambiguity and personal choice. We have three goddesses or we have one mother with three facets or three intensifying images, perhaps with a symbolism close to that of the Christian Trinity.

Conclusion

Multiplicity was an important method of expressing the Celts' vision of their deities. Doubling the image increased its potency twofold; tripling it augmented it to the power of three and gave it also a magical dimension based on the number three itself. Triadism in religious expression reached its peak in the Celtic world. In addition to three heads, three horns, or three deities of the same type, there is also an abundance of triads of three diverse but associated gods: we can see an example of this on the Reims stele, depicting Cernunnos, Mercury, and Apollo.[192] We should remember, though, that religious triads are not the prerogative of the Celtic world. We have only to look at the Capitoline Triad of Rome – Jupiter, Juno, and Minerva – to see that such expression had its place in the contemporary Mediterranean world. But there is no doubt that triadism belongs *par excellence* to the Celtic peoples; the Roman poet Lucan mentions the Celtic triad of Esus, Taranis, and Teutates;[193] and triads abound in the literature of early Ireland and Wales. The significance of these ternary groups is obscure but intensification of entity seems to play some part in literary triplism.

The multiplication of images in Celtic iconography was a strong and important tradition. Plurality of symbolism was a basic method of increasing potency, of honouring the deity represented and, perhaps, of adding magic to the image. Simple repetition was important, but the number three was significant over and above sheer triplication. The differing attributes possessed sometimes by each of the three mothers means that as much relevant symbolism as possible was present on a given piece of iconography. Whilst a single maternal image could be depicted with three or four fertility emblems, it was considered more efficacious sometimes to represent the image itself twice or three times. But was triplism a profound religious concept or could it have been a response rather to artistic considerations, with 'three' forming a pleasing and symmetrical image? It is true that visual factors may have been relevant, but the evidence points to a far deeper significance than pattern alone. Finally, we should ask how triplism and general

plurality should be viewed within the context of other symbolism. Celtic imagery relied a good deal on emphasis. We will see in Chapter 7 that style played an important role. Likewise exaggeration of part of the image was a frequent acknowledgement of potency. Thus triplication or multiplicity may be seen to have fulfilled a purpose similar to that of image-exaggeration or over-emphasis: what was important to the Celtic craftsman or devotee was to convey the message within the symbolism of the deity worshipped and his followers. Triplism was one way of acknowledging the power of the gods and their status as supranatural entities who did not need to conform to the mundane restrictions of realism.

7

Style and belief

The style in which images of deities were presented may be as significant as the gods they portrayed. Through examining how artists and patrons envisaged divine entities, we are able to gain some idea as to attitudes towards the supernatural. One method of representation which differs from naturalism is multiplicity, considered in the previous chapter. Here, we may observe two further ways in which absence of realism in art-style impinges upon the relationship between humankind and the gods: emphasis on the one hand and abstraction on the other. The function of both kinds of representation is similar in that it desecularizes and transforms reality into something appropriate for the divine, through the transmutation of a mundane image to the sublime context of the supernatural.[1] With both stress and schematism, the artist may have been making a deliberate attempt at dehumanizing a given image. Thus, a schematic depiction may present a deity merely as a scratched 'matchstick-man' with no bodily details whatsoever. Or an image may be apparently badly proportioned, with no attempt to make the torso the correct size in relation to the limbs. Hands or heads may be grossly exaggerated. What is revealed by observation of these styles is not incompetence, but either a deliberate form of image-making or, at very least, the realization that realism was not necessary within a Celtic religious milieu.

Under Roman influence, Celtic traditions of symbol and pattern were retained but were adjusted in response to the stimulus of the Roman emphasis on figural imagery. It is to the credit of these Celtic craftsmen that they were able to adapt themselves whilst remaining true to their own traditions. Whilst some Romano-Celtic iconography – namely bronzes and official monumental sculpture – veered more towards classical realism, the vibrance of Celtic imagery flourished particularly within the context of smaller stone sculpture.[2]

Emphasis and exaggeration

The over-emphasis or exaggeration of part of an image is a phenomenon which is widespread both in space and time. Exaggeration in symbolism goes back in Europe to the Upper Palaeolithic (c. 30,000 BC) when the grossly female Gravettian 'Venus' figures were portrayed with facial details disregarded and where concentration was entirely on the imagery of fecundity.[3] In the Bronze Age religious art carved on the rocks of Scandinavia, southern France, and north Italy, images are schematized and simplified in real terms, but such important attributes as horns, weapons, and hands may be overstressed.[4] We have to look at what over-emphasis means in terms of its function, the message conveyed by exaggeration both to the devotee and to the god. First, both the patron commissioning the production of an image and the craftsman carrying out the work are acknowledging, admitting, and recognizing the power residing in the exaggerated part of the body. A further role of stress will include special reverence or propitiation of a particular divinity by means of 'flattery', admiring the strength of a god's horns, genitalia, or head, by making the essential characteristic of an image stand out. The observer of that image will be reminded that the potency of the god is linked to a specific part of his body, from which his power emanates.[5] Both human and animal images may be subject to emphasis. In beasts the stress is generally associated with an attribute or symbolism that is already present, for example ferocity or fertility. Thus horns and antlers (Figure 56) will often be exaggerated and, on boars, the over-emphasis of dorsal bristles acknowledges the terrifying character of this indomitable forest-dweller (Figure 59). In humans, the most common element for exaggeration is the head, in recognition of the special regard in which the Celts held this part of the body as the seat of under-standing and the source of all human strength. But, in addition to the overemphasis of parts of human and animal bodies, there are two other main forms of stress in symbolism: one concerns the enlargement of inanimate attributes of a deity; the other the relative sizes of divine and earthly symbols. I will examine these two phenomena before proceeding to look in detail at exaggeration of parts of images.

Exaggeration of attributes

The enlargement or over-emphasis of a deity's symbol or emblem is not confined to the iconography of the Celts but is something found also in vernacular Celtic literature. An example of this is the enormous club and cauldron of the Irish god, the Dagda[6]. In Romano-Celtic iconography, deities associated with prosperity sometimes possess attributes which emphasize their role: thus, the divine couple at Pagny-la-Ville in Burgundy[7] is depicted with many symbols; he has a pot and hammer of fairly normal

size, but her *patera* and *cornucopiae* are very large (Figure 20). Epona's platter of fruit on a relief at Trier[8] is similarly exaggerated. The *genius*-like god from Netherby[9] should, as a true *genius*, hold a *patera* over an altar, but here the offering-plate is replaced by a huge wheel, far too large for the diminutive altar over which it is held. The exaggeration of the sun symbol is again seen, for example, on Celtic coins such as one from the Bratislava area of Czechoslovakia which bears the image of a horse with an enormous solar wheel above its head[10]. Many other instances of symbol-emphasis could be cited, but those mentioned serve to demonstrate the function of this phenomenon as the enhancement of the power and role of the animate image by means of the accompanying symbol. *Paterae* and *cornuacopiae* – emblems of well-being and florescence – acknowledge the source of a divinity's power. Huge sun-signs express the dominance of the solar image, and this image is perhaps, therefore, of greater significance than the animate beings it accompanies.

Proportions

In some depictions where there is more than one image, the dominance of one over the other is acknowledged by means of relative size. On the Danish cult-cauldron from Gundestrup (Figure 1) deities are generally portrayed as larger than men. On one plate, a god dipping a victim into a vat towers over the humans who surround him[11]. The statuette of Epona at Alesia[12] is far too large for her mare, perhaps in recognition of her divinity and her mount's relegation to earthly status. This divine dominance may be observed, too, on such British reliefs as that at Chepstow Castle, where a large figure is accompanied by two smaller beings, perhaps worshippers[13]; and at Wycomb in Gloucestershire the image of a being resting his hands on the heads of two smaller individuals may likewise represent godly rank acknowledged by superior size[14]. But sometimes the emphasis is curiously placed: the bear-goddess Artio (Figure 10) is dwarfed by her accompanying animal[15], as if it were divine. On a Jupiter-Giant group at Neschers (Puy-de-Dôme) (Figure 53), the massive head, shoulders, and arms of the chthonic monster are much larger than the sky-god and his horse[16]. Here, at least, the powers of darkness were formidable adversaries.

Sometimes proportions of images may be distinctive not for the dominance of any one part but for the general lack of attention to realism. As argued earlier, it seems that this is simply due to the lack of need to portray naturalistically. Thus the hunter-gods at Le Donon[17] display attenuated bodies and disproportionately small heads (Figure 43), similar to Mercury and Rosmerta at Chatenois near Strasbourg[18] and to the Celtic 'Mars' figures at Bisley (Gloucestershire).[19]

The emphasis of parts of the body

I will look separately at the exaggeration of heads, as a very recurrent and distinct phenomenon. Otherwise, exaggeration may effect many varied parts of both human and animal bodies. In animals, the stress is most commonly, but not exclusively, on horns or antlers. Other instances include the carving at Moux in Burgundy (Figure 45)[20] where a god has a bird on each shoulder, with extravagantly large beaks. The horse on a silver coin from Bratislava has huge knee-joints, perhaps merely as part of an artistic pattern, but possibly to emphasize speed.[21] Sometimes the dorsal bristles on a boar are exaggerated, as, at Neuvy-en-Sullias (Figure 59)[22] and at Hounslow in southern Britain.[23] This must surely be both for art's sake and as an acknowledgement of aggression and ferocity (though the Hounslow animal is otherwise a benign-looking creature). The symbolism of the stag is concentrated on the antlers: we have seen (pp. 134–9) that these magnificent prongs reflected the beast's affinity with the forest and virility. Emphasis on antlers was present at Val Camonica, where on the Naquane Rock in the seventh century BC a stag was carved with enormous antlers (Figure 54).[24] The bronze cult-wagon of the same date from Strettweg in Austria shows a ritual stag-hunt where the two stags have bodies totally dwarfed by immense antlers (Figure 56).[25] Such Romano-Celtic stags as that at Colchester[26] also have prominent antlers. Bull- and goat-horns were often similarly acknowledged as symbols of potency, both on animal and human figures. Large horns adorn oxen in both Scandinavian and North Italian rock-art[27]. A seventh-century BC bronze bull from the cemetery at Hallstatt[28] has a slim form but huge upcurled horns dominating its body. The little goat-figurines from south-west Scotland and from Trier on the Moselle have exaggerated horns, presumably to stress their fertility symbolism.[29]

On humans, horns may similarly be emphasized, as on an altar from the Pyrenees.[30] Other stress in human imagery may take the form of enormous hands: this occurs again in European rock-art;[31] in Gaul, where a block-like image at Hallé (Indre) is virtually featureless except for the huge hands folded across the body;[32] and in Britain at Carrawburgh, where the triple Coventinae have large hands.[33] Very often, on human depictions, the eyes are given particular emphasis: Jope[34] has remarked on the importance of eyes in Celtic art; in a pre-Roman context, this may be partly as an artistic feature. Many of the faces which form part of the semi-abstract art-styles on Celtic metalwork have prominent or staring eyes. The Czechoslovakian brooch from Slovenské Pravno, with double face-mask, is a good example.[35] This preoccupation with eyes manifests itself in Romano-Celtic divine imagery where, on otherwise fairly featureless portrayals, the eyes are none the less clearly demarcated. This occurs at Bath, on an extremely schematized schist carving of the triple mothers (Figure 88);[36] and at Magny-sur-Tille in Burgundy another schematized god has huge eyes with deep grooves.[37] At

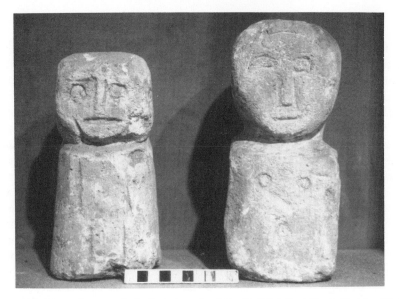

Figure 89 Stone figures of pilgrims: temple at Forêt d'Halatte (Oise). Musée d'Art et d'Archéologique, Senlis. Photograph: Miranda Green.

many of the Gaulish healing-spring sanctuaries which have produced images of pilgrims in wood and stone, the eyes are again stressed (Figure 70). We can observe this, for instance, at *Fontes Sequanae*, where the eye-emphasis may, in part, be due to the eye-disease and blindness which apparently afflicted many of Sequana's supplicants.[38] At another healing site, Forêt d'Halatte near Senlis (Oise), some images of pilgrims are completely featureless apart from the breasts (Figure 89); here again, desire for a cure of that part of the body is probably the reason – more likely to have been milk-failure rather than breast-disease *per se*. In Romano-Celtic religious iconography, breasts are rarely stressed in terms of sexuality or maternity. But male genitals are sometimes exaggerated. Ithyphallic figures are present at Val Camonica,[39] and phalli may be emphasized on stone sculpture. At the Le Donon mountain sanctuary[40] several images are ithyphallic; one of them[41] has a sword and thus both fighting and sexual aggression are indicated. Some of the nude war-gods of Brigantia may be both horned and phallic, as at High Rochester in Northumberland[42] where a nude, horned, schematized god has large genitals, thus demonstrating a link between war and sexuality – the latter reflected by both the sexual organs themselves and the presence of horns.

The emphasis on the head

The human head was recognized by the Celts as the most significant part of the body. Classical writers inform us of Celtic head-hunting and sacrificial ritual involving heads.[43] But such emphasis is reflected *par excellence* in pre-Roman and Romano-Celtic iconography. The stress on heads is shown evocatively on the Iron Age frieze from an *oppidum* at Nâges in southern Gaul[44] where alternating horses and human heads are depicted the same size. At such south Gaulish temple sites as Roquepertuse and Entremont, real skulls and carvings of heads demonstrate the Celtic preoccupation with the seat of understanding. Numerous Celtic heads occur in North Britain,[45] and on Gaulish money heads are depicted;[46] one coin represents a warrior with his war-trumpet, boar-standard and a decapitated head of an enemy.[47] Heads were important constituents in Iron Age Celtic artistic designs: we may cite the fifth/fourth century BC stone pillar from Pfalzfeld in Germany, where four heads at the base of the monument form part of a flowing, foliate design.[48] Iron Age jewellery frequently depicts heads, and we have such metalwork as the first-century BC or first-century AD bronze plaques from

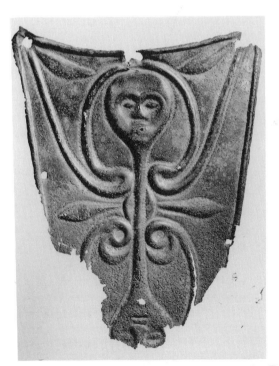

Figure 90 Iron Age bronze plaque with two conjoined heads: Tal-y-Llyn, North Wales. National Museum of Wales. Photograph: National Museum of Wales.

Tal-y-Llyn in North Wales[49] on which are two opposed faces joined by a single long neck (Figure 90).

The exaggeration of the human head on Romano-Celtic cult-images is a striking and recurrent form of emphasis. With this practice in mind, it would seem logical to interpret the occurrence of heads on their own as the natural next step. Both deity and devotee would know exactly who was being represented by what are, to us, anonymous Celtic heads. The image of the head, whether exaggerated or alone, possessed very specific properties. Indeed, the power of the image would have been positively enhanced and augmented because of the concentration on the most important part of the anatomy. In the case of both exaggeration and of representation of the head alone (*pars pro toto*), we are perhaps witnessing a deliberate method of honouring a god.[50] As in the other forms of emphasis already discussed, there is, in addition, the element of desecularization and the elevation of an image to divine status.

Time and again in Celtic iconography, the human head is emphasized, either by its size relative to the rest of the body or by the attention to detail. Sometimes size and detail come together on one and the same portrayal. Many divine images are depicted with heads which are large in relation to their torsos. Sometimes these are recognizable, named deities: Epona at Albaina in Iberia,[51] or Mercury and Rosmerta at Toul near Metz.[52] The hooved bronze god at Bouray in northern Gaul (Figure 37),[53] whose head takes up more than half the monument, may be the stag-god Cernunnos. A mother-goddess whose image was set up in the Sarrebourg Forest had an enormous head, balancing her large *patera* and purse, symbols of prosperity.[54] Anonymous gods, like the crude block-image at Jarnac (Charente)[55] or the Auxerre divinity with striated, cap-like hair,[56] may have, as their only distinctive feature, an exaggerated head. The chalk *genius cucullatus* at Rushall Down in Wiltshire was depicted with a head too big for his body,[57] but a northern British *cucullatus* at Birdoswald (Cumbria) had a small face and a huge hood.[58] This emphasis on head-dress rather than the head itself may be paralleled by the enormous bonnets of the Germanic mother-goddesses.[59]Perhaps most curious is the overemphasis of the head seen on a number of Jupiter-Giant column groups where, interestingly, it is the giant rather than the sky-god who has an enormous head (Figure 53).[60]

On some images where the head is exaggerated, the body itself may be portrayed very schematically. The head may not only be large but also, on occasion, depicted in far more detail than the body. This is true of the goddess at Caerwent (Figure 14)[61] whose large head is relatively well-carved but where scant attention has been paid to her torso; she has a square trunk and diminutive limbs. On many reliefs, the image may be that of a 'pin-man' but with a large round head: this may be observed in Gaul in such images as the horseman from St-Michel-de-Valbonne near Hyères in southern France, where a 'matchstick' horseman with a huge head rides over five severed

heads.[62] Such images occur all over Britain, too, in Oxfordshire at a shrine at Woodeaton,[63] in northern England[64] and in south-east Wales.[65]

There were ways in which attention was paid to the head other than by exaggerating its size. The wooden votive carvings at *Fontes Sequanae* are usually fairly roughly hewn, but often the head is, by contrast, better modelled with the eyes especially well-demarcated (Figure 70).[66] The curative shrine of Chamalières (Puy-de-Dôme) has produced very similar wooden images with the head and sometimes the eyes emphasized.[67] Eye-problems perhaps meant that eyes at least must be carefully modelled in order to effect a cure. At these therapeutic thermal shrines, not only are faces better represented but the heads may be large, a trait enhanced by the frequent presence of hoods. At *Fontes Sequanae* there are several instances of multiple heads (Figure 91), which is another way of stressing the importance of this image.

At the extreme end of the head-emphasis spectrum is the representation of the head alone. Severed heads, maybe representing battle victims (commented upon with righteous horror by Mediterranean observers), may be depicted at such southern Gaulish temples as Entremont and Roquepertuse, where carved heads and real skulls occur together. Some of the warriors from these sites rest their hands on heads with closed eyes, and it may be that these represent the dead.[68] If such an interpretation is valid, death symbolism may then explain the exaggerated heads of some of the giants of the Jupiter-horseman groups. But many divine images could be

Figure 91 Superimposed wooden heads: *Fontes Sequanae*. Musée Archéologique de Dijon. Height approx. 70cm. Illustrator: Paul Jenkins.

represented by heads. Of the vast numbers of Celtic heads recorded for Britain,[69] some at least are authentic (Figure 41). Indeed heads alone form a link between emphasis and schematism – which forms the second section of the present chapter. I have described schematism as a kind of divine shorthand, where reduction to the essentials of imagery has taken place. In a sense, head depiction is fulfilling a similar function. Sometimes both patron and craftsman considered that only the head was necessary for representation of a divine image and that all other details were unnecessary. I turn now to schematism as an artistic and religious concept.

Schematism and abstraction

A great deal of Celtic cult-imagery presents the divine image as an apparently simple incised outline, a 'pin-man' figure which has the immediate appearance of a child's doodling before it begins to look at form. I would argue that, far from being incompetent art, such imagery is the result of deliberate religious choice on the part of both the craftsman and the commissioning patron. In examining such abstract or schematic depictions, it is necessary to be careful neither to judge from a conventional artistic standpoint nor to confuse artistic style with religious function and intent.

The move away from realism on the part of Celtic religious art requires some explanation. In the Mediterranean, particularly in the Greek world, the main function of the artist was to impress man and the gods by portraying them as true to life as possible. Both the Greeks and the Romans were, to an extent, obsessed with the true nature of appearance.[70] Thus art had an imitative rather than an interpretative and symbolic role; the gods were depicted as close to life as possible so that their images were the more comprehensible to the beholder.[71] By contrast, the Celts were not bound by the rigidities of 'mimesis' or realistic copying. In the pre-Roman La Tène phases, human and animal forms were subservient to overall artistic designs, which were essentially geometric, abstract, with pattern the main preoccupation. Celtic art sprang from different roots and intentions from those of classical art; here symbolism played a far greater role than realism. The equation 'mimesis = excellence' had no meaning in a Celtic milieu.

When considering the role of schematism in religious art, we have first to consider the function of imagery itself. As commented upon at the beginning of this chapter, one role of schematic Celtic representation was to transform the real to something appropriate to the supernatural. Thus, superficial criteria of artistic competence (in classical, mimetic terms) become irrelevant when images are judged within the context of their function as religious objects. Schematism, in a Celtic context, was a conscious and successful method of presenting images. It may have been a deliberate shorthand, where mimesis was perhaps rejected as unsuitable for the divine. On occasions, Celtic craftsmen appear to have used 'schemata' or 'minimum

clues of expression'.[72] For an image to be successful, it may be a mere scratching as long as it retains the 'efficacious nature of the prototype'.[73] The success of a representation must be judged in terms of the purpose and requirements of a particular society.[74] The Celtic artist studied his model – a man or a beast – and was able to reduce the essentials for representation to an absolute minimum, enough for recognition but no more. Economy of detail captured the 'numen' or the essence of an image and what it symbolized. All that needed to be retained was the value or symbolism of the prototype; all inessential detail could be abandoned. What is clear is that in simple representative drawing, using symbolic forms, there was no attempt at accurate delineation of the subject and no belief on the part of the artist that the design was a true picture of the object represented. The break with realism may have been partly because the artist wanted a forceful outline from which detail could only detract.[75] Such symbolic art is a form of expression not only of technique but also of emotions and thought, a form of communication almost like writing. Whether in artistic or religious terms, abstraction and schematism may play as important a role in art as naturalism.[76] In Celtic coinage, for example, the scope for artistic expression was severely constrained by the size of the matrix, but it provided, none the less, a medium for an innovative, vibrant, and schematic art unbounded by realism, even though the image prototypes were of Mediterranean origin.[77]

So, then, let us further examine the deliberate use by Celts of schematism to express their thoughts about the divine. The religious function of abstract representation appears at Camonica Valley where, Anati would argue,[78] the most schematic of the carvings are those with a religious theme. Much earlier, in the Europe of the seventh and sixth millennia BC, Gimbutas[79] demonstrates that realistic and schematic representations co-existed and were sometimes arguably the work of the same artists. Perhaps here too we have deliberate choice. Where a Celtic artist or patron chose a schematic representation of a divine image, it may be that there was conscious religious obscurity, enigma, and ambiguity appropriate to the shifting and fluid character of Celtic religion itself. The idea may have been that a schematic, understated image could be interpreted flexibly by different people, a kind of choice of perception. An example of this is in images of Mercury, where projections on his head may be interpreted as Roman wings or as Celtic horns, depending on the ethnic origin and religious leaning of the spectator.[80]

In order to attempt an understanding of Celtic religious schematism, we have to take cognizance not only of free Celtic art traditions but also of pre-Roman belief-systems. These did not include a predilection for the human or animal form. Celtic notions of divinity were deeply rooted in natural phenomena, sensed rather than directly envisaged and perceived. In their religious art, there was no need for a predominantly rural society such as that of the Celts to be preoccupied with realism in imagery.[81] Celtic sculptors and worshippers did not necessarily identify their gods in terms of human

perfection. Stylization, schematism, and abstraction owed their presence to Celtic artistic and religious traditions and, moreover, provided a new dimension in honouring their divine powers. The gods were too important to be bound always by the rigidities of representation through copying the human form. The Celts sometimes strove to transcend their own human parameters and to invoke their deities with images appropriate to their unearthly status.

Schematism in action: gods and goddesses

All kinds of images and deities sometimes underwent schematism in representation. It was not only divinities of Celtic origin who were thus portrayed, but it is possible to observe that certain god-forms lent themselves to 'shorthand' imagery. Our evidence embraces recognizable entities, like Mercury and Epona, Celtic warriors, mother-goddesses, horned gods and *genii cucullati* but, in addition, images without feature or attribute yet whose very visual anonymity may itself be deliberate.

Of all deities of Roman origin worshipped in the Celtic world, Mercury appears, by his popularity, to have been perhaps the most readily adaptable to Celtic concepts of divinity. His purse and fertility emblems gave him an easy Celtic identity as a god of prosperity and well-being. So it is with little surprise that we find Mercury to have been a frequent subject of schematic representation. In Gaul, some images of the god are so abstract that only his purse identifies him: thus he is rendered at Le Donon,[82] Magny-sur-Tille[83] and Chatenois, where he appears with Rosmerta (herself a celticizing feature).[84] British images, too, were sometimes reduced to essentials: at Emberton (Buckinghamshire)[85] and Uley (Gloucestershire)[86] the god's winged *petasos* may easily become horns, and indeed unequivocal horned Mercury-figures were set up in North Britain.[87]

Horned gods and warriors present some of the most schematized images of the Celtic repertoire; very frequently a figure may be both armed and adorned with horns. In Gaul, several 'pin-man' warriors were represented as both foot-soldiers and cavalry: at Magny in Burgundy[88] and Galié in the Pyrenees[89] spear-bearing soldier-gods are thus portrayed; and an image at Le Donon[90] brandishes a sword. Horsemen as 'matchstick' figures occur in southern Gaul, at St-Michel-de-Valbonne[91] and at the pre-Roman site of Mouriès, where incised cavalrymen may date as early as the sixth century BC.[92] Naturally enough, British schematic warriors are concentrated in the frontier regions of Wales[93] and North Britain:[94] at Bewcastle, a god called Cocidius was invoked by two silver plaques which, expensive cult-objects though they were, bore images of war-gods treated none the less with apparent crudity of outline.[95] But warrior-deities such as these could be revered also in areas of Britain which were romanized and pacified early, at Wall in Staffordshire[96] and Chedworth in Gloucestershire,[97] for instance. Schematic horned gods are almost exclusively British,[98] and again cluster in

the northern hegemony of Brigantia. High Rochester in Northumberland has produced a number of these images,[99] sometimes with exaggerated heads or genitals. The facial features are incredibly simply sketched, with small holes for the eyes, the mouth a mere slit and nipples and navel incised circles.[100] Simply-fashioned horned heads[101] were also endemic to this northern frontier region on the periphery of the Roman world (Figure 41).

Occasionally, but only rarely, is Jupiter treated schematically: we have already noted that proportions of the Jupiter-Giant groups are sometimes curious and that the giant's head may be abnormally large (Figure 53). Sometimes the Romano-Celtic horseman himself is stylized; this happens for instance at St-Maho near Plouaret in Brittany.[102] In Rouen Museum is a 'classical' Jupiter with his eagle (not celticized as a rider) but his whole body has been treated in an extremely schematized manner.[103] Again, perhaps curiously, the Celtic hammer-god is rarely schematized; but there is an exception in the Musée de Bourg.[104] By contrast the Celtic *genii cucullati* of the Dobunnic Cotswolds are sometimes represented merely as scratched shapes or as triangular, featureless images (Figure 92).[105] But even here, the essential elements of the *cucullati* – threeness and hoodedness – are present, and the stark understatement of their artistic treatment enhances their enigma.

The goddesses, too, are not exempt: of these, Epona and the mother-goddesses are most frequently treated schematically. All over Gaul, but

Figure 92 Three *genii cucullati*: Cirencester. Corinium Museum. Height 25.5cm. Photograph: Betty Naggar.

especially in the east, realistic and abstract images of the Celtic horse-goddess share the same clusters of distribution. Epona is rarely portrayed as a 'matchstick' figure like the war-gods, but her image may be geometric and angular, with sharp, unnatural lines.[106] Thus at Trier, Epona's hair is depicted as a short striated/pleated cap[107] and, at Luxeuil, she wears a similarly severe pleated skirt.[108] The stylization of Epona's image at Perthes (Haute-Marne) extends to her horse which is similarly treated.[109] Though, as already commented, schematism is rare on bronzes, Epona is thus rendered on a bronze figurine from Naintré, Vieux-Poitiers.[110] Extreme abstraction on images of mother-goddesses is less common but is present in both triple and single representation. A schist plaque at Bath (Figure 88)[111] shows three extremely stylized, geometric ladies with large eyes and no mouths; they wear pleated skirts and their arms are folded across their bodies, but they are two-dimensional and there has been no attempt at accurate representation of the human female form. A very close parellel may be cited in an image of the mothers carved on a rock at Nyon in Switzerland.[112] A single female from a villa at Noyers-sur-Serein (Yonne) is seated, wearing a long garment; her body is a featureless block, with square, massive shoulders and a small head;[113] similar treatment may be observed on a mother at St-Cyr near Poitiers.[114]

Then there are what are, to us, anonymous deities, with no identifying attribute. One group possesses a certain homogeneity in that certain characteristics are shared: the massive block-like torso and the frequent presence of a torc as the only feature – worn round the neck or carried (Figure 93).[115] Other images are more heterogeneous, like the repoussé bronze image at Woodeaton, Oxfordshire,[116] or the gods and animals stamped on a sheet-bronze sceptre-binding in a temple at Farley Heath in Surrey.[117] In Gaul, there are numerous 'crude' stone images, usually simple, naked and without attributes.[118] A distinctive carving is that of a triple image from Chorey in Burgundy, treated with extraordinary schematism but with enigmatic 'X's on their torsos.[119] The significance of this symbol is obscure, but it is possible that it may have a funerary or solar association.[120]

Also representing 'anonymous' gods in simple, schematic form are a number of Celtic heads, looked at earlier (pp. 211–14) in the context of emphasis. Some of these are distinctive in their simplistic imagery. The facial features are often geometric, with the eyes represented as lentoid in form or simply as horizontal grooves, and with wedge-shaped noses and gash-mouths.[121] Some of these heads possess extra features: some, particularly in northern Britain, are horned;[122] others may be janiform[123] or phallic.[124] But all share the characteristics of abstraction in facial features, a frequently shuttered or frightening mien which may have been a deliberate attempt to inspire awe in the worshipper.

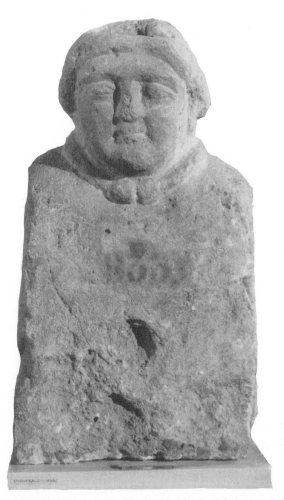

Figure 93 Stone image wearing torc: Alesia. Musée Archéologique de Dijon. Base width 40cm. Photograph: Miranda Green.

Schematism in action: animals and pilgrims

Animals in imagery, whether accompanying deities or alone, may undergo a similar stylistic treatment to their anthropomorphic associates. Here the most dominant animal is the horse: the equine images on Celtic coinage are highly schematic, but the essential element of 'horse' is present – all the power, movement, and beauty with which horses are endowed.[125] The incised horse-profiles at the free Celtic south Gaulish shrine of Roquepertuse

219

(Figure 62)[126] show grace, and the spirit of the beasts is strongly evident. Likewise, the simple mare-and-foal image at Chorey (Figure 64) is schematized, but the 'numen' of the relationship between adult and juvenile is there.[127] The 'matchstick' beasts at Mouriès (Bouches-du-Rhône) are similarly unequivocal horses.[128]

Human devotees represented at the great Celtic healing shrines of Gaul frequently possess a schematism that is peculiar to these sites. Waterlogged conditions mean that quantities of late free Celtic wooden images may survive. These are simply carved in oak or beech. Best-documented is the

Figure 94 Stone pilgrim: Forêt d'Halatte. Musée d'Art et d'Archéologie, Senlis. Base width approx. 18cm. Photograph: Miranda Green.

spring-shrine to Sequana at *Fontes Sequanae*,[129] but Chamalières,[130] Essarois,[131] Luxeuil[132] and Forêt d'Halatte near Senlis[133] have all produced similar images. Stray wooden carvings, too,[134] may possess similar features. The attention paid to the head in many instances has been noted above, but often facial features are themselves stylized, with grooves for eyes, nose, and mouth. Whilst the Romano-Celtic stone pilgrims at *Fontes Sequanae* are frequently more realistically treated.[135] the stone images at Forêt d'Halatte[136] remain very abstract; here the transference from wood to stone was one purely of medium. Romanization may have affected choice of materials, but Roman influence did not change the style of the art-treatment itself (Figures 94-6). What is interesting about *Fontes Sequanae* is the numerous metal votive objects of silver and bronze showing afflicted parts of the body

Figure 95 Stone pilgrim: Forêt d'Halatte. Musée d'Art et d'Archéologie, Senlis. Base width approx. 16cm. Photograph: Miranda Green.

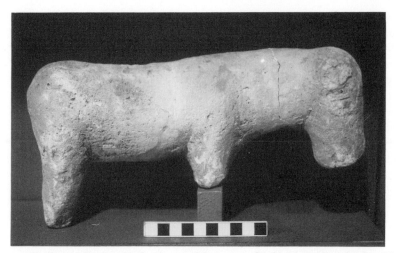

Figure 96 Stone figure of animal, possibly horse: Forêt d'Halatte. Musée d'Art et d'Archéologie, Senlis. Length approx. 15cm. Photograph: Miranda Green.

in miniature. A fascinating group depicts eyes and/or breasts which may be virtually indistinguishable (Figure 74). It may be that the shop suggested as being present at the sanctuary sold these deliberately ambiguous votives for use by people with eye or breast problems. Indeed, malnutrition was probably a cause both of blindness and of milk-deficiency. This ambiguity is observable in the wooden figures of the pilgrims, which Deyts suggests[137] were deliberately imprecise in order that a pilgrim could endow the image with his or her own spiritual identity. What is plain is that on the faces of many of the pilgrims is the mark of suffering.[138]

Conclusion

The style in which certain Celtic images were depicted adds a dimension to their symbolism. Deities were honoured not only by the setting up of representations of and to them – their attributes and identity reflected in their iconography – but also by both over-emphasis and, paradoxically, by understatement. Both types of representation contained a special symbolism, a half-hidden message to both spirit and supplicant. Realism – that is imitation of life – could, on occasions, be eschewed. Instead the sublimity of the divinity could be echoed in his image; the gods were not of this world and thus their images were not bound by human perceptions. Emphasis is the lesser enigma; the stress on an emblem or part of the body was a method of honouring a deity, or sometimes of identifying an afflicted part, by means of a symbolism that was easily comprehended. Schematism is less readily understood. It begs questions of artistic

competence which may cloud the religious issue. Only by recognition that it is cult, not art, that is of primary importance, may abstraction be judged for itself. Apparent simplicity may mask sophistication, and starkness, profound concepts. However such religious art is assessed, what is clear is that naturalism was not necessary, nor even always desirable.

8

Epilogue

This is intended not so much as a conclusion but as a comment on some of the most significant issues emerging from this study of symbolism in the Celtic world. The need to examine iconography both at regional and at supraregional levels has been important in establishing the different strata of belief-systems expressed by image-types which range from the local to the inter-tribal. The sky-god and the mother-goddess were virtually pan-tribal, each with a very broad spectrum of activities; the triple-faced image and the antlered god show distinct regional, sometimes tribal preferences. In some instances, imagery was closely associated with local customs and economies: the Burgundian wine-deities are a superb example. Other images were very localized: Sequana belonged exclusively to her spring sanctuary, and Nehalennia was venerated at just two North Sea coast temples among the Morini.

The iconography of the pre-Roman Celtic period is sparse compared to the great surge of visual symbolic activity which came about as a result of the catalyst born of the meeting between Roman and Celtic tradition. None the less, enough free Celtic iconography survives to demonstrate that there was some tradition, which awaited expansion and adaptation during the Romano-Celtic phase. Once Mediterranean artistic figural traditions arrived in the Celtic world, imagery vastly increased and, indeed, most image-types appeared for the first time under the stimulus of Graeco-Roman influences. Some divine images, as we have seen, were far removed from classical concepts, both in terms of artistic custom and religious expression. In others, influence from the Graeco-Roman world played an important part. Different image-types possessed a greater or lesser bias towards indigenous or Mediterranean concepts. Frequently, however, even if considerable influence from the Roman world was present, such iconography was adapted in a highly idiosyncratic manner to a Celtic divine context. An example of this is the classical theme of the Battle of Gods and Giants, adapted in the Celtic world to display the antithesis of positive and negative forces in a

Celtic sky-cult. The balance and blend of Roman and native symbolic tradition manifests itself in the use of iconography and epigraphy to complement each other. Deities of Roman origin may possess Celtic names but their imagery may remain classical, or vice versa. It would seem that the symbolic message could be conveyed either by epigraphy or iconography or by a blend of both. Thus, perhaps, the indigenous character of, say, the Celtic Mercury could be projected as long as either his surname or his physical appearance possessed a celticizing aspect.

But we must be wary of seeking gratuitously to divide Roman from Celtic belief-systems. There were major differences certainly (some pertaining to the differences between an urban and rural society), but there were also similarities which made the religious conflation between the two cultures so easy. The Italians had topographical spirits and sacred groves, and Mediterranean peoples venerated the *numina* of sacred springs long before they set foot in the Celtic world. They had goddesses of fertility who were readily adapted to become Celtic mother-goddesses, and the Italian Mars, like his Celtic counterpart, had a bucolic as well as a combative role.

Celtic imagery itself has features of considerable interest. First, one may point to the multiplicity of symbolism on one and the same monument: thus an altar may be decorated with repeated hammer symbols, or a mother-goddess might possess several different prosperity emblems. Symbols themselves may be complicated and interactive: thus the composite hammer-barrel-solar attribute of the Vienne hammer-god may convey the symbolism of a striking implement, a wine vessel and the sun, all at the same time. Intensity of imagery occurs in the multiple god-forms like the *Deae Matres*, and in the divine partners, where the marriage itself was an important factor in the symbolism. Sometimes the iconography may be both profound and ambiguous. There is a constantly recurring regenerative theme, with prosperity, healing, and rebirth after death often going hand-in-hand. Symbolism could often be interpreted at a number of levels and there may sometimes have been deliberate ambiguity. Thus a sword need not just convey the image of a war-god but also (or instead) a guardian against disease; a mother-goddess's napkin or scroll may symbolize both a human baby and fertility and the Book of Life; a wine-vessel may be just that, but it may also convey the symbolism of life, blood, and maybe resurrection. Nehalennia had cyclical imagery as a profound goddess of life and death, in addition to her protective role towards seafarers. Epona had the keys to Heaven as well as to her stable.

Much of Celtic religious imagery was highly individualistic: the close links with the natural world manifested themselves in the clear sanctity of animal qualities, so much so that in some iconography, the boundaries between zoomorphic and anthropomorphic images are broken down. The need to intensify imagery and to convey the message of magic 'threeness' is seen in the triple images. Schematism and exaggeration again show Celtic

idiosyncrasy in eschewing the bonds of realism. We should remember the Celtic king Brennus who, in the third century BC, laughed at the Greeks for setting up figures of the gods, probably because they so closely resembled humans.[1] Notwithstanding the profound contribution of Mediterranean tradition, this book has attempted to display the intensely individual character of the Celtic peoples, both in the nature of the gods themselves and in the manner in which beliefs in these gods was expressed. The iconography presents a dazzling panoply of images, each visually explicit (perhaps because the Celts were happier not to rely on epigraphy to convey symbolism) but at the same time often understated and ambiguous. More than anything, examination of such religious imagery demonstrates the profundity of many divine concepts. The gods were supportive of their worshippers, not feared but turned to; they aided humankind in life and death, in illness and prosperity. The lack of contemporary Celtic literature means that Celtic religion is often treated somewhat simplistically. Whilst iconography alone can never give us a Celtic theology, it nevertheless can help to open the door to the Celtic soul.

Abbreviations

CIL *Corpus Inscriptionum Latinarum*, Berlin, Georgium Reimerum, 1861–1943

Espérandieu Espérandieu, E., *Recueil général des bas-reliefs de la Gaule romaine*, Paris, Imprimerie Nationale/Ernest Leroux, 1907–66

RIB Collingwood, R.G. and Wright, RP., *The Roman Inscriptions of Britain*: *Volume I, Inscriptions on Stone*, Oxford, Oxford University Press, 1965

Notes

2 The female image

1 M. J. Green, *The Gods of the Celts*, 1986, p. 73.
2 For example Dio Cassius, LXXVI, 2.
3 Caesar, *de Bello Gallico*, V, 14.
4 E. Thevenot, *Divinités et sanctuaires de la Gaule*, 1968, p. 166.
5 P. MacCana, *Celtic Mythology*, 1983, 84–6.
6 A. Hondius-Crone, *The Temple of Nehalennia at Domburg*, 1955, 14–15.
7 J. van Aartsen, *Deae Nehalenniae*, 1971.
8 F. Jenkins, 'Nameless or Nehalennia', *Archaeologia Cantiana*, vol. 70, 1956, pp. 192–200.
9 For example, Hondius-Crone, op. cit., no. 5.
10 Espérandieu no. 6639; Hondius-Crone, op. cit., no. 1; Museum van Oudheden, Leiden, nos. 1970/12.13; 1970/12.12.
11 At Domburg: Hondius-Crone, op. cit., nos 1–14. Colijnsplaat: Museum van Oudheden 1970/12.18; 1971/11.54; 1971/11.67, etc.
12 Museum van Oudheden, Leiden, no. 1970/12.16.
13 Museum van Oudheden, no. 1971/11.65.
14 Museum van Oudheden, 1971/11.57.
15 Colijnsplaat: Museum van Oudheden, Leiden, 1970/12.12. Domburg: Hondius-Crone, op. cit., no. 3.
16 E. B. Stebbins, *The Dolphin in the Literature and Art of Greece and Rome*, 1929.
17 For example, Colijnsplaat: Museum van Oudheden, 1970/11.64; 1970/12.25. Domburg: Hondius-Crone, op. cit., nos 13, 16.
18 Colijnsplaat: Museum van Oudheden, 1971/11.55; 1970/12.3.
19 For example, Domburg: Expérandieu no. 6640; Hondius-Crone, op. cit., nos 2, 3.
20 Hondius-Crone, op. cit., no. 11.
21 Hondius-Crone, op. cit., p. 111.
22 Hondius-Crone, op. cit., no. 1.
23 ibid., no. 15.
24 Museum van Oudheden, no. 1970/12.18.
25 K. Linduff, 'Epona: a Celt among the Romans', *Collection Latomus*, vol. 38, 1979, pp. 817–37.
26 R. Magnen and E. Thevenot, *Epona*, 1953, nos 2–3; L. S. Oaks, 'The

goddess Epona: concepts of sovereignty in a changing landscape', in M. Henig and A. King (eds), *Pagan Gods and Shrines of the Roman Empire*, 1986, pp. 77–84.

27 At Gannat: Espérandieu no. 1618; Fontaines-lès-Chalon: Espérandieu no. 2110; Meursault: Musée de Beaune; Brazey-en-Plaine: Espérandieu no. 7515, for instance.

28 S. Boucher, *Recherches sur les bronzes figurés de Gaule pré-romaine et romaine*, 1976, p. 163.

29 In the museum at Worms.

30 Espérandieu, German volume, no. 404; Württembergisches Landesmuseum, Stuttgart.

31 Landesmuseum, Zürich; Espérandieu no. 5445.

32 As at Ste-Sabine (Côte d'Or): Musée de Beaune; Luxeuil (Haute Saône): Espérandieu no. 5320; Entraigne Gaubertin (Loiret): Musée d'Orleans; Magnen and Thevenot, op. cit., no. 99.

33 Thevenot, op. cit., 187–91.

34 Espérandieu no. 8235; S. Deyts, *Dijon, Musée Archéologique: sculptures gallo-romaines mythologiques et religieuses*, 1976, no. 8.

35 Landesmuseum Bonn; Espérandieu no. 4219.

36 Espérandieu no. 4188; E. Wilhelm, *Pierres sculptées et inscriptions de l'époque romaine*, 1974, no. 315.

37 Espérandieu no. 1380.

38 Grand: Espérandieu no. 4894, Musée d'Epinal; Gannat: Espérandieu no. 1618, Musée des Antiquités Nationales, St-Germain-en-Laye.

39 Meursault: Magnen and Thevenot, op. cit., no. 181; Clermont Ferrand: ibid., no. 56.

40 Espérandieu no. 5320.

41 Espérandieu nos 5341, 5342.

42 J. J. Hatt, *Les Monuments funéraires gallo-romains du Comminges et du Couserans*, 1945, series D, no. 23.

43 M. Toussaint, *Metz à l'époque gallo-romaine*, 1948, pp. 206–7.

44 Espérandieu nos 4350–5.

45 Espérandieu no. 4355.

46 E. Thevenot, *Autun*, 1932.

47 As at Chassaigne-Montrachet: Espérandieu no. 2033; Musée de Beaune; and Allerey: Espérandieu no. 8235.

48 This can be seen, for instance, at Autun: Espérandieu no. 1855, Musée Rolin; Fontaines-lès-Chalon: Espérandieu no. 2110; Mellecey: Espérandieu no. 2128, Musée Denon, Chalon-sur-Saône; and several other Burgundian stones.

49 Espérandieu no. 2127, Musée Denon, Chalon-sur-Saône.

50 Espérandieu no. 7513, private collection.

51 Espérandieu no. 2046; C. Bémont, *L'Art celtique en Gaule 1983–1984*, 1983–4, p. 196, no. 256, Musée de Beaune.

52 At Autun: Musée Rolin; St-Martin: Espérandieu no. 2124; and at Brazey: Espérandieu no. 7515.

53 G. Drioux, *Cultes indigènes des Lingons*, 1934, pp. 78–82.

54 *CIL*, XIII, no. 5622.

55 Thevenot, 1968, op. cit., pp. 185ff.

56 Magnen and Thevenot, op. cit., no. 117.

57 G. Thill, *Les Epoques gallo-romaine et mérovingienne au Musée d'Histoire et d'Art*, 1978; Wilhelm, op. cit.

58 Wilhelm, op. cit., no. 317; Espérandieu nos 4255 and 4262.

59 Wilhelm, op. cit., no. 320; Espérandieu no. 4263.
60 Luxembourg, Musée des Etats; Wilhelm, op. cit., no. 322.
61 Wilhelm, op. cit.
62 Linduff, op. cit., pp. 817–37; Espérandieu no. 7736; R. Schindler, *Führer durch des Landesmuseum Trier*, 1977, Abb. 101.
63 Musée Archéologique, Strasbourg; Espérandieu no. 7290.
64 Suetonius, *Nero*, 22.
65 Espérandieu no. 5863.
66 For example Köngen: Espérandieu, German volume, no. 586; Landesmuseum Stuttgart; and Oehringen: Espérandieu, German volume, no. 660; Landesmuseum Stuttgart.
67 L. Botouchrova, 'Un nouveau monument de la déesse celto-romaine Epona', *Revue archéologique*, vol. 33, 1949, pp. 164ff.
68 British Museum; C. M. Johns, 'A Roman bronze statuette of Epona', *British Museum Quarterly*, vol. 36, 1971–2, pp. 37–41.
69 op. cit.
70 As at Poitiers in stone: G. Nicolini, 'Informations archéologiques: Poitou-Charentes', *Gallia*, vol. 33, 1975, pp. 381–2; and bronze: J.-Cl. Papinot, 'Circonscription Poitou-Charentes', *Gallia*, vol. 43, 1985, p. 508, pl. 26; and at Saintes in stone and wood: Musée Archéologique de Saintes.
71 H. Roland, 'Inscriptions antiques de Glanum', *Gallia*, vol. 3, 1944, pp. 167–233; Musée des Alpilles, St-Rémy-de-Provence.
72 At Cilli: *CIL* III, no. 5192.
73 Linduff, op. cit., pp. 817–37.
74 P.-M. Duval, *Les dieux de la Gaule*, 1976, p. 50.
75 For example Minucius Felix, *Octavianus*, XXVII, 7; Juvenal, *Satires*, VIII; Apuleius, *Metamorphosis*, III, 27.
76 Thevenot, 1968, op. cit., pp. 187–91.
77 D. F. Allen, *The Coins of the Ancient Celts*, 1980.
78 Linduff, op. cit.; Oaks, op. cit.
79 Oaks, op. cit.
80 Linduff, op. cit.
81 Magnen and Thevenot, op. cit., no. 32.
82 Linduff, op. cit.
83 Oaks, op. cit.
84 G. Olmsted, *The Gundestrup Cauldron*, 1979, pl. 2.
85 H. von Petrikovits, 'Matronen und Verwandte Gottheiten', *Ergebnisse eines Kolloquiums veranstaltet von der Göttinger Akademiekommission für die Altertumskunde Mittel- und Nordeuropas*, 1987, p. 246.
86 S. R. Tufi, *Corpus Signorum Imperii Romani. Great Britain. Vol. 1, Fasc 3. Yorkshire*, 1983, no. 31, pl. 9; A. Ross, *Pagan Celtic Britain*, 1967, p. 217.
87 Tufi, op. cit., no. 30, pl. 9.
88 Musée de Chaumont; Espérandieu no. 7701.
89 Ross, op. cit., p. 217.
90 Green, *The Gods of the Celts*, E. Thevenot, *Sur les traces des Mars celtique*, 1955.
91 Musée d'Epinal; Espérandieu no. 4786.
92 Musée d'Epinal; Espérandieu no. 4831.
93 J. J. Bober, 'Cernunnos: origin and transformation of a Celtic divinity', *American Journal of Archaeology*, vol. 55, 1951, pp. 13–51.
94 E. M. Wightman, *Gallia Belgica*, 1985, p. 178.

95 L. R. Laing, *Coins and Archaeology*, 1969, p. 164; P.–M. Duval, *Monnaies gauloises et mythes celtiques*, 1987.
96 E. Linckenheld, 'Sucellus et Nantosuelta', *Revue de l'histoire des religions*, vol. 99, 1929, p. 72.
97 op. cit., p. 85.
98 Musée Archéologique de Metz; Espérandieu no. 4568.
99 Dedicated by a Mediomatrician; *CIL* XIII, no. 4543.
100 Espérandieu no. 6000.
101 Wilhelm, op. cit., Ross, op. cit., p. 244.
102 Espérandieu no. 2218.
103 J. Le Gall, *Alésia*, 1985, p. 57, fig. 31.
104 Bober, op. cit., pp. 45ff.
105 Ross, op. cit., fig. 103.
106 Boucher, op. cit., p. 161, fig. 292.
107 ibid., p. 161, fig. 291.
108 Jenkins, op. cit., pp. 192–200.
109 E. M. Wightman, *Roman Trier and the Treveri*, 1970, p. 217.
110 ibid., p. 223.
111 Luxembourg, Musée des Etats; Espérandieu no. 4270; Wilhelm, op. cit., nos 327, 328.
112 Thill, op. cit., nos 45, 46.
113 Musée d'Aarau; Espérandieu no. 5455.
114 Rheinisches Landesmuseum Bonn, *Wir Entdecken die Römer*, 1973, p. 76 Abb. 66.
115 G. Ristow, *Religionen und Ihre Denkmäler in Köln*, 1975, no. 42; G. Ristow, *Römischer Götterhimmel und frühes Christentum*, 1980, Bild 43.
116 Römisch-Germanisches Museum, Köln.
117 Jenkins, op. cit., pp. 192–200.
118 P. J. Drury and N. P. Wickenden, 'Four bronze figurines from the Trinovantian Civitas', *Britannia*, vol. 13, 1982, pp. 239–43, pl. XVIII, 4.
119 Römisch-Germanisches Museum, Köln.
120 Espérandieu no. 7538.
121 Musée de Bordeaux; M. Giffault, 'Deux figurines de terre cuite gallo-romaines à Saintes', *Gallia*, vol. 32, 1974, pp. 249–53, fig. 3.
122 Musée Archéologique de Saintes; Giffault, op. cit., fig. 2.
123 Musée de Picardie; Espérandieu no. 3934.
124 Musée de Bar-le-Duc; Espérandieu no. 4678; Thevenot, 1968, op. cit., pp. 168ff.
125 F. Jenkins, 'The role of the dog in Romano-Gaulish religion', *Collection Latomus*, vol. 16, 1957, pp. 60–76.
126 M. J. Green, *A Corpus of Religious Material from the Civilian Areas of Roman Britain*, 1976, p. 220.
127 Green, *The Gods of the Celts*, p. 84.
128 G. Webster, *The British Celts and Their Gods under Rome*, 1986, p. 46.
129 Ristow, 1975, op. cit., no. 42.
130 As at Toulon: M. Rouvier-Jeanlin, *Les Figurines gallo-romaines en terre cuite au Musée des Antiquités Nationales*, 1972, no. 304.
131 ibid., nos 282, 294.
132 ibid., no. 225.
133 F. Jenkins, 'The cult of the Dea Nutrix in Kent', *Archaeologia Cantiana*, vol. 71, 1957, pp. 38–46.
134 For example, a large collection at Autun, of both the one and two infant

types: H. Vertet and G. Vuillemot, *Figurines gallo-romaines en argile d'Autun*, 1973, pl. 1 a–d.

135 As at Trier: Schindler, op. cit., Abb. 104.
136 Ristow, 1975, op. cit., no. 22.
137 At, for instance, Ballerstein: Linckenheld, op. cit., p. 67.
138 Green, *The Gods of the Celts*, pp. 89–90.
139 F. Jenkins, 'Some interesting types of clay statuettes of the Roman period found in London', in J. Bird, H. Chapman, and J. Clark (eds), *Collectanea Londinensia: Studies in London Archaeology and History presented to Ralph Merrifield*, 1978, pp. 149–62.
140 Espérandieu nos 1362, 1333, 1334.
141 Espérandieu no. 1333.
142 F. Benoit, *Art et dieux de la Gaule*, 1969, pl. 100.
143 op. cit., pl. 211.
144 Green, *The Gods of the Celts*, p. 136.
145 op. cit., p. 100.
146 Musée Archéologique de Saintes, *Saintes à la recherche de ses dieux*, 1984, no. 39.
147 Wightman, 1970, op. cit., p. 217.
148 Wightman, 1985, op. cit., p. 178.
149 Musée de Picardie.
150 Drioux, op. cit., pp. 105–17; Espérandieu no. 3225.
151 Musée de Caen; J.-Y. Marin and J. J. Bertaux, 'Le Musée de Normandie', *Archéologia préhistoire et archéologie*, no. 204, 1985, pp. 49–54.
152 Marin and Bertaux, op. cit.
153 As in the 'Dea Nutrix' figurines, or as at Dieburg, where a stone mother-goddess holds a swaddled infant in both hands; Espérandieu, German volume, no. 254.
154 Musée de Châtillon-sur-Seine.
155 Musée Archéologique de Saintes, op. cit., no. 38.
156 Wilhelm, op. cit., no. 326; Espérandieu no. 4272.
157 J. Le Gall, *Alésia archéologie et histoire*, 1963, p. 174; 1985, op. cit., p. 68, fig. 39.
158 Le Gall, 1963, p. 113.
159 For example, Musée Archéologique de Saintes, op. cit., no. 37; Espérandieu no. 1328.
160 For instance, at Poitiers: Musée de Picardie; Papinot, op. cit., pp. 510–12, pl. 33.
161 Espérandieu no. 1611.
162 Espérandieu no. 2269.
163 At Autun: Musée Rolin; Espérandieu no. 1823, and at Vertault: Musée de Châtillon; Espérandieu no. 3375.
164 Espérandieu no. 4269; Wightman, 1970, op. cit., p. 226; Thill, op. cit., no. 18; Wilhelm, op. cit., no. 331.
165 For example, Espérandieu no. 4266; Wilhelm, op. cit., no. 325; Espérandieu no. 4274; Wilhelm, op. cit., no. 326.
166 Espérandieu no. 4269.
167 A goddess in Sarrebourg Forest stands with a purse, symbol of commercial success, and either a *patera* or a crown of sovereignty. The inhabitants of a rural house at Pölich near Trier worshipped a goddess whose sole attribute was a *cornucopiae*; and a deity at Trier sits with a pot and two loaves on her knees; Wightman, 1970, op. cit., pp. 208ff.

168 Ross, op. cit., p. 207, fig. 135.
169 R. J. Brewer, *Corpus Signorum Imperii Romani. Great Britain, Vol. 1, Fasc. 5, Wales*, 1986, no. 14, pl. 6.
170 The triple mothers depicted on a plaque in London bear palm branches, and the German maternal triads frequently are associated with victory images.
171 Ross, op. cit., pl. 10a.
172 R. P. Wright and E. J. Phillips, *Roman Inscribed and Sculptured Stones in Carlisle Museum*, 1975, no. 19.
173 E. J. Phillips, *Corpus Signorum Imperii Romani, Great Britain. Vol. 1, Fasc. 1. Corbridge. Hadrian's Wall East of the North Tyne*, 1977, no. 115, pl. 31.
174 G. Webster, 'What the Britons required from the gods as seen through the pairing of Roman and Celtic deities and the character of votive offerings', in M. Henig and A. King (eds), *Pagan Gods and Shrines of the Roman Empire*, 1986, pp. 57–64, pl. 10.
175 Webster, op. cit., pp. 57–64.
176 Green, *The Gods of the Celts*, pp. 145–8.
177 Wightman, 1985, op. cit., p. 178.
178 B. W. Cunliffe and M. G. Fulford, *Corpus Signorum Imperii Romani. Great Britain, Vol. 1, Fasc. 2. Bath and the rest of Wessex*, 1982, no. 115, pl. 31.
179 Webster, op. cit., pp. 70–2.
180 Suetonius, *Nero*, 22.
181 Green, *The Gods of the Celts*, p. 120.
182 Dio Cassius, LXII, 2.
183 Green, *The Gods of the Celts*, fig. 40.
184 Oaks, op. cit., pp. 77–85.
185 J. J. Hatt, *Celts and Gallo-Romans*, 1970, p. 134.
186 J. de Vries, *La Religion des Celtes*, 1963, pp. 122ff.
187 Schindler, op. cit., Abb. 100.
188 Römisch-Germanisches Museum, Köln.
189 Espérandieu no. 6825.
190 Green, 1976, op. cit., pl. XVe.
191 M. J. Green, *The Wheel as a Cult-symbol in the Romano-Celtic World*, 1984, cat. no. B88.
192 M. J. Green, 'A Celtic God from Netherby, Cumbria', *Transactions of the Cumberland & Westmorland Antiquarian & Archaeological Society*, vol. 83, 1983, pp. 41–7.
193 Rouvier-Jeanlin, op. cit.
194 F. Jenkins, 'The cult of the "Pseudo-Venus" in Kent', *Archaeologia Cantiana*, vol. 72, 1958, pp. 60–76.
195 Green, *The Gods of the Celts*, pp. 165–6.
196 As at Verulamium; Green, *The Gods of the Celts*, p. 95.
197 C. M. Johns, *Sex or Symbol: Erotic Images of Greece and Rome*, 1982, p. 41.
198 C. Bailey, *Phases in the Religion of Ancient Rome*, 1932, p. 119; J. Ferguson, *The Religions of the Roman Empire*, 1970, pp. 26, 71.
199 M. J. Green, 'Mother and sun in Romano-Celtic religion', *Antiquaries Journal*, vol. 64, 1984, pp. 25–33, pl. V, fig. 1.
200 Rouvier-Jeanlin, op. cit., nos 206–7.
201 Green, 'Mother and sun in Romano-Celtic religion', fig. 1b.
202 At Caudebec-lès-Elbeuf (Seine-Inférieure); op. cit., fig. 1a.
203 Rouvier-Jeanlin, op. cit., nos 303–4.
204 de Vries, op. cit., p. 69.
205 *CIL* XIII, no. 4294.

206 Wightman, 1970, op. cit., p. 217.
207 Toussaint, op. cit., pp. 207–8.
208 Wightman, 1970, op. cit., p. 217.
209 Musée Denon, Chalon-sur-Saône.
210 Römisch-Germanisches Museum, Köln; *CIL* XIII, no. 12057.
211 Musée Archéologique de Dijon; S. Deyts, *Le Sanctuaire des Sources de la Seine*, 1985.
212 F. Jenkins, 'The role of the dog in Romano-Gaulish religion', *Collection Latomus*, vol. 16, 1957, pp. 60–76.
213 L. Allason-Jones and B. McKay, *Coventina's Well*, 1985, pp. 3–11.
214 ibid., pl. V, no. 4; and there is a triple image of her too; pl. V, no. 1.
215 Württembergisches Landesmuseum Stuttgart; Espérandieu, German volume, no. 562.
216 Espérandieu, German volume, nos 560, 569.
217 Espérandieu, German volume, no. 634.
218 Espérandieu, German volume, no. 569.
219 Espérandieu no. 3620, Deyts, 1976, op. cit., no. 9.
220 Espérandieu no. 4568; *CIL* XIII, no. 4543; Musée Archéologique de Metz.
221 Drioux, op. cit., pp. 91ff.
222 Espérandieu no. 6000.
223 Linckenheld, op. cit., pp. 40–92.
224 Private collection.
225 Espérandieu no. 4566; *CIL* XIII, no. 4542.
226 Espérandieu, German volume, no. 428.
227 C. Bémont, 'A propos d'un nouveau monument de Rosmerta', *Gallia*, vol. 27, 1969, pp. 23–44.
228 *CIL* XII, 2831.
229 Espérandieu no. 4470.
230 Musée Archéologique de Metz, *La Civilisation gallo-romaine dans la cité des Médiomatriques*, 1981.
231 R. Marache, *Les Romains en Bretagne*, 1979, p. 15.
232 Schindler, op. cit., p. 33, Abb. 92.
233 Green, *The Gods of the Celts*, pp. 222–3.

3 The divine marriage

1 G. Thill, *Les Epoques gallo-romaine et mérovingienne au Musée d'Histoire et d'Art, Luxembourg*, 1978, no. 11.
2 M. J. Green, *The Gods of the Celts*, 1986, p. 153; P. Wuilleumier, *Inscriptions latines des Trois Gaules*, 1984, no. 403.
3 E. Thevenot, *Divinités et sanctuaires de la Gaule*, 1968, p. 125.
4 *RIB*, no. 140; Mainz: *CIL* XIII, nos 7253, 6221, 7241–2.
5 P. MacCana, *Celtic Mythology*, 1983, pp. 146–8.
6 P.-M. Duval, *Les Dieux de la Gaule*, 1976, p. 117.
7 Espérandieu no. 4566; *CIL* XIII, no. 4542; M. Toussaint, *La Lorraine à l'époque gallo-romaine*, 1928, p. 169.
8 Espérandieu no. 5564.
9 Espérandieu no. 5752.
10 In the museum at Karlsruhe; Espérandieu, German volume, no. 352.
11 K. Biltel, *Die Kelten in Baden-Württemberg*, 1981, p. 114, pl. 48.
12 *CIL* XII, no. 1179.

13 J. J. Hatt, ' ''Rota Flammis Circumsepta''. A propos du symbole de la roue dans la région gauloise', *Revue archéologique de l'est et du centre-est*, vol. 2, 1951, pp. 82-7.

14 M. J. Green, *The Wheel as a Cult-symbol in the Romano-Celtic World*, 1984, p. 183.

15 Espérandieu no. 2039; Autun, Musée Rolin.

16 Musée d'Alise Sainte Reine.

17 Musée d'Alise Sainte Reine.

18 Musée Archéologique de Dijon; Espérandieu no. 3441; S. Deyts, *Dijon, Musée Archéologique: sculptures gallo-romaines mythologiques et religieuses*, 1976, no. 118; G. Drioux, *Cultes indigènes des Lingons*, 1934, pp. 91ff.

19 We see this at Dijon: Espérandieu no. 3441; at Alesia: Musée d'Alise Sainte Reine; and Jouey: Espérandieu no. 2039.

20 At, for instance, Pagny-la-Ville: Musée de Beaune; Espérandieu no. 2066; Alesia: Espérandieu no. 7127; Musée des Antiquités Nationales; and Bolards: Musée Archéologique de Dijon, *L'Art de la Bourgogne romaine. Découvertes récentes*, 1973, no. 39, pl. VII.

21 Espérandieu no. 2347; Deyts, op. cit., no. 3; Musée Archéologique de Dijon.

22 Musée d'Alise Sainte Reine.

23 Espérandieu no. 2039.

24 ibid., no. 2347.

25 ibid., no. 7114.

26 ibid., no. 2347.

27 ibid., no. 7127.

28 ibid., no. 3441.

29 Musée de Besançon; Espérandieu no. 5277.

30 Musée de Bourg; Espérandieu no. 7506.

31 A. Blanc, 'Nouveaux bas-reliefs des Déesses-Mères et du Dieu au Maillet chez les Tricastins', *Gallia*, vol. 25, 1967, pp. 67-74.

32 Musée Archéologique de Nîmes; Espérandieu no. 435; E. Espérandieu, *Le Musée Lapidaire de Nîmes. Guide sommaire*, 1924, p. 42, no. 158.

33 Nottingham University Museum; J. M. C. Toynbee, *Art in Britain under the Romans*, 1964, p. 176.

34 Yorkshire Museum; Green, *The Gods of the Celts*, fig. 46.

35 R. G. Goodchild, 'A priest's sceptre from the Romano-Celtic temple at Farley Heath, Surrey', *Antiquaries Journal*, vol. 18, 1938, pp. 391ff; Green, *The Gods of the Celts*, fig. 22.

36 P. Lambrechts, *Contributions à l'étude des divinités Celtiques*, 1942, pp. 117-20.

37 A. Ross, *Pagan Celtic Britain*, 1967, pp. 21, 219.

38 S. Boucher, *Recherches sur les bronzes figurés de Gaule pré-romaine et romaine*, 1976, pp. 164ff.

39 Thevenot, 1968, op. cit., pp. 133ff.

40 Espérandieu no. 6039.

41 Musée Archéologique de Metz.

42 As at Toul near Metz: Espérandieu no. 4709; Autun: Espérandieu no. 1836; and Oberohmbach in Germany: Espérandieu no. 6112.

43 At Condren (Aisne): Espérandieu no. 3962; Schorndorf: Landesmuseum, Stuttgart, Espérandieu, German volume, no. 655; and Dijon: Espérandieu no. 7519, Deyts, 1976, op. cit., no. 119.

44 Landesmuseum Trier, Espérandieu no. 4929; E. M. Wightman, *Gallia Belgica*, 1985, p. 178, *CIL* XIII, no. 3656.

45 J. Colin, Les Antiquités romaines et germains rhénanie, 1927, pp. 162ff.
46 Espérandieu no. 1573; Thevenot, 1968, op. cit., pp. 87–90.
47 At Autun: Espérandieu no. 1836; and Dijon: Espérandieu no. 7519.
48 Two reliefs at the Musée Archéologique, Metz.
49 J. Alfs, 'A Gallo-Roman temple near Bretten (Baden)', *Germania*, vol. 24, 1940, pp. 128–40.
50 At Eisenberg: in the museum at Spire, Espérandieu no. 6039; and at Nöttingen: in the museum at Karlsruhe, Espérandieu, German volume, no. 350.
51 Eisenberg: Espérandieu no. 6054.
52 Musée Archéologique de Metz.
53 Rheinisches Landesmuseum Bonn; Espérandieu, German volume, no. 18.
54 Espérandieu, German volume, no. 428.
55 Musée Archéologique de Strasbourg, Espérandieu no. 7641; J. J. Hatt, *Sculptures antiques régionales Strasbourg*, 1964, no. 199.
56 Musée Archéologique de Metz.
57 In the museum at Wiesbaden; Espérandieu, German volume, no. 39.
58 B. W. Cunliffe and M. G. Fulford, *Corpus Signorum Imperii Romani, Great Britain Vol. 1, Fasc. 2. Bath and the rest of Wessex*, 1982, no. 39.
59 Landesmuseum Stuttgart; Espérandieu, German volume, no. 655.
60 Espérandieu no. 4929.
61 Toynbee, 1964, op. cit., pp. 157–8, pl. XLb; Green, *The Gods of the Celts*, p. 98, fig. 47.
62 Green, *The Gods of the Celts*, fig. 48; J. F. Rhodes, *Catalogue of the Romano-British Sculptures in the Gloucester City Museum*.
63 Musée des Alpilles, St-Rémy-de-Provence; F. Salviat, *Glanum*, 1979, p. 49.
64 C. Bémont, 'A propos d'un nouveau monument de Rosmerta', *Gallia*, vol. 27, 1969, pp. 23–44.
65 Wightman, 1985, op. cit., p. 178; Espérandieu no. 4929.
66 As at Chatenois: Hatt, 1964, op. cit., no. 199.
67 J. J. Hatt, 'Les dieux gaulois en Alsace', *Revue archéologique de l'est et du centre-est*, vol. 22, 1971, pp. 187–276; *CIL* XIII, no. 4208.
68 Hatt, 1971, op. cit.
69 M. J. Green, *A Corpus of Religious Material from the Civilian Areas of Roman Britain*, 1976, p. 11.
70 J. de Vries, *La Religion des Celtes*, 1963, p. 143.
71 Landesmuseum Trier; Espérandieu no. 5102.
72 E. M. Wightman, *Roman Trier and the Treveri*, 1970, pp. 220–1, pl. 22; R. Schindler, *Führer durch des Landesmuseum Trier*, 1977, p. 33, Abb. 92.
73 Duval, 1976, op. cit., p. 77.
74 W. Dehn, 'Ein Quelheiligtum des Apollo und der Sirona bei Hochscheid', *Germania*, vol. 25, 1941, 104ff, Taf. 16, no. 10; F. Jenkins, 'The role of the dog in Romano-Gaulish religion', *Collection Latomus*, vol. 16, 1957, pp. 60–76.
75 Thevenot, 1968, op. cit., p. 110.
76 Wightman, 1970, op. cit., pp. 220–1.
77 M. Szabó, *The Celtic Heritage in Hungary*, 1971, p. 66.
78 Musée Archéologique de Dijon.
79 As at Wiesbaden and Luxeuil; Thevenot, 1968, op. cit., pp. 103–4.
80 J. Le Gall, *Alésia archéologie et histoire*, 1963, pp. 157–9.
81 Green, *The Gods of the Celts*, p. 185; *CIL* XIII, no. 5924; Duval, op. cit., pp. 77, 117.

82 Thevenot, 1968, op. cit., pp. 103–4.
83 Green, *The Gods of the Celts*, p. 165.
84 Wightman, 1970, op. cit., pp. 208ff; Thevenot, 1968, op. cit., pp. 60–72.
85 Wightman, 1970, op. cit., p. 223; *CIL* XIII, no. 4119.
86 Green, *The Gods of the Celts*, p. 165; Wightman, 1970, op. cit., pp. 211–17.
87 *CIL* XIII, no. 3026; Espérandieu nos. 3132, 3133.
88 Thevenot, 1968, op. cit., p. 118.
89 ibid., pp. 67–9; Green, *The Gods of the Celts*, p. 158.
90 Château de Savigny; Espérandieu no. 2067; Deyts, 1976, op. cit., no. 284.
91 Espérandieu no. 2072; Deyts, 1976, op. cit., no. 285.
92 British Museum, *Guide to the Antiquities of Roman Britain*, 1964, p. 54.
93 Musée Archéologique de Dijon; Espérandieu no. 2348; Deyts, 1976, op. cit., no. 4.
94 Espérandieu no. 2347; Deyts, 1976, op. cit., no. 3.
95 Musée d'Alise Sainte Reine; Espérandieu no. 7518.
96 Musée Rolin; Espérandieu no. 1832.
97 W. F. and J. N. Ritchie, *Celtic Warriors* 1985, p. 29; Polybius, II, 28; H. D. Rankin, *Celts and the Classical World*, 1987, p. 68.
98 Ammianus Marcellinus, XV, XII.
99 Green, *The Gods of the Celts*, p. 101.
100 Musée Saint-Rémi, Reims.
101 *CIL* XIII, no. 6072; Hatt, 1964, op. cit., no. 101.
102 Ross, 1967, op. cit., fig. 138.
103 Corinium Museum, Cirencester; Green, *The Gods of the Celts*, p. 91, fig. 40.
104 Duval, 1976, op. cit., p. 103.
105 Espérandieu, German volume, no. 347; in the museum at Karlsruhe.
106 J. J. Hatt, *Les Monuments funéraires gallo-romains du Comminges et du Couserans*, 1945, ch. 3.
107 Corinium Museum, Cirencester; Green, 1986, op. cit., p. 91.
108 Lambrechts, 1942, op. cit., pp. 117–20.
109 At Auxerre (Yonne), the couple are generally depicted seated, both with *paterae* and *cornuacopiae*: Espérandieu nos 2878–81, but on one stone, Espérandieu no. 2880, the couple's close relationship is reflected in their shared *cornucopiae*. At Barzanes nearby, Espérandieu no. 2911, each partner has a *cornucopiae*. Sometimes, as at Alesia, Musée d'Alise Sainte-Reine, and Entrain, Espérandieu no. 2271, each partner carries a *patera*. At Mâlain, Espérandieu no. 3567, the god and goddess each possess the dish and the horn of plenty.
110 Espérandieu nos 1837, 1829.
111 ibid., nos 1829, 1836.
112 Musée de Semur; Espérandieu no. 7121.
113 Espérandieu no. 1564.
114 Musée de Beaune; Espérandieu no. 2065.
115 Musée des Antiquités Nationales, St-Germain-en-Laye; Espérandieu no. 2334.
116 Musée d'Alise Sainte-Reine.
117 Musée de Beaune; Espérandieu no. 2118.
118 Espérandieu no. 7095.
119 Musée d'Alise Sainte-Reine.
120 Musée des Antiquités Nationales; Espérandieu no. 7639.
121 Musée Archéologique de Dijon, 1973, op. cit., no. 179, pl. XLVI.
122 Musée de Châtillon-sur-Seine; Espérandieu no. 3384.
123 Musée de Lorrain, Nancy; Espérandieu no. 4541.

124 Saintes: Musée Archéologique de Saintes, Espérandieu no. 1319;
Sommerécourt: Musée d'Epinal, Espérandieu no. 4831.
125 Musée Archéologique de Saintes, *Saintes à la recherche de ses dieux*, 1984,
no. 30.
126 Wightman, 1985, op. cit., pp. 178–9.
127 J. J. Bober, 'Cernunnos: origin and transformation of a Celtic divinity',
American Journal of Archaeology, vol. 55, 1951, pp. 13–51.
128 The snake is present at Alesia: Espérandieu no. 7637; and at Autun: Musée
Rolin.
129 Musée de Beaune; Espérandieu no. 2043.

4 The male image

1 P. P. Giot, J. Briard, and L. Pape, *Protohistoire de la Bretagne*, 1979,
pp. 393–6.
2 R. Marache, *Les Romains en Bretagne*, 1979, p. 18.
3 M. J. Green, *The Gods of the Celts*, 1986, p. 96; Yorkshire Museum.
4 J.-P. Clébert, *Provence antique 2 L'époque gallo-romaine*, 1970, p. 255.
5 As at Köln: G. Ristow, *Religionen und Ihre Denkmälaer in Köln*, 1975, pl.
38; G. Ristow, *Römischer Götterhimmel und frühes Christentum*, 1980, Bild
38; and Alesia: Musée d'Alise Sainte-Reine.
6 This may be seen, for instance, on a bronze at Prémeaux: Musée de
Beaune.
7 Ristow, 1975, op. cit., pl. 38.
8 This can be observed at Glanum: Musée des Alpilles, St-Rémy-de-Provence.
9 As at Monceau: Espérandieu, no. 2034.
10 This is present, for instance, at St-Paul-Trois-Châteaux (Drôme): Musée
Calvet, Avignon; F. Braemar, *L'Art dans l'occident romain*, 1963, no. 212,
pl. XIX; at Orpierre (Basses Alpes): Musée des Antiquités Nationales; and
Aix-en-Provence: H. Oggiano-Bitar, *Bronzes figurés antiques de Bouches-du-
Rhône*, 1984, no. 219.
11 Musée des Alpilles; F. Salviat, *Glanum*, 1979, p. 52.
12 Salviat, op. cit., p. 6.
13 Espérandieu no. 6695.
14 S. Deyts, *Les Bois sculptés des Sources de la Seine*, 1983; S. Deyts, *Le
Sanctuaire des Sources de la Seine*, 1985.
15 Musée Archéologique de Nîmes; Espérandieu nos 434, 436, 437.
16 Musée Archéologique de Nîmes.
17 Espérandieu no. 876.
18 Oggiano-Bitar, op. cit., no. 220.
19 Espérandieu no. 437.
20 Musée Archéologique de Vaison; A. Dumoulin, *Le Musée Archéologique de
Vaison-la-Romaine*, 1978, no. 5; Espérandieu no. 276.
21 Musée Archéologique de Nîmes.
22 G. Fouet, 'Le Sanctuaire des Eaux de "La Hillère" à Montmaurin', *Gallia*,
vol. 30, 1972, p. 109, fig. 23.
23 Espérandieu no. 301.
24 Musée Archéologique de Nîmes; Espérandieu no. 511.
25 In ruins of church; Espérandieu no. 497.
26 Private collection; Espérandieu no. 6774.
27 Espérandieu no. 1691.

28 E. Espérandieu, *Le Musée Lapidaire de Nîmes. Guide sommaire*, 1924, p. 33, no. 121, pl. 6.

29 *CIL* XIII, no. 6730.

30 M. J. Green, *A Corpus of Religious Material from the Civilian Areas of Roman Britain*, 1976, p. 219; R. G. Goodchild, 'A priest's sceptre from the Romano-Celtic temple at Farley Heath, Surrey', *Antiquaries Journal*, vol. 18, 1938, pp. 391ff.

31 M. J. Green, *The Wheel as a Cult-symbol in the Romano-Celtic World*, 1984, cat. no. C7.

32 S. Boucher, *Recherches sur les bronzes figurés de Gaule pré-romaine et romaine*, 1976, p. 55.

33 As at Lillebonne (Seine-Maritime): E. Espérandieu and H. Rolland, *Bronzes antiques de la Seine Maritime*, 1959, p. 24, no. 9.

34 G. Drioux, *Cultes indigènes des Lingons*, 1934, pp. 67–72.

35 P.–M. Duval, *Les dieux de la Gaule*, 1976, fig. 45.

36 A. Audin, *Musée de la Civilisation Gallo-Romaine à Lyon, 1975*, p. 15.

37 Espérandieu no. 1734.

38 Espérandieu no. 1733.

39 Espérandieu no. 1735.

40 Musée d'Epinal; Espérandieu no. 4804.

41 E. Thevenot, 'Deux figurations nouvelles du Dieu au Maillet accompagnie de tonneau ou amphore', *Gallia*, vol. 11, 1953, pp. 293–304, figs 7–8; E. Thevenot, *Divinités et sanctuaires de la Gaule*, 1968, pp. 133–42.

42 Espérandieu no. 1736.

43 Musée d'Annecy; Espérandieu no. 6792.

44 D. Kent Hill, 'Le "Dieu au Maillet" de Vienne à la Walters Art Gallery de Baltimore', *Gallia*, vol. 11, 1953, pp. 205–23; Boucher, 1976, op. cit., no. 301, pl. 63.

45 Espérandieu no. 5303.

46 Green, *The Gods of the Celts*, fig. 45; Musée des Antiquités Nationales.

47 Espérandieu no. 1735.

48 Espérandieu no. 3568; S. Deyts, *Dijon, Musée Archéologique: sculptures gallo-romaines mythologiques et religieuses*, 1976, no. 145.

49 Espérandieu no. 2034.

50 Beaune, Musée de Vin; Thevenot, 1968, op. cit., pp. 133–42.

51 Private collection; Thevenot, 1953, op. cit.; pp. 293–304.

52 At Sens (Yonne); Thevenot, 1953, op. cit., and at Bourgneuf-val d'Or (Saône et Loire); Musée Denon, Chalon-sur-Saône; Thevenot, 1968, op. cit., pp. 133–42.

53 Musée d'Alise Sainte-Reine.

54 Espérandieu no. 1621.

55 ibid., no. 2750.

56 ibid., no. 2028.

57 ibid., no. 2039.

58 E. Thevenot, 'Sur les figurations du "Dieu au Tonneau" ', *Revue archéologique de l'est et du centre-est*, vol. 8, 1957, pp. 311–14.

59 At Beire-le-Châtel: Espérandieu no. 3633, Deyts, 1976, op. cit., no. 13; Nuits St Georges (Bolards); Deyts, 1976, op. cit., no. 174; and Bouze: E. Thevenot, 'Maillets votifs en pierre', *Revue archéologique de l'est et du centre-est*, vol. 3, 1952, pp. 99–103, fig. 12, no. 1.

60 Musée Archéologique de Dijon; Espérandieu no. 3385.

61 Espérandieu no. 3588.

62 Green, *The Gods of the Celts*, p. 162; M. Dayet, 'Le Borvo Hercule d'Aix-les-Bains', *Revue archéologique*, 1963, p. 167.

63 Musée de Beaune; P. MacCana, *Celtic Mythology*, 1983, p. 40.

64 At Maranville: Drioux, 1934, op. cit., pp. 67–72; Santenay: E. Thevenot, *Le Beaunois gallo-romain*, 1971, no. 572; Aubaine: Thevenot, 1971, op. cit., no. 332; and Saulenay: E. Linckenheld, 'Sucellus et Nantosuelta', *Revue de l'histoire des religions*, vol. 99, 1929, p. 53.

65 Espérandieu no. 4708.

66 Musée d'Epinal; Espérandieu no. 4848.

67 Kunsthistorisches Museum, Geneva; M. Pobé and J. Roubier, *The Art of Roman Gaul*, 1961, pl. 172; W. Deonna, *Ville de Genève: Musée d'Art et d'Histoire: Catalogue des Bronzes*, 1915–16, p. 9, no. 4; F. Benoit, *Art et dieux de la Gaule*, 1969, pl. 169.

68 G. Webster, 'What the Britons required from the gods as seen through the pairing of Roman and Celtic deities and the character of votive offerings', in M. Henig and A. King (eds), *Pagan Gods and Shrines of the Roman Empire*, 1986, pp. 61–3.

69 L. R. Laing, *Coins and Archaeology*, 1969, p. 156.

70 Green, *The Gods of the Celts*, pp. 195–9.

71 E. Anati, *Camonica Valley*, 1965.

72 J. J. Bober, 'Cernunnos: origin and transformation of a Celtic divinity', *American Journal of Archaeology*, vol. 55, 1951, pp. 13–51; Thevenot, 1968, op. cit., pp. 144–9.

73 A. Bergquist and T. Taylor, 'The origin of the Gundestrup Cauldron', *Antiquity*, vol. 61, 1987, pp. 10–24.

74 G. Olmsted, *The Gundestrup Cauldron*, 1979, pl. 2A.

75 ibid., pl. 63; A. Ross, *Pagan Celtic Britain*, 1967, pp. 127–68.

76 G. C. Boon, 'A coin with the head of the Cernunnos', *Seaby Coin and Medal Bulletin*, no. 769, 1982, pp. 276–82; Green, *The Gods of the Celts*, fig. 88.

77 Espérandieu no. 3653.

78 ibid., no. 1319.

79 Corinium Museum, Cirencester; Green, 1986, op. cit., fig. 86.

80 P. Lambrechts, *Contributions à l'étude des divinités celtiques*, 1942, pp. 21–32.

81 Diodorus, V, 28, 4; Athenaeus, VI, 36.

82 *CIL* XIII, no. 3026; Espérandieu nos 3132, 3133.

83 MacCana, op. cit., p. 39.

84 Pobé and Roubier, 1961, op. cit., no. 11; R. Joffroy, *Musée des Antiquités Nationales, St-Germain-en-Laye*, 1979, no. 78.

85 Musée de Beaune; Espérandieu no. 2083.

86 Thevenot, 1968, op. cit., pp. 144–9.

87 Autun, *Autun-Augustodunum Capitale des Eduens. Guide de l'exposition*, 1985.

88 J.-B. Devauges, 'Circonscription de Bourgogne', *Gallia*, vol. 32, 1974, p. 434; E. Planson and C. Pommeret, *Les Bolards*, 1986, fig. 44.

89 Musée de Beaune; Espérandieu no. 2083.

90 Espérandieu no. 4839; Musée d'Epinal.

91 Musée Saint-Rémi, Reims; Espérandieu no. 3653.

92 Espérandieu no. 4195; G. Thill, *Les Epoques gallo-romaine et mérovingienne au Musée d'Histoire et d'Art, Luxembourg*, 1978, pl. 72.

93 Espérandieu no. 3653.

94 As at Gundestrup and Vignory; Lambrechts, 1942, op. cit., pp. 21–32.

95 B. Louibie, 'Statuette d'un dieu gallo-romain au bouc et au serpent trouvée à Yzeures-sur-Creuse (Indre et Loire)', *Gallia*, vol. 23, 1965, pp. 279–84.

96 Corinium Museum, Cirencester; Green, *The Gods of the Celts*, fig. 68.

97 Espérandieu no. 1539.

98 ibid., no. 4195.

99 Devauges, op. cit., p. 434; Planson and Pommeret, op. cit.

100 Espérandieu no. 1319.

101 ibid., no. 2083.

102 P.-H. Mitard, 'La Sculpture gallo-romaine dans le Vexin Français', *Histoire et archéologie*, no. 76, September 1983, pp. 56–71.

103 Louibie, op. cit., pp. 279–84.

104 As at Genainville: Mitard, op. cit.; and Néris-les-Bains: Espérandieu no. 1566.

105 Espérandieu no. 3653.

106 ibid., no. 1539.

107 At Vendoeuvres: Espérandieu no. 1539; Blain: Espérandieu no. 3015; and Meaux: Musée Bossuet, *Collections du Musée de Meaux 1. Préhistoire protohistoire gallo-romain*, 1983, no. 172, pl. III.

108 Espérandieu no. 2083.

109 Devauges, op. cit.

110 J. V. S. Megaw, *Art of the European Iron Age*, 1970, no. 14.

111 D. F. Allen, *The Coins of the Ancient Celts*, 1980, nos 479, 480.

112 ibid., nos 477, 478.

113 Musée Borély, Marseille; Laing, op. cit., p. 156.

114 P.-M. Duval *et al.*, *L'Arc d'Orange*, 1962; P. Gros, 'Une hypothèse sur l'Arc d'Orange', *Gallia*, vol. 44, fasc. 2, 1986.

115 Olmsted, op. cit., pl. 2.

116 Megaw, op. cit., no. 294.

117 R. P. Wright and E. J. Phillips, *Roman Inscribed and Sculptured Stones in Carlisle Museum*, 1975, no. 197.

118 J. B. Bailey, 'Catalogue of Roman inscribed and sculptured stones. . .at Maryport, and preserved at Netherhall', *Transactions of the Cumberland & Westmorland Antiquarian & Archaeological Society*, vol. 15, 1915, pp. 135–72; Green, *The Gods of the Celts*, p. 113.

119 A. Ross, 'The Horned God of the Brigantes', *Archaeologia Aeliana* (4), vol. 39, 1961, pp. 59ff; Ross, 1967, op. cit., pp. 127–68.

120 M. J. Green, *Small Cult Objects from Military Areas of Roman Britain*, 1978, p. 555, pl. 3.

121 Carlisle Museum; Wright and Phillips, op. cit., no. 193, pl. VIIb.

122 Netherby, Cumbria: Wright and Phillips, op. cit., no. 194, pl. VIIIa; and Boldre, Hants: Hampshire County Museum, Winchester; B. W. Cunliffe and M. G. Fulford, *Corpus Signorum Imperii Romani. Great Britain Vol. 1, Fasc. 2. Bath and the rest of Wessex*, 1982, no. 127, pl. 33, are examples of these.

123 A. Ellison, *Excavations at West Uley: 1977. The Romano-British Temple*, 1977.

124 Buckinghamshire County Museum, Aylesbury; Green, *The Gods of the Celts*, fig. 98.

125 At Unterheimbach: in the museum at Spire; Espérandieu no. 6009; and Staufenberg: museum at Karlsruhe; F. Benoit, *Art et dieux de la Gaule*, 1969, pl. 145.

126 Musée Archéologique de Dijon; Deyts, 1976, op. cit., nos 21–2; Espérandieu no. 3622, 1 and 2.

127 Musée des Antiquités Nationales, St-Germain-en-Laye; Espérandieu no. 3001.
128 Clébert, op. cit., p. 253.
129 Salviat, op. cit., pp. 30–1.
130 Musée Saint-Raymond, Toulouse.
131 H. D. Rankin, *Celts and the Classical World*, 1987, p. 281.
132 Musée Saint-Raymond, Toulouse.
133 P.–M. Duval, *Les dieux de la Gaule*, 1976, p. 52.
134 Thill, op. cit., pl. 71.
135 E. J. Phillips, *Corpus Signorum Imperii Romani. Great Britain Vol. 1, Fasc. 1. Corbridge. Hadrian's Wall East of the North Tyne*, 1977, no. 232, pl. 60.
136 Musée des Antiquités Nationales; Pobé and Roubier, op. cit., no. 190.
137 Musée Archéologique de Strasbourg, *Catalogue*, undated, p. 42, pl. 23.
138 J. J. Hatt, *Sculptures antiques régionales Strasbourg*, 1964, pp. 65–7.
139 Espérandieu no. 7800; Hatt, 1964, op. cit., pls 150, 151.
140 Espérandieu no. 7633; Deyts, 1976, op. cit., no. 215.
141 Private collection; Phillips, op. cit., no. 234, pl. 63.
142 R. Merrifield, *London City of the Romans*, 1983, p. 188, fig. 86.
143 A. Ferdière, 'Informations archéologiques: circonscription du centre', *Gallia*, vol. 43, fasc. 2, 1985, pp. 297–301, pl. 5.
144 Espérandieu no. 411.
145 P.–M. Duval, *Paris Antique*, 1961, pp. 197–9; Espérandieu no. 3134; P. MacCana, *Celtic Mythology*, 1983, pp. 29, 33.
146 R. Schindler, *Führer durch des Landesmuseum Trier*, 1977, p. 32, Abb. 91; E. M. Wightman, *Gallia Belgica*, 1985, pp. 177–87.
147 For example, Espérandieu no. 7280.
148 Palais du Roure, Avignon; J. Le Gall, *Alésia archéologie et histoire*, 1963, p. 161; Espérandieu no. 7684.
149 Musée Archéologique de Dijon; Deyts, 1976, op. cit., no. 160.
150 J. M. C. Toynbee, *Animals in Roman Life and Art*, 1973, pp. 275, 279.
151 Thevenot, 1968, op. cit., p. 159.
152 Musée des Antiquités Nationales; Pobé and Roubier, op. cit., no. 6; Espérandieu no. 7702; R. Joffroy, *Musée des Antiquités Nationales, St-Germain-en-Laye*, 1979, no. 77.
153 D. F. Allen, 'Some Contrasts in Gaulish and British Coins', in P.–M. Duval and C. F. C. Hawkes (eds), *Celtic Art in Ancient Europe*, 1976, pp. 265–82.
154 Espérandieu no. 2262.
155 *CIL* XIII, no. 2901.
156 Musée Archéologique de Dijon, *L'Art de la Bourgogne romaine. Découvertes récentes*, 1973, no. 113, pl. XXIX.
157 ibid., no. 117, pl. XLVIII.
158 Musée de Beaune; Espérandieu no. 2112.
159 Musée Lorrain, Nancy; Espérandieu no. 4693.
160 Corstopitum Museum; Phillips, op. cit., no. 61, pl. 18.
161 As at Entrains; in the hand at Autun; Musée Rolin.
162 This is observable at, for example, Dennevy: Espérandieu no. 2131; Autun: Musée Rolin; and Vertault: Musée de Châtillon-sur-Seine.
163 Espérandieu no. 2131.
164 Hatt, 1964, op. cit., pls 163, 164.
165 Espérandieu no. 2332; Drioux, op. cit., pp. 67–72.
166 Hatt, 1964, op. cit.; J. de Vries, *La Religion des Celtes*, 1963.
167 Landesmuseum Bonn; H. G. Horn, *Die Römer in NordRhein-Westfalen*, 1987, Abb. 227.

168 Römisch-Germanisches Museum, Köln.
169 Saintes, Musée Archéologique.
170 Musée Archéologique de Metz.
171 Thevenot, 1968, op. cit., pp. 72–89; Musée des Antiquités Nationales.
172 Musée Saint-Raymond, Toulouse; Thevenot, 1968, op. cit., pp. 72–89.
173 Musée de Beauvais; Thevenot 1968, op. cit., pp. 72–89.
174 Espérandieu no. 1573.
175 F. R. Hodson and R. M. Rowlett, 'From 600 BC to the Roman Conquest', in S. Piggott, G. Daniel, and C. McBurney (eds), *France Before the Romans*, 1973, pp. 157–91.
176 Salviat, op. cit., pp. 40–3.
177 Musée Granet, Aix-en-Provence; F. Benoit, *Entremont*, 1981, pp. 51–99.
178 Marseille, Musée Borély.
179 Musée d'Hyères; Espérandieu no. 38; Thevenot, 1968, op. cit., pp. 56–7.
180 Espérandieu no. 105; Benoit, 1981, op. cit., fig. 49.
181 Diodorus, V, 29, 4; Strabo, IV, 4, 5, for example.
182 Laing, op. cit., p. 159.
183 Musée Archéologique de Nîmes; P.-M. Duval, *Les Celtes*, 1977, p. 109, no. 98.
184 Musée Archéologique de Nîmes; Hodson and Rowlett, op. cit., pp. 157–91.
185 Musée Archéologique de Nîmes.
186 Landesmuseum Stuttgart; Megaw, 1970, op. cit., no. 12.
187 Allen, 1980, op. cit., pp. 133–48.
188 Great Driffield Museum; Green, *The Gods of the Celts*, p. 109, fig. 53.
189 J. Zwicker, *Fontes Historiae Religionis Celticae*, 1935, p. 50; Green, *The Gods of the Celts*, p. 110.
190 J. M. C. Toynbee, 'A Londinium votive leaf or feather and its fellows' , in J. Bird, H. Chapman, and J. Clark (eds), *Collectanea Londinensia: Studies in London Archaeology and History presented to Ralph Merrifield*, 1978, pp. 129–48, no. 26.
191 Thevenot, 1968, op. cit., pp. 53–4.
192 de Vries, op. cit., pp. 93ff.
193 D. B. Charlton and M. M. Mitcheson, 'Yardhope, a shrine to Cocidius?', *Britannia*, vol. 14, 1983, pp. 143–53.
194 *RIB*, nos. 986, 987; Wright and Phillips, 1975, op. cit., nos 9, 10.
195 R. J. Brewer, *Corpus Signorum Imperii Romani. Great Britain Vol. 1, Fasc. 5, Wales*, 1986, no. 15, pl. 6.
196 S. S. Frere, 'Roman Britain in 1976: I Sites Explored', in *Britannia*, vol. 8, 1977, pp. 392–4.
197 Green, 1976, op. cit., pl. IIc.
198 Private collection; Espérandieu no. 837.
199 E. Thevenot, 'Le Cheval sacré dans la Gaule de l'est', *Revue archéologique de l'est et du centre-est*, vol. 2, 1951, pp. 129–41.
200 ibid.
201 St-Andéol-en-Quint: *CIL* XII, no. 1566; and Rochefort Sanson: *CIL* XII, no. 2204.
202 Thevenot, 1968, op. cit., pp. 56–7.
203 E. Thevenot, *Sur les traces des Mars celtique*, 1955; Green, 1986, op. cit., p. 173.
204 Marache, op. cit., p. 3.
205 P. Térouanne, 'Dedicaces à Mars Mullo. Découvertes à Allonnes (Sarthe)', *Gallia*, vol. 18, 1960, pp. 185–9; Thevenot, 1968, op. cit., pp. 65–9.

206 Thevenot, 1955, op. cit.
207 Ross, 1967, op. cit., p. 185.
208 Musée Saint-Rémi.
209 Rheinisches-Landesmuseum Bonn.
210 L. J. F. Keppie and B. J. Arnold, *Corpus Signorum Imperii Romani. Great Britain Vol. 1, Fasc. 4, Scotland*, 1984, no. 93, pl. 27.
211 British Museum; Green, 1976, op. cit., p. 218; *The Gods of the Celts*, pp. 108ff.
212 T. Ambrose and M. Henig, 'A new Roman rider-relief from Stragglethorpe, Lincolnshire', *Britannia*, vol. 11, 1980, pp. 135–8.
213 Lambrechts, 1942, op. cit., pp. 81–99.
214 E. Greenfield, 'The Romano- British shrines at Brigstock, Northants', *Antiquaries Journal*, vol. 43, 1963, pp. 228ff; Green, 1976, op. cit., p. 181, pl. IIIf.
215 Peterborough City Museum; Green, *The Gods of the Celts*, fig. 59.
216 Nottingham University Museum.
217 Green, *The Gods of the Celts*, pp. 171–3.
218 op. cit., p. 171.
219 Ross, 1967, op. cit., pp. 168–203.
220 E. M. Wightman, *Roman Trier and the Treveri*, 1970, pp. 208ff.
221 Green, *The Gods of the Celts*, p. 158; M. J. Green, *The Gods of Roman Britain*, 1983, p. 44, pl. 7.
222 Chedworth Roman Villa Museum; Ross, 1967, op. cit., pp. 168–203.
223 Thevenot, 1955, op. cit.
224 Thevenot, 1968, op. cit., pp. 65–9.
225 Térouanne, 1960, op. cit., pp. 185–9.
226 Thevenot, 1968, op. cit., pp. 65–9.
227 R. E. M. Wheeler, *Report on the Excavations. . . .in Lydney Park, Gloucestershire*, 1932; Green, *The Gods of the Celts*, pp. 159–61.
228 Espérandieu no. 3219.
229 British Museum, *Guide to the Antiquities of Roman Britain*, 1964, p. 54, pl. XVII.
230 Hatt, 1964, op. cit., no. 162.
231 Musée Archéologique de Dijon; Thevenot, 1968, p. 55.
232 Clébert, op. cit., p. 252.
233 Ross, 1967, op. cit., pp. 168–203; Green, *The Gods of the Celts*, p. 37, fig. 14. Gloucester City Museum.
234 Marseille, Musée Borély; Espérandieu no. 8613.
235 Duval *et al.*, op. cit.; Gros, op. cit.
236 Allen, 1980, op. cit., nos 212–14.
237 Olmsted, op. cit., pl. 2.
238 M. J. Green, 'Tanarus, Taranis and the Chester altar', *Journal of the Chester Archaeological Society*, vol. 65, 1982, pp. 37–44.
239 Musée de Rouen; E. Espérandieu and H. Rolland, *Bronzes antiques de la Seine Maritime*, 1959, p. 22, no. 1.
240 Musée Archéologique de Strasbourg, *Catalogue*, undated, pl. 15.
241 Green, 1984, op. cit., pp. 103–34, cats B, C.
242 Espérandieu no. 7749; in the museum at Alzey.
243 Espérandieu no. 2375.
244 Espérandieu no. 513; Green, *The Wheel as a Cult-symbol*, pl. IV, fig. 5.
245 Espérandieu no. 303; Musée Calvet, Avignon.
246 Corstopitum Museum; Green, *The Wheel as a Cult-symbol*, fig. 58.

247 Musée des Antiquités Nationales; Green, *The Wheel as a Cult-symbol*, cat. no. C2; frontispiece.

248 P. M. Johnston, 'Roman vase found at Littlehampton', *Sussex Archaeological Collections*, vol. 46, 1903, pp. 233–4.

249 Green, *The Wheel as a Cult-symbol*, cat. no. A101.

250 ibid., cat. no. C3, pl. LXXX; J. L. Courcelle-Seneuil, *Les Dieux gaulois d'après les monuments figurés*, 1910, p. 67, fig. 22; M. J. Green, 'Mother and sun in Romano-Celtic religion', *Antiquaries Journal*, vol. 64, 1984, fig. 9; Musée des Antiquités Nationales.

251 M. Rouvier-Jeanlin, *Les Figurines gallo-romains en terre cuite au Musée des Antiquités Nationales*, 1972, Type 2; Green, *The Wheel as a Cult-symbol*, cat. no. C9a, pl. LXXXIV.

252 Green, *The Gods of the Celts*, fig. 21; M. J. Green, 'Jupiter, Taranis and the solar wheel', in M. Henig and A. King (eds), *Pagan Gods and Shrines of the Roman Empire*, 1986, pp. 65–76, fig. 11; 1984, op. cit., cat. no. C6.

253 E. B. Stebbins, *The Dolphin in the Literature and Art of Greece and Rome*, 1929.

254 R. G. Goodchild, 'A priest's sceptre from the Romano-Celtic temple at Farley Heath, Surrey', *Antiquaries Journal*, vol. 18, 1938, pp. 391ff; Green, *The Wheel as a Cult-symbol*, cat. no. C7.

255 Wright and Phillips, op. cit., nos 195, 196; M. J. Green, 'A Celtic God from Netherby, Cumbria', *Transactions of the Cumberland & Westmorland Antiquarian & Archaeological Society*, vol. 83, 1983, pp. 41–7.

256 M. J. Green, 'Celtic symbolism at Roman Caerleon', *Bulletin of the Board of Celtic Studies*, vol. 31, 1984, pp. 251–8.

257 G. C. Boon, *Laterarum Iscanum: The Antefixes, Bricks and Tile Stamps of the Second Augustan Legion*, 1984.

258 Green, *The Wheel as a Cult-symbol*, cat. no. B88.

259 ibid., cat. no. B25; Espérandieu no. 6825.

260 Römisch-Germanisches Museum, Köln.

261 M. J. Green 'Mother and sun in Romano-Celtic religion', pp. 25–33.

262 G. Bauchhenss and P. Nölke, *Die Iupitersäulen in den germanischen Provinzen*, 1981; Green, *The Gods of the Celts*, pp. 61–7.

263 G. Bauchhenss, *Jupitergigantensäulen*, 1976.

264 Musée Archéologique de Metz; Espérandieu no. 4425.

265 Bauchhenss, op. cit.

266 Espérandieu no. 2032.

267 Lambrechts, 1942, op. cit., pp. 81–99.

268 P. Lambrechts, *Divinités equestres ou défunts héroisés?*, *L'Antiquité classique*, fasc. 1, 1951.

269 Bauchhenss and Nölke, op. cit.

270 Lambrechts, 1942, op. cit., pp. 81–99.

271 As at Dalheim in Luxembourg: E. Wilhelm, *Pierres sculptées et inscriptions de l'époque romaine*, 1974, no. 313; and Wiesbaden-Schierstein: Bauchhenss and Nölke, op. cit., B. no. 560.

272 At Meaux (Seine-et-Marne): Espérandieu no. 3207; Butterstadt (Hessen): Espérandieu, German volume, no. 76; Obernberg (Bayern): Green, *The Wheel as a Cult-symbol*, cat. no. B102; and Luxeuil (Haute-Saône): Espérandieu no. 5357; E. Espérandieu, 'Le Dieu Cavalier de Luxeuil', *Revue archéologique*, vol. 70, 1917, pp. 72–86.

273 Musée de Châtillon-sur-Seine; Espérandieu no. 7098.

274 Bauchhenss and Nölke, op. cit., B. no. 548.

275 Musée Archéologique de Strasbourg, *Catalogue*, undated, pl. 64.
276 Bauchhenss and Nölke, op. cit., B. no. 417.
277 J. Mertens, 'Reflexions à propos du "cavalier-aux géants anguipèdes" de Tongres', *Revue archéologique de l'est et du centre-est*, vol. 33, 1982, pp. 47–53, figs. 1–2.
278 Ristow, 1975, op. cit., pl. 3.
279 Pobé and Roubier, op. cit., no. 185.
280 As at Dalheim: Wilhelm, op. cit., no. 313.
281 Espérandieu no. 4900.
282 ibid., no. 4998.
283 Green, *The Wheel as a Cult-symbol*, cat. no. B24; A. Blanchet, 'Le Jupiter à la roue trouvé à Champagnat (Creuse)', *Bulletin archéologique du Comité des Travaux Historiques et Scientifiques*, 1923, pp. 156–60, pl. VII.
284 Green, *The Wheel as a Cult-symbol*, cat. no. B34; F. Eygun, 'Informations archéologiques: Poitiers', *Gallia*, vol. 23, 1965, pp. 381–2, fig. 51.
285 Green, *The Wheel as a Cult-symbol*, cat. no. B87; C. Lelong, 'Note sur une sculpture gallo-romaine de Mouhet (Indre)', *Revue archéologique du Centre*, vol. 9, 1970, pp. 123–6, figs 1–2.
286 Green, *The Wheel as a Cult-symbol*, cat. no. B151; C. Ch. Picard, 'Informations archéologiques: Centre', *Gallia*, vol. 26, 1968, p. 343, fig. 24.
287 Thevenot, 1951, op. cit., pp. 129–41.
288 Espérandieu no. 5357.
289 Landesmuseum Bonn.
290 Espérandieu no. 6337.
291 ibid., nos 1249, 1250.
292 Green, *The Wheel as a Cult-symbol*, pp. 172–3.

5 The symbolism of the natural world

1 J. de Vries, *La Religion des Celtes*, 1963, pp. 181ff.
2 H. von Petrikovits, 'Matronen und Verwandte Gottheiten', *Ergebnisse eines Kolloquiums veranstaltet von der Göttinger Akademiekommission für die Altertumskunde Mittel- und Nordeuropas*, 1987, pp. 241–54.
3 P.-M. Duval, *Les dieux de la Gaule*, 1976; E. Thevenot, *Divinités et sanctuaires de la Gaule*, 1968.
4 Thevenot, 1968, op. cit., pp. 149–64.
5 M. J. Green, *The Gods of the Celts*, 1986, pp. 167–73.
6 Espérandieu no. 2978.
7 Hallstatt, Grave 507; J. P. Mohen, A. Duval, and C. Eluère (eds), *Trésors des princes celtes*, 1987, no. 26.
8 ibid., no. 27.
9 D. F. Allen, *The Coins of the Ancient Celts*, 1980, pp. 137ff.
10 D. F. Allen, 'Some contrasts in Gaulish and British coins', in P.-M. Duval and C. F. C. Hawkes (eds), *Celtic Art in Ancient Europe*, 1976, p. 270.
11 For example, G. A. Wait, *Ritual and Religion in Iron Age Britain*, 1985; J. L. Brunaux, *Les Gaulois: Sanctuaires et rites*, 1986.
12 Brunaux, op. cit., pp. 91–9, 120ff.
13 ibid., pp. 120ff.
14 R. Downey *et al.*, 'The Hayling Island temple and religious connections across the Channel', in W. Rodwell (ed.), *Temples, Churches and Religion in Roman Britain*, 1980, pp. 289–304.

15 Wait, op. cit., pp. 153, 235ff.
16 Arrian, *De Venatione*, 34.
17 P. MacCana, *Celtic Mythology*, 1983, p. 50.
18 E. Anati, *Camonica Valley*, 1965.
19 ibid., pp. 112ff.
20 J. V. S. Megaw, *Art of the European Iron Age*, 1970, no. 2.
21 ibid.
22 Anati, op. cit., pl. on p. 172.
23 ibid., pp. 151–232
24 ibid., pp. 168ff.
25 Musée d'Orléans; M. Pobé and J. Roubier, *The Art of Roman Gaul*, 1961, no. 54.
26 Megaw, op. cit., no. 38; Mohen *et al.*, op. cit., no. 27.
27 Anon, *Die Kelten in Mitteleuropa*, 1980, no. 76.
28 ibid., no. 175.
29 L. R. Laing, *Coins and Archaeology*, 1969.
30 Green, *The Gods of the Celts*, fig. 3; National Museum of Wales.
31 Megaw, op. cit., no. 4; Landesmuseum Zürich.
32 M. J. Green, *A Corpus of Religious Material from the Civilian Areas of Roman Britain*, 1976, p. 111; Green, *The Gods of the Celts*, p. 183.
33 Colchester & Essex Museum; Green, *The Gods of the Celts*, p. 183.
34 Espérandieu no. 3653.
35 E. Wilhelm, *Pierres sculptées et inscriptions de l'époque romaine*, 1974, no. 393.
36 Bern Historisches Museum; Anon, 1980, op. cit., no. 216.
37 *CIL* XIII, nos 4113, 5160; E M. Wightman, *Roman Trier and the Treveri*, 1970, p. 217.
38 Thevenot, 1968, op. cit., p. 157.
39 K. H. Jackson, *The Oldest Irish Tradition: a Window on the Iron Age*, 1964.
40 Diodorus, V, 28.
41 Green, *The Gods of the Celts*, pp. 129, 175–89.
42 For example, at Danebury; B. W. Cunliffe, *Danebury: Anatomy of an Iron Age Hillfort*, 1983, pp. 155–71.
43 Strabo, IV, 4, 3.
44 MacCana, op. cit., p. 51.
45 ibid., p. 50.
46 G. Olmsted, *The Gundestrup Cauldron*, 1979, pl. 3E.
47 Green, *The Gods of the Celts*, fig. 3.
48 Allen, 1980, op. cit., pp. 141ff.
49 Allen, 1976, op. cit., fig. 4, 1.2.
50 Megaw, op. cit., no. 226; Espérandieu no. 7702; Musée des Antiquités Nationales, St-Germain-en-Laye.
51 For example, Luncani, Romania, first century BC: Megaw, op. cit., no. 225; Báta, Hungary, second/first century BC; M. Szabó, *The Celtic Heritage in Hungary*, 1971, p. 68; P.-M. Duval, *Les Celtes*, 1977, p. 163, pl. 169.
52 J. Foster, *Bronze Boar Figurines in Iron Age and Roman Britain*, 1977, pp. 26–8, figs 5–6.
53 Megaw, op. cit., no. 238; Espérandieu no. 2984.
54 Green, *The Gods of the Celts*, pp. 167–73.
55 Muntham Court, Sussex; Green, *The Gods of the Celts*, fig. 73; Worthing Museum and Art Gallery.
56 Duval, 1976, op. cit., pp. 52, 66.

57 R. P. Wright and E. J. Phillips, *Roman Inscribed and Sculptured Stones in Carlisle Museum*, 1975, no. 195; Carlisle Museum; M. J. Green, 'A Celtic god from Netherby, Cumbria', *Transactions of the Cumberland & Westmorland Antiquarian & Archaeological Society*, vol. 83, 1983, pp. 41-7.

58 Laing, op. cit.

59 MacCana, op, cit., p. 51.

60 Musée Denon, Chalon-sur-Saône.

61 Allen, 1980, op. cit., pp. 141ff.

62 von Petrikovits, op. cit., pp. 245-6.

63 Espérandieu no. 303; Musée Calvet, Avignon.

64 Thevenot, 1968, op. cit., p. 163.

65 C. Seltman, *The Twelve Olympians*, 1952, pp. 62-77.

66 W. K. C. Guthrie, *The Greeks and their Gods*, 1954, p. 246.

67 Allen, 1980, op. cit., pp. 141ff.

68 For example, ibid., op. cit., no. 526.

69 Anati, op. cit., pp. 151-232.

70 Megaw, op. cit., p. 17.

71 Green, *The Gods of the Celts*, pp. 175-89; Dinéault: Musée de Bretagne, Rennes.

72 S. Deyts, Dijon, Musée Archéologique: *Sculptures gallo-romains mythologiques et religieuses*, 1976, nos 175-9; Musée Archéologique de Dijon, *L'Art de la Bourgogne romaine. Découvertes récentes*, 1973, no. 42, pl. 12.

73 Espérandieu no. 3636, 1-3; Deyts, 1976, op. cit., nos 50-2.

74 Musée d'Alise Sainte-Reine.

75 Musée de Senlis.

76 S. Deyts, *Le Sanctuaire des Sources de la Seine*, 1985.

77 Thevenot, 1968, op. cit., pp. 149-64; Musée de Châtillon-sur-Seine.

78 Thevenot, 1968, op. cit., pp. 149-64; E M. Wightman, *Roman Trier and the Treveri*, 1970, p. 213.

79 A. Ross, *The Pagan Celts*, 1986, pp. 129-30.

80 MacCana, 1983, op. cit., p. 86.

81 Thevenot, 1968, op. cit., p. 68.

82 Green, *The Gods of the Celts*, p. 188; F. Benoit, *Art et dieux de la Gaule*, 1969, pl. 239.

83 Thevenot, 1968, pp. 149-64.

84 Wilhelm, op. cit., no. 332, Espérandieu no. 4265; Wilhelm, op. cit., no. 334, Espérandieu no. 4282.

85 Wait, op. cit.; Green, *The Gods of the Celts*, pp. 175-89.

86 F. Jenkins, 'The role of the dog in Romano-Gaulish Religion', *Collection Latomus*, vol. 16, 1957, pp. 60-76.

87 Guthrie, op. cit., pp. 228, 246.

88 M. J. Green, *Small Cult Objects from Military Areas of Roman Britain*, 1978, p. 51; Chesters Museum.

89 Green, *The Gods of the Celts*, fig. 72; cast of original.

90 Jenkins, 1957, op. cit., pp. 60-76.

91 Thevenot, 1968, op. cit., p. 68.

92 Deyts, 1985, op. cit.

93 Musée Archéologique de Dijon, 1973, op. cit., nos 75, 92.

94 Musée de Beaune.

95 Jenkins, 1957, op. cit. pp. 60-76.

96 von Petrikovits, op. cit.

97 Green, *The Gods of the Celts*, pp. 167–73.
98 F. Benoit, *L'Art primitif Méditerranéan de la vallée du Rhône*, 1969, pls VIII, IX, XI; C. Bémont, *L'Art celtique en Gaule 1983–1984*, 1983–1984, nos 152, 153.
99 Musée Borély, Marseille; Pobé and Roubier, op. cit., no. 13; Bémont, op. cit., no. 160.
100 ibid., no. 154; Musée Archéologique de Nîmes.
101 Musée Archéologique de Nîmes.
102 Benoit, op. cit.
103 Megaw, op. cit., no. 185.
104 Laing, op. cit.
105 Allen, 1980, op. cit., pp. 141ff.
106 For example, a British coin of Tasciovanus: Allen, 1980, op. cit., no. 525.
107 R. Magnen and E. Thevenot, *Epona*, 1953, pp. 13ff.
108 Brunaux, op. cit., pp. 120ff.
109 Megaw, op. cit., no. 35.
110 Wait, op. cit.; Green, 1986, op. cit., pp. 171–5.
111 Brunaux, op. cit., pp. 96–7.
112 Musée d'Orléans; Espérandieu no. 2978.
113 *CIL* XIII, no. 2846; E. Thevenot, 'Le Cheval sacré dans la Gaule de l'est', *Revue archéologique de l'est et du centre-est*, vol. 2, 1951, pp. 129–41.
114 *CIL* XIII, no. 1675.
115 S. J. de Laet, 'Figurines en terre cuite de l'époque romaine trouvées à Assche-Kalkoven', *L'Antiquité classique*, vol. 10, 1942, pp. 41–54.
116 Espérandieu no. 2041; *CIL* XIII, no. 2386.
117 Thevenot, 1951, op. cit., pp. 129–41.
118 Musée de Senlis; Espérandieu no. 3884.
119 S. Deyts, *Les Bois sculptés des Sources de la Seine*, 1983; Deyts, 1985, op. cit.; Bémont, op. cit., no. 276.
120 Cissey: Espérandieu no. 2121; Chorey: Espérandieu no. 2046.
121 L. Pauli, *The Alps: Archaeology and Early History*, 1984.
122 M. J. Green, *The Wheel as a Cult-symbol in the Romano-Celtic World*, 1984, pp. 187–9.
123 Anati, op. cit.
124 For example, in the cemetery at Hallstatt, Grave 507; Mohen *et al.*, op. cit., no. 26, and at Býčískála, Czechoslovakia: Megaw, op. cit., no. 35.
125 Anon, 1980, op. cit., no. 174.
126 Allen, 1980, op. cit., pp. 141ff.
127 Green, *The Gods of the Celts*, pp. 175–89.
128 Brunaux, op. cit., pp. 12ff, 91–2, 120ff.
129 Green, *The Gods of the Celts*, p. 178.
130 Green, *The Wheel as a Cult-symbol*, pp. 187–9.
131 ibid., cat. no. C6, figs. 61, 62.
132 Espérandieu no. 3653.
133 ibid., no. 1319.
134 Wilhelm, op. cit., no. 393.
135 Musée Archéologique de Dijon, 1973, op. cit., no. 91.
136 Musée de Senlis.
137 Deyts, 1983, op. cit.
138 MacCana, op. cit., p. 50.
139 Green, *The Gods of the Celts*, pp. 175–89.
140 Jackson, op. cit.

141 Green, *The Gods of the Celts*, p. 179.
142 Strabo, XII, 5, 1.
143 Tacitus, *Annals*, XIV, 30.
144 Dio Cassius, LXII, 2.
145 Lucan, *Pharsalia*, III, 399–452.
146 *CIL* VII, no. 36.
147 For example at Angers and Altripp; J. de Vries, *La Religion des Celtes*, 1963, p. 144.
148 ibid., pp. 195–9.
149 MacCana, op. cit., pp. 48–9.
150 Cicero, *de Legibus*, II, 8, 19ff.
151 S. Piggott, *The Druids*, 1968, p. 71.
152 D. W. Harding, *The Iron Age in Lowland Britain*, 1974, pp. 96–112; A. Rybova, *Keltská Svatyně ve Středních Čechach: Sanctuaire celtique en Bohême Centrale*, 1962.
153 von Petrikovits, op. cit., p. 248.
154 Downey *et al.*, op. cit., pp. 289–304.
155 R. C. Turner, *Ivy Chimneys, Witham: An Interim Report, 1982.*
156 Allen, 1980, op. cit., p. 145, no. 552.
157 Green, 'A Celtic god from Netherby', pp. 41–7.
158 Anon, 1980, op. cit., no. 216.
159 Espérandieu no. 303.
160 von Petrikovits, op. cit., pp. 242–6.
161 Polybius, *Histories*, II, 15, 2.
162 G. Bauchhenss, *Jupitergigantensäulen*, 1976.
163 Deyts, 1983, op. cit.; 1985, op. cit.
164 Pliny, *Natural History*, XVI, 249.
165 *CIL* XIII, nos 223, 224.
166 Thevenot, 1968, op. cit., pp. 200–21.
167 At Montespan and Aspet: Musée Saint-Raymond, Toulouse.
168 Musée des Alpilles, St-Rémy-de-Provence.
169 Espérandieu nos 859–65.
170 R. J. Brewer, *Corpus Signorum Imperii Romani. Great Britain Vol. 1, Fasc. 5, Wales*, p. 14, pl. 6.
171 Green, *The Wheel as a Cult-symbol*, pp. 259–60; *The Gods of the Celts*, pp. 67–8.
172 Thevenot, 1968, op. cit., pp. 200–21.
173 Megaw, op. cit., p. 99, no. 134.
174 J. M. C. Toynbee, *Art in Roman Bitain*, 1962, no. 96.
175 L. Allason Jones and B. McKay, *Conventina's Well*, 1985, no. 1, pl. V; no. 4, pl. VI.
176 Landesmuseum Stuttgart; Espérandieu, German volume, no. 683.
177 Espérandieu no. 507.
178 ibid., no. 506.
179 ibid., no. 508.
180 ibid., no. 7676.
181 ibid., no. 1573.
182 Musée Archéologique de Dijon; Espérandieu no. 3385.
183 C. Vatin, 'Ex-voto de bois gallo-romain à Chamalières', *Revue archéologique*, vol. 103, 1969, p. 103.
184 Espérandieu no. 5347.
185 Musée de Besançon; Espérandieu no. 7286.
186 Musée de Châtillon-sur-Seine; Espérandieu nos 3417–33.

187 Deyts, 1983, op. cit.; 1985, op. cit.
188 ibid., p. 10.
189 ibid., pp. 21ff.
190 ibid., pp. 24–30.
191 Thevenot, 1968, op. cit., pp. 200–21.
192 MacCana, op. cit., pp. 48–9.
193 River Wharfe: A. Ross, *Pagan Celtic Britain*, 1967, p. 217; Souconna: Musée Denon, Chalon-sur-Saône.
194 Wightman, 1970, op. cit., p. 217.
195 Brunaux, op. cit., pp. 96–7.
196 R. Merrifield, *London City of the Romans*, 1983, p. 15.
197 Musée Archéologique de Dijon.
198 Espérandieu no. 1862.
199 Strabo, IV, 1, 13 – speaking of the sacred lakes of the Volcae Tectosages at Toulouse, some of which were filled with silver and gold.
200 Thevenot, 1951, op. cit., pp. 129–41.
201 Espérandieu no. 3414.
202 P.-M. Duval, 1976, op. cit., p. 58.
203 E. Espérandieu, 'Le Dieu Cavalier de Luxeuil', *Revue archéologique*, vol. 70, 1917, pp. 72–86.
204 Thevenot, 1968, op. cit., pp. 200–21.
205 Green, *The Wheel as a Cult-symbol*, cat. nos A67, A68, fig. 6; A206.
206 J. Zwicker, *Fontes Historiae Religionis Celticae*, 1935, pp. 302–3; J. J. Hatt, ' "Rota Flammis Circumsepta". A propos du symbole de la roue dans la région gauloise', *Revue archéologique de l'est et du centre-est*, vol. 2, 1951, pp. 82–7; Green, *The Wheel as a Cult-symbol*, p. 157.
207 A. B. Cook, *Zeus*, vol. 2, i, 1925, pp. 57–93.
208 Green, *The Wheel as a Cult-symbol*, pp. 45–101.
209 J. Piette, 'Le Fanum de la Villeneuve-au-Châtelot (Aube): Etat des recherches en 1979', *Mémoires de la Société Archéologique Champenoise*, vol. 2, 1981, pp. 367–75.
210 J. Le Gall, *Alésia archéologie et histoire*, 1963; J. Le Gall, *Alésia*, 1985, pp. 41–4, fig. 17.
211 Anati, op. cit., pp. 151–68.
212 Allen, 1980, op. cit., p. 148.
213 P.-M. Duval et al., *L'Arc d'Orange*, 1962.
214 Green, *The Wheel as a Cult-symbol*, pp. 45–101.
215 Surrey Archaeological Society, *Roman Temple, Wanborough*, 1988, p. 16.
216 Green, *The Wheel as a Cult-symbol*, cat. nos BB15, BB5, BB4; *RIB* nos 827, 1981, 1983.
217 Espérandieu no. 6380; *CIL* XIII, no. 8194; Rheinisches Landesmuseum, Bonn.
218 *CIL* XII, no. 4179 Espérandieu no. 517; Green, *The Wheel as a Cult-symbol*, cat. no. B66.
219 Espérandieu no. 6843; Green, *The Wheel as a Cult-symbol*, cat. no. B20.
220 *CIL* XII, no. 2972; Espérandieu no. 2681; Green, *The Wheel as a Cult-symbol*, cat. no. B27.
221 G. Fouet and A. Soutou, 'Une cime pyrénéenne consacrée à Jupiter: Le Mont Saçon (Hautes-Pyrénées)', *Gallia*, vol. 21, 1963, pp. 75–295.
222 ibid., p. 290, fig. 19; Espérandieu no. 8873; G. Fouet, *La Villa gallo-romaine de Montmaurin*, 1969, pl. XLVIII.

223 G. Fouet, 'Le Sanctuaire gallo-romaine de Valentine (Haute-Garonne)', *Gallia*, vol. 42, 1984, pp. 153–73.
224 Green, *The Wheel as a Cult-symbol*, pp. 258–60; *The Gods of the Celts*, pp. 67–8.
225 Pauli, op. cit., p. 180; Green, *The Wheel as a Cult-symbol*, pp. 32–43.
226 Green, *The Wheel as a Cult-symbol*, pp. 119–22; E. Linckenheld, *Les Stèles funéraires en forme de maison chez les Médiomatriques et en Gaule*, 1927.

6 Triplism and multiple images

1 H. von Petrikovits, 'Matronen und Verwandte Gottheiten', *Ergebnisse eines Kolloquiums vernastaltet von der Göttinger Akademiekommission für die Altertumskunde Mittel- und Nordeuropas*, 1987, p. 243.
2 A. Rees and B. Rees, *Celtic Heritage*, 1961, pp. 186–204.
3 Musée d'Alise Sainte-Reine; J. Le Gall, *Alésia*, 1985, pp. 41–4.
4 M.-L. Sjoestedt, *Gods and Heroes of the Celts*, 1982, pp. 29–30.
5 P. MacCana, *Celtic Mythology*, 1983, p. 42.
6 Sjoestedt, op. cit., p. 38.
7 MacCana, op. cit., p. 27.
8 I. M. Stead *et al.*, *Lindow Man. The Body in the Bog*, 1986.
9 Sjoestedt, op. cit., pp. 82ff.
10 MacCana, op. cit., p. 34.
11 P. Lambrechts, *Contributions à l'étude des divinités celtiques*, 1942, pp. 33–4.
12 M. J. Green, *The Gods of the Celts*, 1986, fig. 57; J. F. Rhodes, *Catalogue of the Romano-British Sculptures in the Gloucester City Museum*, 1964.
13 As at Bradenstoke, Wiltshire: B. W. Cunliffe and M. G. Fulford, *Corpus Signorum Imperii Romani. Great Britain Vol. 1, Fasc. 2. Bath and the rest of Wessex*, 1982, no. 135.
14 At Wroxeter.
15 Risingham in northern England and Sutherland in Scotland: Green, *The Gods of the Celts*, pp. 208–11.
16 For example, Espérandieu nos 3651–9; Lambrechts, op. cit., pp. 33–4; E. Thevenot, *Divinités et sanctuaires de la Gaule*, 1968, pp. 86–7.
17 L. R. Laing, *Coins and Archaeology*, 1969, pp. 154–5; T. G. E. Powell, *The Celts*, 1958, pl. 47b.
18 E. Sprockhoff, 'Central European Urnfield culture and Celtic La Tène: an outline', *Proceedings of the Prehistoric Society*, vol. 21, 1955, pp. 257–82.
19 Musée Saint-Rémi, Reims.
20 J. J. Hatt, 'De la Champagne à la Bourgogne: Remarques sur l'origine et la signification du tricéphale', *Revue archéologique de l'est et du centre-est*, vol. 35, 1984, pp. 287–99.
21 Espérandieu no. 7700.
22 ibid., no. 7699.
23 ibid., no. 3669.
24 idid., no. 3137; Lambrechts, op. cit., fig. 11.
25 Espérandieu no. 3756.
26 Thevenot, 1968, op. cit., pp. 86–7.
27 Musée d'Epernay; Hatt, 1984, op. cit., figs. 1–2.
28 Musée Saint-Rémi, Reims; Hatt, 1984, op. cit., figs. 9–12.
29 This occurs on a stele at Reims: Espérandieu no. 3745; Hatt, 1984, op. cit., figs. 19–21.

30 Musée Saint-Rémi, Reims; Hatt, 1984, op. cit., fig. 22.
31 At Beaune: Espérandieu no. 2083; and Dennevy: Espérandieu no. 2131.
32 Espérandieu no. 4937.
33 ibid., no. 7233.
34 J. L. Courcelle-Seneuil, *Les Dieux gaulois d'après les monuments figurés*, 1910, p. 101; Lambrechts, op. cit., fig. 38.
35 Notably at Bavay, Jupille, and Troisdorf: Lambrechts, op. cit., pp. 33–4; B. W. Cunliffe, *The Celtic World*, 1979, p. 70.
36 A. Ross, *Pagan Celtic Britain*, 1967, pp. 73–8; MacCana, op. cit., p. 17.
37 Ross, 1967, op. cit., pp. 73–8; D. W. Harding, *The Iron Age in Lowland Britain*, 1974, p. 102.
38 J. V. S. Megaw and D. D. A. Simpson, *Introduction to British Prehistory*, 1979, pp. 478–9; Green, *The Gods of the Celts*, pp. 208–11.
39 Cunliffe and Fulford, op. cit., no. 135.
40 E. J. Phillips, *Corpus Signorum Imperii Romani. Great Britain Vol. 1, Fasc. 1, Corbridge: Hadrian's Wall East of the North Tyne*, 1977, no. 215, pl. 55.
41 G. Drioux, *Cultes indigènes des Lingons*, 1934, pp. 67–72.
42 Lambrechts, op. cit., p. 21; Autun, *Autun-Augustodunum, capitale des Eduens. Guide de l'exposition*, 1985.
43 Espérandieu no. 1316; F. Benoit, *Art et dieux de la Gaule*, 1969, pl. 162; C. Bémont, *L'Art celtique en Gaule 1983–1984*, 1983–4, no. 258.
44 Espérandieu no. 3287; Drioux, op. cit., pp. 67–72.
45 Espérandieu no. 2083.
46 ibid., no. 2131.
47 J.-B. Devauges, 'Circonscription de Bourgogne', *Gallia*, vol. 32, 1974, p. 434; E. Planson and C. Pommeret, *Les Bolards*, 1986.
48 W. Deonna, 'Trois, superlatif absolu: à propos du taureau tricornu et du Mercure triphallique', *L'Antiquité classique*, vol. 23, 1954, p. 406; J. Santrot, 'Le Mercure phallique du Mas-Agenais et un dieu stylite inédit', *Gallia*, vol. 44, fasc. 2, 1986, pp. 203–28.
49 J. V. S. Megaw, *Art of the European Iron Age*, 1970, no. 236; Marseille, Musée Borély.
50 Megaw, 1970, op. cit., no. 14.
51 Laing, op. cit., pp. 154–5.
52 E. Linckenheld, 'Sucellus et Nantosuelta', *Revue de l'histoire des religions*, vol. 99, 1929, p. 84.
53 Virgil, *Aeneid*, VI, l. 417.
54 Deonna, 1954, op. cit., p. 420; A. Fol and I. Marazov, *Thrace and the Thracians*, 1977, p. 28.
55 D. F. Allen, *The Coins of the Ancient Celts*, 1980, nos. 241, 246–7, pl. 18.
56 L. Zachar, *Keltische Kunst in der Slowakei*, 1987, pl. 201.
57 F. Benoit, *L'Art primitif Méditerranéan de la vallée du Rhône*, 1969, pl. VIII.
58 M. Dayet, 'Le sanglier à trois cornes du Cabinet des Medailles', *Revue archéologique de l'est et du centre-est*, vol. 5, 1954, pp. 334–5.
59 Ross, 1967, op. cit., pp. 130, 335.
60 A. Colombet and P. Lebel, 'Mythologie gallo-romaine', *Revue archéologique de l'est et du centre-est*, vol. 4, no. 2, 1953, p. 112.
61 Yugoslavia: S. Boucher, *Recherches sur les bronzes figurés de Gaule pré-romaine et romaine*, 1976, p. 171; Holland: Thevenot, 1968, op. cit., pp. 154–6.

62 Thevenot, 1968, op. cit., pp. 154–6; Boucher, 1976, op. cit., fig. 310.

63 Boucher, 1976, op. cit., pp. 170ff.

64 G. Charrière, 'Le taureau aux trois grues et le bestiaire du héros celtique', *Revue de l'histoire des religions*, vol. 69, 1966, pp. 155ff.

65 Autun, Musée Rolin: *CIL* XIII, no. 2656; P. Lebel and S. Boucher, *Bronzes figurés antiques* (Musée Rolin), 1975, p. 108, no. 232.

66 Drioux, op. cit., pp. 72–5.

67 Boucher, 1976, op. cit., pp. 170ff.

68 Musée Archéologique de Dijon; S. Deyts, *Dijon, Musée Archéologique: Sculptures gallo-romaines mythologiques et religieuses*, 1976, nos. 21, 22, 44–6.

69 Musée des Alpilles, Saint-Rémy de Provence; Colombet and Lebel, op. cit., p. 112.

70 M. J. Green, *The Wheel as a Cult-symbol in the Romano-Celtic World*, 1984, cat. no. C6, pl. LXXXI.

71 Colchester: Colchester & Essex Museum, Green, *The Gods of the Celts*, fig. 84; Cutry: R. Billoret, 'Informations archéologiques: Lorraine', *Gallia*, vol. 34, 1976, p. 353.

72 S. Read *et al.*, 'Three-horned bull', *Britannia*, vol. 17, 1986, pp. 346–8.

73 S. Reinach, *Description raisonnée du Musée de Saint-Germain-en-Laye. Bronzes figurés de la Gaule romaine*, 1984, p. 277.

74 Green, *The Gods of the Celts*, p. 191. fig. 85; County Museum, Dorchester, Dorset.

75 Boucher, 1976, op. cit., pp. 170ff.

76 Espérandieu no. 1319; J. J. Hatt, *Celts and Gallo-Romans*, 1970, pls. 118, 119.

77 G. Olmsted, *The Gundestrup Cauldron*, 1979, pl. 3.

78 *CIL* XIII, no. 3026; Espérandieu nos. 3132-7; P.-M. Duval, *Paris antique*, 1961, pp. 197–9, 264.

79 Espérandieu no. 4929; *CIL* XIII, no. 3656; E. M. Wightman, *Gallia Belgica*, 1985, p. 178; R. Schindler, *Führer durch des Landesmuseum Trier*, 1977, p. 32, Abb. 91.

80 Ross, 1967, op. cit., p. 279.

81 Green, *The Gods of the Celts*, p. 170.

82 P.-M. Duval, *Les Dieux de la Gaule*, 1976, p. 53; MacCana, op. cit., p. 87.

83 Hôtel Guain.

84 Green, *The Gods of the Celts*, p. 208; Anon, 'A Roman carved stone', *Transactions of the Bristol & Gloucestershire Archaeological Society*, vol. 73, 1954, p. 233, pl. 21.

85 Green, *The Gods of the Celts*, p. 115, fig. 57.

86 F. Benoit, *Art et dieux de la Gaule*, pl. 161.

87 J. M. C. Toynbee, *Art in Britain under the Romans*, 1964, pp. 180–1.

88 ibid., p. 181; R. J. Brewer, *Corpus Signorum Imperii Romani. Great Britain, Vol. 1, Fasc. 5, Wales*, 1986, no. 51, pl. 19.

89 Espérandieu no. 3219; Drioux, op. cit., pp. 67–72.

90 Deyts, 1976, op. cit., nos 21, 22.

91 Deonna, 1954, op. cit., p. 420.

92 Santrot, op. cit., pp. 203–8.

93 Espérandieu no. 497.

94 R. Egger, 'Genius cucullatus', *Wiener Praehistorische Zeitschrift*, vol. 19, 1932, pp. 311–23.

95 F. M. Heichelheim, 'Genii cucullati', *Archaeologia Aeliana* (4), vol. 12, 1935, pp. 187–94.

96 F. Hettner, *Drei Tempelbezirke im Trevererlande*, 1901, nos 212a, 213, pl. XI, 22, 26.
97 E. M. Wightman, *Roman Trier and the Treveri*, 1970, p. 213.
98 Heichelheim, op. cit., nos 14–16.
99 At Autun, Lyon, and Vindonissa: S. Loeschcke, *Lampen aus Vindonissa*, 1919, pp. 157–60.
100 F. Staehelin, *Der Schweiz in Römische Zeit*, 1931, pp. 507–8; fig. 145.
101 J. M. C. Toynbee, *Art in Roman Britain*, 1962, p. 77, pl. 83.
102 Cunliffe and Fulford, op. cit., no. 103, pl. 27.
103 Rhodes, op. cit.
104 Green, *The Gods of the Celts*, pp. 85, 91, fig. 39.
105 ibid., p. 91.
106 Ross, 1967, op. cit., p. 188.
107 Green, *The Gods of the Celts*, fig. 90; Corinium Museum, Cirencester.
108 R. P. Wright and E. J. Phillips, *Roman Inscribed and Sculptured Stones in Carlisle Museum*, 1975, no. 189.
109 S. Deyts, *Les Bois sculptés des Sources de la Seine*, 1983; S. Deyts, *Le Sanctuaire des Sources de la Seine*, 1985.
110 R. Magnen and E. Thevenot, *Epona*, 1953, no. 117.
111 Cunliffe, 1979, op. cit., p. 76.
112 Espérandieu no. 7297; J. J. Hatt, *Sculptures antiques régionales Strasbourg*, 1964, no. 7.
113 MacCana, op. cit., p. 137.
114 *CIL* XIII, no. 8798; A. Hondius-Crone, *The Temple of Nehalennia at Domburg*, 1955, no. 16, pp. 58–9.
115 MacCana, op. cit., p. 86.
116 Sjoestedt, op. cit., pp. 40–3.
117 von Petrikovits, op. cit., pp. 241ff.
118 Espérandieu no. 1318.
119 Musée Archéologique de Saintes, *Saintes à la recherche de ses dieux*, 1984, pp. 23–30.
120 Thevenot, 1968, op. cit., pp. 170–3.
121 The Poitiers relief of two goddesses portrays them on a folding camp-stool, with fruit in their laps; they have long tresses and one has a *cornucopiae*: Espérandieu no. 1394. The depiction on a stone at Besançon is very similar: Espérandieu no. 5271.
122 Espérandieu no. 4348.
123 ibid., no. 2325.
124 Tacitus, *Germania*, 40; Green, *The Gods of the Celts*, p. 77.
125 Thevenot, 1968, op. cit., pp. 170–3.
126 For example, in Capua: von Petrikovits, op. cit., p. 248.
127 Espérandieu nos 3378, 3373, 3377.
128 ibid., no. 3373.
129 Musée de Châtillon-sur-Seine; Espérandieu no. 3378.
130 Musée de Châtillon-sur-Seine; Espérandieu no. 3377.
131 Musée de Beaune; Espérandieu no. 2081.
132 Autun, Musée Rolin, Musée Lapidaire: Espérandieu nos 1816, 1827, 1831.
133 Musée Rolin.
134 Musée de Beaune; Espérandieu no. 2064.
135 Deyts, 1976, op. cit., no. 171.
136 ibid., no. 170.

137 Musée Archéologique de Dijon, *L'Art de la Bourgogne romaine. Découvertes Récentes*, 1973, no. 178.
138 Thevenot, 1968, op. cit., pp. 173–6.
139 For example, at Chalon: Espérandieu no. 7638; and Bressey-sur-Tille: Espérandieu no. 3593.
140 Drioux, op. cit., pp. 105–17.
141 Espérandieu no. 7107; Deyts, 1976, op. cit., no. 5.
142 J. J. Hatt, 'Le Double Suovetaurile de Beaujeu et le culte des Déesses-Mères et de la Tutelle à Lyon', *Revue archéologique de l'est et du centre-est*, vol. 86, 1986, p. 263; Espérandieu no. 1742.
143 Hondius-Crone, op. cit.
144 Hatt, 1986, op. cit.
145 Espérandieu no. 1741; *CIL* XIII, no. 1762; B. Rémy, 'Les inscriptions de médicins en Gaule', *Gallia*, vol. 42, 1984, pl. 13.
146 Espérandieu no. 338.
147 ibid., no. 327.
148 ibid., nos 282, 283, 7455.
149 ibid., no. 4937.
150 ibid., no. 7233; Lambrechts, 1942, op. cit., fig. 34.
151 von Petrikovits, op. cit., p. 246.
152 Rheinisches Landesmuseum in Bonn.
153 Espérandieu no. 7760.
154 For example, Espérandieu no. 6307.
155 ibid., no. 6560.
156 ibid., no. 7761.
157 J. P. Wild, 'Die Frauentracht der Ubier', *Germania*, vol. 46, 1968, pl. 1.
158 Espérandieu no. 7762.
159 ibid., no. 7763.
160 ibid., no. 7774.
161 ibid., no. 6559.
162 For example, Espérandieu nos 7765, 7768.
163 ibid., no. 7772.
164 ibid., no. 7775.
165 ibid., nos 6336, 6349.
166 H. Lehner, 'Der Tempelbezirk der Matronae Vacallinehae bei Pesch', *Bonner Jahrbücher*, vols 125–6, 1918–21, pp. 74ff.
167 Espérandieu no. 6610.
168 ibid., no. 6616.
169 ibid., nos 6401, 4412.
170 ibid., no. 6506.
171 *CIL* XIII, no. 8216; Espérandieu, nos 6401, 6506, etc.
172 G. Ristow, *Römischer Götterhimmel und frühes Christentum*, 1980, Bild 47.
173 Espérandieu no. 7762.
174 ibid., no. 4269; E. Wilhelm, *Pierres sculptées et inscriptions de l'époque romaine*, 1974, no. 331.
175 Naix: Wightman, 1985, op. cit., p. 179; Vendoeuvres: Espérandieu no. 1539.
176 Green, *The Gods of the Celts*, p. 80.
177 ibid., p. 84.
178 S. Barnard, 'The *Matres* of Roman Britain', *Archaeological Journal*, vol. 142, 1985, pp. 237–43; F. Haverfield, 'The mother goddesses', *Archaeologia Aeliana* 2, vol. 15, 1892, no. 3.

179 R. Merrifield, *London City of the Romans*, 1983, pp. 167–70, 180.
180 J. M. C. Toynbee, 'A Londinium votive leaf or feather and its fellows', in J. Bird, H. Chapman, and J. Clark (eds), *Collectanea Londinensia: Studies in London Archaeology and History presented to Ralph Merrifield*, 1978, pp. 129–48, fig. 1, no. 39.
181 Corinium Museum, Cirencester; Green, *The Gods of the Celts*, fig. 35.
182 Toynbee, 1962, op. cit., pl. 76; Green, *The Gods of the Celts*, fig. 34.
183 Toynbee, 1964, op. cit., pl. XLIII; Green, *The Gods of the Celts*, fig. 30.
184 Toynbee, 1962, op. cit., no. 73, pl. 84; 1964, op. cit., pp. 172ff; Green, *The Gods of the Celts*, fig. 29.
185 For example, Lincoln: British Museum; Bakewell: Haverfield, op. cit., no. 8; and, most important, Ancaster, Lincs: Toynbee, 1964, op. cit., pp. 172ff; Barnard, op. cit., pp. 237–43; M. J. Green, *A Corpus of Religious Material from the Civilian Areas of Roman Britain*, 1976, pp. 167–8, pl. XVf.
186 S. R. Tufi, *Corpus Signorum Imperii Romani. Great Britain Vol. 1, Fasc. 3, Yorkshire*, 1983, no. 26, pl. 7.
187 *RIB*, nos 951, 953.
188 Haverfield, op. cit., no. 45; Phillips, op. cit., no. 236; no. 242.
189 Carlisle: Wright and Phillips, op. cit., no. 185; Netherby: ibid., no. 186, pl. VIb.
190 L. J. F. Keppie and B. J. Arnold, *Corpus Signorum Imperii Romani. Great Britain, Vol. 1, Fasc. 4, Scotland*, no. 61, pl. 19.
191 Green, *The Gods of the Celts*, pp. 78–85.
192 Espérandieu no. 3653.
193 Lucan, *Pharsalia*, I 444–6.

7 Style and belief

1 M. J. Green, *The Gods of the Celts*, 1986, pp. 212–13.
2 S. Boucher, *Recherches sur les bronzes figurés de Gaule pré-romaine et romaine*, 1976, p. 64.
3 T. G. E. Powell, *Prehistoric Art*, 1966, pp. 16–17.
4 J. Briard, *The Bronze Age in Barbarian Europe*, 1979, p. 164.
5 Green, *The Gods of the Celts*, pp. 201–13.
6 M.-L. Sjoestedt, *Gods and Heroes of the Celts*, 1982, pp. 82–4.
7 Espérandieu no. 2066.
8 M. Pobé and J. Roubier, *The Art of Roman Gaul*, 1961, no. 181; R. Schindler, *Führer durch das Landesmuseum Trier*, 1977, p. 37, Abb. 101.
9 R. P. Wright and E. J. Phillips, *Roman Inscribed and Sculptured Stones in Carlisle Museum*, 1975, no. 196.
10 P.-M. Duval, *Monnaies gauloises et mythes celtiques*, 1987, p. 41; L. Zachar, *Keltische Kunst in der Slowakei*, 1987, pl. 201.
11 G. Olmsted, *The Gundestrup Cauldron*, 1979, pl. 3E; P. MacCana, *Celtic Mythology*, 1983, pp. 28–9.
12 Espérandieu no. 2356; Pobé and Roubier, op. cit., no. 180.
13 J. M. C. Toynbee, *Art in Britain under the Romans*, 1964, p. 181; R. J. Brewer, *Corpus Signorum Imperii Romani. Great Britain, Vol. 1, Fasc. 5, Wales*, no. 51, pl. 19.
14 Toynbee, 1964, op. cit., pp. 180–1.
15 E. Thevenot, *Divinités et sanctuaires de la Gaule*, 1968, p. 158.
16 Musée de Vichy; Pobé and Roubier, op. cit., no. 185.
17 J. J. Hatt, *Sculptures antiques régionales Strasbourg*, 1964, nos 150–1.

18 ibid., no. 199.
19 A. Ross, *Pagan Celtic Britain*, 1967, pl. 59b; Green, *The Gods of the Celts*, fig. 14.
20 S. Deyts, *Dijon, Musée Archéologique: sculptures gallo-romaines mythologiques et religieuses*, 1976, no. 160.
21 Duval, 1987, op. cit., p. 41; Zachar, op. cit., pl. 201.
22 J. V. S. Megaw, *Art of the European Iron Age*, 1970, no. 238.
23 Green, *The Gods of the Celts*, p. 211, fig. 15.
24 Megaw, op. cit., no. 2.
25 J. P. Mohen, A. Duval, and C. Eluère (eds), *Trésors des princes celtes*, 1987, no. 27.
26 Green, *The Gods of the Celts*, fig. 79.
27 ibid., pp. 202ff.
28 Grave no. 507: Mohen, Duval, and Eluère, op. cit., no. 26.
29 M. J. Green *et al.*, 'Two bronze animal figurines of probable Roman date recently found in Scotland', *Transactions of the Dumfriesshire & Galloway Natural History & Antiquarian Society*, vol. 60, 1985, pp. 43–50.
30 Musée Saint-Raymond, Toulouse.
31 Green, *The Gods of the Celts*, pp. 202ff.
32 Musée de Châteauroux; Thevenot, 1968, op. cit., p. 13.
33 L. Allason Jones and B. McKay, *Coventina's Well*, 1985, no. 1, pl. V.
34 E. M. Jope, *Celtic Art. Expressiveness and Communication: 500 BC – AD 1500*, 1987.
35 Zachar, op. cit., pls 13–16.
36 B. W. Cunliffe and M. G. Fulford, *Corpus Signorum Imperii Romani. Great Britain. Vol. 1, Fasc. 2, Bath and the rest of Wessex*, 1982, no. 38.
37 Deyts, 1976, op. cit., no. 141.
38 S. Deyts, *Le Sanctuaire des Sources de la Seine*, 1985, pp. 23ff.
39 E. Anati, *Camonica Valley*, 1965.
40 Hatt, 1964, op. cit., nos 162, 163.
41 ibid., no. 162.
42 E. J. Phillips, *Corpus Signorum Imperii Romani. Great Britain, Vol. 1, Fasc. 1, Corbridge. Hadrian's Wall East of the North Tyne*, 1977, no. 324, pl. 87.
43 Green, *The Gods of the Celts*, pp. 28–32.
44 Musée Archéologique de Nîmes.
45 A. Ross, *Pagan Celtic Britain*, 1967, pp. 61–127.
46 D. F. Allen, *The Coins of the Ancient Celts*, 1980, pp. 135–6.
47 P. Lambrechts, *L'Exaltation de la tête dans la pensée et dans l'art des Celtes*, 1954.
48 Megaw, op. cit., no. 75.
49 Green, *The Gods of the Celts*, fig. 100; H. N. Savory, *Guide Catalogue of the Iron Age Collections*, 1976, pl. III.
50 Green, *The Gods of the Celts*, pp. 216–20.
51 J. M. Blazquez, *Primitivas religiones ibericas, Tomo II, Religiones prerromanas*, 1983, no. 158, top.
52 Musée Archéologique de Metz; Espérandieu no. 4709.
53 Pobé and Roubier, op. cit., pl. 11; P. MacCana, op. cit., pp. 116, 117.
54 Espérandieu no. 4543; Musée de Saverne.
55 Espérandieu no. 1381.
56 C. Bémont, *L'Art celtique en Gaule 1983–1984*, 1983–4, p. 196, no. 257.
57 Cunliffe and Fulford, op. cit., no. 103, pl. 27.
58 Wright and Phillips, op. cit., no. 189.

59 Rheinisches Landesmuseum Bonn; Römisch-Germanisches Museum Köln.
60 At Neschers (Puy-de-Dôme): Pobé and Roubier, op. cit., no. 185; Portieux near Epinal: Espérandieu no. 4789; Trier: Espérandieu no. 5034.
61 Brewer, op. cit., no. 14, pl. 6.
62 Espérandieu no. 38; F. Benoit, *L'Art primitif méditerranéan de la vallée du Rhône*, 1969, pl. XXVI, 3.
63 On a triangular bronze plaque: Green, *The Gods of the Celts*, fig. 95; Ashmolean Museum, Oxford.
64 For example, at High Rochester: Phillips, 1977, op. cit., no. 325, pl. 87; and Maryport: J. B. Bailey, 'Catalogue of Roman inscribed and sculptured stones...at Maryport, and preserved at Netherhall', *Transactions of the Cumberland & Westmorland Antiquarian & Archaeological Society*, vol. 15, 1915, no. 59, pl. VI.
65 At Chepstow Castle, where three very schematized figures have large heads only partly accounted for by head-dresses: Brewer, op. cit., no. 51, pl. 19.
66 Musée Archéologique de Dijon; Deyts, 1985, op. cit., pp. 23ff.
67 Bémont, op. cit., nos 269, 270.
68 Green, *The Gods of the Celts*, p. 30, fig. 11; F. Benoit, *Entremont*, 1981, p. 87.
69 Ross, 1967, op. cit., pp. 61–127.
70 G. M. A. Richter, *A Handbook of Greek Art*, 1955, p. 49; A. Bonnano, 'Sculpture', in M. Henig (ed.), *A Handbook of Roman Art*, 1983, p. 82.
71 J. Onians, *Art and Thought in the Hellenistic Age*, 1979, p. 101.
72 E. H. Gombrich, *Art and Illusion*, 1968, pp. 68ff, 104ff; Megaw, op. cit., pp. 11–13.
73 Gombrich, op. cit., p. 104.
74 ibid., p. 90.
75 F. Boas, *Primitive Art*, 1955, pp. 68–9.
76 Powell, 1966, op. cit., p. 7.
77 Duval, 1987, op. cit., p. 15.
78 Anati, op. cit., p. 111.
79 M. Gimbutas, *The Goddesses and Gods of Old Europe*, 1982, pp. 37–8.
80 Green, *The Gods of the Celts*, pp. 200–25.
81 I. Finley, *Celtic Art: an Introduction*, 1973, pp. 20, 54.
82 Hatt, 1964, op. cit., nos 162–4.
83 Espérandieu no. 3609; Deyts, 1976, op. cit., nos 141, 142.
84 Musée Archéologique de Strasbourg; Espérandieu no. 7641; Hatt, 1964, op. cit., no. 199.
85 Green, *The Gods of the Celts*, fig. 98.
86 A. Ellison, *Excavations at West Uley: 1977. The Romano-British Temple*, 1977.
87 Ross, 1967, op. cit., pp. 158–60.
88 Musée Archéologique de Dijon.
89 Espérandieu no. 837.
90 Hatt, 1964, op. cit., no. 162.
91 Espérandieu no. 38.
92 Bémont, op. cit., nos 152, 153
93 As at Tre-Owen, Powys, a simple outline with a round shield and a sword: R. Goodburn, 'Roman Britain in 1977', *Britannia*, vol. 9, 1978, p. 473, pl. XXXb; Brewer, op. cit., no. 15, pl. 6.
94 For example, Maryport: Bailey, op. cit., nos 39, 42, 61; and Burgh-by-

Sands, Cumbria; Kirkby Underdale, Yorkshire: Ross, 1967, op. cit., pl. 50a, b.

95 Wright and Phillips, 1975, op. cit., nos 9, 10; *RIB*, nos 986, 987.

96 S. S. Frere, 'Roman Britain in 1976', *Britannia*, vol. 8, 1977, pp. 392–4; Goodburn, op. cit., pp. 435–6, pls XXV–XXVI.

97 Ross, 1967, op. cit., pl. 60a, b.

98 An exception being a relief at Unterheimbach, Germany: Ross, 1967, op. cit., pl. 50c.

99 Phillips, 1977, op. cit., no. 324, pl. 87; no. 325, pl. 87.

100 Similar examples exist at Willowford, Cumbria: Wright and Phillips, op. cit., no. 98; and again at Wall, Staffordshire, away from Brigantia: Frere, op. cit., pp. 392–4.

101 As at Netherby: Wright and Phillips, op. cit., no. 194; and at Corbridge: Phillips, op. cit., no. 126, pl. 34.

102 Espérandieu no. 3036.

103 Acquired in Marseille: E. Espérandieu and H. Rolland, *Bronzes antiques de la Seine Maritime*, 1959, p. 22, no. 1.

104 Espérandieu no. 7506.

105 At Lower Slaughter: Ross, 1967, op. cit., pl. 62b; Cirencester: Toynbee, 1962, op. cit., p. 156, no. 76, pl. 82; Green, *The Gods of the Celts*, fig. 90.

106 As at Hiéraple: Espérandieu no. 4444; Chevillot near Frémfontaine: Espérandieu no. 4773; Senon: Espérandieu no. 7257; Mainz: Espérandieu no. 7355; Steig: Espérandieu, German volume, no. 552; and Mussig Vicenz near Strasbourg: Espérandieu no. 7290, Hatt, 1964, op. cit., no. 121.

107 Espérandieu no. 7735.

108 ibid., no. 5320.

109 F. Benoit, *Art et dieux de la Gaule*, 1969, pls 234, 235.

110 J.-Cl. Papinot, 'Circonscription Poitou-Charentes', *Gallia*, vol. 43, fasc. 2, 1985, pp. 510–12, pl. 26.

111 Cunliffe and Fulford, op. cit., no. 38, pl. 11.

112 Espérandieu no. 5381.

113 Thevenot, 1968, op. cit., p. 167.

114 Papinot, op, cit., pl. 33.

115 As at Alesia: Deyts, 1976, op. cit., no. 1; Jarnac, Charente: Espérandieu no. 1381; Rodez, Aveyron: Musée Fenaille, Rodez; MacCana, op. cit., p. 71.

116 Green, *The Gods of the Celts*, fig. 95.

117 Green, *The Gods of the Celts*, fig. 22; R. G. Goodchild, 'A priest's sceptre from the Romano-Celtic temple at Farley Heath, Surrey', *Antiquaries Journal*, vol. 18, 1938, pp. 391ff.

118 For example, near Panosses, Isère: Espérandieu no. 410; Tarquimpol near Metz: Espérandieu no. 4503; Le Châtelet: Espérandieu no. 4753.

119 B. W. Cunliffe, *The Celtic World*, 1979, p. 70; Benoit, 1969, op. cit., pl. 161.

120 M. J. Green, *The Wheel as a Cult-symbol in the Romano-Celtic World*, 1984, pp. 163–5.

121 For example, at Corbridge: Toynbee, 1962, op. cit., p. 146, no. 42, pl. 49; Phillips, op. cit., no. 123, pl. 32; the Entremont head-pillar: Pobé and Roubier, op. cit., nos 25, 26; Beire le Châtel: Deyts, 1976, op. cit., no. 12; Dorset: Cunliffe and Fulford, op. cit., no 123, pl. 32; nos 125, 126, pl. 32; Caerhun, Gwynedd (associated with a Roman fort): Brewer, op. cit., no. 52, pl. 19; Caerwent (associated with a late Roman house): Brewer, op. cit., no. 53, pl. 19.

122 For example, Netherby: Wright and Phillips, op. cit., no. 194.

123 For example, at Great Bedwyn, Wiltshire: Cunliffe and Fulford, op. cit., no. 138.
124 As at Eype in Dorset: Cunliffe and Fulford, op. cit., no. 124, pl. 32.
125 Duval, 1987, op. cit.
126 Pobé and Roubier, op. cit., no. 13; F. Benoit, *L'Art primitif méditerranéen de la vallée du Rhône*, 1969, pl. XIII.
127 Thevenot, 1968, op. cit., p. 190.
128 Benoit, *L'Art primitif*, pl. VIII; Bémont, op. cit., nos 152–3.
129 S. Deyts, *Les Bois sculptés des Sources de la Seine*, 1983; *Le Sanctuaire des Sources de la Seine*, 1985.
130 Bémont, op. cit., nos 269, 270.
131 Musée de Châtillon-sur-Seine; Espérandieu nos 3420, 3430–3.
132 Espérandieu no. 5347.
133 ibid., nos 3876–88.
134 For example, a male figure from Ralaghan, Co. Cavan: Ross, 1967, op. cit., pl. 110.
135 Deyts, 1985, op. cit.,
136 Espérandieu nos 3876–88.
137 Deyts, 1985, op. cit.,
138 Bémont, 1983, op. cit., no. 274.

8 Epilogue

1 H. D. Rankin, *Celts and the Classical World*, 1987, p. 260; Diodorus, XXII, 11.

Bibliography

Aartsen, J. van, *Deae Nehalenniae*, Middelburg, Rijksmuseum van Oudheden, 1971.

Abbaye de Daoulas, *Au temps des Celtes Ve – Ier siècle avant JC*, Daoulas, Association Abbaye de Daoulas. Musée Départemental Breton de Quimper, 1986.

Alfs, J., 'A Gallo-Roman temple near Bretten (Baden)', *Germania*, vol. 24, 1940, pp. 128–40.

Allason-Jones, L. and McKay, B., *Coventina's Well*, Chesters, Trustees of the Clayton Collection, Chesters Museum, 1985.

Allen, D. F., 'Belgic coins as illustrations of life in the late pre-Roman Iron Age in Britain', *Proceedings of the Prehistoric Society*, vol. 24, 1958, pp. 43–63.

——'Some contrasts in Gaulish and British coins', in P.–M Duval and C. F. C. Hawkes (eds), *Celtic Art in Ancient Europe*, London, Seminar Press, 1976, pp. 265–82.

——*The Coins of the Ancient Celts*, Edinburgh, Edinburgh University Press, 1980.

Altheim, F., *A History of Roman Religion*, London, Methuen, 1938.

Ambrose, T. and Henig, M., 'A new Roman rider-relief from Stragglethorpe, Lincolnshire', *Britannia*, vol. 11, 1980, pp. 135–8.

Anati, E., *Camonica Valley*, London, Jonathan Cape, 1965.

Anon., 'A Roman carved stone', *Transactions of the Bristol & Gloucestershire Archaeological Society*, vol. 73, 1954, p. 233.

Anon., *Die Kelten in Mitteleuropa*, Salzburg, Keltenmuseum Hallein, 1980.

Audin, A., *Musée de la Civilisation Gallo-Romaine à Lyon*, Lyon, Fayard, 1975.

Autun, *Autun-Augustodunum, capitale des Eduens. Guide de l'exposition*, Autun, Musée Rolin, 1985.

Bailey, C., *Phases in the Religion of Ancient Rome*, London, Oxford University Press, 1932.

Bailey, J. B., 'Catalogue of Roman inscribed and sculptured stones . . . at Maryport, and preserved at Netherhall', *Transactions of the Cumberland & Westmorland Antiquarian & Archaeological Society*, vol. 15, 1915, pp. 135–72.

Barnard, S., 'The *Matres* of Roman Britain', *Archaeological Journal*, vol. 142, 1985, pp. 237–43.

Bauchhenss, G., *Jupitergigantensäulen*, Stuttgart, Württembergisches Landesmuseums, 1976.

Bauchhenss, G. and Nölke, P., *Die Iupitersäulen in den germanischen Provinzen*, Köln/Bonn, Rheinland-Verlag, 1981.

Bémont, C., 'A propos d'un nouveau monument de Rosmerta', *Gallia*, vol. 27, 1969, pp. 23–44.

Bémont, C., *L'Art celtique en Gaule 1983–1984*, Paris, Direction des Musées de France, 1983–4.

Benoit, F., *Art et dieux de la Gaule*, Paris, Arthaud, 1969.

——*L'Art primitif méditerranéen de la vallée du Rhône*, Aix-en-Provence, Publications des Annales de la Faculté des Lettres, 1969.

——*Entremont*, Paris, Ophrys, 1981.

Bergquist, A. and Taylor, T., 'The origin of the Gundestrup Cauldron', *Antiquity*, vol. 61, 1987, pp. 10–24.

Billoret, R., 'Informations archéologiques: Lorraine', *Gallia*, vol. 34, 1976, pp. 352–3.

Biltel, K., *Die Kelten in Baden-Württemberg*, Stuttgart, Theiss, 1981.

Blanc, A., 'Nouveaux bas-reliefs des Déesses-Mères et du Dieu au Maillet chez les Tricastins', *Gallia*, vol. 25, 1967, pp. 67–74.

Blanchet, A., *Traité des monnaies gauloises*, Paris, Ernest Leroux, 1905.

——'Le Jupiter à la roue trouvé à Champagnat (Creuse)', *Bulletin archéologique du Comité des Travaux Historiques et Scientifiques*, 1923, pp. 156–60.

Blazquez, J. M., *Primitivas religiones ibericas, Tomo II, Religiones Prerromanas*, Madrid, Cristiandad, 1983.

Boardman, J., *Greek Art*, London, Thames & Hudson, 1973.

Boas, F., *Primitive Art*, New York, Dover Publications, 1955.

Bober, J. J., 'Cernunnos: origin and transformation of a Celtic divinity', *American Journal of Archaeology*, vol. 55, 1951, pp. 13–51.

Bonnano, A., 'Sculpture', in M. Henig (ed.), *A Handbook of Roman Art*, London, Phaidon, 1983, pp. 66–96.

Boon, G. C., 'A coin with the head of the Cernunnos', *Seaby Coin and Medal Bulletin*, no. 769, 1982, pp. 276–82.

——*Laterarum Iscanum: The Antefixes, Bricks and Tile Stamps of the Second Augustan Legion*, Cardiff, National Museum of Wales, 1984.

Botouchrova, L., 'Un nouveau monument de la déesse celto-romaine Epona', *Revue archéologique*, vol. 33, 1949, pp. 164ff.

Boucher, S., *Recherches sur les bronzes figurés de Gaule pré-romaine et romaine*, Paris and Rome, Ecole Française de Rome, 1976.

Braemar, F., *L'Art dans l'occident romain*, Paris, Editions de la Réunion des Musées Nationaux, Palais du Louvre, 1963.

Brewer, R. J., *Corpus Signorum Imperii Romani. Great Britain. Vol. 1, Fasc. 5, Wales*, London and Oxford, British Academy and Oxford University Press, 1986.

Briard, J., *The Bronze Age in Barbarian Europe*, London, Book Club Associates, 1979.

British Museum, *Guide to the Antiquities of Roman Britain*, London, British Museum, 1964.

Brogan, O., *Roman Gaul*, London, Bell, 1953.

Brunaux, J. L., *Les Gaulois: sanctuaires et rites*, Paris, Errance, 1986.

Charlton, D. B. and Mitcheson, M. M., 'Yardhope, a shrine to Cocidius?', *Britannia*, vol. 14, 1983, pp. 142–53.

Charrière, G., 'Le taureau aux trois grues et le bestiaire du héros celtique', *Revue d'histoire des religions*, vol. 69, 1966, pp. 155ff.

Chassaing, M., 'Les Barillets de Dispater', *Revue archéologique*, vol. 47, 1956, pp. 156ff.

Clébert, J.-P., *Provence antique 2 L'époque gallo-romaine*, Paris, Laffont, 1970.

Colin, J., *Les Antiquités romaines et germains rhénanie*, Paris, Société d'Edition 'Les Belles Lettres', 1927.

Collingwood, R. G. and Wright, R. P., *The Roman Inscriptions of Britain*, Oxford, Oxford University Press, 1965.

Colombet, A. and Lebel, P., 'Mythologie gallo-romaine', *Revue archéologique de l'est et du centre-est*, vol. 4, no. 2, 1953 pp. 108–30.

Cook, A. B., *Zeus: A Study in Ancient Religion*, Cambridge, Cambridge University Press, 1925.

Courcelle-Seneuil, J. L., *Les Dieux gaulois d'après les monuments figurés*, Paris, Ernest Leroux, 1910.

Cravayat, P., 'Les cultes indigènes dans la cité des Bituriges', *Revue archéologique de l'est et du centre-est*, vol. 6, 1955, pp. 210–28.

Cunliffe, B. W., *The Celtic World*, London, Bodley Head, 1979.

——*Danebury: Anatomy of an Iron Age Hillfort*, London, Batsford, 1983.

Cunliffe, B. W. and Fulford, M. G., *Corpus Signorum Imperii Romani. Great Britain Vol. 1, Fasc. 2. Bath and the rest of Wessex*, London and Oxford, British Academy and Oxford University Press, 1982.

Dayet, M., 'Le sanglier à trois cornes du Cabinet des Medailles', *Revue archéologique de l'est et du centre-est*, vol. 5, 1954, pp. 334–5,

——'Le Borvo Hercule d'Aix-les-Bains', *Revue archéologique*, 1963, p. 167.

Dehn, W., 'Ein Quelheiligtum des Apollo und der Sirona bei Hochscheid', *Germania*, vol. 25, 1941, pp. 104ff.

Deonna, W., *Ville de Genève: Musée d'Art et d'Histoire: Catalogue des bronzes figurés antiques*, Geneva, *Extrait de l'indicateur d'antiquités suisses*, 1915–16.

——'Trois, superlatif absolu: à propos du taureau tricornu et de Mercure triphallique', *L'Antiquité classique*, vol. 23, 1954, pp. 403–28.

Devauges, J.-B., 'Circonscription de Bourgogne', *Gallia*, vol. 32, 1974, p. 434.

Deyts, S., *Dijon, Musée Archéologique: sculptures gallo-romaines mythologiques et religieuses*, Paris, Editions de la Réunion des Musées Nationaux, 1976.

——*Les Bois sculptés des Sources de la Seine*, Paris, XLIIe supplément à *Gallia*, 1983.

——*Le Sanctuaire des Sources de la Seine*, Dijon, Musée Archéologique, 1985.

Downey, R., Kings A., and Soffe, G., 'The Hayling Island temple and religious connections across the Channel', in W. Rodwell (ed.), *Temples, Churches and Religion in Roman Britain*, Oxford, British Archaeological Reports, 1980, pp. 289–304.

Drioux, G., *Cultes indigènes des Lingons*, Paris and Langres, Picard and Imprimerie Champenoise, 1934.

Drury, P. J. and Wickenden, N. P., 'Four bronze figurines from the Trinovantian Civitas', *Britannia*, vol. 13, 1982, pp. 239–43.

Dumézil, G., *Archaic Roman Religion*, Chicago, University of Chicago Press, 1970.

Dumoulin, A., *Le Musée Archéologique de Vaison-la-Romaine*, Vaison, Office de Tourisme – Syndicat d'Initiative, 1978.

Duval, P.-M. 'Le dieu "Smertrios" et ses avatars gallo-romains', *Etudes celtiques*, vol. 6, 2, 1953–4, pp. 219–38.

——*Paris antique*, Paris, Hermann, 1961.

——*Les Dieux de la Gaule*, Paris, Payot, 1976.

——*Les Celtes*, Paris, Gallimard, 1977.

——*Monnaies gauloises et mythes celtiques*, Paris, Hermann, 1987.

Duval, P.-M., Amy, R., Formigé, J., Hatt, J. J., Piganiol, A., Picard, Ch., and Picard, G. Ch., *L'Arc d'Orange*, Paris, XVe supplément à *Gallia*, 1962.

Egger, R., 'Genius cucullatus', *Wiener Praehistorische Zeitschrift*, vol. 19, 1932, pp. 311–23.

Ellison, A., *Excavations at West Uley: 1977. The Romano-British Temple*, CRAAGS Occasional Paper, no. 3, 1977.

Espérandieu, E., *Recueil général des bas-reliefs de la Gaule romaine et pré-romaine*, Paris, Ernest Leroux, 1907–66.

——'Le Dieu cavalier de Luxeuil', *Revue archéologique*, vol. 70, 1917, pp. 72–86.

——*Le Musée Lapidaire de Nîmes. Guide sommaire*, Nîmes, Imprimerie Générale, 1924.

Espérandieu, E. and Rolland, H., *Bronzes antiques de la Seine Maritime*, Paris, XIIIe supplément à *Gallia*, 1959.

Eygun, F., 'Informations archéologiques: Poitiers', *Gallia*, vol. 23, 1965, pp. 349–87.

Ferdière, A., 'Informations archéologiques: circonscription du centre', *Gallia*, vol. 43, fasc. 2, 1985, pp. 297–301.

Ferguson, J., *The Religions of the Roman Empire*, London, Thames & Hudson, 1970.

Finley, I., *Celtic Art: An Introduction*, London, Faber & Faber, 1973.

Fol, A. and Marazov, I., *Thrace and the Thracians*, London, Cassell, 1977.

Foster, J., *Bronze Boar Figurines in Iron Age and Roman Britain*, Oxford, British Archaeological Reports, no. 39, 1977.

Fouet, G., *La Villa gallo-romaine de Montmaurin*, Paris, XXe supplément à *Gallia*, 1969.

——'Le Sanctuaire des eaux de "La Hillère" à Montmaurin', *Gallia*, vol. 30, 1972, pp. 83–124.

——'Le Sanctuaire gallo-romain de Valentine (Haute-Garonne)', *Gallia*, vol. 42, 1984, pp. 153–73.

Fouet, G. and Soutou, A., 'Une cime pyrénéenne consacrée à Jupiter: Le Mont Saçon (Hautes-Pyrénées)', *Gallia*, vol. 21, 1963, pp. 75–295.

Frere, S. S., 'Roman Britain in 1976', *Britannia*, vol. 8, 1977, pp. 356–425.

Freudenburg, J., 'Darstellungen des Matres oder Matronae in Thonfiguren aus Uelmen', *Bonner Jahrbücher*, vol. 18, 1852, pp. 97–129.

Giffault, M., 'Deux figurines de terre cuite Gallo-Romaines à Saintes', *Gallia*, vol. 32, 1974, pp. 249–53.

Gimbutas, M., *The Goddesses and Gods of Old Europe*, London, Thames & Hudson, 1982.

Giot, P. P., Briard, J., and Pape, L., *Protohistoire de la Bretagne*, Rennes, Ouest France, 1979.

Goodburn, R., 'Roman Britain in 1977', *Britannia*, vol. 9, 1978, pp. 404–72

Goodchild, R. G., 'A priest's sceptre from the Romano-Celtic temple at Farley Heath, Surrey', *Antiquaries Journal*, vol. 18, 1938, pp. 391ff.

Gombrich, E. H., *Art and Illusion*, London. Phaidon, 1968.

Green, M. J., *A Corpus of Religious Material from the Civilian Areas of Roman Britain*, Oxford, British Archaeological Reports, no. 24, 1976.

——*Small Cult Objects from Military Areas of Roman Britain*, Oxford, British Archaeological Reports, no. 52, 1978.

——'Model objects from military areas of Roman Britain', *Britannia*, vol. 12, 1981, pp. 253–70.

——'Tanarus, Taranis and the Chester Altar', *Journal of the Chester Archaeological Society*, vol. 65, 1982, pp. 37–44.

——'A Celtic god from Netherby, Cumbria', *Transactions of the Cumberland & Westmorland Antiquarian & Archaeological Society*, vol. 83, 1983, pp. 41–7.

——*The Gods of Roman Britain*, Princes Risborough, Shire Archaeology, 1983.

——'Celtic symbolism at Roman Caerleon', *Bulletin of the Board of Celtic Studies*, vol. 31, 1984, pp. 251–8.

——'Mother and sun in Romano-Celtic religion', *Antiquaries Journal*, vol. 64, 1984, pp. 25–33.

——*The Wheel as a Cult-symbol in the Romano-Celtic World*, Brussels, Latomus, 1984.

——*The Gods of the Celts*, Gloucester and New Jersey, Alan Sutton and Barnes & Noble, 1986.

——'Jupiter, Taranis and the solar wheel', in M. Henig and A. King (eds), *Pagan Gods and Shrines of the Roman Empire*, Oxford, University Committee for Archaeology, 1986, pp. 65–76.

Green, M. J., Cowie, T., and Lockwood, D., 'Two bronze animal figurines of probable Roman date recently found in Scotland', *Transactions of the Dumfriesshire & Galloway Natural History & Antiquarian Society*, vol. 60, 1985, pp. 43–50.

Greenfield, E., 'The Romano-British shrines at Brigstock, Northants', *Antiquaries Journal*, vol. 43, 1963, pp. 228ff.

Gros, P., 'Une hypothèse sur l'Arc d'Orange', *Gallia*, vol. 44, fasc. 2, 1986, pp. 192–201.

Guthrie, W. K. C., *The Greeks and Their Gods*, London, Methuen, 1954.

Harding, D. W., *The Iron Age in Lowland Britain*, London, Routledge & Kegan Paul, 1974.

Hatt, J. J., *Les Monuments funéraires gallo-romains du Comminges et du Couserans*, Toulouse, Annales du Midi, 1945.

——' "Rota Flammis Circumsepta". A propos du symbole de la roue dans la région gauloise', *Revue archéologique de l'est et du centre-est*, vol. 2, 1951, pp. 82–7.

——*Sculptures antiques régionales Strasbourg*, Paris, Musée Archéologique de Strasbourg, 1964.

——*Celts and Gallo-Romans*, London, Barrie & Jenkins, 1970.

——'Les dieux gaulois en Alsace', *Revue archéologique de l'est et du centre-est*, vol. 22, 1971, pp. 187–276.

——'De la Champagne à la Bourgogne: remarques sur l'origine et la signification du tricéphale', *Revue archéologique de l'est et du centre-est*, vol. 35, 1984, pp. 287–99.

——'Le Double Suovetaurile de Beaujeu et le culte des déesses-mères et de la tutelle à Lyon', *Revue archéologique de l'est et du centre-est*, vol. 87, 1986, pp. 263–7.

Haverfield, F., 'The Mother Goddesses', *Archaeologia Aeliana* (2), vol. 15, 1892, pp. 314–39.

Heichelheim, F. M., 'Genii cucullati', *Archaeologia Aeliana* (4), vol. 12, 1935, pp. 187–94.

Hettner, F., *Drei Tempelbezirke im Trevererlande*, Trier, Kommissionsverlag der Fr Lintschen Buchhandlung Friedr. Val. Lintz, 1901.

Hodson, F. R. and Rowlett, R. M., 'From 600 BC to the Roman Conquest', in S. Piggott, G. Daniel, and C. McBurney (eds), *France before the Romans*, London, Thames & Hudson, 1973, pp. 157–91.

Hondius-Crone, A., *The Temple of Nehalennia at Domburg*, Amsterdam, Meulenhoff, 1955.

Horn, H. G., *Die Römer in NordRhein-Westfalen*, Stuttgart, Theiss, 1987.

Jackson, K. H., *The Oldest Irish Tradition: a Window on the Iron Age*, Cambridge, Cambridge University Press, 1964.

Jenkins, F., 'Nameless or Nehalennia', *Archaeologia Cantiana*, vol. 70, 1956, pp. 192–200.

——'The cult of the Dea Nutrix in Kent', *Archaeologia Cantiana*, vol. 71, 1957, pp. 38–46.

——'The role of the dog in Romano-Gaulish religion', *Collection Latomus*, vol. 16, 1957, pp. 60–76.

——'The cult of the "Pseudo-Venus" in Kent', *Archaeologia Cantiana*, vol. 72, 1958, pp. 60–76.

——'Some interesting types of clay statuettes of the Roman period found in London', in J. Bird, H. Chapman, and J. Clark (eds), *Collectanea Londinensia: Studies in London Archaeology and History presented to Ralph Merrifield*, London & Middlesex Archaeological Society, 1978, pp. 149–62.

Joffroy, R., *Musée des Antiquités Nationales, St-Germain-en-Laye*, Paris, Editions de la Réunion des Musées Nationaux, 1979.

Johns, C. M., 'A Roman bronze statuette of Epona', *British Museum Quarterly*, vol. 36, nos. 1–2, 1971–2, pp. 37–41.

——*Sex or Symbol: Erotic Images of Greece and Rome*, London, British Museum, 1982.

Johnston, P. M., 'Roman vase found at Littlehampton', *Sussex Archaeological Collections*, vol. 46, 1903, pp. 233–4.

Jope, E. M., *Celtic Art. Expressiveness and Communication: 500 BC – AD 1500*, Sir John Rhŷs 44th Memorial Lecture, British Academy, London, 28, April 1987.

Kent Hill, D., 'Le "Dieu au Maillet" de Vienne à la Walters Art Gallery de Baltimore', *Gallia*, vol. 11, 1953, pp. 205–24.

Keppie, L. J. F. and Arnold, B. J., *Corpus Signorum Imperii Romani. Great Britain Vol. 1, Fasc. 4. Scotland*, London and Oxford, British Academy and Oxford University Press, 1984.

Laet, S. J. de, 'Figurines en terre cuite de l'époque romaine trouvées à Assche-Kalkoven', *L'Antiquité classique*, vol. 10, 1942, pp. 41–54.

Laing, L. R., *Coins and Archaeology*, London, Weidenfeld & Nicolson, 1969.

Lambrechts, P., *Contributions à l'étude des divinités celitiques*, Brugge, Rijksuniversitaet te Gent, 1942.

——'Note sur une statuette en bronze de Mercure au Musée de Tongres', *L'Antiquité classique*, vol. 10, 1942, pp. 71ff.

——*Divinités equestres celtiques ou défunts héroisé?, L'Antiquité classique*, fasc. 1., 1951.

——*L'exaltation de la tête dans la pensée et dans l'art des Celtes*, Brugge, Dissertationes Archaeologicae Gandenses, 2, 1954.

Lebel, P. and Boucher, S., *Bronzes figurés antiques (Musée Rolin)*, Paris, de Boccard, 1975.

Lefébure, L., *Les Sculptures gallo-romaines du Musée d'Arlon*, Arlon, Musée d'Arlon, 1975.

Le Gall, J., *Alésia archéologie et histoire*, Paris, Fayard, 1963.

——*Alésia*, Paris, Ministère de la Culture, 1985.

Lehner, H., 'Der Tempelbezirk der Matronae Vacallinehae bei Pesch', *Bonner Jahrbücher*, vols 125–6, 1918–21, pp. 74ff.

Lelong, C., 'Note sur une sculpture gallo-Romaine de Mouhet (Indre)', *Revue archéologique du centre*, vol. 9, 1970, pp. 123–6.

Linckenheld, E., *Les Stèles funéraires en forme de maison chez les Médiomatriques et en Gaule*, Paris, Société d'Edition 'Les Belles Lettres', 1927.

——'Sucellus et Nantosuelta', *Revue de l'histoire des religions*, vol. 99, 1929, pp. 40–92.

Lindgren, C., *Classical Art-Forms and Celtic Mutations: Figural Art in Roman Britain*, New Jersey, Noyes Press, 1978.

Linduff, K., 'Epona: a Celt among the Romans', *Collection Latomus*, vol. 38, fasc. 4, 1979, pp. 817–37.

Loeschcke, S., *Lampen aus Vindonissa*, Zürich, In Kommission bei Beer & Cie, 1919.

Louibie, B., 'Statuette d'un dieu gallo-romain au bouc et au serpent cornu trouveé à Yzeures-sur-Creuse (Indre et Loire)', *Gallia*, vol. 23, 1965, pp. 279–84.

MacCana, P., *Celtic Mythology*, London, Newnes, 1983.

McCarthy, M. R., Padley, T. G., and Henig, M., 'Excavations and finds from the Lanes, Carlisle', *Britannia*, vol. 13, 1982, pp. 79–89.

Magnen, R. and Thevenot, E., *Epona*, Bordeaux, Delmas, 1953.

Marache, R., *Les Romains en Bretagne*, Rennes, Ouest France, 1979.

Marin, J.-Y. and Bertaux, J. J., 'Le Musée de Normandie', *Archéologia préhistoire et archéologie*, no. 204, July/August 1985, pp. 49–54.

Megaw, J. V. S., *Art of the European Iron Age*, New York, Harper & Row, 1970.

Megaw, J. V. S. and Simpson, D. D. A., *Introduction to British Prehistory*, Leicester, Leicester University Press, 1979.

Merrifield, R., *London City of the Romans*, London, Batsford, 1983.

Mertens, J., 'Reflexions à propos du "cavalier-aux-géants anguipèdes" de Tongres', *Revue archéologique de l'est et du centre-est*, vol. 33, 1982, pp. 47–53.

Mitard, P.-H., 'La Sculpture gallo-romaine dans le Vexin Français', *Histoire et archéologie*, no. 76, September 1983.

Mohen, J. P., Duval, A., and Eluère, C. (eds) *Trésors des princes celtes*, Paris, Editions de la Réunion des Musées Nationaux, 1987.

Musée Archéologique de Dijon, *L'Art de la Bourgogne romaine découvertes récentes*, Dijon, Musée Archéologique, 1973.

Musée Archéologique de Metz, *La Civilisation gallo-romaine dans la cité des Médiomatriques*, Metz, Musée Archéologique, 1981.

Musée Archéologique de Saintes, *Saintes à la recherche de ses dieux*, Saintes, Société d'Archéologue et d'Histoire de la Charente-Maritime, 1984.

Musée Archéologique, Strasbourg, *Catalogue*, Strasbourg, Musée Archéologique, undated.

Musée Bossuet, *Collections du Musée de Meaux 1. Préhistoire protohistoire gallo-romain*, Meaux, Musée Bossuet, 1983.

Nicolini, G., 'Informations archéologiques: Poitou-Charentes', *Gallia*, vol. 33, 1975, pp. 381–2.

Oaks, L. S., 'The goddess Epona: concepts of sovereignty in a changing landscape', in M. Henig and A. King (eds), *Pagan Gods and Shrines of the Roman Empire*, Oxford, University Committee for Archaeology, 1986, pp. 77–84.

Oggiano-Bitar, H., *Bronzes figurés antiques de Bouches-du-Rhône*, Paris, XLIIIe supplément à *Gallia*, 1984.

Olmsted, G., *The Gundestrup Cauldron*, Brussels, Latomus, 1979.

Onians, J., *Art and Thought in the Hellenistic Age*, London, Thames & Hudson, 1979.

Papinot, J.-Cl., 'Circonscription Poitou-Charentes', *Gallia*, vol. 43, fasc. 2, 1985.

Pauli, L., *The Alps: Archaeology and Early History*, London, Thames & Hudson, 1984.

Petrikovits, H. von, 'Matronen und Verwandte Gottheiten', *Ergebnisse eines Kolloquiums veranstaltet von der Göttinger Akademiekommission für die Altertumskunde Mittel- und Nordeuropas*, Köln and Bonn, Beihafte der Bonner Jahrbücher, Band 44, 1987, pp. 241–54.

Pétry, F., 'Circonscription d'Alsace', *Gallia*, vol. 32, 1974.

Phillips, E. J., *Corpus Signorum Imperii Romani. Great Britain Vol. 1, Fasc. 1. Corbridge. Hadrian's Wall East of the North Tyne*, London and Oxford, British Academy and Oxford University Press, 1977.

Picard, G. Ch., 'Informations archéologiques: Centre', *Gallia*, vol. 26, 1968, pp. 321–45.

Piette, J., 'Le Fanum de la Villeneuve-au-Châtelot (Aube): état des recherches en 1979', *Mémoires de la Société Archéologique Champenoise*, vol. 2, 1981, pp. 367–75.

Piggott, S., *The Druids*, London, Thames & Hudson, 1968.

Pirling, R., *Römer und Franken am Niederrhein*, Mainz am Rhein, Verlag Phillip von Zabern, 1986.

Planson, E. and Pommeret, C., *Les Bolards*, Paris, Ministère de la Culture/Imprimerie Nationale, 1986.

Pobé, M. and Roubier, J., *The Art of Roman Gaul*, London, Galley Press, 1961.

Powell, T. G. E., *The Celts*, London, Thames & Hudson, 1958.

——*Prehistoric Art*, London, Thames & Hudson, 1966.

Rankin, H. D., *Celts and the Classical World*, London and Sydney, Croom Helm, 1987.

Read, S., Henig, M., and Cramm, L., 'Three-horned bull', *Britannia*, vol. 17, 1986, pp. 346–8.

Rees, A. and Rees, B., *Celtic Heritage*, London, Thames & Hudson, 1961.

Reinach, S., *Description raisonnée du Musée de Saint-Germain-en-Laye. Bronzes figurés de la Gaule romaine*, Paris, Librairie de Firmin-Didot et Cie, 1894.

Rémy, B., 'Les Inscriptions de médicins en Gaule', *Gallia*, vol. 42, 1984, pp. 115–52.

Rheinisches Landesmuseum Bonn, *Wir Entdecken die Römer*, Bonn, Rheinisches Landesmuseum, 1973.

Rhodes, J. F., *Catalogue of the Romano-British Sculptures in the Gloucester City Museum*, Gloucester, City Museum, 1964.

Richter, G. M. A., *A Handbook of Greek Art*, London, Phaidon, 1955.

Ristow, G., *Religionen und Ihre Denkmäler in Köln*, Köln, Römisch-Germanisches Museum der Stadt Köln, 1975.

——*Römischer Götterhimmel und frühes Christentum*, Köln, Wienard Verlag, 1980.

Ritchie, W. F. and Ritchie, J. N. G., *Celtic Warriors*, Princes Risborough, Shire Archaeology, no. 41, 1985.

Rolland, H., 'Inscriptions antiques de Glanum', *Gallia*, vol. 3, 1944, pp. 167–223.

Römisch-Germanisches Museum, Köln, *Museum*, Köln, Römisch-Germanisches Museum, 1983.

Ross, A., 'The horned god of the Brigantes', *Archaeologia Aeliana* (4), vol. 39, 1961, pp. 59ff.

——*Pagan Celtic Britain*, London, Routledge & Kegan Paul, 1967.

——*The Pagan Celts*, London, Batsford, 1986.

Rouvier-Jeanlin, M., *Les Figurines gallo-romaines en terre cuite au Musée des Antiquités Nationales*, Paris, XXIVe supplément à *Gallia*, 1972.

Rybova, A., *Keltská Svatyně ve Středních Cechách: Sanctuaire celtique en Bohême Centrale*, Prague, Nakladatelství Československé Akademie Věd, 1962.

Salviat, F., *Glanum*, Paris, Caisse Nationale des Monuments Historiques et des Sites, 1979.

Santrot, J., 'Le Mercure phallique du Mas-Agenais et un dieu stylite inédit', *Gallia*, vol. 44, fasc. 2, 1986, pp. 203–28.

Savory, H. N., *Guide Catalogue of the Iron Age Collections*, Cardiff, National Museum of Wales, 1976.

Schindler, R., *Führer durch des Landesmuseum Trier*, Trier, Selbstverlag des Rheinischen Landesmuseums, 1977.

Seltman, C., *The Twelve Olympians*, London, Pan, 1952.

Sjoestedt, M.-L., *Gods and Heroes of the Celts*, Berkeley, Calif., Turtle Island Foundation, 1982.

Smith, D. J., 'A Romano-Celtic head from Lemington, Tyne & Wear', in R. Miket and C. Burgess (eds), *Between and Beyond the Walls*, Edinburgh, John Donald, 1984, pp. 221-3.

Sprockhoff, E., 'Central European Urnfield culture and Celtic La Tène: an outline', *Proceedings of the Prehistoric Society*, vol. 21, 1955, pp. 257-82.

Staehelin, F., *Der Schweiz in Römische Zeit*, Basel, Benno Schwabe & Co. Verlag, 1931.

Stead, I. M., Bowke, J. B., and Brothwell, D., *Lindow Man. The Body in the Bog*, London, British Museum, 1986.

Stebbins, E. B., *The Dolphin in the Literature and Art of Greece and Rome*, Menasha, Wisc., dissertation, Johns Hopkins University, 1929.

Surrey Archaeological Society, *Roman Temple, Wanborough*, Guildford, Surrey Archaeological Society, 1988.

Szabó, M., *The Celtic Heritage in Hungary*, Budapest, Corvina, 1971.

Térouanne, P., 'Dédicaces à Mars Mullo. Découvertes à Allonnes (Sarthe)', *Gallia*, vol. 18, 1960, pp. 185-9.

Thevenot, E., *Autun*, Autun, Imprimerie-Librairie L. Taverne & Ch. Chandioux, 1932.

——'Le Cheval sacré dans la Gaule de l'Est', *Revue archéologique de l'est et du centre-est*, vol. 2, 1951, pp. 129-41.

——'Maillets votifs en pierre', *Revue archéologique de l'est et du centre-est*, vol. 3, 1952, pp. 99-103.

——'Deux figurations nouvelles du Dieu au Maillet accompagne de tonneau ou amphore', *Gallia*, vol. 11, 1953, pp. 293-304.

——*Sur les traces des Mars celtiques*, Bruges, Dissertationes Archaeologicae Gandenses, vol. 3, 1955.

——'Sur les figurations du "Dieu au Tonneau" ', *Revue archéologique de l'est et du centre-est*, vol. 8, 1957, pp. 311-14.

——*Divinités et sanctuaires de la Gaule*, Paris, Fayard, 1968.

——*Le Beaunois gallo-romain*, Brussels, Latomus, fasc. 113, 1971.

Thill, G., *Les Epoques gallo-romaine et mérovingienne au Musée d'Histoire et d'Art, Luxembourg*, Luxembourg, Musée d'Histoire et d'Art, 1978.

Toussaint, M., *La Lorraine à l'époque gallo-romaine*, Nancy, J. Dory, 1928.

——*Metz à l'époque gallo-romaine*, Metz, Imprimerie Paul Even, 1948.

Toynbee, J. M. C., *Art in Roman Britain*, London, Phaidon, 1962.

——*Art in Britain under the Romans*, Oxford, Oxford University Press, 1964.

——*Animals in Roman Life and Art*, London, Thames & Hudson, 1973.

——'A Londinium votive leaf or feather and its fellows', in J. Bird, H. Chapman, and J. Clark (eds), *Collectanea Londinensia: Studies in London Archaeology and History presented to Ralph Merrifield*, London & Middlesex Archaeology, 1978, pp. 129-48.

Tufi, S. R., *Corpus Signorum Imperii Romani. Great Britain. Vol. 1, Fasc. 3. Yorkshire*, London and Oxford, British Academy and Oxford University Press, 1983.

Turner, R. C., *Ivy Chimneys, Witham: an interim Report*, Essex County Council Occasional Paper no. 2, 1982.

Vatin, C., 'Ex-voto de bois gallo-romain à Chamalières', *Revue archéologique* vol. 103, 1969.

Vertet, H. and Vuillemot, G., *Figurines gallo-romaines en argile d'Autun*, Autun, Collections du Musée Rolin, 1973.

Vries, J. de, *La Religion des Celtes*, Paris, Payot, 1963.

Wait, G. A., *Ritual and Religion in Iron Age Britain*, Oxford, British *Archaeological Reports* (British Series), vol. 149, 1985.

Webster, G., *The British Celts and Their Gods under Rome*, London, Batsford, 1986.

——'What the Britons required from the gods as seen through the pairing of Roman and Celtic deities and the character of votive offerings', in M. Henig and A. King (eds), *Pagan Gods and Shrines of the Roman Empire*, Oxford, University Committee for Archaeology, 1986, pp. 57–64.

Wheeler, R. E. M., *Report on the Excavations. . . .in Lydney Park, Gloucestershire*, Oxford, Oxford University Press, 1932.

Wightman, E. M., *Roman Trier and the Treveri*, London, Hart-Davis, 1970.

——*Gallia Belgica*, London, Batsford, 1985.

Wild, J. P., 'Die Frauentracht der Ubier', *Germania*, vol. 46, 1968, pp. 67–73.

Wilhelm, E., *Pierres sculptées et inscriptions de l'époque romaine*, Luxembourg, Musée d'Histoire et d'Art, 1974.

Wright, R. P. and Phillips, E. J., *Roman Inscribed and Sculptured Stones in Carlisle Museum*, Carlisle, Tullie House Museum, 1975.

Wuilleumier, P., *Inscriptions latines des Trois Gaules*, Paris, XVIIe supplément à *Gallia*, 1984.

Zachar, L., *Keltische Kunst in der Slowakei*, Bratislava, Tatran, 1987.

Zwicker, J., *Fontes Historiae Religionis Celticae*, Berlin, Walter de Gruyter, 1935.

Index